*Selected Far Eastern Art
in the Yale University
Art Gallery*

Selected Far Eastern Art
In The Yale University
Art Gallery

A Catalogue by George J. Lee

Published for the
Yale University Art Gallery by
Yale University Press
New Haven and London, 1970

Designed by Sally Sullivan,
set in Linotype Garamond type,
and printed in the United States of America by
The Carl Purington Rollins Printing-Office
of the Yale University Press.

Distributed in Great Britain, Europe, and Africa by
Yale University Press, Ltd., London; in Canada by
McGill-Queen's University Press, Montreal; in Mexico
by Centro Interamericano de Libros Académicos,
Mexico City; in Australasia by Australia and New
Zealand Book Co., Pty., Ltd., Artarmon, New South
Wales; in India by UBS Publishers' Distributors Pvt.,
Ltd., Delhi; in Japan by John Weatherhill, Inc., Tokyo.

Contents

Foreword

This catalogue, whose publication was assisted by a grant from the Ford Foundation, presents one of the lesser-known assets of the Yale Art Gallery. Yet it should come as no great surprise, for Yale's cultural contacts with the Far East began in the 1830s, the decade of the founding of the gallery. Later, S. Wells Williams, some of whose collection appears in this volume, accompanied Admiral Perry in the opening of Japan in 1854. Williams eventually became a University Professor at Yale, and his descendants continued his interest in Oriental culture and in the gallery.

The current curator, Mr. George J. Lee, is aware of the continuing past at Yale and is grateful for the expertise of donors, past and visiting curators, and all other members of the department who have assisted in the research of these objects. He is also aware of the continuing present and has brought new and broadened techniques to the examination of individual works of Far Eastern art.

Recent years have brought tremendous growth to the Oriental as well as other areas of the Yale Art Gallery. That the Far Eastern holdings have coalesced into a valuable teaching collection is amply demonstrated by this catalogue.

ANDREW C. RITCHIE
Director

Preface

The first Oriental objects entered the collection of Yale College more than a century ago. They consisted, as might be anticipated from the date, of commissioned portraits and other pictures rendered in Western techniques by Chinese artists. Over the decades, changes have taken place in the collecting of Oriental art for Yale. At first the objects secured were secondary to the activities of the people who collected—missionaries, scholars, and businessmen with Far Eastern connections. They collected with vigor, and pieces of considerable significance can be found among the objects accumulated. One may cite the material collected by John Hadley Cox while teaching at Yale-In-China at Ch'ang-sha in the 1930s. Within the last two decades, the University has benefited from enthusiastic collectors of Oriental art among her devoted alumni. Wayland Wells Williams, continuing his family's interests and traditions, and Dr. Yale Kneeland, Jr., have presented pieces that would bring distinction to any collection. But first, of course, come the gifts and bequests of Mrs. William H. Moore, whose generosity has enabled the Yale Art Gallery to operate in recent years on wholly new levels in the presentation of Far Eastern as well as Near Eastern art.

It is hoped that this catalogue of Far Eastern pieces will serve a number of purposes. It may, first, produce illustrations of and scholarship on previously unpublished objects. This is particularly true of the material from Ch'ang-sha, where recent archaeological finds on mainland China supplement the knowledge about the Yale pieces. Second, it will try to amend scholarship on a number of objects of distinction, often illustrated in out-of-date publications. Third, the catalogue will establish the presence of certain pieces at Yale and clarify their relationship with generally parallel objects. Last, it will we hope make small contributions to the general field of knowledge in Far Eastern art.

Translations, unless they are otherwise indicated, are by the author. Where possible, the place of probable manufacture of an object is given, or the place of discovery. For the system of dating used, see the chronology.

We are grateful to colleagues at Yale and visitors, who have often contributed pregnant suggestions. Credit for the vast majority of the photographs belongs to Mr. Charles Uht of New York City. All the departmental assistants over the last ten years have contributed directly or indirectly to this catalogue; this might involve preliminary research on or even the manual cleaning of an object to establish its importance. To the recent research assistant, Miss Rosalyn Driscoll, goes a major share of any success achieved in unifying and standardizing the diverse catalogue entries. The members of the Gallery staff at Yale have been long-suffering as the Oriental department and this catalogue were slowly pulled together; for their tolerance we are indeed grateful.

GEORGE J. LEE
Curator of Oriental Art

Abbreviations

ACASA: Archives of the Chinese Art Society of America

BAFAYU: Bulletin of the Associates in Fine Arts at Yale University (Yale Art Gallery Bulletin after 1958)

BMFEA: Bulletin of the Museum of Far Eastern Antiquities

CASA: Chinese Art Society of America

Ch'ang-sha Cemeteries: Ch'ang-sha fa chüeh pao-kao (Cemeteries excavated in Ch'ang-sha), Peking, 1957

"Ch'ang-sha liang-chin:" Hunan Provincial Museum, "Ch'ang-sha liang-chin nan-ch'ao sui mu fa chüeh pao-kao" (Report of excavated graves of the two Chin, Nan-ch'ao, and Sui dynasties at Ch'ang-sha), *KKHP,* 1959, no. 3, pp. 75–105

"Ch'ang-sha nan-chiao:" Hunan Provincial Museum, "Ch'ang-sha nan-chiao ti liang-chin, nan-chao, sui tai mu tsang" (Excavations of Western Tsin, Southern Dynasties, and Sui tombs in the southern suburbs of Ch'ang-sha), *K'ao-ku,* 1965, no. 5, pp. 225–29

"Ch'ing:" "The Arts of the Ch'ing Dynasty," *Transactions of the Oriental Ceramic Society,* 35 (1963–64)

Chou, "Lüeh-t'an:" Chou Shih-jung, "Lüeh-t'an Ch'ang-sha ti wu-tai liang-sung mu" (Short discussion of authentic tombs from Five Dynasties and both Sungs from Ch'ang-sha), *Wên-wu,* 1960, no. 3, pp. 59–63

Chūgoku: Japan Ceramic Society, *Chūgoku nisen nen nō bi* (China's beauty of 2000 years), Tokyo, 1965

Construction Sites Material Cheng Chên-to, ed., *Ch'üan-kuo chi-pên chien-shê kung-chêng chung ch'u-t'u wên-wu chan-lan t'u-lu* (A pictorial record of the profusion of historical material displayed through excavations resulting from the construction of public works projects all over the country), 2 vols. Shanghai, 1955

CPAM: Wên-wu kuan li wei yüan hui (Management association for the proper things [art])

ECAC: An Exhibition of Chinese Antiquities from Ch'ang-sha lent by John Hadley Cox, Yale University Art Gallery, New Haven, 1939

FECB: Far Eastern Ceramics Bulletin

Fêng, "T'ung-kuan" Fêng Hsien-ming, "Ts'ung-liang hsien tiao-ch'a Ch'ang-sha t'ung-kuan yao so te tao chi tien-shou huo" (By two test investigations an attempt to gain a little genuine progress toward T'ung-kuan ware, Ch'ang-sha), *Wên-wu,* 1960, no. 3, pp. 71–74

Hobson, *Eumo. Cat.:* Hobson, R. L., *The Catalogue of the George Eumorfopoulos collection of Chinese, Corean and Persian Pottery and Porcelain,* 6 vols. London, 1925

Hoyt Memorial: The Charles B. Hoyt Collection, Memorial Exhibition, Museum of Fine Arts, Boston, Feb. 13–Mar. 30, 1952.

IAAS: Institute of Archaeology Academia Sinica

JOS: Journal of Oriental Studies

KKHP: K'ao-ku Hsüeh Pao

Newton, "CCWH," *FECB:* Isaac Newton, "Chinese Ceramic Wares from Hunan," *FECB, 10,* nos. 3–4 (1958) pp. 3–49

OA: Oriental Art

STZ: *Sekai Tōji Zenshu* (Ceramic Art of the World), 16 vols. Japan, 1955

TOCS: Transactions of the Oriental Ceramic Society

Selective Chronology

Chinese Dynasties

Shang: (?)1776 B.C.–(?)1122 B.C.
 Middle: 16th century B.C.–15th century B.C.
 Late: 14th century B.C.–12th century B.C.
Chou: (?)1122 B.C.–256 B.C.
 Western: (?)1122 B.C.–771 B.C.
 Eastern: 771 B.C.–256 B.C.
Ch'in: 221 B.C.–206 B.C.
Han: 206 B.C.–A.D. 220
 Western: 206 B.C.–A.D. 8
 Eastern: A.D. 25–220
Six Dynasties: A.D. 220–589
 Northern dynasties include Chin, 265–419
 and Northern Ch'i, 550–77
 South is divided into Chin, 265–419
 and Southern Six Dynasties, 420–577
Sui: 589–618
T'ang: 618–906
Five Dynasties: 907–60
 Liao (Mongols) 907–1125
Sung: 960–1279
 Northern Sung, 960–1127
 Southern Sung, 1127–1279
 Chin (Tartars), 1115–1234
Yüan: 1260–1368
Ming: 1368–1644
 Some reign periods include:
 Yung Lo, 1403–24
 Hsüan Tê, 1426–35
 Ch'êng Hua, 1465–87
 Chia Ching, 1522–66
Ch'ing: 1644–1912
 Some reign periods include:
 K'ang Hsi, 1662–1722
 Yung Chêng, 1723–35
 Ch'ien Lung, 1736–95
 Chia Ch'ing, 1796–1820
 Tao Kuang, 1821–50

Japanese arts periods

Late Tomb period: 6th–7th century
Heian: 794–1185
Kamakura: 1185–1333
Nanbokuchō: 1333–92
Muromachi: 1392–1573
Momoyoma: 1573–1615
Edo: 1615–1868

Korean art periods

Three Kingdoms period: c. 440–608
Koryō dynasty: 918–1392

Glossary

Appliqué: in ceramics, smaller pieces of clay which are applied with slip to a clay surface

Biscuit: in ceramics, fired but unglazed ware

Black Hawthorne: porcelain ware in which the colored enamels are painted directly on the biscuit with a black glaze background

Celadon: term used for a large group of green-colored glazes in Far Eastern ceramics

Chien: dark-bodied, dark-glazed porcelaneous stoneware made in Fukien province

Ch'i-lin: single horned animal of fantasy

Ch'ing-pai: lit. blue/green white, refers to a group of pale blue green porcelaneous stonewares made over a large area of China

Chüeh: archaic bronze vessel form, usually a spouted, handled cup resting on three legs

Chün: gray-bodied, primarily blue glazed porcelaneous stoneware, usually made in North China, and taking its name from Chün-chou in Honan province

Clair de lune: French term, lit. light of the moon, refers to a pale blue glazed porcelain

Colophon: inscription following a handscroll or album painting, written usually by others than the artist, containing information, commentary, or poetry; often, but not always, refers to painting

Earthenware: class of pottery sufficiently low fired to be scratched with fingernail

Famille rose, famille verte: French terms, lit. rose family and green family, used in connection with Chinese porcelains decorated with enamels dominated by those hues

Fang-i: archaic bronze vessel form, usually a container whose horizontal cross section is rectangular

Graviata: decorative technique in which overall scroll patterns are engraved on enameled surfaces

Hu: archaic bronze vessel form, usually a vase with bulging midsection and narrower shoulder and footrim

Jadeite: mineral within the group known as jade, largely found in Burma, not recorded before eighteenth century

Ju: buff-bodied, primarily blue glazed porcelaneous stoneware, said to have been made at Ju-chou in Honan province

Ku: archaic bronze form, usually an elongated goblet

Kuan: lit. official, refers to a group of dark-bodied porcelaneous stoneware often with blue gray glazes made in Chekiang province

Kuan-yin: Buddhist deity, especially associated with compassion (Japanese Kannon)

Kuei: archaic bronze form, usually a circular vessel of substantial depth

Lien: archaic bronze form, a cylindrical vessel, often covered

Lohan: originally a major disciple of Buddha, later a legendary human with supernatural gifts (Japanese Rakan)

Lute: join "leather hard" surfaces of clay by slip

Mei-p'ing: tall vase with wide shoulder and short neck

Nephrite: mineral within the group known as jade; used for most archaic jade carving

P'an: archaic bronze vessel form, basically a low circular basin

Patination: film from the breakdown of the surface of a bronze usually caused by the chemical action of the soil

Pi: archaic jade form, a flat disk with hole roughly one-third of total diameter, often considered a symbol of heaven

Pi-hsieh: fabulous animal which wards off evil, usually a kind of winged lion

Porcelain: fine-grained, white-bodied, highly fired, translucent ceramic ware

Porcelaneous: ware involving many, but not all, of the characteristics of porcelain

Sang de boeuf: French term, lit. blood of beef, refers to an intense monochrome red glaze

Shu-fu: lit. fundamental palace, a porcelaneous stoneware with pale blue gray glaze made during the Yüan dynasty

Slip: clay in liquid form

Stoneware: class of pottery sufficiently high fired to resist the scratch of the fingernail

T'ao t'ieh: design based presumably on varying concepts of animal masks, found on archaic bronzes

Tê-hua: town in Fukien province making porcelain, known as Blanc de Chine (China white)

Ting: archaic bronze vessel form, usually a caldron with three or four legs

Ting: white-bodied, neutral glazed porcelaneous or porcelain ware made at Tingchou in Hopei province

Tou: archaic bronze form, essentially a bowl, often hemispheric, on a high stem

Tsun: archaic bronze form, a generalized wine container shape

Tui: archaic bronze vessel form, often made of two hemispherical cups, each capable of resting on three feet

Tung-ch'i (Dong-khe): ivory white porcelaneous stoneware with translucent glaze made in the village of that name in Fukien province

Tz'ŭ Chou: generalized group of porcelaneous stoneware, often with slip decoration, taking its name from Tz'ŭ-chou, a town in Hopei province

Yüeh: gray-bodied, green glazed porcelaneous stoneware made in various kilns around Yüeh-chou (now Shao-hsing) in Chekiang province

Major Objects in Bronze,
Jade, Ceramics,
Sculpture, and Painting

Bronzes

1. Libation cup of type *chüeh*

1955.4.144
Hobart and Edward Small Moore Memorial
Collection; bequest of Mrs. William H. Moore
Bronze; H. 5¼″, W. 6½″

Worked with flat base, reinforced upper rim,
and small triangular columns. *T'ao t'ieh* de-
sign repeated on both sides. Single handle and
three legs separately made and brazed onto
body.

Date: Middle Shang dynasty.

Condition: Partially covered with encrusta-
tions of earth.

Provenance: A. W. Bahr Collection; sold
through N. E. Montross, New York, 1918.

Exhibition: Ritual Vessels of Bronze Age
China, Asia House, Asia Society, New York,
Sept. 10–Dec. 15, 1968.

Bibliography: S. Howard Hansford, "Pre-
Anyang," pp. 3–4; Max Loehr, *Ritual Vessels
of Bronze Age China,* no. 5.

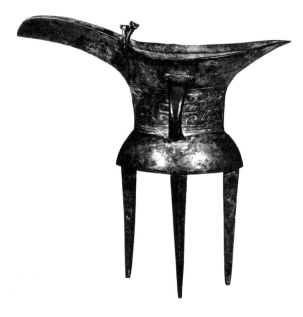

A metallographic examination made in 1946
by Colin G. Fink, Columbia University, estab-
lished antiquity for the metal. A general par-
allel with a chüeh from Hui-hsien has been
reported by Hansford, "Pre-Anyang," p. 4.
Recent documentation can be derived from a
number of bronze vessels including two chüehs
in tomb M2 on Ming-kung Road, Chêng-
chou; see Chêng-chou Municipal Museum,
"Chêng-chou shih ming-kung lu hsi-ts'ê ti
liang-tso shang-tai mu" (Two Shang tombs
excavated on the west side of Ming-kung
Road), pp. 500–06. One chüeh (M2:22) has
an over-all shape like the Yale piece and the
same columns on the rim (pl. 3, no. 5). The
second chüeh (M2:21) has legs similar to the
Yale object and the same reinforced rim (pl.
3, no. 4).

2. Vessel of type *ting*

1955.4.145

Hobart and Edward Small Moore Memorial Collection; bequest of Mrs. William H. Moore

Bronze; H. 5½″, D. 5½″

Vessel cast with three legs, each in the shape of a dragon, and two upright handles. The main design consists of a t'ao t'ieh repeated three times against a spiral-filled background.

Inscription: A cast, three-character inscription in Shang archaic on body interior may be rendered *tzǔ yü chi.* Multiple interpretations are possible: "Prince Yü (dedicates) to Chi," or "Yü of the Tzǔ clan (dedicates) to Chi." The above were suggested by R. S. Britton, while J. M. Menzies preferred tzǔ as a substitute for ssǔ, meaning master or superintendent. Thus his translation might approximate "the officer (in charge of matters of) rain (dedicates) to Chi."

Date: Late Shang dynasty.

Condition: Repair on one leg.

Exhibition: Chinese Bronzes, Metropolitan Museum, New York, Oct.–Nov. 1938, no. 18; Exhibition of Early Chinese Bronzes, CASA, New York, Oct. 1946.

Bibliography: Bernard Karlgren, "New Studies on Chinese Bronzes," *BMFEA, 9* (1937), pl. 29; Phyllis Ackerman, *Ritual Bronzes of Ancient China,* pl. 58; Eleanor von Erdberg Consten, "A Terminology of Chinese Bronze Decoration," *Monumenta Sinica, 16* (1957), 287–314, fig. 5.

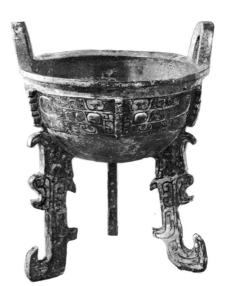

3. Covered vessel of type *fang-i*

1955.1.2

Hobart and Edward Small Moore Memorial Collection; gift of Mrs. William H. Moore

Bronze; H. 9⅛″, W. 5⅝″

Cast with high relief design of owls on four sides of the body and on two sides of the gable-shaped cover. Background of spirals and snakes.

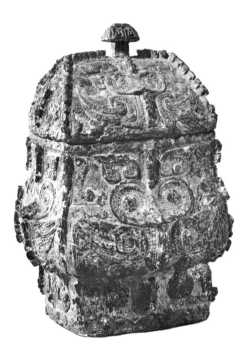

Inscription: A cast, three character inscription in Shang archaic is currently undecipherable.

Date: Late Shang dynasty.

Condition: Break and substantial repair on upper part of body; repairs on cover.

Exhibition: Chinese Bronzes, Metropolitan Museum, 1938, no. 2.

Bibliography: Umehara Sueji, *Shina kodō seika* (The essence of ancient Chinese bronzes), *1*, pl. 42; Alfred Salmony, "The Owl as an Ornament in Archaic Chinese Bronzes," *Parnassus, 6,* no. 2 (1934), pp. 23–25, ill. on p. 24; Umehara Sueji, *Kodōki keitai no kōkogaku teki kenkyū* (Study of ancient bronzes by shapes), pl. 20, no. 2; Jung Kêng, *Shang chou i-ch'i t'ung-k'ao* (The bronzes of Shang and Chou), *2,* no. 600; Florence Waterbury, *Early Chinese Symbols and Literature; Vestiges and Speculations,* pl. 64; Ackerman, *Ritual Bronzes,* pl. 61; Margaret T. J. Rowe, "The Moore Collection at Yale," *BAFAYU,* 22, no. 2 (1956), p. 3; "Oriental Art Recently Acquired by American Museums," *ACASA, 10* (1956), 78.

4. Pole-top

1954.48.10

Hobert and Edward Small Moore Memorial Collection; gift of Mrs. William H. Moore

Bronze; H. 7″, W. 4½″

Cast in high relief with one side of t'ao t'ieh design and the other a human face. The long, hollow neck is perforated with four holes.

Date: Late Shang dynasty.

Condition: Very heavily covered with malachite patination; deep cracks in patination of head; chips out of horns.

Provenance: Otto Burchard and Co., Inc., New York, 1930.

Exhibition: Chinese Art, Arden Gallery, New York, 1938; Chinese Bronzes, Metropolitan Museum, 1938, no. 125 (ill.); Chinese Bronze Exhibition, Princeton Bicentennial, Princeton, 1946.

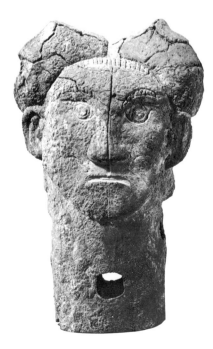

Bibliography: Carl Hentze, *Objets Rituels, Croyances et Dieux de la Chine Antique et de l'Amérique,* pl. 6a,b; Ackerman, *Ritual Bronzes,* pl. 64; J. LeRoy Davidson, "Three Bronzes in the Hobart and Edward Small Moore Memorial Collection," p. 5 and figs. 3–4.

Pole-tops with human faces and three animal masks are to be found in the collections of the Minneapolis Institute of Arts, the British Museum, and Mme. D. David-Weill (Neuilly-sur-Seine).

5. Libation cup of type chüeh

1954.48.11

Hobart and Edward Small Moore Memorial Collection; gift of Mrs. William H. Moore

Bronze; H. 9⅝″, W. 9″

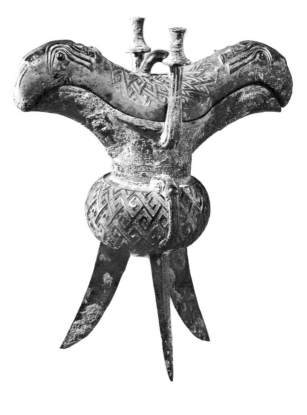

Cast with double protruding lips and three slender legs. One band of diaper design runs around the body with t'ao t'ieh band above it. The cover has the diaper design, and lip ends in the shape of animal heads with horns and heavily lidded eyes.

Inscription: Three archaic characters are cast on the cover, and perhaps cut on the side of the vessel. These were rendered as *yung hsi hu* by C. F. Yau and may be translated as an "eternally bestowed hu."

Date: Western Chou dynasty, probably eleventh century B.C.

Condition: Malachite and lapis lazuli patination.

Provenance: Ton-ying and Company, New York, 1928.

Exhibition: International Exhibition of Chinese Art, Royal Academy of Arts, London, Nov. 1935–Mar. 1936, no. 262; Chinese Art, Arden Gallery, 1938; Chinese Bronzes, Metropolitan Museum, 1938, no. 6.

Bibliography: Ackerman, *Ritual Bronzes,* pl. 22; Dagney Carter, *Four Thousand Years of Chinese Art,* 25(a); Davidson, "Three Bronzes," pp. 4–5 and fig. 2.

At least two similar pieces exist, differing only

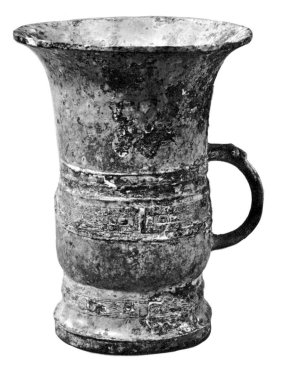

in inscription. One of these is in the collection of the Hakutsuru Museum, Kobe.

6. Vessel of type *tsun*

1954.49.2
Hobart and Edward Small Moore Memorial Collection; gift of Mrs. William H. Moore
Bronze, jade encrusted; H. 8", D. (at top) 6½"

Trumpet shaped and bearing a single handle, the vessel is decorated with a band around the center of four t'ao t'iehs, three raised ridges above, and a band near the base with eyes and diagonal spirals. Cicada of white jade encrusted on inside of vessel.

Inscription: A cast inscription of five archaic characters may be rendered *cha fu yi lu i* and translated, "first to Father Yi a sacrificial vessel (of i type)."

Date: Western Chou dynasty, probably eleventh century B.C.

Condition: Covered with malachite patination and encrustations of mud.

Provenance: A. C. de Frey, Paris; obtained through Alfred Kohl, Oakland, California, 1935.

Exhibition: First Exhibition of Chinese Art, Mills College, Oakland, Oct.–Nov. 1934, no. 48; 3000 Years of Chinese Jade, Arden Gallery, New York, 1939, no. 82; Exhibition of Chinese Ritual Bronzes and Paintings, Wellesley College, Wellesley, May 1943, no. 16; Exhibition of Early Chinese Bronzes, CASA, 1946.

While handled tsuns are not common, others have been published. Similar objects, differing in design details, include a tsun lent by John Sparks to the International Exhibition in London, 1935–36, a second exhibited at C. T. Loo and Co., New York, 1941–42, and a third published by Umehara in *Shina, I,* 1, fig. 26, and in *Kodōki,* pl. 8, fig. 12.

7. Miniature bronze stag

1955.4.146

Hobart and Edward Small Moore Memorial Collection; bequest of Mrs. William H. Moore

Bronze; H. 4½", L. 3½"

Cast in the full round with details such as eyes, nostrils, mouth, and hooves.

Date: Western Chou dynasty, probably eleventh or tenth century B.C.

Condition: Partially covered with malachite patination and earth encrustations; part of one horn missing.

Provenance: Edgar Worch, Berlin (Trübner, New York), 1928.

Exhibition: Master Bronzes, Albright Art Gallery, Buffalo, 1937, no. 24.

Bibliography: Otto Kümmel, *Jörg Trübner zum gedächtnis,* pl. 50, d–e; Phyllis Ackerman, "China and the Western World," *China,* 16 (1945), fig. 6; Loehr, "The Stag Image in Scythia and the Far East," fig. 26.

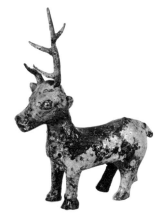

8. Vessel of type *tou*

1954.49.3

Hobart and Edward Small Moore Memorial Collection; gift of Mrs. William H. Moore

Bronze; H. 6", D. (at rim) 9"

Cast with high-stemmed base decorated with perforated scales. Rim has band of conventionalized figures, likely derived from animals.

Date: Western Chou dynasty, probably ninth–eighth century B.C.

Condition: Thickly encrusted with malachite patination.

Provenance: Collection of W. F. Collins, who attributed the piece to the site Hsin-chêng, Honan province; purchased P. Jackson Higgs, New York, 1926.

Exhibition: Chinese Bronzes, Metropolitan Museum, 1938, no. 139.

A similar but simpler piece from Shang-ts'un-ling was published in IAAS, *Shang-ts'un-ling kuo-kuo mu-ti* (The Cemetery of the State of Kuo at Shang-ts'un-ling), pl. 34, no. 4.

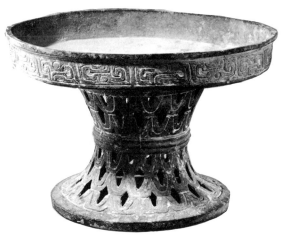

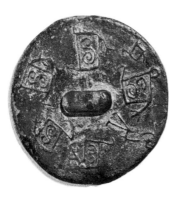

9. Mirror

1953.27.27

Hobart and Edward Small Moore Memorial Collection; gift of Mrs. William H. Moore

Bronze; D. 2½"

Cast with rectangular handle. Thread relief design of man and five dancing figures.

Date: Eastern Chou dynasty, probably eighth–seventh century B.C.

Condition: Few rim chips.

Provenance: Edgar Gutmann, Berlin, 1931.

Exhibition: An Exhibition of Chinese Mirrors, CASA, New York, Feb. 1951, no. 21.

Bibliography: Carl Hentze, *Mythes et Symboles Lunaires* (Anvers, 1933), pl. 3, A.

Two mirrors found at Shang-ts'un-ling in Honan in 1956–57 establish the date of the Yale piece; see IAAS, *Shang-ts'un-ling.* One mirror (pl. 23, 1–2) has same size, handle, and lack of rim ridge; another (pl. 40, 2) has a thread relief design. The antecedent of all these mirrors has presumably been found at Hou-chia-chuang, An-yang; two comparable specimens of Chou date are located in Japan, one in the collection of the Kyoto University and the other formerly in the collection of the late Mr. Moriya, Kyoto.

10. Vessel of type ting

1940.318

Van Volkenburgh Collection

Bronze; H. 8½", D. 11"

Cast with two bands of diaper pattern decoration separated by a rope band. T'ao t'iehs top the three legs. The cover, shown in earlier publications, seems a later addition.

Inscription: Cast inscription of seven characters may be rendered as *wang yu chu tzŭ tso ssu ting.* A likely translation is "the king's son Chu had made privately this food vessel ting."

Date: Eastern Chou dynasty, probably sixth century B.C.

Condition: Spots of azurite and malachite patination cover the vessel, especially heavily on bottom.

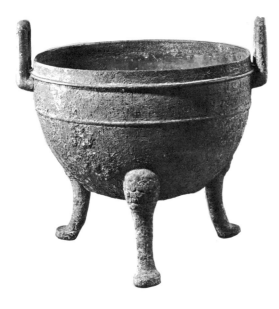

Provenance: Yamanaka and Co., New York, 1940.

Bibliography: Umehara Sueji, *Sengoku shiki dōki no kenkyū* (Study of Warring States bronzes), pl. 37; Umehara, *Kodōki,* pl. 24, no. 14; Jung, *Shang chou, 2,* 158.

There are generally parallel pieces in the National Museum, Tokyo, the Metropolitan Museum, and the Art Institute of Chicago. The dating of the Yale piece is based primarily on the recent stylistic studies of Charles Weber; see Charles Weber, "Chinese Pictorial Bronze Vessels of the Late Chou Period," esp. pp. 109, 135.

11. Cup

1952.52.28

Hobart and Edward Small Moore Memorial Collection; gift of Mrs. William H. Moore.

Bronze, inlaid gold and silver; H.3″, D. 2¾″

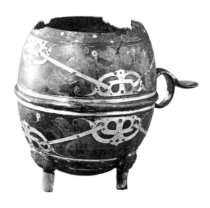

Divided into two zones by central ridge edged with bands of silver. Repeated knotlike patterns in gold alternate with naturalistic beasts in various attitudes drawn in gold and silver. Broad lines are in strip inlay technique; thin lines in wire inlay. Three legs emerge from snail forms. Areas of brown patination.

Inscription: Two characters on bottom, probably incised, currently undecipherable.

Origin: Presumably Chin-ts'un, Honan province.

Date: Eastern Chou dynasty, fifth–third century B.C.

Condition: Losses around lip; one snail leg a modern repair; some inlay missing.

Very similar in style, in technique, and in unusual combination of abstract and naturalistic to a bronze mirror from Chin-ts'un in the Hosokawa Collection, Tokyo, illustrated William C. White, *Tombs of Old Lo-yang,* pl. 47, no. 121.

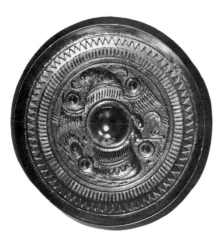

12. Mirror

1953.27.30
Hobart and Edward Small Moore Memorial
Collection; gift of Mrs. William H. Moore
Bronze; D. 3¼″
Cast with center design of bird reserved in re-
lief. Four bosses.
Date: Six Dynasties, perhaps fourth century.
Condition: Complete.
Provenance: Ton-ying, New York, 1922.
While the design is rare, several variants of it
are known. A generally parallel mirror, but
apparently with a flat rim, has been recovered
in Szechuan province and attributed to the
Chao period (304–52); See Ssǔ-ch'ûan Pro-
vincial Museum, *Ssǔ-ch'ûan shêng ch'u-t'u
tung-ching* (Bronze mirrors excavated in Ssǔ-
ch'ûan province), no. 42. Another, without
bosses, is the frontispiece of Komai Kazuchika,
Chūgoku kokyō no kenkyū (A study of ancient
Chinese mirrors). A third, also without bosses
and with a more diffused bird, was in the J. M.
Plumer Collection and is now in the Museum
of Art, University of Michigan, acc. no.
1961/2.61.

13. Mirror

1953.27.29
Hobart and Edward Small Moore Memorial
Collection; gift of Mrs. Wliliam H. Moore
Bronze, gilt, inlaid crystal and turquoise;
D. 2⅞″
Cast silvery bronze on obverse. Reverse deco-
rated with a gilt floral pattern inlaid with
crystal and turquoise against a granulation
background.
Date: T'ang dynasty.
Condition: Some inlay and areas of gilt lost.
Exhibition: Exhibition of Chinese Art, Mills
College, 1934, no. 257.
Bibliography: Umehara, *Shina, 2, 2*, pl. 134G.
A related T'ang mirror with granulation back-
ground and inlaid floral design has been found
at Sian in the tenth month of 1954; see Shensi

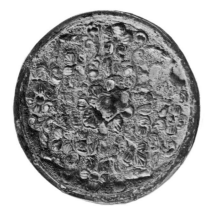

Provincial Committee, *Shensi shêng ch'u-t'u t'ung-ching* (Bronze mirrors excavated in Shensi province), pl. 125.

14. Stem cup

1952.52.27

Hobart and Edward Small Moore Memorial Collection; gift of Mrs. William H. Moore

Silver, gilt; H. 2″, D. 2¾″

Sides and bottom of cup, encircled by ten hammered lotus petals, are decorated with traced and gilt hares, birds, and insects in landscape on ring-matted ground. Stem, cast and soldered on, is also divided tenfold and decorated with gilt floral patterns.

Date: T'ang dynasty, probably second half seventh century.

Condition. Stem once broken off.

Provenance: C. T. Loo and Co., New York, 1931.

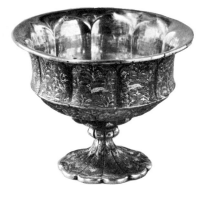

Thirteen silver pieces were found at Sha-p'o village in 1936, including four stem cups. The piece similar to the Yale cup is illustrated CPAM, City of Sian, "Si-an shih tung-nan chiao Sha-p'o ts'un ch'u-t'u i-p'i t'ang-tai yin-ch'i" (T'ang dynasty silver vessels unearthed at Sha-p'o village in the southeastern outskirts of the city of Sian), pp. 30–32, pl. 11, fig. 3. Closer parallel piece illustrated in Bo Gyllensvärd, *Chinese Gold and Silver in the Carl Kempe Collection,* no. 111a,b.

15. Vessel of type tsun

1954.48.7

Hobart and Edward Small Moore Memorial Collection; gift of Mrs. William H. Moore

Bronze, inlaid silver; H. 9″, W. 3¾″

Cast in the shape of an owl with removable cover as head. Linear design mostly inlaid with silver.

Date: Sung dynasty.

Condition: Several small holes, a few filled in with metal.

Provenance: Peytel Collection, Paris; sold through C. T. Loo, New York, 1926.

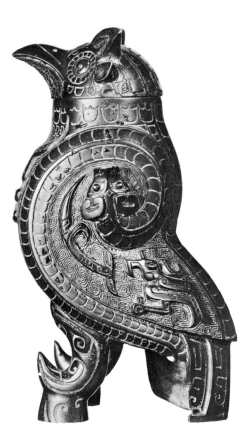

Exhibition: Master Bronzes, Albright, 1937, no. 27; Chinese Art, Arden Gallery, 1938; Chinese Bronzes, Metropolitan Museum, 1938, no. 91; Bronzes and Paintings, Wellesley, 1943, no. 11.

Bibliography: Ardenne de Tizac, *Les Animaux dans l'Art Chinois* (Paris, 1923), pl. 2A; Alfred Salmony, "The Cicada in Ancient Chinese Art," *The Connoisseur, 91* (1933), 175; Umehara, *Shina, 1,* pl. 40; Hentze, *Objets Rituels,* figs. 112–14; *The Art Digest, 12,* no. 9 (Feb. 1, 1938), cover, p. 5; University Prints, *Series for Early Chinese Art* (Newton, 1938); Umehara, *Kodōki,* pl. 34, no. 7; Jung, *Shang chou, 2,* no. 689; Waterbury, *Early Chinese,* pl. 54; Alfred Salmony, "A Problem in the Iconography of Three Early Bird Vessels," pl. 8, fig. 1; Ackerman, *Ritual Bronzes,* pl. 6; Carter, *Four Thousand Years,* p. 31; Bernard Karlgren, "Notes on the Grammar of Early Bronze Decor," *BMFEA, 23* (1951), pl. 7a; Bernard Karlgren, "Some New Bronzes in the Museum of Far Eastern Antiquities," *BMFEA, 24* (1952), postscript, pl. 16; Davidson, "Three Bronzes," fig. 1; Carl Hentze, "Le Symbolisme des oiseaux dans la Chine ancienne," fig. 2a; Mizuno Seiichi, *Inshū seidōki to gyoku* (Bronzes and jades of Yin and Chou), pl. 72; Institute of Chinese Culture, *Wên-wu ching-hua* (The cream of proper things [art]), 1, pl. 24; Bernard Karlgren, "Miscellaneous Notes on some Bronzes," *BMFEA, 33* (1961), pl. 1, no. 2.

The dark bronze shown in the many illustrations of this owl vessel was in part colored wax. Removal of the wax led to the discovery that the interstices had been filled with a mixture resembling earth and glue. When this mixture was removed, the silver inlay was readily discernable. Other archaizing elements were the lack of symmetrical design elements in the face, especially around the eyes, and the rather poor casting which involved both the current holes and metal plugs. The piece is now covered with a water patination of greenish hue. While the theoretical span of date might run from late Chou to recent times, known inlaid copies of Sung

manufacture suggest Sung as an appropriate
date.

16. Pair of vases

1958.89.2a,b

Gift of Winston F. C. Guest, B.A. 1927

Enamel and gilt on copper; H. 5⅞", D. 2½"

Design on body is two panels depicting mother
and child in a multitude of enamel colors, with
shading suggested, and two smaller panels de-
picting landscape scenes in rose enamel; green
"brocade pattern" background. Multicolored
floral designs against a yellow background else-
where. Metal areas are gilt; interiors covered
with blue enamel.

Inscription: Four character Ch'ien Lung mark
in blue enamel on base.

Date: Ch'ing dynasty, Ch'ien Lung reign.

Condition: Complete.

Provenance: Believed to have come from the
Imperial Collection, Peking. After the revolu-
tion of 1911, they were said to have been
placed as loan security in the Salt Industry
Bank, Peking, later sold to Ton-ying, and then
to Ralph Chait, art dealers in New York.

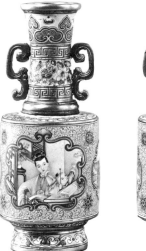

Jades

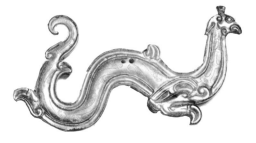

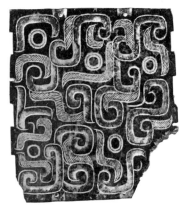

17. Pendant in form of phoenix

1955.52.30
Hobart and Edward Small Moore Memorial
Collection; gift of Mrs. William H. Moore
Nephrite; L. 4¼″, T. ⅜″

Flat pendant with edges squared off and both
sides identical. Thick, concave border outlines
slightly swelling body and narrows toward
head and tail. Legs and features of head in
low but plastic relief. Delicately incised scale
pattern on neck, wave pattern on body. Light
olive green with touches of dark brown.

Date: Eastern Chou dynasty, fifth–third cen-
tury B.C.

Condition: Complete.

Provenance: C. T. Loo, New York, 1933.

Exhibition: Chinese Jades, Arden Gallery,
1939, no. 170; An Exhibition of Chinese Jade
Objects, China House, New York, 1946.

Bibliography: Alfred Salmony, *Carved Jade of
Ancient China* (Berkeley, 1938), pl. 43, no. 1.
Similar object in C. T. Loo, *An Exhibition of
Chinese Archaic Jades* (New York, 1950), pl.
50, no. 8.

18. Plaque

1955.4.155
Hobart and Edward Small Moore Memorial
Collection; bequest of Mrs. William H. Moore
Nephrite; L. 2½″, W. 2¼″

Thin, translucent brown appliqué with traces
of cinnabar. Incised with dissolved animal
motifs reduced to circles, spirals, and striated
bands. Notches along long edges, two tiny
holes along each short edge.

Origin: Chin-ts'un, Honan province.

Date: Eastern Chou dynasty, fifth–third cen-
tury B.C.

Provenance: Yamanaka, New York, 1932.

For parallel pieces see White, *Tombs,* pl. 134,
no. 328; Alfred Salmony, *Archaic Chinese
Jades from the Edward and Louise B. Sonnen-
schein Collection,* p. 230, pl. 88, no. 9.

19. Chimera, called *pi-hsieh*

1953.27.19

Hobart and Edward Small Moore Memorial Collection; gift of Mrs. William H. Moore

Nephrite; H. 2⅜″, L. 3¼″

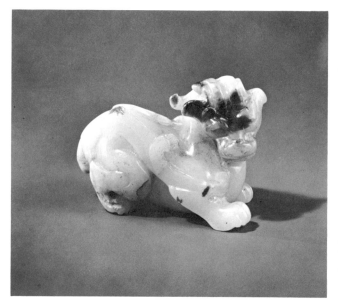

Finely carved and fully rendered in three dimensions. Details include open, snarling mouth; long bifid horns; curling, striated eyebrows and cheek wings; little striations indicating fur on chest, tail, face, flanks, and legs; and long trifid tail. Both right legs are advanced, the shifting of weight in this movement creating an S-curve through the length of the body. Pale gray-green stone with spots of brown on face and elsewhere.

Origin: Reportedly excavated Shensi province.

Date: T'ang dynasty.

Condition: Flaw in stone on right rear leg; three coins wrapped in textile and lodged under chin in burial now removed.

Provenance: Lai-yuan and Co., New York, 1917.

Exhibition: Chinese Jades, Arden Gallery, 1939, no. 224.

Bibliography: Arden Gallery, *3000 Years of Chinese Jades,* ill. on p. 83.

Close in surface detail to another chimera discussed by Desmond Gure in "Some Unusual Jades and Their Dating," *TOCS, 33* (1960–62), 42–48, pl. 38. The Yale piece, however, is more compact and contained, and more three-dimensional in its movement and conception.

20. Vessel of type *kuei*

1955.4.177

Hobart and Edward Small Moore Memorial Collection; bequest of Mrs. William H. Moore

Nephrite; H. 2½″, W. 5¼″

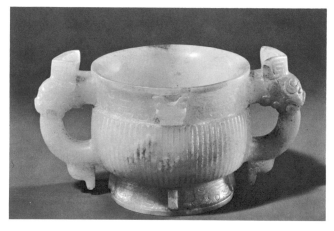

Upper zone bears two partial tiger heads in relief against background of dragon motifs in very low relief. Background design repeated on foot, while body is covered with vertical ribbing. Plain tubular handles come out of open mouths of horned tiger heads. Pale gray-green stone.

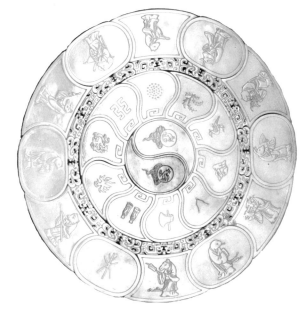

Date: Sung dynasty.

Condition: Chip from foot.

Provenance: A. W. Bahr, New York, 1928.

A nearly identical piece is in the collection of Sir Alan and Lady Barlow; see Michael Sullivan, *Chinese Ceramics, Bronzes and Jades in the Collection of Sir Alan and Lady Barlow,* pl. 159a.

21. Zodiacal disc

1955.4.161

Hobart and Edward Small Moore Memorial Collection; bequest of Mrs. Willam H. Moore

Nephrite; D. 11¼″, T. ¼″

Disc of twenty-four separate segments, each with flat, raised border. Outer segments, in alternating shapes, are incised with twelve animals of duodenary cycle, the reverse with archaic characters for each; archaistic scrollwork on inner edges. Band of S-curved segments incised with ten imperial symbols, characters on the reverse. Yin and yang, in light and dark jade, in the center. Pure, translucent white stone.

Date: Ch'ing dynasty, eighteenth century.

Condition: Complete.

Provenance: Prince Kung Collection; sold at American Art Association, New York, Feb. 27, 1913.

Exhibition: Chinese Jades, Arden Gallery, 1939, no. 263; Chinese Jade, China House, 1946.

Bibliography: China House, *Exhibition of Chinese Jade Objects* (New York, 1946), pl. 2, no. 24.

22. Bowl

1950.161

John Hadley Cox, B.A. 1935, Collection

Earthenware; H. 2½", D. 6½"

Made of dark gray clay with many areas show-
ing striations from the turning of the wheel.
Complicated upper rim: inner ridge, concave
curve to upper edge, convex curve to outer
edge. Slightly flaring footrim.

Date: Late Shang dynasty.

Condition: Some imperfections at time of mak-
ing; later, one large and several small chips on
upper rim; much mud encrustation.

Provenance: Walter Hochstadter, New York.

A bowl of almost identical proportions was
found in tomb no. 53, Ta-ssŭ-kung, An-yang;
see An-yang Archaeological Team, IAAS,
"1962 nien An-yang Ta-ssŭ-kung ts'un fa
chüeh chien-pao" (A short report of the 1962
excavations at Ta-ssŭ-kung village, An-yang),
fig. 3, no. 9 on p. 383, and pl. 2, no. 3.

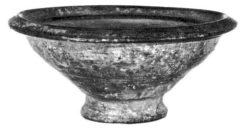

23. Model of a lizard

1955.6.325

Hobart and Edward Small Moore Memorial
Collection; bequest of Mrs. William H. Moore

Glass; L. 6¼", W. 1¼"

Mold made of dark green glass wth decayed
and encrusted surfaces. Conceived in the round
with a few surface details such as eyes and rib
cage.

Origin: Probably Chin-ts'un, Honan province.

Date: Eastern Chou dynasty, probably fifth-
third century B.C.

Condition: Unclean break across the tail with
small areas missing.

Provenance: R. Bensabott, Inc., Chicago, 1932.

Bibliography: C. G. Seligman, "Early Chinese
Glass," pl. 2, fig. c.

The analysis of the material, as cited by Selig-
man, was made in April 1939 by W. J. Young
of the Museum of Fine Arts, Boston. Seligman
also commented on the difficulties of precise
dating, for only one other parallel piece is

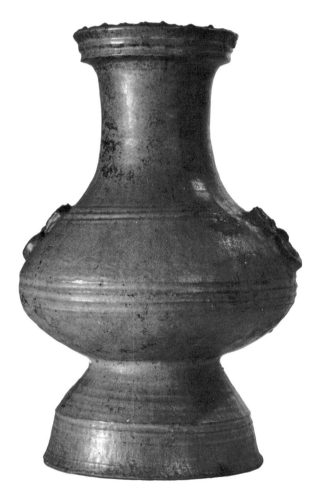

known, a slightly smaller, black glass lizard at the Royal Ontario Museum, published by White, *Tombs,* p. 154. No additional documentation having appeared in twenty-five years, one continues to attribute the Moore lizard with some hesitation to Eastern Chou dynasty.

24. Jar in shape of *hu*

1955.4.60
Hobart and Edward Small Moore Memorial Collection; bequest of Mrs. William H. Moore
Earthenware; H. 20″, D. 14″
Made of red clay with large flaring foot. Bands of raised ridges and two appliquéd t'ao t'iehs (based on tiger heads?) with ring handles. Much of green surface of lead glaze has degenerated into silvery iridescence. Fired upside down: three spur marks and drips of glaze on upper rim.
Date: Western Han dynasty.
Condition: Few areas of glaze missing; two firing cracks on base.
Provenance: Yüeh Hsin, Peking; Yamanaka, New York, 1918.
A close parallel to the Yale piece is a smaller, but covered, hu in the Cleveland Museum; see T. Sizer, "A Chinese Jar of the Han Dynasty," *Bulletin of the Cleveland Museum of Art, 11,* no. 4 (1924), pp. 77–80 and cover.

25. Amphora-shaped vase

1959.64.1

Gift of George H. Fitch, B.A. 1932, and Mrs. Fitch

Stoneware; H. 13⅜″, D. 6″

Made of light gray clay and covered with thin white slip. Dragon handles with appliquéd buttons luted to body. Finely crackled, gray green glaze covers upper part of body.

Date: Sui dynasty, probably seventh century.

Condition: Few losses on dragon handles; glaze specks from original firing.

Bibliography: "Recent Ceramic Acquisitions," *FECB, 11,* no. 2 (1959), pl. 15.

An attempt to deal stylistically with Sui and T'ang amphorae has been made by E. T. Chow and F. S. Drake in "Sui-T'ang: a study of Sui Dynasty and early T'ang porcellaneous stoneware," pp. 355–56. The Yale piece appears to have more Sui than T'ang characteristics.

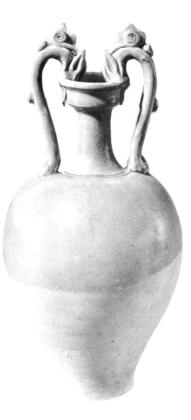

26. Miniature cup and stand

1955.4.3

Hobart and Edward Small Moore Memorial Collection; bequest of Mrs. William H. Moore

Earthenware; H. (incl. stand) 2½″, D. 2 ½″

Made of buff clay, slipped and covered with a neutral lead glaze. The three-color effect is achieved by streaks of metallic oxides, resulting in iron brown and copper green. Openwork stand of same materials with eight busts appliquéd.

Date: T'ang dynasty.

Condition: Firing crack on cup.

Provenance: A. W. Bahr Collection; purchased through N. E. Montross, New York, 1918.

A miniature three-color stand of this type was found at Sian in 1955; see *Wên-wu,* 1956, no. 8, p. 38, ill. 23. For a discussion of this stand type, which derives from an inkstone, see H. C. Tseng and R. P. Dart, *The Charles B. Hoyt Collection in the Museum of Fine Arts: Boston, 1* no. 70.

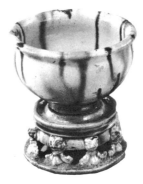

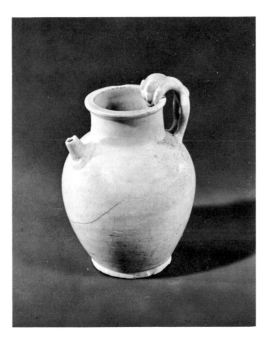

27. Small ewer with animal handle

1955.4.1
Hobart and Edward Small Moore Memorial Collection; bequest of Mrs. William H. Moore

Porcelaneous stoneware; H. 4¼", D. 3⅜"

Made of fine-grained, whitish clay. Flat foot slightly splayed. Lionlike handle and short spout appliquéd. A thin neutral glaze applied inside and out, stopping short of footrim.

Origin: Probably *Ting* area, Hopei province.
Date: T'ang dynasty, probably ninth century.
Condition: Substantial flaws upper and lower rims; one major and several minor kiln cracks.

Small ewers of this general shape are known in such English collections as Eumorfopoulos, Oppenheim, and Schiller. Two similar ewers (with *hsing* attributions) are in the Kempe collection (cf. Gustav Lindberg, "Hsing-yao and Ting-yao: an investigation of some Chinese T'ang and Sung white porcelain in the Carl Kempe and Gustav Lindberg Collections," pls. 38–39), and another in a Roman collection (cf. Mario Prodan, *The Art of the T'ang Potter,* pl. 105). A probable source for many of these pieces, including the one at Yale, is indicated by trial digging on the mainland in the early 1960s; see the Hopei Bureau of Culture Archaeological Team, "Ho-pei Ch'ü-yang hsien Chien-tz'ŭ ts'un ting-yao i chih tiao-ch'a yü shih-chüeh" (Reconnaissances and trial diggings conducted on the Ting Yao kiln sites at Chien-tz'ŭ village, Ch'ü-yang county, Hopei province), pp. 394–412. Pl. 5, no. 5 reproduces an animal-handled ewer with proportions similar to the Yale piece.

28. Long-necked bottle

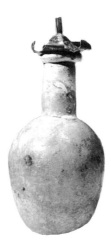

1955.6.265
Hobart and Edward Small Moore Memorial Collection; bequest of Mrs. William H. Moore

Glass with gilt bronze cover; H. (incl. cover) 4", D. 1¾"

Made of neutral-toned glass with decomposition to whitish color. Crackled surface with brown encrustation.

Date: T'ang dynasty.

Condition: Cracked at top of shoulder.

Provenance: C. T. Loo, New York, 1929.

Bibliography: Hugh Scott, *The Golden Age of Chinese Art: the lively T'ang dynasty* (Rutland, 1966), pl. 38.

29. Piecrusted bowl

1955.4.5

Hobart and Edward Small Moore Memorial Collection; bequest of Mrs. William H. Moore

Porcelain; H. 2¾″, D. 4¾″

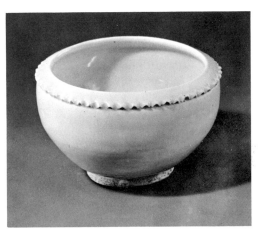

Made of fine-grained, whitish porcelain clay. Outer edge of upper rim regularly pressed to give piecrust effect. Flat white glaze, soft to the touch, covers bowl to footrim.

Date: T'ang dynasty or later, ninth–tenth century.

Condition: Some losses in piecrusted area.

Bowls of this type have been attributed to Hsing-chou by Lindberg, "Hsing-yao," pls. 20 and 21, and to T'ang Ching-tê Chên by Japanese scholars in *STZ, 9,* fig. 62. Another possible source is Ho-pi-chi in Honan province where a generally similar bowl (less piecrusting) was found by Chinese archaeologists; see the Archaeological Team, Bureau of Culture, Honan province, "Ho-nan shêng Ho-pi-chi tz'ŭ-yao i chih fa chüeh chien-pao" (Excavations of the remains of an ancient porcelain kiln at Ho-pi-chi, Honan province), fig. 3, no. 4 on p. 4. A piecrusted bowl was found among the T'ang kilns supplying Ting-chou; see the Hopei Bureau of Culture Archaeological Team, "Ho-pei Ch'ü-yang hsien," pl. 8, no. 8. Thus we can assume that this was a fairly common type made in different parts of China during the late T'ang dynasty and immediately thereafter.

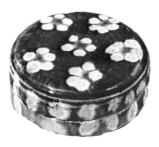

30. Covered box

1955.4.97
Hobart and Edward Small Moore Memorial
Collection; bequest of Mrs. William H. Moore
Stoneware; H. 1″, D. 3″

Flat box made of buff clay with two lightly in-
cised concentric circles on top. Six prunus blos-
soms on blue glazed top are in amber and white
glaze; centers of petals unglazed. Sides spotted
with amber and white glaze; interior bottom
amber glazed.

Date: T'ang dynasty or later, ninth–tenth cen-
tury.

Condition: Small crack on cover.

Provenance: Parish-Watson, New York, 1918.

Exhibition: The Arts of the T'ang Dynasty, Los
Angeles County Museum, Jan. 8–Feb. 17,
1957, no. 214.

Bibliography: Henry Trubner, *The Arts of the
T'ang Dynasty,* no. 214.

A similar piece is owned by Mr. and Mrs.
Desmond Gure, London; see *Exhibition of
Chinese Art,* no. 338.

31. Jar

1947.77
Collection of Wayland Wells Williams, B.A.
1910; gift of Mrs. Frances Wayland Williams
Pottery; H. 5½″, D. 6¼″

Buff body with a cobalt blue glaze covering
inside of lip and most of body. Glaze dappled,
containing many small imperfections includ-
ing streaks of yellow. Interior covered with
lime yellow glaze with occasional spots of blue
glaze dripped down from lip.

Date: T'ang dynasty or later, probably tenth
century.

Condition: Two small blisters at shoulder line
with evidence of repair; small chip on lip.

Provenance: Eumorfopoulos Collection;
bought at the Eumorfopoulos Sale at Sotheby's,
London, May 28, 1940, no. 42 (through Bluett
and Sons).

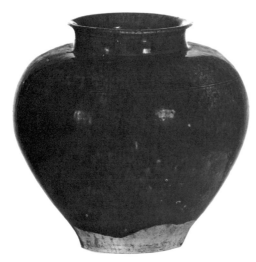

Exhibition: Arts de la Chine Ancienne, Musée de l'Orangerie des Tuileries, Paris, 1937, no. 369.

Bibliography: Hobson, *Eumo. Cat., 1,* no. 336, pl. 51.

A number of parallel pieces exists; see:
City Art Gallery, Bristol, *The Schiller Collection of Chinese Ceramics, Jades and Bronzes* (Bristol, England, 1948), no. 2402;
Henry Trubner, *Chinese Ceramics from the Prehistoric Period through Ch'ien Lung,* pl. 61, lent by Russell Tyson, Chicago;
Trubner, *Arts of T'ang,* pl. 179, lent by Mrs. Alfred Clark, Fulmer, England;
Prodan, *T'ang Potter,* pl. 31, Collection Marchese G. Litta-Modignani, Capalbio;
Sullivan, *Barlow,* color pl. 3.

32. Cup stand

1954.49.43
Hobart and Edward Small Moore Memorial Collection; gift of Mrs. William H. Moore
Porcelaneous stoneware; H. 2″, D. 5¼″

Made of very fine-grained, gray white clay. Carved lotus petals on stand; high foot pierced with quatrefoil openwork. Entirely covered with white glaze except base of footrim.

Date: Sung dynasty.

Condition: Small chips off rim.

Cup stand of this general shape with cut lotus petal design, but pale *ch'ing-pai* glaze, was recovered in a tenth-century Sung tomb at Nan-ch'êng, Kiangsi; see Hsüeh Jao, "Kiangsi Nan-ch'êng Ch'ing-chiang ho Yung-hsiu ti sung mu" (Excavations of Sung tombs at Nan-ch'êng, Ch'ing-chiang and Yung-hsiu, Kiangsi), p. 572, pl. 9, no. 4.

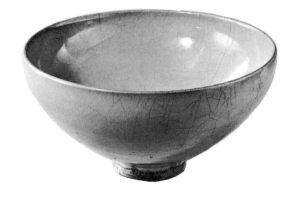

33. Bowl

1958.88.34

Gift of Dr. Yale Kneeland, Jr., B.A. 1922

Porcelaneous stoneware; H. 4", D. 8¾"

Made of fine-grained gray clay which fires light millet when covered with thin glaze and dark millet where directly exposed to kiln. Sky blue glaze develops a double crackle, ice and dark.

Origin: Chün ware, Honan province.

Date: Sung dynasty.

Condition: Half-dozen long firing cracks; foot-rim imperfect.

Rim shard of a Chün bowl shaped exactly like the Yale bowl has been recovered at Lin-ju; see Fêng Hsien-ming, "Ho-nan shêng Lin-ju hsien sung-tai ju-yao i chih-tiao-ch'a" (Reconnaissances of the remains of Sung dynasty Ju Yao kilns at Lin-ju, Honan province), p. 19, fig. 10, no. 9.

34. Bowl

1955.4.16

Hobart and Edward Small Moore Memorial Collection; bequest of Mrs. William H. Moore.

Porcelain; H. 2", D. 6¾"

Thinly made of white porcelain with straight sides. Interior decorated with modeled pair of phoenixes and flowers below scroll band. Covered with pale blue ch'ing-pai glaze except for flat base.

Date: Sung dynasty.

Condition: Complete.

A bowl of this shape and general design was recovered in a tomb datable to 1213 at Cho-tao-ch'üan; see CPAM, Hupei province, "Wu-chang Cho-tao-ch'üan liang-tso nan-sung mu-tsang ti-ch'ing-li" (Excavation of two Southern Sung tombs at Cho-tao-ch'üan, Wu-chang), p. 239, fig. 4. Parallel pieces are in Sullivan, *Barlow,* pl. 117c, and in "The Arts of the Sung Dynasty," *TOCS, 32* (1959–69), no. 204, from the collection of Mr. and Mrs. F. Brodie Lodge.

35. Vase

1955.4.6

Hobart and Edward Small Moore Memorial Collection; bequest of Mrs. William H. Moore

Porcelaneous stoneware; H. 5⅛", D. (at lip) 5¼"

Made of fine gray clay. Decorated with carved peonies on lower body; serrated, flaring petals on upper body; and pierced openwork in high, slightly splayed foot. Lower part of interior covered with gray slip; whole piece covered except for interior base and base of footrim with thin olive green glaze which runs from dark olive to light gray according to thickness. Light crackle on interior side of petals.

Origin: Northern *celadon* type.

Date: Sung dynasty.

Condition: Chip from lip; firing accident on interior.

Provenance: Otto Burchard, New York, 1930.

Parallel piece, labelled *Ju* ware, is in *STZ, 10, 182,* fig. 14.

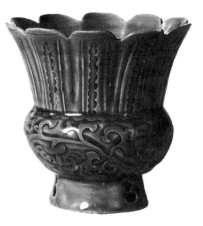

36. Low bowl with foliate rim

1950.219

John Hadley Cox, B.A. 1935, Collection

Porcelain; H. 1½", D. 8"

Made of fine-grained, grayish-white porcelain. Six raised radiants rise to rim indentations. Center bears incised lotus design. Covered except for footrim base with a neutral, slightly warm-toned glaze.

Origin: Ting ware, Hopei province.

Date: Sung dynasty.

Condition: Long firing crack and few other small firing imperfections.

Provenance: Walter Hochstadter, 1940.

Exhibition: Hochstadter Exhibition, Nierendorf Gallery, New York, May 13–25, 1940.

A flat bowl of this shape, including rim and footrim, has been uncovered in the Ting area; see Hopei Bureau of Culture Archaeological

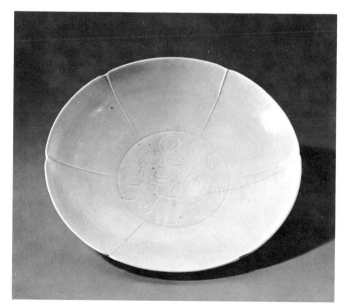

Team, "Ho-pei Ch'ü-yang hsien," text fig. 10, no. 6. While this bowl bears a fish design, another piece has been recovered with a similar lotus design; ibid., text fig. 10, no. 2. Both low bowls are attributed to Northern Sung. Sung bowls with similar shape and design were recovered in 1962 at Ch'in-chia village, Huai-tê district, Kirin province; see *K'ao-ku,* 1964, no. 2, p. 82, text fig. 3.

37. Vase of flower bud form

1949.266
Collection of Wayland Wells Williams, B.A. 1910; gift of Mrs. Frances Wayland Williams
Porcelaneous stoneware; H. 5½″
Made of fine gray clay which fires dark brown on exposure to kiln. Elliptical in cross section and ribbed from high foot to scalloped mouth. Covered except for base of footrim with finely crackled, blue green glaze.
Origin: Kuan type, Chekiang province.
Date: Southern Sung dynasty.
Condition: Repairs of crack around neck and of areas on footrim.
Provenance: Walter Hochstadter, New York, 1942.
Parallel piece illustrated in Tanaka Sakutarō, "Seiji no mi-iru chikara" (The Charm of Chinese Celadon), *Museum,* no. 122 (1961), fig. 1.

38. Vase

1955.4.64
Hobart and Edward Small Moore Memorial Collection; bequest of Mrs. William H. Moore
Porcelaneous stoneware; H. 14¾″, D. 6¼″
Made of gray clay with appliquéd design of lotus flowers and leaves on body. Outline and details of appliqués may be heightened by slip painting. Covered inside and out with green celadon glaze.
Origin: Chekiang province.
Date: Yüan dynasty.
Condition: Few minute firing flaws in glaze.

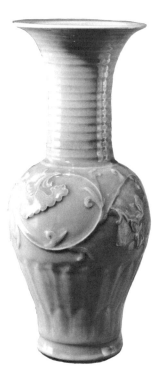

Exhibition: China House, China Institute in America, New York, Nov. 20, 1944–Jan. 20, 1945 (opening exhibition).

The general parallel is a larger vase in the David Foundation, dated in accordance with 1327. One may also call attention to a vase closely paralleling the Yale piece, found in Java, in the Stadtisches Volkermuseum, Frankfurt. This piece, incomplete, but differing only in neck detail, was published by Robert Schmidt, *Chinesische Keramik,* pl. 30(a). A probable source of many of these large Lungch'üan pieces as Ao-t'ou has been indicated by Nils Palmgren in *Sung Sherds.* On pl. 24, he publishes a fragment (no. 12), again in shape similar to the Yale piece, but with small design differences.

39. Pilgrim bottle

1949.289
Collection of Wayland Wells Williams, B.A. 1910; gift of Mrs. Frances Wayland Williams
Porcelain; H. 10″, D. 7½″

Made of extremely fine-grained white porcelain. Small oval foot unglazed; most of onion-top neck has been cut off. Main design of an eight petal rosette painted in underglaze blue. Entire piece except foot and cut neck covered with a nearly colorless glaze of substantial thickness, almost ch'ing-pai in tint.

Origin: Ching-tê Chên kilns, Kiangsi province.
Date: Ming dynasty, probably Yung-Lo reign.
Condition: Top of neck cut off.
Provenance: Mathias Komor, New York, 1943.
Bibliography: Cornelius Osgood, *Blue-and-white Chinese Porcelain,* pl. 48, upper right, as Hsüan Tê (?); cited E. T. Chow and F. S. Drake, "Yung-Lo and Hsüan Tê: A study on Chinese Blue and White Porcelain," part 1, *JOS,* 4, 1/2 (1957–58), pp. 112, 114.

A half-dozen pieces of this type and design are illustrated and analyzed by Chow and Drake. The authors mention three additional pieces: one in Japan, one in Batavia, and the last at Ardebil. Perhaps their most significant omis-

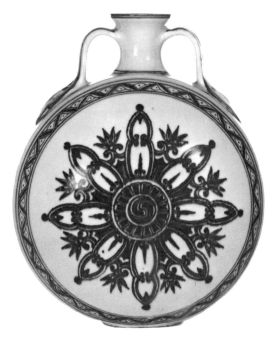

sion is the pilgrim bottle in the Victoria and Albert Museum, London, acquired in 1878 (cf. John Ayers, "Early Ming taste in porcelain," *Victoria and Albert Museum Bulletin, 2,* no. 1 (1966), p. 23, fig. 2.) On the stylistic criteria evolved by Chow and Drake, and on its own merits, the Yale piece seems to be among the earliest and finest of its type.

40. Hexagonal bulb bowl

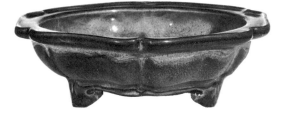

1948.52

Collection of Wayland Wells Williams, B.A. 1910; gift of Mrs. Frances Wayland Williams

Porcelaneous stoneware; H. 2¼", D. 7⅝"

Made of fine-grained gray clay with cloud-scroll feet. Blue gray glaze suffused with strawberry on exterior. Blue gray glaze on interior, and green on underbase.

Inscription: Impressed character *chiu* (nine) on base.

Origin: Chün ware, Honan province.

Date: Ming dynasty.

Condition: Complete.

Provenance: Richard Bennett; George Eumorfopoulos, London; bought at the Eumorfopoulos Sale at Sotheby's, London, May 29, 1940, no. 190 (through Bluett and Sons).

Bibliography: Hobson, *Eumo. Cat.,* 3, pl. 6, no. 196.

41. Round bulb bowl

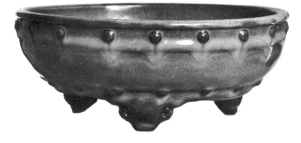

1960.25.1

Gift of Mrs. Dewees W. Dilworth

Porcelaneous stoneware; H. 3¼", D. 8¾"

Made of fine-grained gray clay with cloud-scroll feet and two rows of bosses. Covered with a thick blue gray glaze inside and out; green glaze on underbase.

Inscription: Impressed character *êrh* (two) on base.

Origin: Chün ware, Honan province.

Date: Ming dynasty.

Condition: Complete.

42. Hsüan Ti, the dark lord, lord of the north

1957.41.8

Gift of Dr. Yale Kneeland, Jr., B.A. 1922

Porcelain; H. 12½", W. 6⅜"

Figure and pedestal separately made of fine-grained gray white clay, probably in two-part molds. Details and decoration painted in gray blue underglaze cobalt. All except footrim covered by a neutral glaze of bluish tint.

Date: Ming dynasty, probably sixteenth century.

Condition: Many small firing flaws in glaze; repairs at back of head.

Generally similar piece illustrated by Hobson, *Eumo. Cat., 4,* pl. 39, no. D 171.

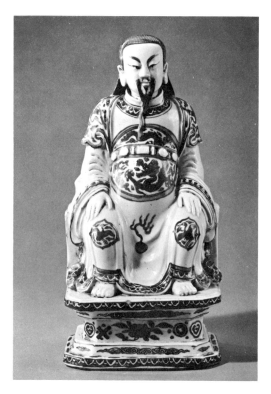

43. Long-necked jar

1955.4.143

Hobart and Edward Small Moore Memorial Collection; bequest of Mrs. William H. Moore

Porcelain; H. 16¾", D. 8½"

Decorated with underglaze cobalt blue design of prunus in reserve with cracked ice background (the "hawthorn" pattern). Neutral glaze covers body except for footrim.

Origin: Ching-tê Chên kilns, Kiangsi province.

Date: Ch'ing dynasty, K'ang Hsi reign.

Condition: Piece has leaned slightly during firing; few minute glaze imperfections.

Provenance: Henry Sampson Collection; purchased Dreicer and Co., New York, 1915.

A very limited number of these blue and white bottle-shaped jars has survived. The most famed and continually illustrated piece was in the Salting Collection and is now the property of the Victoria and Albert Museum. Another piece, from an American collection, is in the Walters Gallery; see S. W. Bushell, *Oriental Ceramic Art, illustrated by examples from the Collection of W. T. Walters, 5,* 188, fig. 247.

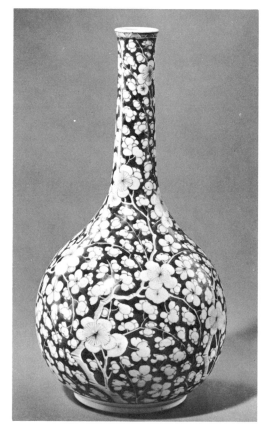

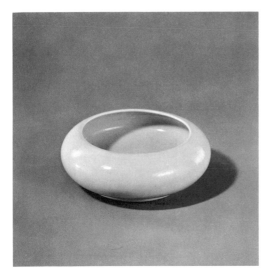

44. Brush washer

1955.4.101

Hobart and Edward Small Moore Memorial Collection; bequest of Mrs. William H. Moore

Porcelain; H. 1½″, D. 4¾″

Fine porcelain body uniformly covered with monochrome glaze of pale blue, a light variant of the *clair de lune* family. Neutral glaze on base.

Inscription: Six character K'ang Hsi mark in underglaze blue on base.

Origin: Ching-tê Chên kilns, Kiangsi province.

Date: Ch'ing dynasty, K'ang Hsi reign.

Condition: Small chip on foot.

Close parallel pieces, among others, are to be found in the Widener and David Collections. For the former, see Erwin O. Christensen, *Chinese Porcelains of the Widener Collection,* p. 33; for the latter, see "Ch'ing," pl. 90.

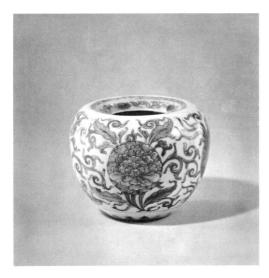

45. Bowl

1940.228

Bequest of Florence Baiz Van Volkenburgh in memory of her husband, Thomas Sedgwick Van Volkenburgh, B.A. 1866

Porcelain; H. 2⅞″, D. 3¾″

Made of fine-grained porcelain decorated with floral elements in underglaze red. Several thin lines in underglaze blue at neck and foot. Neither the red nor the blue has matured perfectly.

Inscription: Six character K'ang Hsi mark in underglaze blue on base.

Origin: Ching-tê Chên kilns, Kiangsi province.

Date: Ch'ing dynasty, K'ang Hsi reign.

Condition: Complete.

For a close parallel see "Ch'ing," no. 109, pl. 43, from the collection of Sir Harry and Lady Garner.

46. Vase

1954.48.3

Hobart and Edward Small Moore Memorial Collection; gift of Mrs. William H. Moore

Porcelain; H. 7½″, D. 2⅞″

Graceful amphora shape with double ring band on neck. Fine-grained porcelain with raised design of two dragons in the waves. Body and neck interior covered with light green celadon glaze. Footrim unglazed, and underbase has neutral glaze.

Inscription: Six character K'ang Hsi mark in underglaze blue on base.

Origin: Ching-tê Chên kilns, Kiangsi province.

Date: Ch'ing dynasty, K'ang Hsi reign.

Condition: Few firing flaws on rim.

Provenance: Henry Sampson Collection, 1914.

For two celadon amphorae with generally similar shape, and extremely close design, see Bushell, *Collection of W. T. Walters, 1,* pl. 7; and J. Pierpont Morgan, *Catalogue of the Morgan Collection of Chinese Porcelains, 2,* no. 1310, pl. 117.

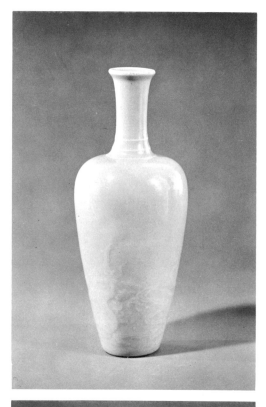

47. Vase

1955.4.84

Hobart and Edward Small Moore Memorial Collection; bequest of Mrs. William H. Moore

Porcelain; H. 17½″, D. 8″

Made of fine-grained white porcelain, thrown in two parts with a horizontal joining. Neutral glaze covers entire piece except for footrim. Bird, flower, and rock design executed in overglaze enamels of blue, green, yellow, aubergine, and rust red.

Inscription: Six character Ch'êng Hua mark in underglaze blue on base.

Origin: Ching-tê Chên kilns, Kiangsi province.

Date: Ch'ing dynasty, K'ang Hsi reign.

Condition: Few minute firing flaws.

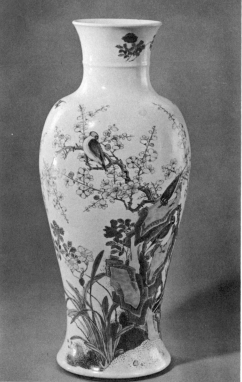

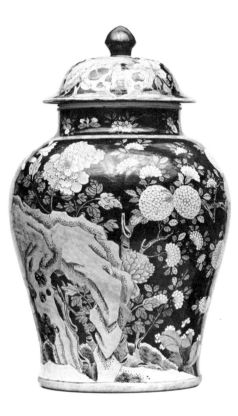

48. Temple jar

1954.36.3a,b
Gift of Wilson P. Foss, Jr., Ph.B. 1913
Porcelain; H. (incl. cover) 22½″, D. 12¾″
Black "hawthorn" ware, painted on the biscuit with hyacinth, peonies, magnolias, and rocks in *famille verte* enamels. Black glaze.
Origin: Ching-tê Chên kilns, Kiangsi province.
Date: Ch'ing dynasty, K'ang Hsi reign.
Condition: A few small surface repairs.
Provenance: Mortimer L. Schiff Collection.
For a close parallel see "Ch'ing," no. 157, from the Ascott Collection, the National Trust.

49. Covered jar

1956.42.5
Gift of Dr. Yale Kneeland, Jr., B.A. 1922
Porcelain; H. (incl. cover) 12⅜″, D. 6⅝″
Made of fine-grained white porcelain clay. Design of flowering fruit sprays painted in underglaze red with formal bands above and below main design. Underglaze red on cover has matured more completely.
Origin: Ching-tê Chên kilns, Kiangsi province.
Date: Ch'ing dynasty, first half eighteenth century.
Condition: Crack and repair on cover.
Parallel piece illustrated in Soames Jenyns, *Later Chinese Porcelains,* pl. 22, from the collection of Sir Harry Garner.

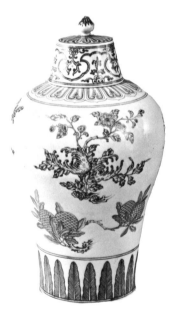

50. Jar

1928.234

S. Wells Williams Collection; bequest of F. Wells Williams, B.A. 1879

Glass; H. 2⅝″, D. 3⅝″

Made of a layer of opaque white glass with an outer layer of ruby glass on sides and bottom. Sides carved with three bands and floral scroll design.

Inscription: Incised six character Ch'ien Lung inscription and the character *chiang* (ginger) on base.

Date: Ch'ing dynasty, Ch'ien Lung reign.

Condition: Complete.

For a piece parallel in technique, see "Ch'ing," no. 332, from the City Art Gallery, Bristol.

51. Vase

1952.52.32

Hobart and Edward Small Moore Memorial Collection; gift of Mrs. William H. Moore

Porcelain; H. 5″, D. 3″

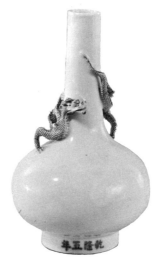

Made of fine-grained white porcelain. A dragon in the round is appliquéd to lower part of long neck and decorated in enamels of blues, yellows, green, and brown. Remainder is plain, covered with a neutral glaze.

Inscription: Ch'ien Lung wu nien (the fifth year of Ch'ien Lung) on the side of the foot in underglaze blue; *Wo hui t'ang chih* (made for the hall of disordered enrichment) on the base in underglaze blue.

Origin: Ching-tê Chên kilns, Kiangsi province.

Date: Ch'ing dynasty, Ch'ien Lung reign, dated in accordance with 1740.

Condition: Repair on lip.

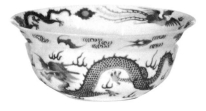

52. Bowl (one of a pair)

1928.201
S. Wells Williams Collection; bequest of F.
Wells Williams, B.A. 1879
Porcelain; H. 1¾″, D. 4½″

Made of eggshell porcelain, entirely covered
except for very low footrim with neutral glaze.
Decorated with a painted dragon and phoe-
nixes in translucent red enamel with a few
flowers in opaque white enamel on interior.

*Inscription: Chia Ch'ing wu wu shih ching
t'ang chih"* (the *wu wu* year of the Chia Ch'ing
period [1798], made for the Hall of Respect-
ful Matters), in red enamel on base.

Origin: Ching-tê Chên kilns, Kiangsi province.

Date: Ch'ing dynasty, Chia Ch'ing reign, dated
in accordance with 1798.

Condition: Small firing flaws; repair on upper
rim.

Bibliography: L. R., "The Williams Collec-
tion of Chinese Porcelain," *BAFAYU, 3*
(1928), 8.

See commentary for no. 388.

53. Vase (one of a pair)

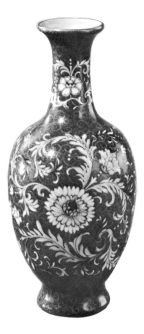

1956.42.10a
Gift of Dr. Yale Kneeland, Jr., B.A. 1922
Porcelain; H. 7⅞″, D. 3½″

Made of fine porcelain with exterior covered
by rose *graviata* pattern. Over this, flower
sprays are painted in blue, yellow, green, and
coral enamels.

Inscription: Ch'ien Lung mark, enclosed in a
double square frame; four characters in blue
on bottom of recessed foot.

Origin: Ching-tê Chên kilns, Kiangsi province.

Date: Ch'ing dynasty, Ch'ien Lung reign.

Condition: Complete.

Provenance: Imperial Collection, Peking;
Ton-ying, 1930.

54. Bowl

1955.4.24

Hobart and Edward Small Moore Memorial
Collection; bequest of Mrs. William H. Moore

Porcelain; H. 2⅜″, D. 4⅛″

Made of fine white porcelain and covered with
neutral glaze. Decorated outside in *famille rose*
enamels with a floral design which winds over
the rim to decorate the interior.

Inscription: Six character Ch'ien Lung mark
in seal characters in underglaze blue on base.

Origin: Ching-tê Chên kilns, Kiangsi province.

Date: Ch'ing dynasty, Ch'ien Lung reign.

Condition: Hairline crack at rim.

Provenance: Startseff Collection; purchased
by Thomas B. Clarke, New York, 1910.

For a parallel piece, see Lady David, *Illus-
trated Catalogue of Ch'ing Enamelled Wares
in the Percival David Foundation of Chinese
Art*, sec. 2, pl. 12.

55. Cup

1940.240

Bequest of Florence Van Volkenburgh in
memory of her husband, Thomas Sedgwick
Van Volkenburgh, B.A. 1866

Glass; H. 2″, D. 2½″

Semitranslucent glass, decorated with a design
of two phoenixes and a dragon in blue, brown,
yellow, and green enamels. Design bands in
blue near upper rim and on foot.

Inscription: Four character Ch'ien Lung mark
in blue enamel on base.

Date: Ch'ing dynasty, Ch'ien Lung reign.

Condition: Few small firing flaws on interior.

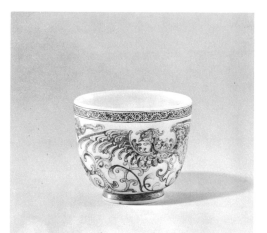

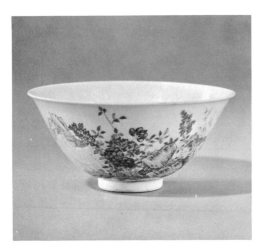

56. Bowl

1928.213

S. Wells Williams Collection; bequest of F. Wells Williams, B.A. 1879

Porcelain; H. 2½″, D. 5⅜″

Translucent porcelain with neutral glaze, decorated with landscape scene including goats in enamels of famille rose with accents of orange, gray, beige, and a liberal use of white.

Inscription: Six character Tao Kuang mark in seal characters in underglaze blue on base.

Origin: Ching-tê Chên kilns, Kiangsi province.

Date: Ch'ing dynasty, Tao Kuang reign.

Condition: Fine crack at upper edge; slight wearing in small area along upper edge.

The following parallel pieces seem pertinent: Daisy Lion-Goldschmidt, *Les Poteries et Porcelaines Chinoises* (Paris, 1957), pl. 28C, collection Grandidier (Tao Kuang); R. L. Hobson, *The Later Ceramic Wares of China* (London, 1925), pl. 26, fig. 2, in the possession of Capt. A. T. Warre (Ch'ien Lung); E. T. Chow and F. S. Drake, "Kuan-Yao and Min-Yao" (A Study on Imperial Porcelain and People's Porcelain from K'ang Hsi to the end of the Ch'ing Dynasty), *ACASA, 13* (1959), pl. 21, 1 (Tao Kuang).

57. Bird

1949.267
Collection of Wayland Wells Williams, B.A.
1910; gift of Mrs. Frances Wayland Williams
Earthenware; H. 6¾″, L. 12½″

Modeled of gray clay with three openings (two
for legs perhaps) on base, opening for mouth,
and openings in molded ears. Wings and tail
detachable. Eyes and square on back incised.
Red pigment on eyes, ears, mouth, wings, and
tail.

Date: Eastern Chou dynasty, probably fifth-
third century B.C.

Condition: Some areas of pigmentation in-
complete.

Provenance: Meerkerk, New York, 1942.

Apparently the first of these birds with de-
tachable wings and tail was reported by G.
Eumorfopoulos in "Description of specimens
exhibited," *TOCS,* 8 (1928–30), 11. The ex-
cavations at Chêng-chou in Honan province,
1952, provided the first documentation of the
type and permitted attribution to Eastern
Chou; see IAAS, *Chêng-chou Êr-li-kang,* pp.
63, 89, pl. 25, no. 3. A bird generally similar
to the Yale piece is in the collection of the
Nelson Gallery-Atkins Museum in Kansas
City. The Nelson Gallery piece was described
and illustrated by Walter Hochstadter, "Pot-
tery and Stonewares of Shang, Chou and Han,"
p. 76, fig. 77. Still a third bird is reputedly in
the Junkunc collection, Chicago.

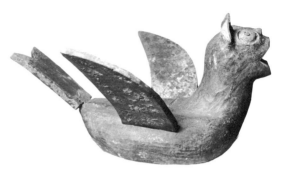

58. Buddhist Votive Stele

1929.45
F. Wells Williams, B.A. 1879, Collection
Gray limestone; H. 82″, W. 26″, T. 8″

The stele illustrates the *Lotus Sutra.* Three
scenes on the front are fully discussed by J.
LeRoy Davidson in *The Lotus Sutra in Chinese
Art* (see below). Back portrays, in the top
register, Amida Buddha in his Western Para-
dise; in the second, two identical Buddhas; in
the third, Sakyamuni between Manjusri and
Vimalakirti. Inscription covers lowest portions
of both sides.

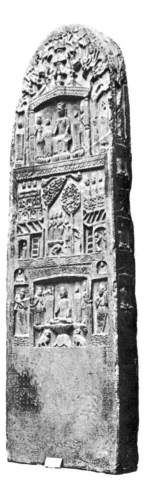

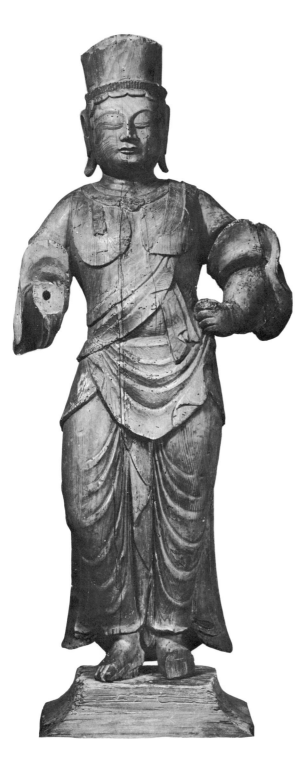

Date: Northern Ch'i dynasty.

Condition: Damage to hands and faces of many figures; large areas of inscription effaced; entire surface appears to have been coated with shiny, varnishlike substance, which largely wore off but was later heavily reapplied on front and sides.

Bibliography: BAFAYU, 5, nos. 1–3 (1931), p. 24; J. LeRoy Davidson, "Traces of Buddhist Evangelism in Early Chinese Art," *Artibus Asiae, 11,* no. 4 (1948), figs. 3, 4; J. LeRoy Davidson, *The Lotus Sutra in Chinese Art,* pp. 34–35, 42–45, pls. 5–8.

The characters for "Great Ch'i" occur several times in the front inscription, confirming the Northern Ch'i date. The differences in quality of execution among the registers are probably accounted for by a difference in hands; in the front middle register perhaps by a lack of precedent iconographic tradition. One donor inscription suggests the original location of this stele was Nan-fên-chou, a city about halfway up the Fên river and close to the boundary between Shansi and Shensi provinces.

59. *Bon-ten,* Buddhist deity

1963.31

Leonard C. Hanna, Jr., B.A. 1913, Fund

Wood with traces of gesso and polychrome; H. 41″

Bon-ten carved from a single piece of wood (*ichiboku* technique) except right hand and part of left sleeve. Suggestion of provincial origin in the lack of hollows in the back to reduce weight (*uchiguri* technique).

Date: Fujiwara period, tenth century.

Condition: A few losses, cracks, and old repairs; right hand and part of left foot missing; base not original.

Provenance: Mathias Komor, New York, 1963.

Bibliography: BAFAYU, 30, no. 1 (1964), cover, p. 9.

Companion piece in Matsunaga Memorial Museum, Odawara, illustrated in Kuno Ta-

keshi, ed., *Kantō chōkoku no kenkyū* (A study of Kantō sculpture) p. 289, and in *Zuroku, 8* (1963), pl. 5.

60. *Kuan-yin,* Bodhisattva

1956.39.1
Gift of Winston F. C. Guest, B.A. 1927
Wood, gilt, and polychrome; H. 5′ 5″
Kuan-yin seated in posture of royal ease (*mahâjâralila*) on rocky ledge. Assembled of several pieces: rock base, torso-head, each leg, right arm, right hand, and jutting rock to figure's left. Robe originally painted red and flesh pink; later gilded overall; regilding and bands of colors on robe painted on relatively recently.

Inscription: Carved on back: *Ta T'ing Pa Nien Wu Yueh Erh Shih Erh Jin Li* (This was erected on the twenty-second day of the fifth month of the eight year of the reign of Ta T'ing).

Date: Chin dynasty, dated in accordance with 1168.

Condition: Ends of fingers and scarves broken off; a few cracks; paint noted above.

Provenance: Ton-ying, New York.

Bibliography: Leigh Ashton, *Chinese Sculpture,* p. 99; Osvald Sirén, *Chinese Sculpture from the Fifth to the Fourteenth Century,* pl. 587; Alan Priest, *Chinese Sculpture in the Metropolitan Museum* (New York, 1944), pl. 17; Ludwig Bachofer, *A Short History of Chinese Art* (New York, 1946), pl. 74; Otto Fischer, *Chinesische Plastik* (Munich, 1948), pl. 112; *Encyclopaedia Britannica, 5,* 14th ed., 587; *BAFAYU, 23,* nos. 1–2 (1957), cover and pp. 24–25.

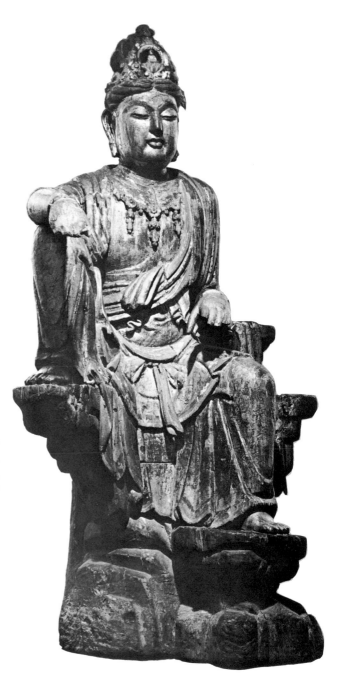

Painting

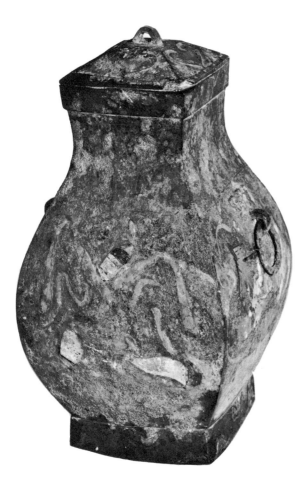

61. Covered jar of type hu, painted

1954.49.1

Hobart and Edward Small Moore Memorial Collection; gift of Mrs. William H. Moore

Bronze with polychrome; H. 7½"

Cast with two t'ao t'iehs holding ring handles. Body and cover once covered overall with polychrome (black, green, rust, blue, and white). Main figures of priests and musicians in autumn ceremony remain on sides of body. Cover has small ring and quatrefoil in relief.

Date: Eastern Han dynasty.

Condition: Paintings worn; vessel partly covered with malachite patination; chip off corner of lid.

Provenance: Ton-ying, New York, 1938.

Exhibition: Chinese Bronzes, CASA, 1946; Chinese Paintings at Yale, Yale University Art Gallery, New Haven, 1963, no. 2.

Bibliography: Umehara Sueji, "Nirerinfu shutsudo to tsutaeru ichi gun no kansai edagōki" (One group of brightly painted Han bronze objects passed on from the excavation in Yulinfu), *Yamato Bunka, 17* (1955), p. 76, fn. 9.

There are similar pieces in Umehara, *Kodōki,* pl. 48, from the Museum of Fine Arts, Boston.

62. Ching-shêng-fo, the Buddha of the Clear Voice

1945.388

Artist: The monk Chih-kuo

Dates: Active early seventh century

Bequest of Louise Wallace Hackney

Ink and color on paper; H. 12½", W. 11¼"

Ching-shêng-fo flanked by two smaller attendants. Outlined in black with red, green, tan, brown, and black coloring in figures; green ground for inscription.

Inscription: Includes the date and "Praise to the Buddha Ching-shêng-fo," and that it was made by Chih-kuo of the Ta-chuang Monastery for the protector of Tun-huang, Ling-hu.

Date: Sui dynasty, dated in accordance with 607.

Condition: Paper brown with age, water-stained and imperfect; some repairs on back with paper bearing Chinese characters.

Another version of the same subject and date is to be found in the Museum of Fine Arts, Boston; see Tomita Kojiro, *A Portfolio of Chinese Paintings in the Museum,* pl. 9A. The discovery of a second Chih-kuo version of *Ching-shêng-fo* enables us to submit addenda to a long-term discussion. In what appears to be the earliest publication of the Chih-kuo group, an anonymous writer in *Kokka,* no. 416 (1925), pp.203–04, declares the inscriptions to be printed, a point categorically denied by Tomita Kojiro in "Two More Dated Buddhist Paintings from Tun-huang," p. 12. Usher Coolidge, twenty years later, revived the controversy by including the Fogg Chih-kuos in his exhibition, *Religious Wood-block Prints of the Far East* (Fogg Museum, Harvard University, Cambridge, 1948), nos. 1–2. A quick comparison of the *Ching-shêng-fo* pictures at Boston and Yale may inhibit further discussion. A multitude of small differences in line, especially in those depicting the attendants, rules out the possibility of the pictures' being printed. As for the calligraphy, careful inspection of a single line of characters (the right hand one) reveals sufficient differences of spacing within and around certain characters so that the idea of their being printed has to be rejected. The major flaw in the Tomita article cited above rests in his suggestion that each of the two hundred Chih-kuo pictures was devoted to a different deity.

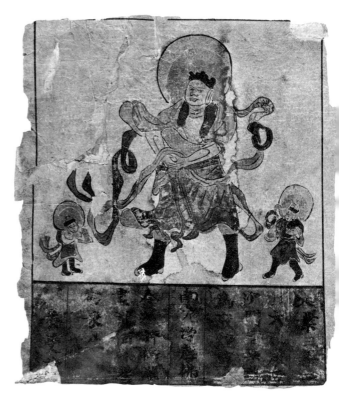

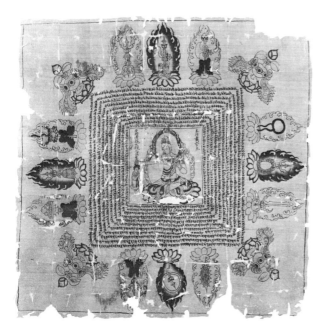

63. Buddhist charm

1955.7.1

Hobart and Edward Small Moore Memorial Collection; bequest of Mrs. William H. Moore

Ink and color on silk; H. 8½″, W. 8½″

The central goddess is enclosed by text and surrounded by sixteen symbols. Blue, red, and yellow used occasionally.

Inscription: Parts translated by H. N. von Koerber in Louise Wallace Hackney and Yau Chang-foo, *A Study of Chinese Paintings in the Collection of Ada Small Moore* (hereafter referred to as Hackney and Yau) p. 167.

Origin: Said to have been found in Honan province.

Date: T'ang dynasty, ninth century.

Condition: Many small areas lost.

Provenance: Edgar Worch, New York, 1930.

Exhibition: Paintings, Yale, 1963, no. 4.

Bibliography: Otto Kümmel, *Jörg Trübner zum gedächtnis* (Berlin, 1930), pl. 72; Hackney and Yau, pp. 167–68.

64. Fragment of painted banner (Indian side shown)

1937.5576

Hobart and Edward Small Moore Memorial Collection; gift of Mrs. William H. Moore

Ink and color on woven and sized cotton; H. 9½″, W. 8⅛″

Painted on both sides, one representing a female figure in Uiger dress, and the other an Indian female with caste marks; both presented in three-quarter view, bearing a dish of fruit. Colors include red, two tones of blue, two tones of green, and white.

Origin: Bäzäklik in the Turfan district of Chinese Turkestan.

Date: T'ang dynasty, ninth century or a little later.

Condition: Many areas lacking within the fragment.

Provenance: Albert von Le Coq, Berlin.

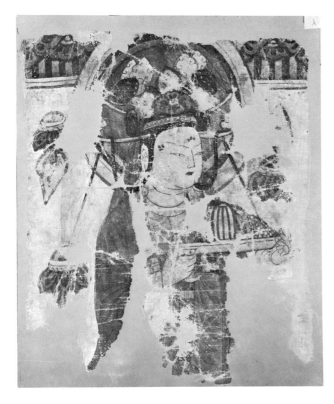

Exhibition: Paintings, Yale, 1963, no. 3.

Similar examples have been published by A. von Le Coq; see *Chotscho* (Berlin, 1913), pl. 38, and *Die Buddhistische Spätäntike in Mittelasien, 3* (Berlin, 1924), pls. 13, 16.

65. Fragment of gauze

1937.5625

Hobart and Edward Small Moore Memorial Collection; gift of Mrs. William H. Moore

Gauze made of silk threads with lacquer, gold; H. 12⅜″, W. 12″

Purple gauze with design painted in lacquer, then gold filings applied *(makie* technique). The central figure is a bird-god figure *(karyō-binga)* surrounded by a stylized floral pattern *(hōsōge).*

Origin: Japan.

Date: Heian period, probably eleventh–twelfth century.

Condition: Some broken threads; areas of lacquer and gold missing.

Provenance: Yamanaka, New York, 1933.

It has been suggested that this fragment may be derived from an altar cloth. Both the techniques and the patterns employed were known in eighth-century Japan. A somewhat later date is suggested by the stylization of the central figure and the floral background. These designs seem related to the well-known document box at Ninna-ji (dated 919) and to the numerous karyōbinga and hōsōge representations, in other media, of the eleventh and twelfth centuries. The Yale piece may possibly be the only surviving textile of this design, although mandalas on purple silk, and decorated in gold and silver, have come down from the Heian period.

66. Calligraphy (commentary)

1952.52.15a 1
Artist: Fan Ch'un-jên
Dates: 1027–1101
Hobart and Edward Small Moore Memorial Collection; gift of Mrs. William H. Moore
Ink on paper; H. 12½″, W. 7½″
Written in *hsing-shu* (running script). Translated Hackney and Yau, p. 43. T'ang family seal at beginning, calligrapher's seal at end.
Date: Northern Sung dynasty.
Condition: Holes; paper very thin to completely gone in lower third.
Bibliography: Hackney and Yau, no. 11, p. 43. Mounted as a colophon to the T'ang family portrait scroll.

67. Calligraphy (commentary)

1952.52.15a 2
Artist: Ch'êng Hao
Dates: 1032–1085
Hobart and Edward Small Moore Memorial Collection; gift of Mrs. William H. Moore
Ink on paper; H. 11″, W. 12″
Written in *k'ai-shu* (standard script). Translated Hackney and Yau, p. 43. T'ang family seal at beginning calligrapher's seal at end (seal of the Chung-chuang Kung).
Date: Northern Sung dynasty.
Condition: Several holes; paper thin.
Bibliography: Hackney and Yau, no. 11, p. 43. Mounted as a colophon to the T'ang family portrait scroll.

68. Portrait of Chu Kuan

1953.27.11
Hobart and Edward Small Moore Memorial Collection; gift of Mrs. William H. Moore
Ink and color on silk; H. 15¾″, W. 12½″
Portrait in black and white.
Inscription: (Trans. C. F. Yau) "Chu Kuan, Retired Secretary of the Third Rank of the Department of War. Eighty-eight."

Origin: One leaf of the album, the Five Old Men of Sui-yang.

Date: Sung dynasty, probably eleventh century.

Condition: Many creases and small losses in silk; few small silk fill-ins.

Exhibition: Paintings, Yale, 1963, no. 5.

Bibliography: Tu Mu, *T'ieh-wang-shan-hu,* yu i, p. 1, and cited from this source by four Ch'ing dynasty works; F. S. Kwen, *Descriptive Catalogue of Ancient and Genuine Chinese Paintings* (Shanghai, 1916), no. 60; Hackney and Yau, no. 18 (ill. as no. 17).

The long history of the picture is available from other album leaves now in the collection of the Metropolitan Museum; a summary of this history is given in Kwen, *Descriptive Catalogue,* no. 60. Two portrait leaves are in the Freer Gallery, two at Yale, and one in the Metropolitan Museum. Recent critical studies of this album have been made by Chuang Shen and Li Lin-ts'an; see articles in *The Continent Magazine, 12, 13, 15.*

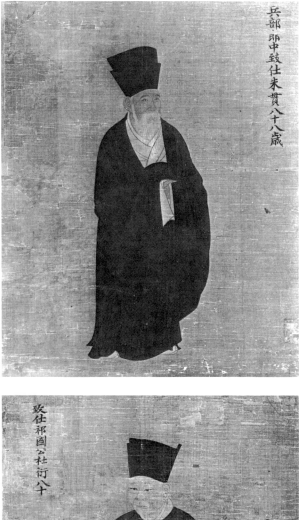

69. Portrait of Tu Yen

1953.27.12

Hobart and Edward Small Moore Memorial Collection; gift of Mrs. William H. Moore

Ink and color on silk; H. 15¾", W. 12½"

Portrait primarily in black and white, the belt in red.

Inscription: (Trans. C. F. Yau) "Tu Yen, retired, Duke of Ch'i, Eighty."

Origin: One leaf of the album, The Five Old Men of Sui-yang.

Date: Sung dynasty, probably eleventh century.

Condition: Many creases and losses in silk; substantial silk fill-ins.

Exhibition: Paintings, Yale, 1963, no. 6.

Bibliography: See no. 68.

See Commentary for no. 68.

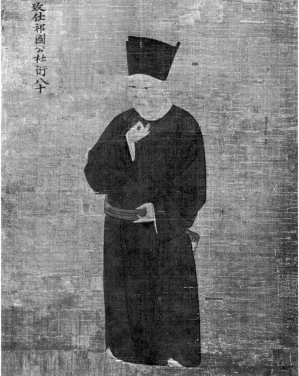

70. T'ien Tan on the Move (detail shown)

1955.38.1
Gift of Earl Morse
Ink and color on silk; H. 9⅞", L. 35⅞"

Vigorously drawn procession of five adults and a baby riding or with animals. Animals in grays and brown while the humans wear clothes of yellow, pale red, and green. 104 character inscription tells the story involving T'ien Tan.

Date: Sung dynasty.

Condition: Many surface cracks, probably due to past folding; some losses; this is presumably the last part of a substantially longer scroll.

Provenance: Owen Roberts Collection.

Exhibition: Chinese Paintings, Walker Art Center, Minneapolis, 1942; Paintings, Yale, 1963, no. 18.

Bibliography: J. LeRoy Davidson, *Chinese Paintings* (Minneapolis, 1942), no. 65.

Three seals, one on the brocades preceding the scroll and two overlapping the end of the painting and the adjoining brocade, are those of the Chin Emperor Chang Tsung (d. 1209). These read respectively Pi fu, Yü fu pao hiu, and Nei tien chên wan. The depicted subject concerns the fleeing of the people of the Ch'i state from Yo I. These people had better protected their carts (not shown in the present fragment) on the advice of T'ien Tan. While originally attributed to Han Kuang of T'ang, the Yale picture seems rather to be an honest Sung copy, and likely the earliest and best of the several versions which have survived.

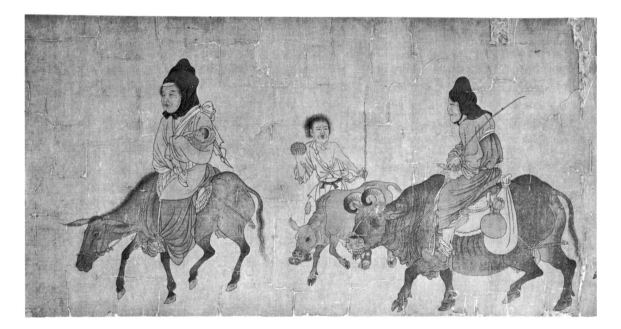

71. Birds on a river bank (details shown)

1953.27.4

Hobart and Edward Small Moore Memorial Collection; gift of Mrs. William H. Moore

Ink and color on silk; H. 9″, L. 72¼″

Brightly colored representation of birds on a willow, bamboo, and mallow lined river bank, traditionally attributed to Huang Ch'üan. A wide variety of colors is used, blue and green predominant. Much repainting, but bamboo in particular seems original.

Date: Sung dynasty.

Condition: Many surface cracks and some losses; extensive repainting.

Provenance: Chinese Imperial Collection, eighteenth–twentieth century; Yamanaka, Osaka, 1932.

Exhibition: International Exhibition, London, 1935–36, no. 1005; Yale, 1941; Paintings, Yale, 1963, no. 13.

Bibliography: Shih-ch'ü pao-chi, Ning-shou vol. Osvald Sirén, *History of Early Chinese Painting, 1,* 112, pls. 76–77; *International Exhibition of Chinese Art* (London, 1935–36), large catalogue, pl. 93; Harada Bizen, *Pageant of Chinese Painting* (Tokyo, 1936), pls. 36–37; Hackney and Yau, no. 6; William Cohn, *Chinese Painting* (London, 1948), pp. 64–65, pls. 27–28; Benjamin Rowland, "The Problem of Hui Tsung," *ACASA, 5* (1951), 17–18, fig. 8; Osvald Siren, *Chinese Painting: Leading Masters and Principles, 2,* 28, and *3,* pl. 136; Max Loehr, "Chinese Paintings with Sung Dated Inscriptions," *Ars Orientalis, 4* (1961), 230–31; Michael Sullivan, *Great Art and Artists of the World—Chinese and Japanese Art* (New York, 1965), p. 174.

Despite the discussion this painting has engendered, two items have not been noted. First, there is an overstamping of some (presumably) early seals. Second, one finds that the collection of the notorious Ming official, Yen Sung, contained two anonymous Sung handscrolls with this precise title. Thus it seems probable that we are dealing with an old painting, but that the attribution to Huang Ch'üan does not go back beyond Hsiang Yuan-pien (1525–1590).

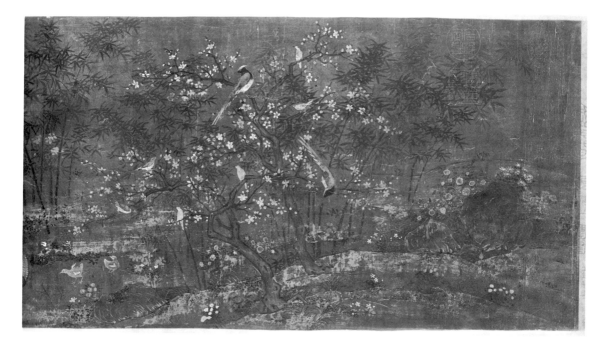

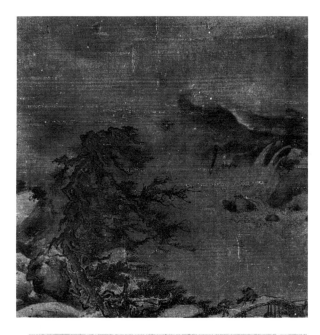

72. Snow landscape

1952.52.25g

Hobart and Edward Small Moore Memorial Collection; gift of Mrs. William H. Moore

Ink and color on silk; H. 9½″, W. 9¾″

Traditionally attributed to Li Sung. Slight color used in depicting the humans of the scene.

Date: Chin dynasty.

Condition: Cracks and small losses in silk.

Provenance: Ton-ying, New York, 1926.

Exhibition: Paintings, Yale, 1963, no. 10.

Bibliography: Hackney and Yau, no. 30, 7; Susan Bush, "Clearing after snow in the Min Mountains," pp. 163–72, fig. 2.

For a discussion of this painting as Chin rather than Sung, see the Bush article cited above.

73. Calligraphy (commentary)

1952.52.15a3

Artist: Ao T'ao-sun

Dates: 1154–1227

Hobart and Edward Small Moore Memorial Collection; gift of Mrs. William H. Moore

Ink on paper; H. 12¼″, W. 12″

Written in *hsing-shu* (running script). Translated Hackney and Yau, p. 43. Round seal at end nearly effaced.

Date: Southern Sung dynasty.

Condition: A few tiny losses.

Bibliography: Hackney and Yau, no. 11, p. 43.

Mounted as a colophon to the T'ang family portrait scroll.

74. Lady among bamboo trees

1952.52.25d

Hobart and Edward Small Moore Memorial Collection; gift of Mrs. William H. Moore

Ink and color on silk; H. 9″, W. 8¾″

Traditionally attributed to Chou Fang. Shades of pink, sepia, white, and green are used in depicting the lady, the bamboo, and occasional areas of ground. Three seals on left have been read as those of Kêng Chao-chung (Hackney

and Yau, no. 30, p. 4). Two of the seal remnants on the right also belong to this collector. The last seal fragment, upper right, remains unresolved.

Date: Southern Sung dynasty.

Condition: Many cracks and creases; substantial fill-ins of silk.

Provenance: Ton-ying, New York, 1926.

Exhibition: Paintings, Yale, 1963, no. 11.

Bibliography: Hackney and Yau, no. 30, p. 4.

Other versions of this subject are to be found in the collection of the Philadelphia Museum, published James Cahill, *The Art of Southern Sung China,* no. 24; and in the collection of the National Palace Museum, Taiwan, published *Ku-kung chou-k'an* (1930, 9th month, 5th day), no. 51.

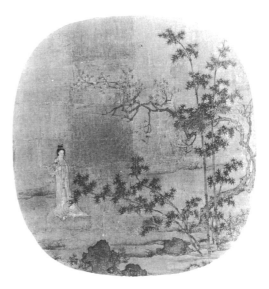

75. *Lohan*

1952.40.12

Gift of Mrs. Jared K. Morse

Ink and color on silk; H. 45½″, W. 20½″

Lohan seated on a rock underneath a tree, depicted with his servant in bright colors, especially reds, blues, and golds, against a primarily ink background. This may represent the fifth lohan, No-ku-lo.

Date: Sung-Yüan dynasty, thirteenth–fourteenth century.

Condition: Many surface losses and a few fill-ins; all edges have been trimmed; silk has darkened, colors and ink lightened.

This type of painting was early transmitted to Japan (see two Japanese *Rakan* paintings, closely related to the Yale picture, in the Freer Gallery of Art, illustrated in Mayuyama Junkichi, ed., *Japanese Art in the West* [Tokyo, 1966], pl. 109, A, B). This evidence, plus the Japanese mounting of the Yale piece, raised the possibility of a Japanese origin. The style is, however, Chinese, especially in the brush stroke and the depiction of the rocks and trees. For related Chinese paintings, from Seiryō-ji, dated Northern Sung, see Takasaki Fujihiko, "Rakan ga nitsuki" (Lohan Paintings), pp. 24–28.

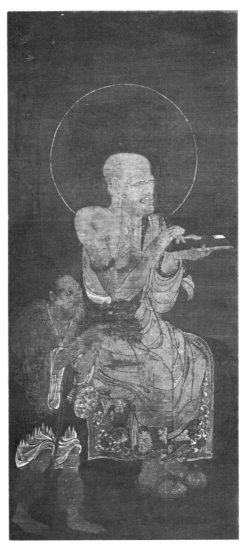

76. Cloudy landscape

1953.27.7

Hobart and Edward Small Moore Memorial Collection; gift of Mrs. William H. Moore

Ink on paper; H. 7¼", L. 28⅜"

A group of houses huddled in the woods beneath mountains and clouds. Traditionally attributed to Mi Yu-jên.

Inscription: Trans. Hackney and Yau, p. 46; another translation of the Tsung Hsia poem is given by A. G. Wenley in a review of the Moore volume in *Journal of the American Oriental Society,* pp. 297–98.

Date: Yüan dynasty.

Condition: Cut slightly all around; some repairs in paper; substantial repainting.

Provenance: Pien Yung-yü, seventeenth century; Lu Hsin-yüan, nineteenth century; Ching Wei-hsien, twentieth century; Ton-ying, New York, 1922.

Exhibition: Paintings, Yale, 1963, no. 16.

Bibliography: Pien Yung-yü, *Shih-ku t'ang shu-hua hui-k'ao* (first edition in K'ang Hsi period), *13,* 55–56; Lu Hsin-yüan, *I-ku t'ang t'i-pa* (Collection of colophons), *15* (1890), 10; Lu Hsin-yüan, *Jang-li kuan kuo-yen lu* (Observations from the Jang-li Kuan), *2* (1891), 25–26; Hackney and Yau, no. 12.

One may note that nothing on the painting itself, neither seals nor inscriptions, associates the picture with Mi Yu-jên. That association is made by the colophons of which the earliest is dated in accordance with 1367.

While the name Tsung Hsia remains an enigma, the seal near his poem, and bearing the characters of the White Cloud Mountain Studio, might be that of the Yüan official Ch'a Han, whose life fits the general outline of the poem. Ch'a Han spent the closing years of his life at the White Cloud Mountain country house at Tê-an in Chiang-nan, not far from the monastery of Lu Shan. The monastery staff include a priest, Ju Ti, whose courtesy title was P'ing-shih and who was presumably the P'ing-shih who wrote the first colophon.

Thus it seems likely that a genuine and unpretentious Yüan painting became in the mid-fourteenth century a Mi Yu-jên. The painting then dropped out of sight for several centuries but bears the seals of the Ming scholar-painter, Mo Shih-lung (second half of the sixteenth century).

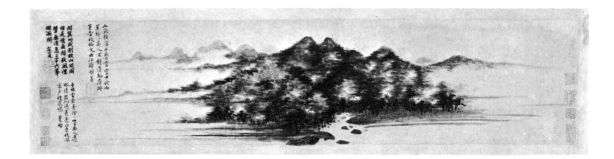

77. Bamboo and wagtail

1965.28

Gift of the Art Gallery Associates in honor of Mrs. Paul Moore

Ink on silk; H. 33¼″, W. 15¾″

Bird stands on a small ledge and is backed by bamboo and thorn.

Origin: Japan.

Date: Nanbokuchō period.

Condition: Silk has darkened; small surface losses.

Exhibition: Exhibition of Kamakura Period Ink Paintings, Kamakura City Museum, Nov. 10–30, 1961.

Bibliography: Matsushita Ryusho, *Ink Paintings of the Kamakura Period, 9,* no. 1.

Dr. Matsushita relates this painting to a wagtail picture in Japan bearing an inscription by Taikyo Genju. One may add that both paintings are stylistically akin to a bird and bamboo picture bearing the seal of Kao in the collection of the Yamato Bunka-kan, Nara.

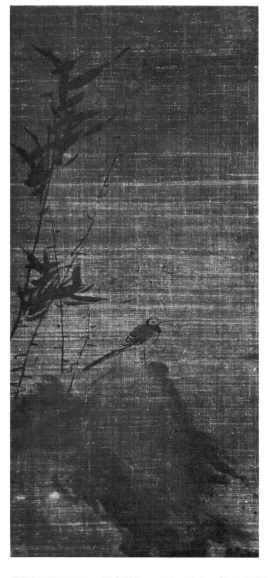

78. Calligraphy (poem)

1968.14

Artist: Sakugen

Dates: 1501–1579

Mrs. William H. Moore Fund and Fred Olsen Fund

Ink on paper; H. 16¾″, W. 25½″

Poem written in *ts'ao-shu* (grassy script). Translated:

> "Reading the scrolls by rote gives the support of one fishing rod,
> But pondering over the three breaths changes these streams and mountains."

Signed lower left "Sakugen kambun, a Chinese composition," with two seals of Sakugen. Seal upper right appears to read "Min-ki-sai" (part of a Sakugen book title). Seal lower right unidentified.

Origin: Probably Tenryū-ji Kyoto, Japan.

Date: Muromachi period, probably 1540–49.

Condition: Four small repaired wormholes.

Provenance: Mayuyama and Co., Tokyo, 1968.

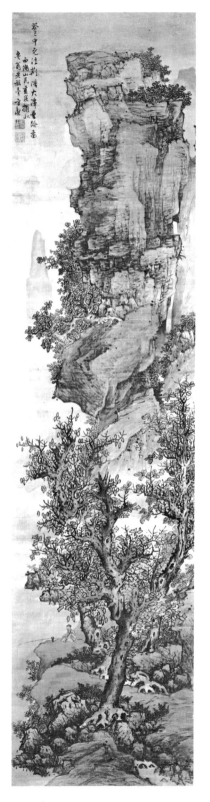

79. Landscape inspired by Ching Hao

1967.75
Artist: Lan Ying
Dates: 1585–c. 1665
Anonymous gift in honor of Nelson Wu
Ink and color on silk; H. 76½″, W. 19¼″
The artist as fisherman seated in colorful landscape, dominated by russets and greens.

Inscription: Translated: "In the *kuei-ssŭ* year (1653), fixing the mind on Ch'u-k'u (Ching Hao), that great enricher beyond compare, Lan Ying, the West Lake recluse, finds comfort as an aged fisherman contemplating a single harmonious end." Two seals of the artist: Lan Ying chih yin and T'ien-shu.

Date: Ch'ing dynasty, dated in accordance with 1653.

Condition: One large and a few small fill-ins.

Provenance: Ogawa Nagaharu, 1932; Okada Kōen, 1939.

80. Leaf from Album of Landscapes

1965.130a
Artist: Wang Hui
Dates: 1632–1717
Gift of Wango H. C. Wêng
Ink and color on gold-flecked paper; H. 12⅜″,
W. 13⅛″
Faint washes of sepia used in depicting house,
bridge, and scholar. Servant in blue.

Inscription: Translated: (The first section is
damaged and has not been translated.) "A
landscape dashed off in the first month of the
ping-wu year (1696). Fifty *shou* (long life) to
Chiang Mu, a very elegant lady. Ch'uan-shih
[his family name was Chên], Yang and Hsü
are three distinguished painters. Signed Shih-
ku-tzŭ, Wang Hui." Two seals of the artist:
Wang Hui chih yin and Shih-ku-tzŭ.

Date: Ch'ing dynasty, dated in accordance with
1696.
Condition: A few small losses of surface.
Provenance: Wêng Tung-ho Collection.

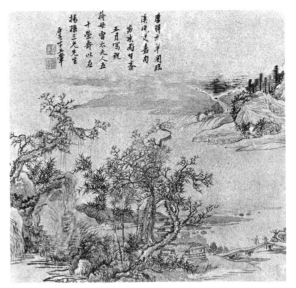

81. Orchid, bamboo, and rock

1967.81.1
Artist: Chêng Hsieh
Dates: 1693–1765
Gift of Wango H. C. Wêng
Ink on paper; H. 37″, W. 20½″
The flower, bamboo, and rocks depicted with
broad ranges of brush stroke and ink tonality.
Calligraphy well integrated into painting.

Inscription: Translated:

"Orchid, bamboo and stone are obdurate
Every labored effort seeks their nature
A cogent parallel is splitting the *lindera**
And what of the retired Pan-ch'iao?
An old mite determined to finish eminent,
While I can only follow the elders."

"Sketched in the *hsin-ssŭ* year of Ch'ien Lung
(1761) by Pan-ch'iao Chêng Hsieh." Two
seals of the artist follow the inscription: Chêng
Pan-ch'iao and K'o-jou.

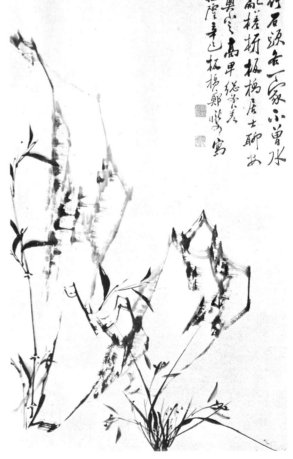

*A hard wood often used for wood blocks in China.

Oriental painting and calligraphy 53

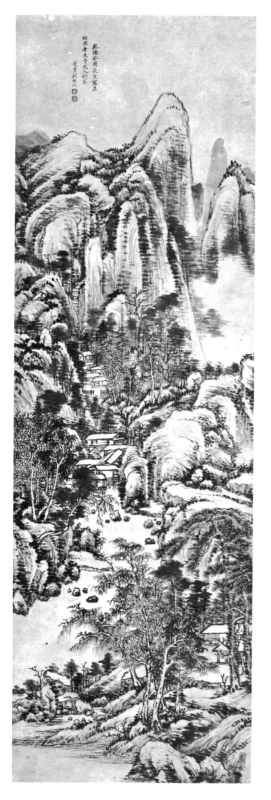

Date: Ch'ing dynasty, dated in accordance with 1761.

Condition: One repair in paper.

Provenance: Wêng Tung-ho Collection.

82. Landscape after Huang Kung-wang

1966.135

Artist: Ch'ien Wei-ch'êng

Dates: 1720–1772

Gift of Leopold H. Steiner

Ink on paper; H. 44″, W. 22″

A wide variety of brush strokes and washes creates a series of spatial tensions in this mountainous landscape.

Inscription: Translated: "On the solstice of the *kuei-yu* year of Ch'ien Lung (1753), I painted the Ch'êng-cha district. The *tao-t'ai,* an officer of the distinguished ruler on the throne, Ch'ien Wei-ch'êng." Two seals of the artist follow: Wei-ch'êng and Tsung-p'an.

Date: Ch'ing dynasty, dated in accordance with 1753.

Condition: Small repairs.

Provenance: Wêng Tung-ho Collection; Wango H. C. Wêng Collection.

Ch'ang-sha

The city of Ch'ang-sha, on the east bank of the Hsiang River in Hunan province, dates at least to the middle of the first millenium B.C. At that time, it seems to have been an important cultural center in Ch'u, a feudal state in south central China. In 223 B.C., Ch'u was defeated by Ch'in and was absorbed into what was to become the first empire of China. Ch'ang-sha has continued to exist as a city to our own day.

Apparently a few objects from Ch'u have been known since early historic times in China. During the 1920s and 1930s, however, material from the two sites, Shou Hsien in Anhui and Ch'ang-sha in Hunan, drifted onto the antiquarian market in substantial quantity. Formal archaeological techniques were not employed at Ch'ang-sha until 1951.

The Ch'ang-sha collections at Yale derived initial impetus from the perspicuity and energy of John Hadley Cox, B.A. 1935. As a member of the teaching staff at Yale-in-China in 1936 and 1937, he sought to see and acquire the tomb objects revealed as land was being leveled outside Ch'ang-sha for municipal purposes. He donated every item in the Ch'ang-sha section which follows unless the piece is specifically credited otherwise.

Two perennial friends of art at Yale, Mrs. William H. Moore and Mr. Paul Mellon, B.A. 1929, underwrote far more of the Ch'ang-sha activity than their names attached to a few pieces might suggest. The Governing Board of the Art Gallery also stepped in to help financially at a critical hour.

The Ch'ang-sha ceramics at Yale may be reckoned one of the most important and extensive collections of that material outside the China mainland. If our collections in other artistic media from Ch'ang-sha are less strong, perhaps time will help to remedy that situation.

83. Tripod of type ting

1940.835

University Purchase Fund

Earthenware; H. 9″, D. 7½″

Wheel made of white clay, slipped black. Ap-
pliqéd legs, handles, and animal head cover
attachments.

Date: Eastern Chou dynasty.

Condition: Two of the legs, one lug, and one
cover attachment broken off and glued; mud
encrustations.

Provenance: Purchased Yamanaka, New York,
1938 by John Hadley Cox.

Exhibition: An Exhibition of Chinese Antiq-
uities from Ch'ang-sha lent by John Hadley
Cox, Yale University Art Gallery, New Haven,
1939.

A light, elegant ting with long legs and high
lugs has been found in tomb 215 at Ch'ang-
sha; see *Ch'ang-sha Cemeteries,* pl. 10, nos.
1–2, and text fig. 25, no. 1.

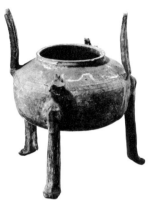

84. Ovoid tripod of type *tui*

1940.825

Gift of Mrs. William H. Moore

Stoneware; H. 9½″, D. 7″

Made of gray clay with incised rings at regular
intervals. Appliqués in form of debased drag-
ons. Exterior originally covered with tinfoil, of
which substantial amounts still adhere.

Date: Eastern Chou dynasty.

Condition: Missing areas of tinfoil.

Provenance: Purchased Yamanaka, New York,
1938 by John Hadley Cox.

Exhibition: Ch'ang-sha, Yale, 1939; Aspects of
Ch'ang-sha Culture, Metropolitan Museum,
1967.

A similar piece is illustrated on pl. 10 of *Ch'u
wên-wu chan-lan t'u-lu* (An illustrated cata-
logue of cultural objects from Ch'u), an exhi-
bition held in Peking, June–Nov. 1953.

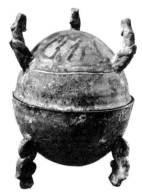

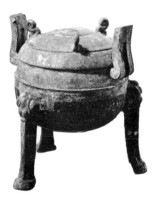

85. Covered tripod of type ting

1940.826

Gift of Mrs. William H. Moore

Stoneware; H. 9¾", D. 8½"

Wheel made of gray clay with appliquéd legs and lugs. Raised ridges and decorative appliqués on cover. Lower part of body slipped black; upper part plus cover originally covered with tinfoil.

Date: Eastern Chou dynasty.

Condition: Most of tinfoil now missing.

Provenance: Purchased Yamanaka, New York, 1938 by John Hadley Cox.

Exhibition: Yale, 1939; Metropolitan Museum, 1967.

A similar ting has been recovered in tomb 345 at Ch'ang-sha; see *Ch'ang-sha Cemeteries,* pl. 8, no. 6, and text fig. 24, no. 5.

86. Covered tripod of type ting

1940.827

Gift of Mrs. William H. Moore

Stoneware; H. 10¼", D. 8¼"

Wheel made of gray white clay. Appliquéd legs, lugs, and cover decoration. Lower part of body slipped black; upper part and cover originally covered with tinfoil.

Date: Eastern Chou dynasty.

Condition: Fragments of tinfoil remain.

Provenance: Purchased Yamanaka, New York, 1938 by John Hadley Cox.

Exhibition: Yale, 1939.

Close parallels to this ting have been found in Hunan in pottery at Ch'ang-sha *(Ch'ang-sha Cemeteries,* pl. 8, no. 6) and in bronze at Ch'ang-tê *(K'ao-ku,* 1963, no. 9, pl. 3, fig. 6).

87. Vase of type hu

1940.833

University Purchase Fund

Stoneware; H. 11", D. 7½"

Wheel made of whitish clay slipped black. Appliquéd animal masks with ring handles. All

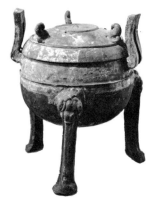

covered with a thin layer of tinfoil, much of which has become detached and lost.

Date: Eastern Chou dynasty.

Condition: Small chips on upper and lower rim.

Exhibition: Yale, 1939.

Hus of this shape reported from tomb 15 of Tso-chia kung shan, Ch'ang-sha; see *KKHP,* 1957, no. 1, pl. 2 following p. 101. Also reported from tomb 25 of Yang-t'ien hu, Ch'ang-sha; see *KKHP,* 1957, no. 2, pl. 3 following p. 94.

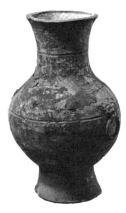

88. Covered vase of type hu

1940.834

University Purchase Fund

Stoneware; H. 10⅜″, D. 7″

Wheel made of whitish clay slipped black. One appliquéd animal mask once had ring handle. Cover has three appliquéd ears. Much of thin layer of tinfoil has become detached and lost.

Date: Eastern Chou dynasty.

Condition: Substantial chips on lower rim.

Exhibition: Yale, 1939.

Mainland finds of this ware discussed under no. 87. Similar piece described by Newton, "CCWH," *FECB,* no. 3, pp. 9–10, and ill. 3.

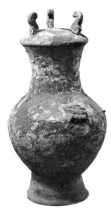

89. Covered tripod of type ting

1940.836

University Purchase Fund

Stoneware; H. 9½″, D. 8″

Made of white clay with appliqués on cover and body. Cover and upper inch of body slipped and then painted with orange and black geometric swirls. Remainder of body covered with black and tinfoil.

Date: Eastern Chou dynasty.

Condition: Much of painted design lost; some small textile fragments adhere to body as do remnants of tinfoil.

Provenance: Purchased Yamanaka, New York, 1938 by John Hadley Cox.

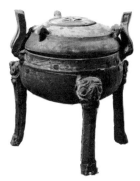

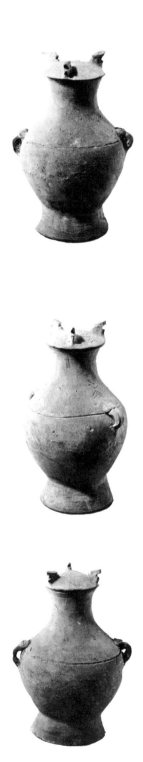

90. Covered jar of type hu

1947.507

Stoneware; H. 9⅛″, D. 5⅜″

Heavily potted of blue gray clay. Incised groove around body at height of appliquéd handles. Handles are probably debased t'ao t'iehs; three appliqués on lid are likely debased animals. Incised potter's mark (?) on body.

Date: Eastern Chou dynasty.

Condition: Substantial loss near incised groove; few firing imperfections.

Generally similar pottery has been recovered in tombs 273 and 349 at Ch'ang-sha; see Ch'ang-sha Cemeteries, pl. 10, nos. 1–2, and text fig. 25, no. 1.

91. Covered jar of type hu

1947.508

Stoneware; H. 9¼″, D. 5¼″

Heavily potted of blue gray clay. Single incised groove around body at height of appliquéd handles. Handles are probably debased t'ao t'iehs; three appliqués on lid are likely debased animals. Incised potter's mark (?) on body and lid.

Date: Eastern Chou dynasty.

Condition: Chip on one of lid appliqués; scattered small surface imperfections.

Exhibition: Metropolitan Museum, 1967.

See commentary for no. 90.

92. Covered jar of type hu

1947.509

Stoneware; H. 9″, D. 5½″

Heavily potted of blue gray clay. Incised groove around the body at height of appliquéd handles. Handles are probably debased t'ao t'iehs; three appliqués on lid are

likely debased animals. Incised potter's mark (?) on body and lid.

Date: Eastern Chou dynasty.

Condition: Substantial chips on upper and lower rims of body; small surface imperfections.

See commentary for no. 90.

93. Covered jar of type hu

1947.510

Stoneware; H. 9⅜″, D. 5⅝″

Heavily potted of blue gray clay. Incised groove around body at height of appliquéd handles. Handles are probably debased t'ao t'iehs; three appliqués on lid are likely debased animals. Incised potter's mark (?) on body.

Date: Eastern Chou dynasty.

Condition: Two large losses and several chips on footrim.

The cover, which has traces of glaze, may not be the one originally associated with this jar.

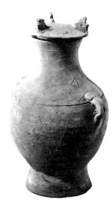

94. Covered jar of type hu

1947.512

Stoneware; H. 8⅞″, D. 5⅜″

Heavily potted of blue gray clay. Incised groove around body at height of appliquéd handles. Handles are probably debased t'ao t'iehs; three appliqués on lid are likely debased animals. Incised potter's mark (?) of crosshatching on body.

Date: Eastern Chou dynasty.

Condition: Substantial losses on lower rim; scattered surface imperfections.

See commentary for no. 90.

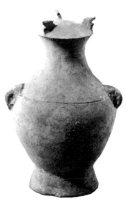

95. Covered vessel of type ting

1947.513

Stoneware; H. 4½″, D. 7⅝″

Wheel thrown of gray clay with ridge on body. Three appliquéd legs and two lug handles. Three appliqués on lid, perhaps derived from birds. Incised character *wu* (five) on underbase and inside of lid.

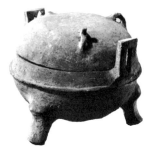

Date: Eastern Chou dynasty.

Condition: One of lid appliqués and part of lug handle missing; chip on one foot; usual firing flaws.

96. Jar with stamped design

1947.515
Stoneware; H. 8″, D. 6½″

Made of blue gray clay with string-cut base. Outer surface mainly covered with impressed rectangular designs made by a stamp about an inch square.

Date: Eastern Chou dynasty.

Condition: Small chips on upper rim; irregularity and surface imperfections on lower part of jar.

Exhibition: Yale, 1939.

Presumably a provincial copy of ware better known from sites on or near the southeast coast; see Nishitani Shenji, "Stamped Earthenware from the Southeastern Coast," *STZ*, 8, 271–77.

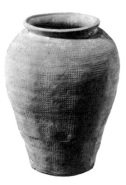

97. Jar with stamped design

1947.516
Stoneware; H. 8½″, D. 6¾″

Made of blue gray clay with string-cut base. Outer surface mainly covered with impressed rectangular designs made by a stamp about an inch square.

Date: Eastern Chou dynasty.

Condition: Few minor surface imperfections.

Exhibition: Yale, 1939; Metropolitan Museum 1967.

See commentary for no. 96.

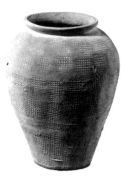

98. Caldron of type *tsêng*

1947.517

Earthenware; H. 4⅜", D. 8"

Wheel made of blue gray clay. Radial design cut in center. Appliquéd handles and rings.

Date: Eastern Chou dynasty, third century B.C.

Condition: Chips on upper rim; repair on foot-rim.

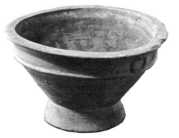

A tsêng was found among a group of Western Han painted ceramics; see *Ch'ang-sha Cemetaries,* pl. 55, no. 1, fig. 80, no. 2. The Yale piece appears to be earlier in shape and materials.

99. Support in tiger form

1950.191a

Wood, lacquered; H. 8¾", L. 14¾"

Sculptured in the round. Recessed area behind shoulder to provide support for an object. Once covered with brown lacquer with details in white.

Date: Eastern Chou dynasty.

Condition: Much shrunken from original form; most of lacquer has disappeared.

Exhibition: Yale, 1939.

A pair of addorsed tiger supports was found in a Ch'u tomb in Hsin-yang, Honan in 1957 and illustrated as a colored frontispiece in *Wên-wu,* 1957, no. 9. The use of the Hsin-yang piece was discussed by Yüan Chüan-yu, "Kuan yü hsin-yang ch'u mu hu tso ku ti fu-yüan wên-t'i" (The restoration of the lacquered drum with tiger-shaped stand excavated from a Ch'u tomb at Hsin-yang, Honan), *Wên-wu,* 1963, no. 2, pp. 10–12. See also Chia Ngo, "Tsai t'an hsin-yang ch'u-mu hsüan ku chi ku-ch'i ti fu-yüan wên-t'i" (Further notes on the reconstruction of the drum and drum stand unearthed from the Ch'u tomb at Hsin-yang), *Wên-wu,* 1964, no. 10, pp. 23–26. The Yale piece is one of a pair with no. 100.

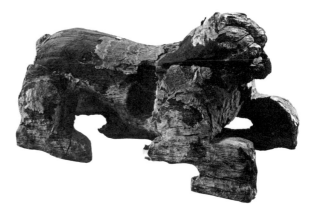

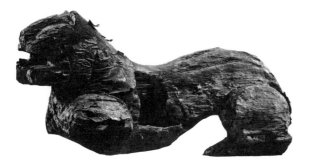

100. Support in tiger form

1950.191b

Wood, lacquered; H. 8¾″, L. 14¾″

Sculptured in the round. Recessed area behind shoulder to provide support for an object. Once covered with brown lacquer with details in white.

Date: Eastern Chou dynasty.

Condition: Much shrunken from original form; most of lacquer has disappeared; part of a foot has separated from remainder of animal.

Exhibition: Yale, 1939.

One of a pair with no. 99; see commentary.

101. Libation cup

1950.214

Wood, lacquered; H. 1¾", L. 6"

Brown lacquer on a wood core. Design of birds and geometric forms in vermilion and silver black lacquer pigments.

Date: Western Han dynasty.

Condition: Wood has dried, and much of lacquer has curled away from wood surface.

Exhibition: Paintings, Yale, 1963, no. 1.

A cup with similar colors and certain design parallels has been found in Western Han tomb 203 at Ch'ang-sha; see *Ch'ang-sha Cemeteries,* colored frontisplate no. 4. John Hadley Cox indicates that the Yale piece came from a tomb outside the north gate of Ch'ang-sha.

102. Model of an incense burner

1948.281

Gift of John Hadley Cox for the Gertrude Murdock Brown Memorial Collection

Earthenware; H. 7¼", D. 4"

Molded of gray clay with black and green washes or adhesions. Cover of stylized mountains with human and animal figures. Base has dragon design, while raised ridge decorates the midsection.

Date: Western Han dynasty.

Condition: Many surface imperfections, especially where cover and body meet.

Exhibition: Yale, 1939.

Bibliography: ECAC, fig. 8; A. G. Wenley, "The Question of the Po-Shan-Hsiang-Lu," pl. 11C.

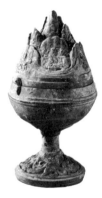

103. Model of a stove

1947.519a,b

Earthenware; H. 10⅝", W. 11¼", L. 18¼"

Molded of buff clay with kitchen utensils indicated in relief at back of stove. Single flattish bowl fits cut-out hole on stove top; second cut-out hole was probably made to hold a second pot. Exterior generally covered with locally made green lead glaze.

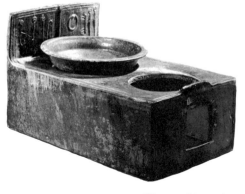

Date: Western Han dynasty.

Condition: Small areas of lead glaze missing.

Exhibition: Yale, 1939; Metropolitan Museum, 1967.

Stove models of somewhat different type have been excavated at Ch'ang-sha tombs 203 and 401; see *Ch'ang-sha Cemeteries,* pl. 53, nos. 2, 4.

104. Covered jar of type hu

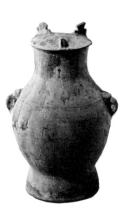

1947.511

Stoneware; H. 8″, D. 4¾″

Heavily potted of gray clay. Incised groove around body at height of appliquéd handles. Handles are probably debased t'ao t'iehs; three appliqués on lid may be debased animals. Substantial amounts of a thin feldspathic glaze of olive brown color remain on body and cover.

Date: Western Han dynasty.

Condition: Rim of lid missing in one area.

Exhibition: Yale, 1939.

105. Vase of type hu

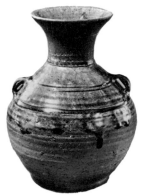

1940.339

Porcelaneous stoneware; H. 8⅜″, D. 6¾″

Wheel made of fine, light gray clay. Incised ring and combed patterns with appliquéd handles. Inside lip and outer shoulder covered with a thin, crackled, alkaline glaze of olive green hue. Remainder fired unprotected or with a very thin slip glaze now ruddy brown.

Date: Western Han dynasty.

Condition: Chip on lip; small firing imperfections.

Exhibition: Yale, 1939.

This class of ware was originally discussed by Berthold Laufer in *The Beginnings of Porcelain in China* (Chicago, 1917) and attributed to Shensi province. A hu of this type has been found in tomb 244 at Ch'ang-sha and dated to Western Han; see *Ch'ang-sha Cemeteries,* pl. 61, no. 5. The report authors mention a hard body for their hu, and the fact that the piece

is singled out for a description suggests the possibility of its being imported into Ch'angsha. The Yale piece may also be considered a probable early ceramic import into Ch'angsha.

106. Model of a barnyard

1940.321

Earthenware; H. 9½″, W. and L. 10½″

Made of buff clay with detachable roof on tower. Outer surface covered with a light green lead glaze.

Date: Han dynasty.

Condition: Substantial areas of glaze missing.

Exhibition: Yale, 1939; Arts of the Han Dynasty, CASA, Asia House, New York, Feb.–Mar. 1961, no. 9; Metropolitan Museum, 1967.

Bibliography: Henry Trubner, *Arts of the Han Dynasty* (CASA, New York, 1961), no. 9, pp. 24–25.

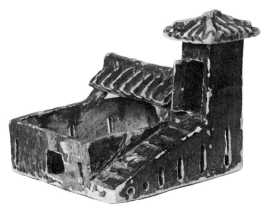

107. Model of a barnyard

1940.323

Earthenware; H. 8¾″, L. 11⅝″, W. 5¾″

Made of buff clay with detachable towers. Exterior covered with brown green lead glaze, which runs irregularly toward the base.

Date: Han dynasty.

Condition: Small areas of lead glaze missing.

Exhibition: Yale, 1939; Metropolitan Museum 1967.

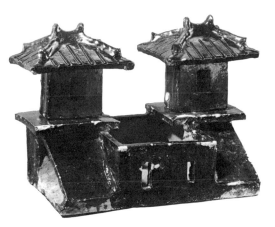

108. Model of a chicken

1940.325

Earthenware; H. 2″, L. 1⅝″

Roughly modeled with appliquéd eyes and wings. Coarse clay buff where exposed to kiln. Glassy lead glaze varying in thickness and color runs irregularly onto sections of the base. The dominant shade is light green.

Date: Han dynasty.

Condition: Several small areas of glaze lost.

Exhibition: Yale, 1939.

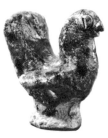

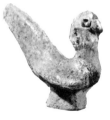

109. Model of a rooster

1940.329

Earthenware; H. 2¼″, L. 2¾″

Freely modeled of fine yellow clay with appliquéd eyes and cut wattle. Surface covered with a thin lead glaze, probably originally green and brown, now deteriorated into a silvery appearance.

Date: Han dynasty.

Condition: Large area of one wing devoid of glaze.

Exhibition: Yale, 1939.

110. Model of tou

1940.331

Earthenware; H. 7½″, D. 4⅛″

Wheel made of buff clay. Almost entirely covered with thin light green glaze of lead type.

Date: Han dynasty.

Condition: Firing crack; substantial areas of lead glaze now missing.

Exhibition: Yale, 1939; Metropolitan Museum, 1967.

Tous have been recorded in pottery and bronze at Ch'ang-sha, but none, as far as known at present writing, are made in this low-fired lead glaze technique used for mortuary objects.

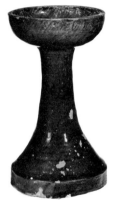

111. Model of an incense burner

1940.332

Earthenware; H. 7″, D. 7¼″

Made of buff clay. Lower section wheel thrown; upper section has wedges of clay cut and pushed out to alter the profile of the top. Other decorative techniques include cut-out circles, cut semicircular lines, and incised lines in herringbone pattern. Most of the exterior covered with a green glaze of lead type, which runs to lower edge of footrim.

Date: Han dynasty.

Condition: Many small areas of lead glaze have failed to adhere.

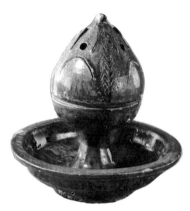

Exhibition: Yale, 1939; Metropolitan Museum, 1967.

This piece may serve as a standard specimen of Ch'ang-sha local lead glaze manufacture.

112. Model of tiger's head

1940.337

Earthenware; H. 7¼″, W. 5½″

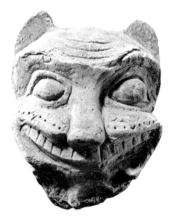

Modeled of gray clay which has turned buff in many areas. Details include character *wang* (prince, royal, to rule) on forehead, as well as nostrils, teeth, and many small holes which may originally have held whiskers.

Date: Han dynasty.

Condition: Substantial losses in certain surface areas.

Exhibition: Yale, 1939.

The use of this piece is not clear at present writing.

113. Monster mask

1940.338

Earthenware; H. 7″, W. 8″

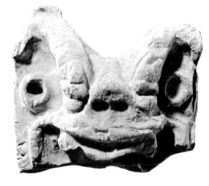

Crudely modeled of gray clay with remnants of white slip.

Date: Han dynasty.

Condition: Irregular outline suggests piece incomplete.

Exhibition: Yale, 1939; Metropolitan Museum 1967.

Similar pieces do not seem to have been reported thus far from Ch'ang-sha. This object was presumably used as a tomb architectural detail.

114. Cover

1947.519c

Earthenware; H. 3¾″, D. 6⅝″

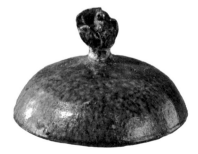

Wheel thrown of red clay with appliquéd handle of cock. Green lead glaze has colored unevenly in the kiln, has flowed onto base, and later acquired a lustered surface.

Date: Han dynasty.

Condition: Small areas of glaze missing; handle repaired.

Exhibition: Yale, 1939; Metropolitan Museum, 1967.

Other small pottery birds from Ch'ang-sha in the Yale collection may have served a similar function.

115. Covered tripod of type ting

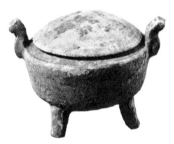

1940.380

Earthenware; H. 4¾″, D. 6½″

Wheel thrown of light gray blue clay with legs and handles appliquéd and covered with a white slip. Handles have been cylindrically pierced, probably to aid in securing cover.

Date: Han dynasty.

Condition: Mud encrustations.

Exhibition: Yale, 1939.

Perhaps the closest parallel to the form of this piece has been found in stone; see *Ch'ang-sha Cemeteries,* pl. 89, no. 4.

116. Tripod of type ting

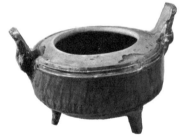

1940.335

Earthenware; H. 5½″, D. 8¾″

Wheel made of buff clay with appliquéd legs and handles. Outer side of body and handles covered with relatively thin, light green lead glaze seemingly applied irregularly to the three feet.

Date: Han dynasty.

Condition: Mud encrustations.

Since this piece shows no signs of wear, one may conclude that it was made for burial purposes only.

117. Jar of type hu

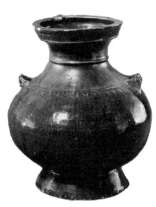

1940.334
Earthenware; H. 9½″, D. 8¼″
Made of buff clay with combed design band
on shoulder. Appliquéd loop handles. Lead
glaze varies in color from green to brown and
runs irregularly to lower edge of footrim.
Date: Han dynasty.
Condition: Substantial chipping on footrim.

118. Model of a house

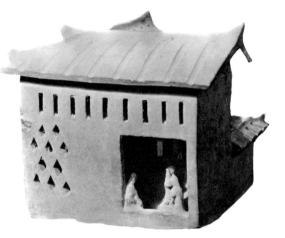

1940.327
Stoneware; H. 9½″, L. 11″, D. 10½″
Modeled of fine-grained buff clay. Incised and
cut-out details of roof, walls, doors, and win-
dows. Appliquéd human and animal figures.
Date: Han dynasty.
Condition: Complete.
Exhibition: Yale, 1939.
Bibliography: ECAC, fig. 7.
A house model with many similarities to this
piece has been recovered at Ch'ang-sha; see
Construction Sites Material, 2, pl. 185.

119. Basin cover

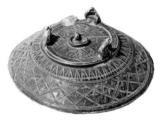

1940.824a
Gift of Mrs. William H. Moore
Porcelaneous stoneware; H. 2¾″, D. 8½″
Wheel made of fine-grained gray clay. Incised
crosshatched and quatrefoil patterns. Appli-
quéd ring handle and three recumbent rams.
Exterior covered with a thin slip glaze fired
ruddy brown.
Date: Han dynasty.
Condition: During the firing, a chunk of glaze
and body from another piece adhered to cover;
few small chips in rim area.
Exhibition: Yale, 1939.
This cover is not appropriate for the Yale
Ch'ang-sha basin (no. 120). This can be estab-
lished by comparison with a documented basin
of similar shape, but differing cover, excavated
at Ch'ang-sha; see *Construction Sites Material,
2,* pl. 188.

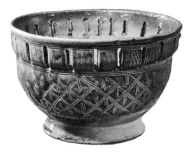

120. Large basin (originally covered)

1940.824b

Gift of Mrs. William H. Moore

Porcelaneous stoneware; H. 5⅜″, D. 9¼″

Wheel made of gray clay. Vertical perforated design and incised crosshatched pattern below. Part of exterior covered with a thin alkaline glaze of olive green hue. Remainder of outer surface is buff brown from firing or perhaps a slip glaze.

Date: Han dynasty.

Condition: One substantial adhesion to glaze during firing; small area of glaze deterioration.

Exhibition: Yale, 1939.

Basin of same shape, same upper design, and similar lower design recovered at Ch'ang-sha; see *Construction Sites Material, 2,* pl. 188. A similarly shaped piece with perforations below the lip has been recovered at Canton and dated Eastern Han; see CPAM, Canton, "Kuang-chou shih Lung-shêng-k'ang 43 hao tung-han mu-kuo mu" (Tomb no. 43 with wooden chamber of the Eastern Han period excavated at Lung-shêng-k'ang, Canton), *KKHP,* 1957, no. 1, no. 1 on pl. 3 following p. 153.

121. Jar of *cha tou* type

1940.341

Stoneware; H. 3½″, D. 5″

Made of gray white clay with two incised rings on body, and other wheel marks. Glaze transparent and speckled, tends to buff color over clay.

Date: Eastern Han dynasty.

Condition: Two chips in lip; firing crack.

Exhibition: Yale, 1939; Metropolitan Museum, 1967.

A slightly larger piece in this general shape, called T'ang, belongs to Isaac Newton; see Newton, "CCWH," *FECB,* no. 153. The Yale piece seems more closely related to the objects immediately following in this catalogue and especially to no. 124.

122. Pedestaled bowl

1940.342

Stoneware; H. 4⅛″, D. 7¼″

Wheel made of gray white clay, covered with thin alkaline glaze, and fired to lower edge of stoneware. Glaze mainly neutral in tint, but one large drop below lip (probably from another piece) is crackled, glassy green.

Date: Eastern Han.

Condition: Minor chips on upper rim.

Exhibition: Yale, 1939; Metropolitan Museum, 1967.

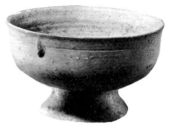

This shape, derived from the tou of Chou times, is not common in Han ceramics. One general parallel, however, has been reported by O. Janse, *Archaeological Researches in Indo-China, 1* (Cambridge, 1947), pl. 35, no. 2.

123. Single-handled bowl

1940.343

Stoneware; H. (incl. handle) 4¾″, W. (incl. handle) 9″

Wheel thrown of gray clay with appliquéd handle in form of dragon's head with incised and appliquéd details. Large area of thin alkaline glaze on exterior and interior is mainly red brown.

Date: Eastern Han dynasty.

Condition: Chip on upper rim; presumably much of original glaze now missing.

Exhibition: Yale, 1939; Metropolitan Museum, 1967.

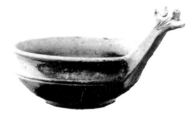

A similarly shaped glazed bowl, minus the handle, has been found in tomb 262 at Ch'angsha; see *Ch'ang-sha Cemeteries,* pl. 96, no. 6. John Hadley Cox indicated that the Yale piece was found with nos. 122, 124, and 126.

124. Single-handled bowl

1940.344

Stoneware; H. 3½", L. 8"

Wheel made of gray clay. Appliquéd handle modeled in marine form, perhaps an alligator. Alkaline glaze varies from neutral to buff to olive green where thick.

Date: Eastern Han dynasty.

Condition: Glaze has worn away from few small exposed areas.

Exhibition: Yale, 1939.

A similar piece, minus the handle, has been found in tomb 262 at Ch'ang-sha; see *Ch'ang-sha Cemeteries,* pl. 96, no. 9. The Yale piece was reported by John Hadley Cox to have been found with nos. 122, 123, and 126.

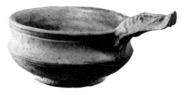

125. Vase

1940.345

Stoneware; H. 7¾", D. 5½"

Wheel made of slate gray clay. Incised patterns above mid-body based on lines and semicircles. Glaze varies from green where thickest to dark brown and red brown.

Date: Eastern Han dynasty.

Condition: Many substantial areas of glaze lost.

Exhibition: Yale, 1939.

This shape is well known in late Chou and Han in bronze and pottery. For a close parallel from Ch'ang-sha stoneware, see *STZ, 8,* pl. 64, from the Metropolitan Museum.

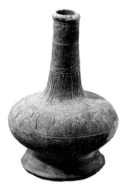

126. Covered jar of type *lien*

1940.375

Stoneware; H. 7", D. 7"

Wheel made of fine-grained gray clay with three appliquéd bear feet. Incised quatrefoil and double arc designs on cover with appliquéd handle and lugs. Thin, alkaline, ruddy brown glaze with splashes of light green (intrusions?), mainly on cover.

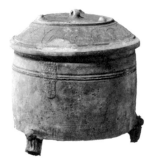

Date: Eastern Han dynasty.

Condition: Lip severely damaged; large chip on lid.

Exhibition: Yale, 1939.

A covered bowl, related in style and technique, is illustrated in *STZ, 8,* pl. 15. John Hadley Cox reported this piece found with nos. 122–24.

127. Jug of type hu

1940.376

Stoneware; H. 6¾″, D. 7″

Wheel made of gray clay with incised rings and appliquéd handles. Thin light green glaze of alkaline type bears a few transmutations into blue.

Date: Eastern Han dynasty.

Condition: Much of glaze has deteriorated and flaked away from body.

The unusual shape may suggest the influence of, or origin in, the southern coastal area.

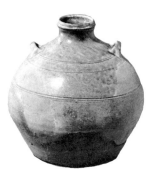

128. Model of a boar

1940.326

Earthenware; H. 4″, L. 4½″

Roughly modeled in dark gray clay with appliquéd eyes, ears, and tail. A few incised details, and actual cutting to indicate mouth. Lead glaze assumes light green hue in firing and flows irregularly on the legs.

Date: Eastern Han-Chin dynasty.

Condition: Two imperfect areas of glaze lost after firing.

Exhibition: Yale, 1939.

A boar model has been found in documented Eastern Han material at Ch'ang-sha; see *KKHP,* 1957, no. 4, pl. 11 following p. 67. The stylistic differences in the Yale piece, however, suggest that a slightly later date may also be considered.

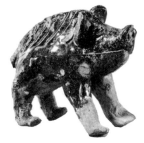

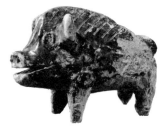

129. Model of a boar

1940.322

Earthenware; H. 3¼″, L. 5″

Modeled of light buff clay with appliquéd ears and tail. Few incised details. Mainly covered with a light green lead glaze, much of which has peeled off.

Date: Eastern Han-Chin dynasty.

Condition: In areas where glaze has peeled away, substantial losses below surface.

Exhibition: Metropolitan Museum, 1967.

See commentary for no. 128.

130. Model of a duck

1940.328

Earthenware; H. 3¼″ L. 5″

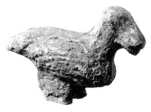

Made of very light buff clay in a two-piece mold and luted together. Small stamped circles and incised lines on body. Covered except for the base of the feet with a light green lead glaze.

Date: Eastern Han-Chin dynasty.

Condition: Substantial areas of glaze missing one side; much encrustation.

131. Model of a rooster

1940.324

Earthenware; H. 2″, L. 2¾″

Crudely modeled with appliquéd eyes and wings. Clay fired light buff where exposed to kiln. Neutral lead glaze appears brown over body clay.

Date: Chin dynasty.

Condition: Numerous small areas of glaze lost.

Exhibition: Yale, 1939.

A number of small animal models with somewhat satiric rendering was found in a Chin dynasty tomb at Ch'ang-sha; see "Ch'ang-sha liang-chin," pl. 13, 1–5, 8–9.

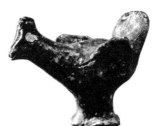

132. Jar

1940.348

Stoneware; H. 4¾″, D. 4½″

Impure gray clay darkens on exposure to kiln. Edge of base beveled. Brownish green glaze runs in parallel diagonal striations.

Date. Chin dynasty.

Condition: Kiln cracks on base and shoulder.

Exhibition: Yale, 1939.

The unusual glaze striations apparently derive from the method of application. A similarly glazed jar, although squatter in shape and with handles, was found in a Chin dynasty tomb at Ch'ang-sha; see "Ch'ang-sha liang-chin," pl. 4, 7.

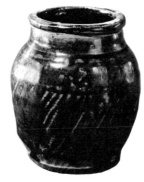

133. Jar

1940.346

Porcelaneous stoneware; H. 7¾″, D. 7½″

Light gray clay turns buff where exposed to kiln. Two pairs of parallel lines incised, two small handles appliquéd. Flat base, mainly glazed, retains traces of kiln supports. Light gray green glaze, somewhat crackled, shows many impurities.

Date: Chin dynasty.

Condition: Kiln cracks on neck and many other firing imperfections.

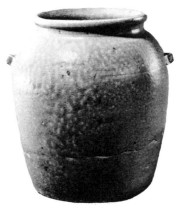

Exhibition: Yale, 1939; Metropolitan Museum 1967.

John Hadley Cox associated this jar with the year 344 but failed to enumerate his reasons. The piece seems clearly inspired by the *Yüeh* wares of Chekiang provinces. One parallel piece, but with four handles, was reported in "Ch'ang-sha liang-chin," pl. 4, 8. A second four-handled jar was found at Ch'ang-sha in 1960 and dated to Western Chin; see Liu Lienyin, "Hunan Ch'ang-sha tso-chia t'ang hsi-chin mu" (Grave of Western Chin date on the Tso family embankment at Ch'ang-sha, Hunan), *K'ao-ku,* 1963, no. 2, p. 107, and pl. 8, 8.

134 Cock-spouted ewer

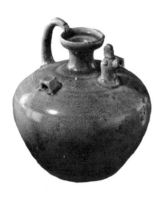

1941.18
Stoneware; H. 5¼", D. 5½"

Impure clay fires buff on exposure to kiln. Spout, handle, and two squared loops appliquéd to body. Glassy, crackled glaze assumes green tint where thick and runs close to base.

Date: Chin dynasty.

Condition: Small areas of glaze missing.

Cock-spouted ewers are known at Ch'ang-sha, as well as from Yüeh sites, as early as Chin times. The Yale piece receives its early date by close parallels with certain ewers recovered during the 1964 excavations; see "Ch'ang-sha nan-chiao," pl. 7, fig. 3.

135. Funerary vessel

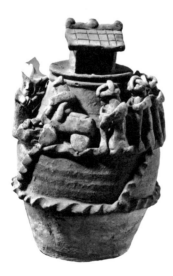

1940.377
Stoneware; H. 9½", D. 6⅜"

Made of gray clay. Two bands of piecrust appliqués divide the body of the jar into rough thirds and are connected by slanting bands. Highest section filled with appliquéd mourners and musicians, all rendered in three dimensions. Upper two-thirds then covered with dark (black?) paint. Cover, also painted, is topped with a spirit house.

Date: Chin dynasty.

Condition: Complete.

Exhibition: Yale, 1939.

This piece probably represents a provincial adaptation of a type known through much of South China. For a comparable example in Yüeh ware, see *STZ, 8,* pl. 17.

136. Inkstone

1940.374
Stoneware; H. 2¼″, L. 5½″

Modeled gray clay in freely conceived tiger form with details incised and appliquéd. Monkey in full round added to tiger back. One large surface left unglazed; remainder, except for tiger paws, covered with thin, crackled, green glaze which turns deeper toned where thick.

Date: Southern Six Dynasties.

Condition: At least two major areas have been separated from this inkstone, but repairs presumably made with original fragments.

Exhibition. Metropolitan Museum, 1967.

One can easily see the influence of the Six Dynasties Yüeh potters of Chekiang province on the maker of this piece.

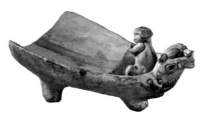

137. Cover in form of owl face

1940.330
Stoneware; H. 1″, D. 3″

Made of impure gray clay with appliquéd ears. Facial details incised and cut. Base of cover slipped; cover top bears thin brown glaze.

Date: Southern Six Dynasties.

Condition: Part of inner rim missing; some glaze lost.

Exhibition: Yale, 1939; Metropolitan Museum, 1967.

While the design elements are known in Han, their use here suggests a later date.

138. Model of an attendant figure

1941.13
Earthenware; H. 4½″, W. 1½″

Made of very light buff clay in a two-piece mold and luted together.

Date: Southern Six Dynasties.

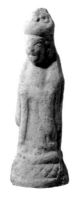

Condition: Complete, although details somewhat imperfect.

Some twenty figurines have been found in assorted tombs of Chin dynasty date at Ch'angsha. These pieces are both more expressionistically modeled and have a better handling of details than is found on the Yale piece; see "Ch'ang-sha liang-chin," text fig. 5 and pls. 6–12.

139. Model of an attendant figure

1941.15
Earthenware; H. 4¾", W. 1¾"
Made of very light buff clay in a two-piece mold and luted together.
Date: Southern Six Dynasties.
Condition: Some surface losses; much encrustation.
See commentary for no. 138.

140. Jar

1940.365
Stoneware; H. 3⅞", D. 4"
Made of gray clay and covered with light buff, crackled glaze which stops just short of foot. Large splash of brown green glaze around mouth of jar.
Date: Southern Six Dynasties.
Condition: Some flaking away of both glazes.
Exhibition: Yale, 1939.

This appears to be an interesting transitional piece between the brown glazed pieces of the Chin dynasty, as exemplified at Yale by no. 132, and the later multicolored jars with handles, such as no. 172.

141. Small jar

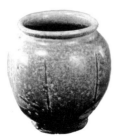

1940.398
Stoneware; H. 3", D. 3"
Made of dark gray clay, the body divided into six lobes; string-cut base. Slipped and covered with a green glaze which has not matured well in all areas and runs irregularly toward and onto foot.

Date: Southern Six Dynasties.

Condition: Chip on lip; small firing imperfections.

A smaller jar with seven lobes made from apparently similar material is in the collection of the Hongkong government; see Mary Tregear, "Ch'ang-sha Pottery in Hongkong," pp. 126–30, no. 8.

142. Cup

1941.20a

Stoneware; H. 1⅝″, D. 2½″

Small cup of gray clay sits on solid foot with beveled edge. Glassy, crackled glaze assumes green tint where thick and runs irregularly to just short of foot.

Date: Southern Six Dynasties.

Condition: Glaze affected by general firing mishaps and stained somewhat from burial; loss of surface on one sector of rim.

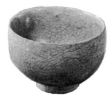

In all, some thirteen examples of this type of cup have been recovered from the documented Nan Ch'ao tombs at Ch'ang-sha; see "Ch'ang-sha liang-chin," p. 93. The one usually illustrated (ibid., pl. 17, 7, and fig. 10–3) has a single stamped floral design in the bottom, while the Yale piece has an impressed ring pattern.

143. Cup

1941.20b

Stoneware; H. 1⅝″, D. 2⅝″

Small cup of gray clay sits on solid foot with beveled edge. Glassy, crackled glaze assumes green tint where thick and comes close to foot.

Date: Southern Six Dynasties.

Condition: Some areas of glaze lost, others stained in burial.

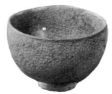

See commentary for no. 142.

144. Two-handled jar

1940.400

Stoneware; H. 3″, D. 2¾″

Made of gray clay with solid foot with beveled edge. Wheel turned, appliquéd handles; string-cut base. Glassy, crackled glaze assumes yellow green hue where thick and comes close to foot.

Date: Southern Six Dynasties.

Condition: Small losses of glaze on upper rim; crackle stained in burial.

The dating of this piece is established by close parallels in paste, glaze, and potting techniques to the small cups nos. 142–43. The piece is an important transitional object foreshadowing in multiple ways the larger handled jars of Sui and T'ang. Newton records a somewhat similar jar but with a dark body; see Newton, "CCWH," *FECB,* no. 71c.

145. Jar of type *t'o hu* (saliva jar)

1941.19

Stoneware; H. 3½″, D. 4½″

Heavily potted of light gray clay, jar has received a wash of iron-bearing clay on the base, and perhaps on the entire outer surface. A glassy, crackled glaze assumes a green hue where thick and stops just short of base.

Date: Southern Six Dynasties.

Condition: A few chips on base; small areas of imperfection in glaze.

Exhibition: Metropolitan Museum, 1967.

Of the three pieces of this shape found among the documented tombs at Ch'ang-sha, only one is briefly described and illustrated; see "Ch'ang-sha liang-chin," p. 92, pl. 16, 5.

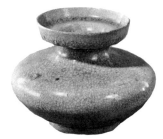

146. Model of an attendant figure

1941.12

Earthenware; H. 4⅜″, W. 1½″

Made of dark gray clay in a two-part mold and luted together.

Date: Sui dynasty.

Condition: Substantial encrustation.

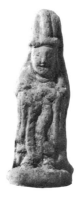

147. Cup

1940.362

Stoneware; H. 1¾″, D. 2½″

Made of light gray clay with very high foot, beveled on the edge and concave on the base. A repeat floral design is stamped within a band of incised parallel lines. A brown green glaze covers interior and upper part of exterior, stopping irregularly.

Date: Sui dynasty.

Condition: Some areas of glaze peeled away from body.

Exhibition: Yale, 1939.

Two cups of this shape and size have been reported from documented Sui excavations at Ch'ang-sha. The design stamped on the documented cups differs from the Yale piece, but the design on the latter can be found on documented pieces of the period; see "Ch'ang-sha liang-chin," text fig. 13, pl. 20, 3, 8.

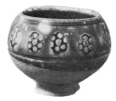

148. Covered jar

1940.379

Stoneware; H. (incl. cover) 4¼″, D. 4½″

Made of light gray clay. Incised parallel lines create panels with impressed leaflike and rosette design stamped into alternate panels. Six small handles appliquéd. A thin brownish green glaze has mainly disappeared on exterior, while much remains inside. The cover, with a cut lotus petal and stamped circle design, has the same glaze but applied more thickly.

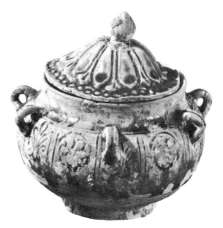

Date: Sui dynasty.

Condition: One handle missing; large chip from cover rim; areas of glaze missing.

The documented Sui tombs at Ch'ang-sha have yielded a covered circular box of approximately these dimensions with some of the same stamped designs and the same feeling of lush decoration; see "Ch'ang-sha liang-chin," text fig. 13, and pl. 20, 11–12.

149. Jar of hu shape with four handles

1940.401

Stoneware; H. 2⅞", D. 3"

Impure gray clay darkens on exposure to kiln. Stamped parallel lines create trapezoidal panels, each stamped with a five-pointed leaflike design. Remnants of a brown green glaze are on upper part of body.

Date: Sui dynasty.

Condition: Flaking away of glaze.

A piece of this shape and size has been found among the documented Sui pieces at Ch'ang-sha; see "Ch'ang-sha liang-chin," p. 96, text fig. 13, 3, pl. 20, 3. The stamped design is somewhat different, and the piece in China appears to have a browner cast to the glaze.

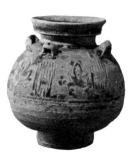

150. Water well

1950.185

Stoneware; H. 2¼", D. 3¼"

The body clay fires dark gray where exposed to kiln. Wheel made with a string-cut base. Lotus petal design appliquéd, cut, and incised. Covered with pale gray green glaze of light crackle which stops just short of foot.

Date: Sui dynasty.

Condition: Substantial areas of glaze lost by deteriorating.

This piece appears to be generally related to a covered box in the Newton collection; see Newton, "CCWH," *FECB,* no. 62.

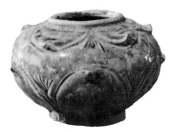

151. Cup

1950.187

Stoneware; H. 2″, D. 3″

Light gray clay changes to light buff on exposure to kiln. Sturdy, wedged foot is nearly flat on base and beveled on edge. Glassy, crackled glaze assumes green hue where thick, especially in cup center. Glaze flows unevenly on exterior.

Date: Sui dynasty.

Condition: Chip on footrim.

Slight differences in foot proportions, side profile, and glaze texture, as compared with nos. 142–43, suggest the later Sui date for this cup and for no. 152.

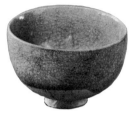

152. Cup

1950.188

Stoneware; H. 1⅞″, D. 3″

Light gray clay changes little on exposure to kiln. Sturdy, wedged foot is nearly flat on base and beveled on edge. At center of bottom there is what appears to be an impressed ring design, now obscured by glaze. A glassy, crackled, runny glaze assumes a green hue where thick, especially in large drips of glaze at the irregular glaze line.

Date: Sui dynasty.

Condition: Body imperfections caused perhaps by firing conditions.

See commentary for no. 151.

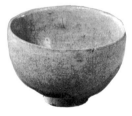

T'ang

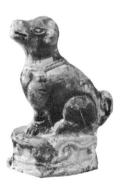

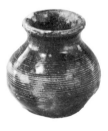

153. Model of a rooster

1941.16
Earthenware; H. 4″, W. 3″

Made of buff clay in a two-part mold and luted together. Remnants of a green alkaline glaze with pitted surface.

Date: T'ang dynasty.

Condition: Encrustation and some erosion of clay surface; disintegration of glaze.

154. Model of a dog

1941.17
Earthenware; H. 3⅝″, W. 2½″

Made of buff clay in a two-part mold and luted together. Areas of whitish slip remain.

Date: T'ang dynasty.

Condition: Small areas of encrustation cover the figure.

155. Model of a dog

1950.210
Earthenware; H. 4⅛″, W. 2¾″

Made of buff clay in a two-part mold and luted together. Body is covered with white slip and almost entirely by a thin, green lead glaze.

Date: T'ang dynasty.

Condition: Some encrustation.

A smaller dog in the Isaac Newton collection is covered with a three-color glaze; see Newton, "CCWH," *FECB,* no. 188.

156. Small jar

1940.333
Earthenware; H. 2½″, D. 2½″

Wheel-turned jar of impure, whitish clay. Some twenty incised horizontal grooves encircle main part of body. Covered on exterior and on inner surface of neck with a dark green lead glaze which varies in intensity of tone.

Date: T'ang dynasty.

Condition: Chips on upper rim; absence of glaze in some areas.

This glaze seems closely related to that on the T'ang lead-glazed dog, no. 155.

157. High-shouldered jar

1940.350
Stoneware; H. 4¼″, D. 4″

Wheel made of gray clay with flat base and small neck. After slipping, the body is covered with a crackled glaze which assumes a green color where thick and runs unevenly onto footrim. A series of small blobs of glaze on shoulder appears to have been applied by brush.

Date: T'ang dynasty, probably seventh century.

Condition: Small firing imperfections.

Exhibition: Yale, 1939; Metropolitan Museum, 1967.

A jar parallel in size and shape is owned by Isaac Newton; see Newton, "CCWH," *FECB,* no. 112.

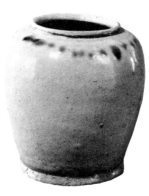

158. High-shouldered jar

1940.395
Stoneware; H. 3⅞″, D. 3⅜″

Jar of unusual shape made of dark gray clay with primitive footrim. Slipped and covered with a crackled, green glaze which stops above footrim.

Date: T'ang dynasty, probably seventh century.

Condition: Chips on upper lip and footrim; major firing imperfections.

A generally similar piece, but made of light gray clay, is in the Hongkong government collection; see Tregear, "Ch'ang-sha Pottery," no. 2.

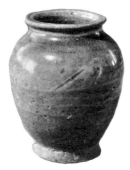

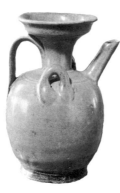

159. Small ewer

1940.366

Stoneware; H. 4½", D. (excl. spout) 2⅞"

Made of dark gray clay with primitive foot and with neck terminating in a cup-shaped lip.

Two loops, broad strap handle, and a straight spout appliquéd. The piece is slipped and covered with a gray green crackled glaze which stops above footrim.

Date: T'ang dynasty.

Condition: Upper and lower rims imperfect.

Exhibition: Yale, 1939.

Comparison with no. 194 suggests an earlier dating for this piece. It may eventually be attributed to the beginnings of T'ang.

160. Small jar

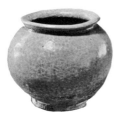

1940.393

Stoneware; H. 2⅞", D. 3½"

Wheel thrown of dark gray clay with a string-cut base. Covered with slip and then with a lightly crazed, olive green glaze which stops short of footrim.

Date: T'ang dynasty.

Condition: Firing imperfections; chip on lip.

Exhibition: Yale, 1939.

This jar suggests a provincial attempt to reproduce the earlier ware of Yüeh.

161. Palette

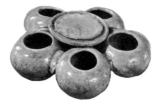

1950.189

Stoneware; H. 1", D. 3⅞"

Formed by joining five small bowls to each other and to a circular central disk. Made of light gray clay. Covered, except for bases of bowls and center of circular unit, with a light gray green glaze, extensively crackled.

Date: T'ang dynasty.

Condition: Scattered firing flaws in glaze.

Isaac Newton illustrates a similarly conceived object; see Newton, "CCWH," *FECB,* no. 123A.

162. Covered cosmetic box

1940.382

Stoneware; H. 2¼″, D. 2¾″

Made of gray white clay. Top and bottom molded in quatrefoil shape and cut apart; top decorated with quatrefoil design in relief. Thin, neutral, crackled glaze inside, outside the remnants of a poorly adhering green glaze.

Date: T'ang dynasty.

Condition: Section of footrim missing; exterior glaze mainly disappeared.

Exhibition: Yale, 1939.

The relief design seems derived from metallic sources.

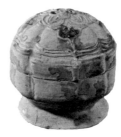

163. Covered box

1940.336

Stoneware; H. 1½″, D. 2¼″

Wheel thrown of gray clay in circular form. Tiered cover has a brush design in brown suggesting flowers. The whole is covered except for base with a lightly crazed, green glaze unevenly applied.

Date: T'ang dynasty.

Condition: Areas of glaze missing on lower part of box.

Isaac Newton possesses a small box of similar shape, but with bright green glaze; see Newton, "CCWH," *FECB,* no. 148.

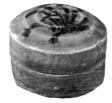

164. Two-handled jar

1941.34a

Stoneware; H. 3⅞″, D. 4¼″

Wheel turned of gray clay on a flat foot with appliquéd handles. Slip covers upper two-thirds of body and entire neck. Light green crackled glaze covers slip area and runs below slip line; two large "splashed" areas of brown green near the handles.

Date: T'ang dynasty.

Condition: Two firing imperfections in splashed areas; small area of glaze loss near lip.

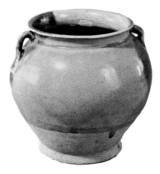

Simple versions of the "splashed" wares at Ch'ang-sha have been reported from the Wa-cha-p'ing kilns; see Hunan Provincial Museum, "Ch'ang-sha Wa-cha-p'ing t'ang-tai yao chih-tiao-ch'a chi" (A report of the investigation of T'ang dynasty kiln remains at Wa-cha-p'ing, Ch'ang-sha), pp. 67–70, pls. 31–32.

165. Two-handled jar

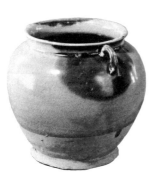

1941.34b
Stoneware; H. 3⅞", D. 4¼"
Wheel turned of gray clay on flat foot with appliquéd handles. Slip covers the upper half of body exterior and entire neck. Light green crackled glaze covers slip area and runs below slip line; two large "splashed" areas of brown green near the handles.

Date: T'ang dynasty.

Condition: Small firing imperfections; some flaking of glaze.

Exhibition: Metropolitan Museum, 1967.

See commentary for no. 164. The control of the glaze has been less successful than on no. 164, for it tends to drip and create bubbles of glaze.

166. Covered box

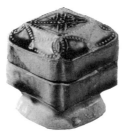

1950.190
Stoneware; H. 2", D. 2¼"
Made of gray white clay in square shape, cut apart. A high, flaring footrim has been wheel finished. Molded design of geometric elements in relief on cover. Thin neutral glaze on interior; on exterior it has been infused with metallic oxide to create a series of green areas.

Date: T'ang dynasty.

Condition: Areas of glaze missing.

Exhibition: Metropolitan Museum, 1967.

A single character (created by slip painting?) is located under a patch of glaze on the underbase. Presumably it stands for the surname *chang.* This piece generally resembles in medium and concept no. 162.

167. Bowl with indented rim

1940.349
Stoneware; H. 2″, D. 3½″

Neatly potted of fine-grained, light gray clay.
Lip has been indented into five foils. Interior
and upper part of exterior covered with a
chocolate brown glaze with one patch of Chün-
like blue.

Date: T'ang dynasty.

Condition: One kiln crack; glaze has failed to
adhere, especially on lip.

Exhibition: Metropolitan Museum, 1967.

This piece seems likely to have been made at
Ch'ang-sha.

168. Covered box

1940.381
Stoneware; H. 1¾″, D. 2¼″

Made of light gray clay in circular form.
Wheel-thrown box with a cover of three tiers.
Interior mainly covered with a thin neutral
glaze; exterior, except for base, covered with a
blue green feldspathic glaze.

Date: T'ang dynasty.

Condition: Small section of top missing.

Exhibition: Yale, 1939.

A somewhat similar piece has been reported by
Isaac Newton; see Newton, "CCWH," *FECB,*
no. 148.

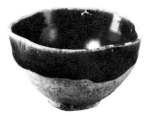

169. Gourd-shaped ewer

1950.183
Stoneware; H. 7⅞″, D. 4¾″

Made of light gray clay. Wheel turned into
gourd shape with following appliqués: petal
ends on body, twisted strand handle, and spout
with bird (?) head. A few details incised on
body and on appliqués. All exterior areas ex-
cept footrim covered with a ch'ing-pai glaze.

Date: T'ang dynasty.

Condition: Some of appliqué leaf ends im-
perfect; damage on spout and handle.

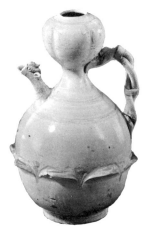

Exhibition: Metropolitan Museum, 1967.

The clay suggests Ch'ang-sha ware, and presumably this piece was made there, despite its elaborate concept and execution.

170. Small jar

1940.394
Stoneware; H. 2⅞", D. 3¾"

Made of dark gray clay with string-cut base. Covered with slip and then with a buff green, lightly crazed glaze which stops just short of footrim.

Date: T'ang dynasty, probably ninth century.

Condition: Small firing imperfections.

Exhibition: Yale, 1939.

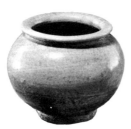

This piece seems to show stylistic progression from no. 160 and is fairly close in shape and glaze to such established tenth century pieces as nos. 197–200.

171. Pillow

1940.364
Stoneware; H. 3⅛", L. 6⅛", D. 4⅛"

Made of gray clay with top and bottom added, and perforated by an air hole at the back. Covered with a light buff glaze, lightly crackled, much of which has degenerated. A design has been painted on before firing with a few cursive strokes in a material which, combined with the glaze, fires to bluish green.

Date: T'ang dynasty, probably ninth century.

Condition: Some firing imperfections; later flaking of glaze.

Exhibition: Yale, 1939.

A related pillow has been found on the mainland. Generally similar in shape, it appears to have pale yellow green glaze and supplementary green painting on it. Fêng Hsien-ming attributes it to Yo-chou and calls it T'ung-kuan, one of six T'ang green glazes from that site. Apparently the only date now associated with the ware is 835. See Fêng, "T'ung-kuan," p. 73.

172. Two-handled jar

1940.384

Stoneware; H. 4½″, D. 3½″

Made of gray clay with small handles running from collar to shoulder. A light buff, heavily crackled glaze covers jar to just short of foot. Remnants of a design in blue and dark brown glaze.

Date: T'ang dynasty, probably ninth century.

Condition: Much of glaze has flaked away, the buff glaze as well as the more colorful areas.

It is easy to see a difference between this piece and the later-dated no. 184, also a multicolored handled jar; the contrasting shapes, for example, seem to attest to this. Some of the differences, however, may be credited to a relative provincialism (lack of slip, etc.) rather than to a very great difference in years.

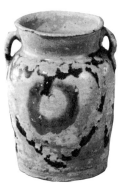

173. Miniature water well

1941.28

Stoneware; H. ⅞″, D. 1½″

Wheel made of light gray clay with a solid foot, string-out base, and a beveled edge on footrim. A thin bluish glaze covers half of exterior, and a neutral glaze the interior.

Date: T'ang dynasty or later.

Condition: Glaze fails to adhere to lip; chip on lip.

Isaac Newton owns a similar piece but with a green glaze on the interior; see Newton, "CCWH," *FECB,* no. 170.

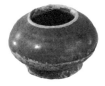

174. Miniature water well

1941.26

Stoneware; H. 1″, D. 8⅛″

Wheel made of light gray clay with a solid foot, string-cut base, and beveled edge on footrim. A light wash of colorless glaze covers interior; thick, mottled blue glaze applied to upper two-thirds of exterior.

Date: T'ang dynasty or later.

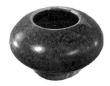

Condition: Glaze failed to adhere to lip; glaze flaking in small areas on body.

While this piece is parallel in shape to the other blue green Ch'ang-sha water wells at Yale, its scale is considerably greater.

175. Cup

1941.25
Stoneware; H. 2¼″, D. 3⅛″

Made of buff clay with a solid foot, string-cut base, and beveled rim. Covered with a blue green glaze on interior and on exterior to an inch above foot.

Date: T'ang dynasty or later.

Condition: Few firing imperfections; glaze gone on upper rim.

Exhibition: Metropolitan Museum, 1967.

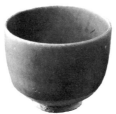

The attribution of this cup shape to T'ang is almost automatic. The blue green glaze, however, suggests late T'ang or an even later date. Chou Shih-jung, in "Lüeh-t'an," pp. 59–63, reports (p. 61) a category of Northern Sung Ch'ang-sha ceramics glaze in blue. His descriptive term, *ch'ing lu,* suggests an intensive blue glaze which may be similar to that on this Yale piece.

176. Foliate dish

1940.351
Stoneware; H. 1⅝″, D. 4¼″

Made of gray white clay with a high footrim. Body and upper rim are divided into ten foliations. Mainly covered, except for under-base, with a light gray-white-blue glaze, perhaps of ch'ing-pai family, which has degenerated into buff tones in some areas.

Date: Ninth–tenth century.

Condition: Some firing imperfections; chip on lip.

Exhibition: Yale, 1939.

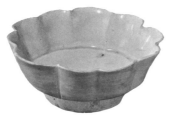

This piece may demonstrate a provincial approximation of ch'ing-pai ware, made at Ch'ang-sha itself.

177. Bowl with reinforced rim

1940.405
Stoneware; H. 2⅜″, D. 7″

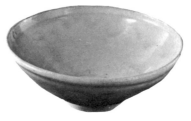

Wheel made of light gray clay. Well potted with reinforced upper rim and neatly finished footrim. Most of body covered by a thin ch'ing-pai glaze, which ran to different thickness during firing.

Date: Ninth–tenth century.

Condition: Some firing imperfections; chemical degeneration of glaze during burial on exterior and interior.

Exhibition: Yale, 1939.

The strength of shape combined with the lack of glaze control suggests this piece may be rather early ch'ing-pai ware.

178. Bowl

1941.35
Porcelaneous stoneware; H. 1½″, D. 6″

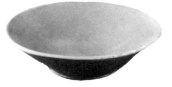

Wheel made of gray, fine-grained porcelaneous and clay and finished with a broad, neatly beveled footrim and a small recessed underbase. Six spur marks visible in unglazed band on footrim, which has oxidized to rust color during firing. Remainder of piece entirely covered with a gray green glaze suffused with buff areas.

Date: Ninth–tenth century.

Condition: Part of rim unglazed, as it pulled away during firing.

This piece, along with no. 179, may be considered Yüeh ware, made in the south coastal province of Chekiang.

179. Bowl

1941.36
Porcelaneous stoneware; H. 1½″, D. 6″

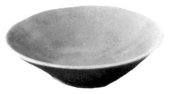

Wheel made of fine-grained, gray porcelaneous clay and finished with a broad, neatly beveled footrim and a small recessed underbase. Six spur marks visible in the unglazed band on footrim. Remainder of piece entirely covered with a gray green glaze tinged with buff areas.

Date: Ninth–tenth century.

Condition: A few minor firing flaws in glaze.

Exhibition: Metropolitan Museum, 1967.

This type of Yüeh ware, exported to the Near East, was apparently sent to Ch'ang-sha as well.

180. Bowl

1941.31

Porcelaneous stoneware; H. 1½″, D. 5¾″

Wheel made of fine-grained porcelaneous clay with a broad footrim beveled at outer edge and reinforced upper rim. Entirely covered except for footrim and base with a thin neutral glaze full of many small bubbles.

Date: Ninth–tenth century.

Condition: Sections of glaze stained during burial.

This well-known type of late or post T'ang white ware is an obvious import into Ch'ang-sha. Pieces with identical footrims and reinforced rims have been reported from the Ting ware digs in Hopei; see Hopei Bureau of Culture Archaeological Team, "Ho-pei Ch'ü-yang hsien," *K'ao-ku,* 1965, no. 8, pl. 6, nos. 2–3 following p. 412.

181. Bowl

1941.32

Porcelaneous stoneware; H. 1¾″, D. 5¾″

Wheel made of fine-grained, white porcelaneous clay with broad footrim beveled at outer edge, and reinforced rim. Entirely covered except for base with a thin neutral glaze full of many small bubbles.

Date: Ninth–tenth century.

Condition: Badly warped in firing; fragments of kiln supports adhere; substantial areas of clay colored by soil action during burial.

See commentary for no. 180.

182. Water well

1940.361

Stoneware; H. 2″, D. 2¾″

Wheel turned of dark gray clay with string-cut base. Upper two-thirds of body covered with a light green brown, crackled glaze. Vertical stripes of brown and dark green applied to shoulder before firing.

Date: Five Dynasties.

Condition: Firing imperfections mar contrasting stripes; chip on upper lip.

Exhibition: Yale, 1939; Metropolitan Museum, 1967

A similarly marked piece, differing in clay and shape, is reported by Isaac Newton; see Newton, "CCWH," *FECB,* no. 150. Documented dating for such floating objects is established by a Five Dynasties tomb at Yang-chou, which contained a vertically striped water well; see CPAM, Kiangsu Province and Nanking Museums, "Kiang-su Yang-chou Wu-t'ai shan t'ang, wu-tai, sung mu fa chüeh chien-pao" (Excavations of the T'ang, Five Dynasties and Sung tombs at Wu-t'ai shan, Yang-chou, Kiangsu), *K'ao-ku* 1964, no. 10, pl. 7, fig. 10 following p. 536.

183. Pillow

1940.363

Stoneware; H. 2⅞″, L. 6¾″, D. 4″

Made of gray clay. Lower part fashioned in the form of a fantastic animal with details appliquéd and incised. A separate slab added on top as a head rest. Covered, except base, with a yellow green, crackled glaze with abstract designs (from flowers?) painted before firing in a darker green and brown.

Date: Five Dynasties.

Condition: A band about 1¼″ wide missing from one end of upper slab; usual firing imperfections and later substantial flaking of glaze.

Exhibition: Yale, 1939; Metropolitan Museum, 1967.

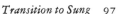

A pillow with contrasting glaze colors excavated at Ch'ang-sha provides archaeological documentation for this type of ware; see Fêng, "T'ung-kuan," p. 73.

184. Two-handled jar

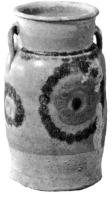

1940.383
Stoneware; H. 5¼", D. 3"
Made of gray clay and slipped. Upper three-quarters of exterior covered with a finely crackled, light green brown glaze and painted before firing with dot and circle patterns in dark brown and blue.

Date: Five Dynasties.

Condition: Glaze fails to adhere in three areas on one side.

Exhibition: Metropolitan Museum, 1967.

A closely related piece is in the collection of the Hongkong government; see Tregear, "Ch'ang-sha Pottery," no. 21.

185. Two-handled jar

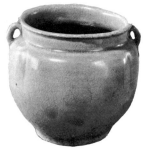

1940.370
Stoneware; H. 3⅝", D. 4¼"
Wheel made of gray clay with appliquéd handles, finished with a string-cut base and beveled foot. Body decorated with four vertical indentations. Exterior covered with a crackled, light buff glaze, green where thick.

Date: Five Dynasties.

Condition: Some imperfections due to firing accidents; major chip on lip.

This would appear to be a transition piece between the bulbous T'ang shapes of nos. 164–65 and the handled Sung jars, which are also known from northern sites.

186. Dish

1940.402

Stoneware; H. 1¼″, D. 6¼″

Wheel made of light gray clay. Sides bear five vertical indentations and curve into a lip trimmed to suggest five petals. Upper part of body covered by a slip and then with a glaze which appears yellow beige over the slip and green over the clay. Glaze covers all except footrim. Five neat spur marks on underbase.

Date: Five Dynasties.

Condition: Warped in firing; imperfections on lip.

Exhibition: Yale, 1939.

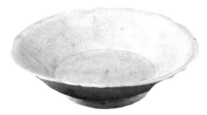

187. Bowl

1941.21

Stoneware; H. 2¼″, D. 6½″

Wheel made of light gray clay. Sides bear five short vertical indentations with lip slightly cut above each. Entirely covered with a watery green glaze with a small, continuous crackle into which the red soil has substantially penetrated. Five spur marks on underbase.

Date: Five Dynasties.

Condition: Small firing imperfections.

Exhibition: Metropolitan Museum, 1967.

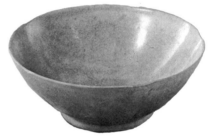

188. Water well

1940.392

Stoneware; H. 1¾″, D. 3⅛″

Wheel made of gray white clay with solid foot and string-cut base. A thin buff glaze covers the piece to within half inch of footrim.

Date: Five Dynasties.

Condition: Glaze peeled away in several small areas.

Exhibition: Yale, 1939.

This piece would appear to be a forerunner of no. 204, which apparently dates to Northern Sung. Differences include shape, style of foot, and character and maturing of glaze.

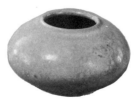

189. Bowl

1940.829

Gift of Paul Mellon, B.A. 1929

Porcelaneous stoneware; H. 3⅞", D. 8"

Wheel thrown of fine-grained gray clay into Buddhist begging bowl shape. Covered, except for supporting areas on base, with gray green glaze, lightly crazed.

Date: Five Dynasties.

Condition: Chip on lip; minute glaze imperfections.

Exhibition: Yale, 1939; Metropolitan Museum, 1967.

It seems probable that this is Yüeh ware of Chekiang, imported into Ch'ang-sha. Newton, however, attributes a fairly similar piece to the Yo kilns near Ch'ang-sha; see Isaac Newton, "Some Coloured and White Wares from Hunan," *TOCS,* 27 (1951–53), pl. 6, no. 14.

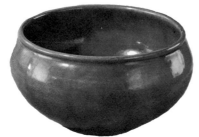

190. Bowl

1941.39

Porcelaneous stoneware; H. 2⅝", D. 6 ⅞"

Wheel made of fine-grained, compact, gray porcelaneous clay with a sturdy foot. Covered, except for base of footrim, with a blue green glaze, some of which has been attacked by soil chemicals and turned a rusty hue.

Date: Five Dynasties.

Condition: Small areas of glaze missing.

Exhibition: Metropolitan Museum, 1967.

The interior of the bowl shows the remnants of supports which held another piece. This technique, combined with the heavy spur marks on the foot, shows the influence of Yüeh ware from Chekiang. The shape of the bowl and its foot also suggest Yüeh influence, and the glaze may be regarded as an effort to imitate Yüeh celadon.

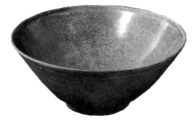

191. Two-handled jar

1940.358

Stoneware; H. 2½", D. 2⅞"

Wheel made of gray white clay. Body divided into six lobes by the repeated application of a rectangular tool ⅛" wide. Entire piece except a section of footrim and underbase glazed off-white, most areas now buff as a result of chemical action by the soil.

Date: Probably Five Dynasties.

Condition: Substantial chip on lip.

Exhibition: Yale, 1939.

The slight awkwardness of shape and rendering, combined with the stoneware firing of the piece, suggests this is a provincial copy of the porcelaneous stoneware of the day.

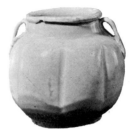

192. Ewer

1941.29

Porcelaneous stoneware; H. 8¼", D. 4½"

Made of fine-grained, gray white clay with appliquéd spout and handle. Raised ridge and two incised lines around body at spout height. A thin whitish glaze, applied over entire piece except footrim, has been substantially discolored by chemical action of burial soil.

Date: Probably Five Dynasties.

Condition: Two large breaks on upper rim; spout imperfect.

Exhibition: Metropolitan Museum, 1967.

This shape is far more common in the east of China, and perhaps we should look for the origin of the piece there, rather than at Ch'ang-sha.

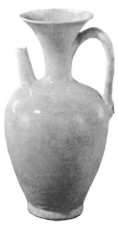

193. Bowl with foliate rim

1941.33

Porcelaneous stoneware; H. 2", D. 6½"

Wheel made from white porcelaneous clay. Divided into five sections by raised radii, each terminating in a cut in the upper rim. Entirely covered except for footrim with an off-white glaze.

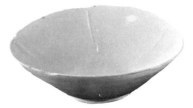

Date: Five Dynasties.

Condition: Badly warped during firing; small chips on upper lip.

Exhibition: Metropolitan Museum, 1967.

This bowl seems to be a provincial copy of the high-fired porcelaneous stoneware of the day.

194. Small ewer

1940.367

Stoneware; H. 4½″, D. 3⅛″

Made of dark gray clay with beveled footrim and flaring neck. Body divided into six faintly indented lobes. Two loop handles, a strap handle, and a curving spout appliquéd. Exterior covered, except for base of footrim, with a variegated green buff, crackled glaze.

Date: Sung dynasty, probably tenth century.

Condition: Imperfections on rim of spout.

Exhibition: Yale, 1939; Metropolitan Museum, 1967.

The underbase is glazed, a characteristic associated with Sung wares at Ch'ang-sha.

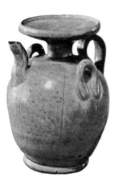

195. Small jar

1950.184

Stoneware; H. ½″, D. 2¾″

Made of dark clay with beveled footrim and flaring neck. Covered with slip and then with a green crackled glaze which stops just short of footrim.

Date: Sung dynasty, probably tenth century.

Condition: Some imperfections in upper rim.

The underbase is glazed, a characteristic usually associated with Sung wares at Ch'ang-sha.

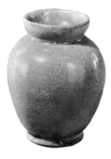

196. Pillow

1940.371

Porcelaneous stoneware; H. 4¾″, W. 6½″

Made of white sugary-textured clay with the bottom luted onto hollow base. Two trefoils cut from base and two semicircular holes from bottom. Pale blue ch'ing-pai glaze crackled and penetrated by burial soil.

Date: Sung dynasty, probably tenth century.

Condition: Chips on edge of neck rim and base rim.

Exhibition: Yale, 1939; Metropolitan Museum, 1967.

Bibliography: George Lee, "Some Ch'angsha Ceramics," pp. 62–63, fig. 1.

This piece bears archaeological documentation by being uncovered in the presence of John Hadley Cox at Ch'ang-sha. Five small celadon jars were found in the same grave, and one of them contained two coins which can be dated in accordance with 952 and 993.

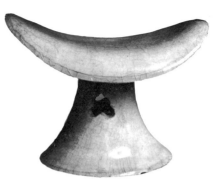

197. Small jar

1940.372a

Stoneware; H. 2⅜″, D. 3½″

Wheel made of gray clay with rudimentary footrim. Covered with slip, then with a buff green, lightly crazed celadon glaze which stops just above footrim.

Date: Sung dynasty, probably tenth century.

Condition: Some firing imperfections; glaze peeling away from body in a few small areas.

Exhibition: Yale, 1939.

See commentary for no. 196. This jar was found with a ch'ing-pai pillow and four other celadon jars; see Lee, "Ch'ang-sha," p. 63.

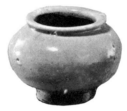

198. Small jar

1940.372b

Stoneware; H. 2⅜″, D. 3¼″

Wheel made of dark gray clay with solid, slightly concave foot. Slipped and then covered with a crackled, green celadon glaze which stops above footrim.

Date: Sung dynasty, probably tenth century.

Condition: Somewhat encrusted with soil.

Exhibition: Yale, 1939.

Bibliography: Lee, "Ch'ang-sha," fig. 2.

See commentary for no. 196. This jar was found with a ch'ing-pai pillow and four other celadon jars.

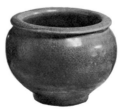

199. Small jar

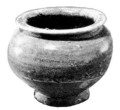

1940.372c

Stoneware; H. 2⅜", D. 3¼"

Wheel made of dark gray clay which turns buff on exposure to kiln. Finished with solid foot and short neck. Slipped and then covered with crackled, dark celadon glaze on upper two-thirds of body.

Date: Sung dynasty, probably tenth century.

Condition: Many firing imperfections, large and small.

Exhibition: Yale, 1939.

See commentary for no. 196. This piece was found with a ch'ing-pai pillow and four other celadon jars; see Lee, "Ch'ang-sha," p. 63.

200. Small jar

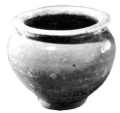

1940.372d

Stoneware; H. 2½", D. 3¼"

Wheel made of gray clay with a hallowed-out foot rather than an actual footrim. Slipped and then covered with a light green, crazed celadon glaze which stops above footrim.

Date: Sung dynasty, probably tenth century.

Condition: Small firing imperfections; large areas where glaze has deteriorated.

Exhibition: Yale, 1939.

See commentary for no. 196. This piece was found with a ch'ing-pai pillow and four other celadon jars; see Lee, "Ch'ang-sha," p. 63.

201. Squat Jar

1940.828

Earthenware; H. 4⅜″, D. 4⅞″

Wheel made of soft, buff clay and slipped inside and out. Band of green lead glaze on upper part of body; central section decorated with a freehand brush design in green glaze and some brown material which may have degenerated from a magenta hue; lowest section bears black paint.

Date: Northern Sung dynasty.

Condition: A few firing flaws; deep gash in lower section of body.

Exhibition: Yale, 1939.

In view of the fragility of the material, one may assume a Ch'ang-sha origin for this object.

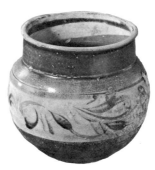

202. Jar

1940.397

Stoneware; H. 3″, D. 3½″

Made of gray clay with crudely finished footrim. Slightly raised band around shoulder incised with five lotus petals and fan-shaped patterns. Entirely covered except for footrim with a variegated green buff glaze of small, irregular crackle.

Date: Northern Sung dynasty.

Condition: Small areas of glaze have failed to adhere; chemical elements in soil have turned crackle buff.

Exhibition: Metropolitan Museum, 1967.

A jar of very similar shape, again with the cut lotus design, has been reported from Ch'ang-sha by Chou Shih-jung, who includes it in his categories of Northern Sung stonewares and illustrates it as fig. 7; see Chou Shih-jung, "Lüeh-t'an," p. 61.

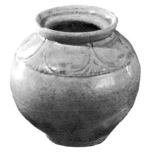

203. Water well

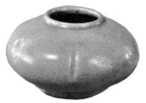

1950.186
Stoneware; H. 1¾", D. 3½"
Wheel made of light gray clay with five indentations on body. Well-finished footrim is unglazed. Remainder covered with a brown green glaze of small, irregular mesh crackle.
Date: Northern Sung dynasty.
Condition: A glaze chip one side.

Both in the manner of making and in the glaze, this piece displays rather close parallels with no. 202.

204. Water well

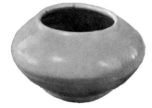

1940.391
Stoneware; H. 1¾", D. 3¼"
Wheel made of light gray clay with neatly finished footrim. A buff glaze of small, irregular crackle covers entire piece except footrim.
Date: Northern Sung dynasty.
Condition: Kiln imperfections; small area where glaze has not adhered.

A similar water well has been reported from Ch'ang-sha by Chou Shih-jung, who includes it in his categories of Northern Sung stonewares; see Chou Shih-jung, "Lüeh-t'an," p. 61.

205. Bowl

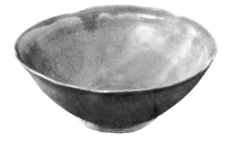

1941.38
Stoneware; H. 2¼", D. 6¾"
Made of light gray clay with rim indented to form five lobes. Brown green glaze, crazed and pitted, covers most of body, none of foot. Underbase stamped with three generally indistinguishable characters; possible interpretations of the first two are *shih hsiao* (ten small), but the third remains totally incomprehensible.
Date: Northern Sung dynasty.
Condition: A few firing imperfections on interior.

Newton reports other inscribed bowls from Ch'ang-sha; see Isaac Newton, "A Thousand Years of Potting in Hunan Province," *TOCS,* 26 (1950–51), 27–36, esp. 36.

206. Small bowl

1941.24
Stoneware; H. 1¾″, D. 3⅛″

Finely potted of gray clay with well-finished footrim. Mainly covered, except for base, with a thin green brown glaze which takes on a neutral-toned crazing after firing.

Date: Northern Sung dynasty.

Condition: Complete.

This piece is of exceptionally good quality and seems to have been made from materials of Ch'ang-sha origin.

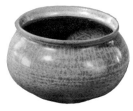

207. Small bowl

1941.22
Stoneware; H. 1¾″, D. 3¼″

Well potted of light gray clay and mainly covered, except for base, with a thin brown glaze which matures in certain areas to green. Neutral-colored, random crazing covers much of glaze surface.

Date: Northern Sung dynasty.

Condition: Gouge in upper rim.

Probably from a different kiln, this piece is less successful ceramically than no. 206.

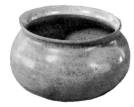

208. Jar with flaring rim

1950.182
Stoneware; H. 3¾″, D. 6¼″

Wheel made of light gray clay with crudely finished footrim. Design of six lotus petals cut into body near base, with a daub of clay added to the tip of each petal. Tan glaze covers entire body except footrim and in certain areas matures into green. Glaze bears a small, neutral-toned crazing.

Date: Northern Sung dynasty.

Condition: A few kiln cracks on body; gouge in rim; scattered minor imperfections.

Exhibition: Metropolitan Museum, 1967.

Yüeh and white porcelain versions of this shape have been recorded and are usually attributed to T'ang. Comparison with a docu-

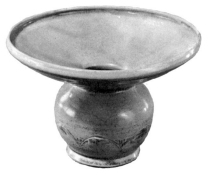

mented T'ang object from area of Ch'ang-sha, actually from Lo-chia Ta-shan, suggests that the Yale piece is of later date; see Hunan Provincial Museum, "Ch'ang-sha Lo-chia Ta-shan ku mu tsang ch'ing-li chien-pao" (The excavation of ancient undisturbed burials at Lo-chia Ta-shan, Ch'ang-sha), ill. 14 on p. 53.

209. Miniature water well

1941.27
Stoneware; H. 1", D. 1⅞"
Wheel made of gray clay with solid foot, string-cut base, and beveled footrim. Upper part of piece covered with a thick blue green glaze on exterior.

Date: Northern Sung dynasty.

Condition: Glaze fails to adhere to upper rim.

Exhibition: Metropolitan Museum, 1967.

At present writing, no close parallels to this precise shape seem to have been reported from Ch'ang-sha, and the glaze on this piece is more intensely blue than that on other Yale examples from Ch'ang-sha. Thus the source of the object is uncertain.

210. Jar

1940.399
Stoneware; H. 2⅝", D. 2¾"
Made of gray white clay. Body divided vertically by six ridges and six indentations. A pale, bubbly ch'ing-pai glaze covers upper five-sixths of exterior and all of interior.

Date: Northern Sung dynasty.

Condition: Cover missing (see below); long firing crack extends down from upper rim.

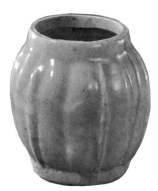

A similar jar of slightly more bulging shape, and a cover, was found in a 1951 excavation at Tang-fu shan near Nanking; see Nanking Museum, "Nan-ching Tang-fu shan ku-ts'an mu liang-ch'ih chih ssŭ-ch'ih ch'ing-li chien-chieh" (Preliminary report on the ancient remnants of tombs—two in good order and four intact—at Tang-fu shan, Nanking), *Wên-wu,* 1955, no. 11, p. 36 (ill.).

211. Stemcup with foliate rim

1940.360

Porcelaneous stoneware; H. 2½″, D. 3⅞″

Wheel made of fine-grained porcelaneous clay. Five indentations around rim and in upper body of cup. Thin neutral glaze covers cup, interior and exterior, except stem, and appears white.

Date: Northern Sung dynasty.

Condition: Few small firing imperfections.

Exhibition: Yale, 1939; Metropolitan Museum 1967.

Bibliography: ECAC, fig. 9.

This type of ware is well known from its importation into the Near East. It was presumably exported to Ch'ang-sha as well.

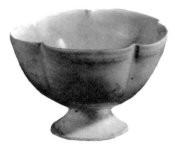

212. Bowl with foliate rim

1941.37

Porcelaneous stoneware; H. 2½″, D. 6″

Made of light gray clay and divided into five sections, indicated by indentations on body and lip. Mostly covered, except footrim, with a light gray green glaze.

Date: Northern Sung dynasty.

Condition: Glaze deterioration by soil on side and underbase; one large and several small chips.

Exhibition: Metropolitan Museum, 1967.

This piece seems influenced in shape and glaze by the Yüeh wares of the tenth century. One may suggest that the Yale piece was made in imitation of Yüeh somewhere in south central China, but not necessarily at Ch'ang-sha.

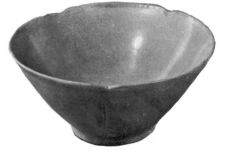

213. Small dish

1940.352

Stoneware; H. ⅞″, D. 3½″

Made of gray white clay without footrim. Upper rim trimmed to suggest six petals, and toward each foliate cut, inner body has been painted with an upward stroke of white slip. A crackled ch'ing-pai glaze covers piece except for flat base.

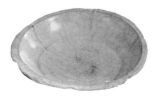

Date: Sung dynasty.
Condition: Slightly warped in firing.
Exhibition: Yale, 1939.

The relatively high degree of sophistication of the piece and the control of the ch'ing-pai glaze suggest that this piece may have come from the kilns which supplied the Lung-hu mountain area of Kiangsi province.

214. Bowl with foliate rim

1940.353
Stoneware; H. 1⅜″, D. 4½″

Made of sugary gray white clay. Upper rim trimmed to suggest six petals, and a lightly incised design inside presumably continues the floral motif. Entirely covered except for underbase and small footrim with ch'ing-pai glaze.

Date: Sung dynasty.
Condition: Slightly warped in firing.

See commentary for no. 213.

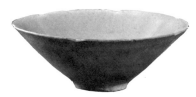

215. Bowl

1940.354
Stoneware; H. 2⅛″, D. 6½″

Thinly made of gray white clay with poorly finished footrim. Floral design created on interior by incised single lines and combing. Covered, except for footrim and underbase, with a thin ch'ing-pai glaze.

Date: Sung dynasty.
Condition: Glaze much invaded by chemical action of soil.
Exhibition: Yale, 1939.

A fairly common type of ch'ing-pai ware, the origin of this particular piece is difficult to determine.

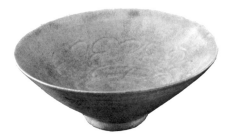

216. Dish

1941.30
Stoneware; H. 1¼″, D. 6¼″

Made of gray white clay with rim indentations to suggest five petals in everted lip. Covered, except for underbase, with an off-white glaze, colored buff by the chemical action of the soil.

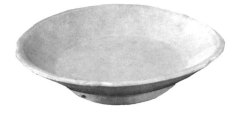

Date: Sung dynasty.

Condition: Firing imperfections.

Exhibition: Metropolitan Museum, 1967.

Warped in the firing, this piece appears to be a provincial effort to duplicate the famous white porcelains of Sung.

217. Bowl

1941.40

Porcelaneous stoneware; H. 2⅝″, D. 6⅜″

Made of gray porcelaneous clay with sturdy footrim and rough underbase. Interior bears a molded design of lotus arabesques. Covered with a lightly crazed olive green glaze except for base of footrim, underbase, and small area in center of bowl.

Date: Sung dynasty.

Condition: Small areas of glaze lost in firing.

Exhibition: Metropolitan Museum, 1967.

Similar pieces can be found in the collection of the Boston Museum, where they have been tentatively attributed to Hsiang-hu in Kiangsi province; see *Hoyt Memorial* (Boston, 1952), nos. 343–44.

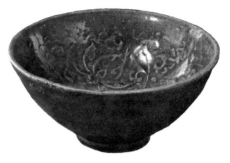

218. Bowl with foliate rim

1941.41a

Porcelaneous stoneware; H. 1⅝, D. 5½″

Made of fine-grained, light gray clay with crisply executed footrim. Flaring lip cut into five foliations. Interior and upper part of exterior covered with a chocolate brown glaze, substantially crazed.

Date: Sung dynasty.

Condition: Small loss on footrim.

Exhibition: Metropolitan Museum, 1967 .

In view of Isaac Newton's remark on the poor quality of his T'ang brown glazed pieces from Ch'ang-sha, one may wish to consider a different provincial origin for this piece; see Newton, "CCWH," *FECB,* nos. 163–65.

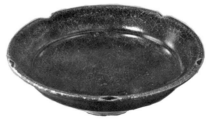

219. Bowl with foliate rim

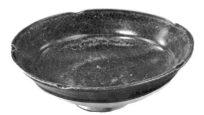

1941.41b
Porcelaneous stoneware; H. 1⅝″, D. 5½″
Made of fine-grained, light gray clay with crisply executed footrim. Flaring lip cut into five foliations. Interior and upper part of exterior covered with a chocolate brown glaze, substantially crazed.
Date: Sung dynasty.
Condition: Small loss of footrim.
See commentary for no. 218.

220. Miniature ewer

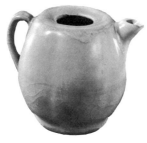

1940.390
Porcelaneous stoneware; H. 2½″, D. 2½″
Made of fine-grained gray clay which turns red on exposure to kiln. Spout and handle appliquéd. Body in five lobes. Covered, except for underbase, with blue gray feldspathic glaze.
Date: Sung dynasty.
Condition: Intrusions of red earth on glaze of shoulder; chips on spout.
Exhibition: Yale, 1939.

This ewer is clearly an import into Ch'ang-sha. It presumably originates in Chekiang province and may be considered a lesser example of Hangchou ware.

221. Covered box

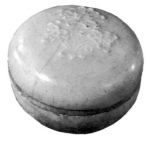

1940.355
Porcelaneous stoneware; H. 2″, D. 3⅛″
Made of white clay. Cover decorated with a raised slip design of flowering plant. Thick ch'ing-pai glaze partially covers interior of cover and stops evenly short of rim on exterior; on bottom half, glaze covers interior and on exterior stops unevenly short of base.
Date: Sung dynasty.
Condition: Stained from burial.
Exhibition: Metropolitan Museum, 1967.

Round ch'ing-pai box with raised slip design dated to the thirteenth century was recovered near Kedah, Malaya in 1957; see Michael Sullivan, "Notes on Chinese Export Wares in Southeast Asia," *TOCS,* 33 (1960–62), 64, pl.

49a. This find raises the possibility that the Yale piece is an import into Ch'ang-sha.

222. Shallow bowl

1940.832
Stoneware; H. 1½″, D. 6″

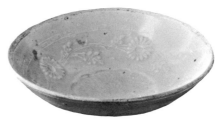

Made of light gray clay with design band of chrysanthemums and leaves between a floral center and a border of fretwork. All these designs molded, but flowers and leaves may also be heightened by painting in slip. Covered, except for upper rim, footrim, and underbase, with thin ch'ing-pai glaze.

Date: Southern Sung dynasty.

Condition: Small firing imperfections in glaze.

Exhibition: Yale, 1939.

Generally similar pieces have, in the past, usually been attributed to Kiangsi province.

223. Small lion on pedestal

1950.211
Stone; H. 2⅜″, L. 1¾″, W. 1¼″

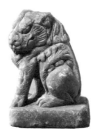

Carved of soft stone, possibly talc or soapstone. Material of gray has acquired a buff surface, probably through oxidation over the years.

Date: Sung dynasty.

Condition: Substantial section missing one side.

Exhibition: Metropolitan Museum, 1967.

Signed with an incised character *li*, probably here used as personal name of maker.

224. Oval cosmetic box

1950.209
Stone; H. ⅞″, D. 3¼″

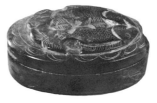

Box and cover carved from pieces of gray slate. Box top has design of two fish reserved in relief with details incised in thin lines.

Date: Sung dynasty.

Condition: Part of outer rim of top missing.

Exhibition: Metropolitan Museum, 1967.

A pair of fish, shown in relief, often decorates Sung celadon wares, although the origin of the motif is much earlier.

Ming

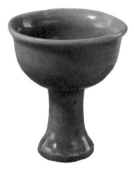

225. Stemcup

1940.378
Porcelaneous stoneware; H. 3¼″, D. 3⅛″
Heavily made of gray clay. One hole pierced on side of cup. Covered, except lower footrim, with thick sea green glaze.
Date: Yüan dynasty.
Condition: Footrim imperfect.
Exhibition: Yale, 1939.

A piece of Chekiang celadon, from the Lung-ch'üan area, but not attributable to any specific kiln as of present writing. This cup is surely, however, an import into Ch'ang-sha.

226. Bowl

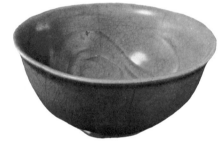

1940.356
Stoneware; H. 2⅞″, D. 7″
Made of fine-grained gray clay with sturdy footrim. Incised trefoil design decorates interior. Covered, except underbase, with a light gray green crackled glaze.
Date: Ming dynasty.
Condition: Some firing cracks and major chip on footrim.
Exhibition: Yale, 1939.

This object has apparently been imported into Ch'ang-sha. Shards of this general nature—that is, with respect to body clay, glaze, and type of incised pattern—have been found by Palmgren at T'a-tzu Ch'i-ko, a few miles from the modern Li-shui in Chekiang province; see Palmgren, *Sung Sherds,* pl. opp. p. 136, esp. nos. 39, 76.

227. Water well

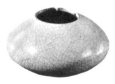

1940.368
Stoneware; H. 1½″, D. 2⅞″
Made of white clay, apparently uncharacteristic of Ch'ang-sha. Recessed underbase, again unusual in this area. A finely crackled white glaze covers entire piece except for a narrow ring at base.

Date: Ming dynasty.

Condition: Substantial flaw on upper lip.

Exhibition: Yale, 1939.

Likely an import into Ch'ang-sha, this piece may have its origins in the coastal province of Fukien.

228. Jar

1940.357
Porcelain; H. 5⅜″, D. 4½″

Made of fine, gray white clay which turns brick red on exposure to kiln. Central design of lotus sprays with leaf band above and linear band below, all in underglaze blue. Warm-toned, neutral glaze.

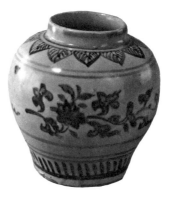

Date: Ming dynasty.

Condition: Firing flaws on glaze surface; chips on footrim.

Exhibition: Yale, 1939.

Presumably an import into Ch'ang-sha from the Kiangsi kilns.

Bronzes

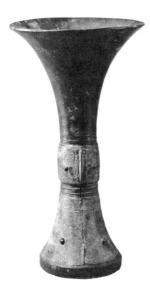

229. Libation cup of type *ku*

1940.127a

Gift of J. Watson Webb, B.A. 1907, and Electra Havemeyer Webb

Bronze; H. 10¼″, D. 6″

Cast with two bands of design, each band below two raised ridges. Design bands consist primarily of dissolved t'ao t'iehs.

Inscription: Two cast characters may be rendered *fu ssŭ* (for father ssŭ).

Date: Late Shang dynasty.

Condition: Some flaws in original casting; areas of malachite patination.

Provenance: Horace O. Havemeyer Collection, New York.

A ku with many parallels to the Yale piece, and especially with an openwork slot instead of the usual cross, has been excavated at Êrh-lang-p'o in Shansi province; see *Wên-wu,* 1958, no. 1, p. 37.

230. Vessel of type *kuei*

1954.49.4

Hobart and Edward Small Moore Memorial Collection; gift of Mrs. William H. Moore

Bronze; H. 6″, D (incl. handles) 12¼″

Upper and lower design bands contain whirl disk and water chestnut elements. Central band of ribbing in relief.

Inscription: Cast single character may be rendered *kê* (caldron).

Date: Western Chou dynasty, twelfth–tenth century B.C.

Condition: One side damaged, presumably during excavation; solder fill-ins and other moderate repairs.

Exhibition: Exhibition of Early Chinese Bronzes, CASA, 1946.

This piece is stylistically related to the K'ang Hou kuei in the Malcolm Collection discussed in W. Percival Yetts, "An Early Chou Bronze," *The Burlington Magazine,* 70, no. 409 (1937), pp. 168–77.

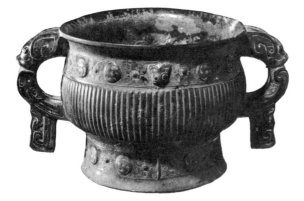

231. Mirror

1953.27.26

Hobart and Edward Small Moore Memorial Collection; gift of Mrs. William H. Moore

Bronze; D. 8″

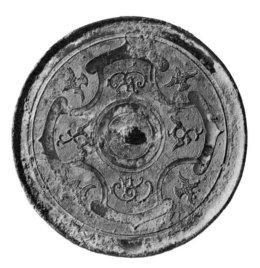

Main design band dominated by large quatrefoil with four realistic birds outside the petals and four stylized birds inside.

Date: Eastern Chou dynasty, third century B.C.

Condition: Cracked and repaired.

Provenance: C. T. Loo, New York, 1931.

Exhibition: Exhibition of Chinese Art, Mills College, 1934, no. 107.

Bibliography: Exhibition of Chinese Art (Mills College, Oakland, 1934), pl. 13.

This piece falls into Karlgren's type D; see Karlgren, "Huai and Han," pl. 32.

232. Vessel of type *p'an*

1940.319

Gift of Yamanaka and Co., New York

Bronze; H. 5″, D. 9¼″

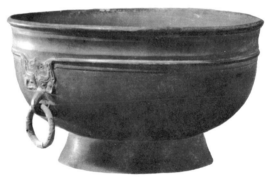

Around top is a molded concave band with ridges along top and bottom. On sides, interrupting lower ridge, are two t'ao t'iehs holding ring handles.

Date: Eastern Chou or Western Han dynasty, third–first century B.C.

Condition: Lightly covered with grayish green water patination; small hole on side.

There was a very similar piece in *The Exhibition of Early Chinese Bronzes* (Stockholm, 1933), no. 6, pl. 43, fig. 1, designated as Han style.

233. Mirror

1953.27.32

Hobart and Edward Small Moore Memorial Collection; gift of Mrs. William H. Moore

Bronze; D. 3⅝″

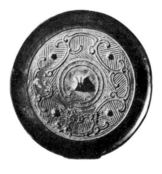

Design based on volutes and curving lines against converging groups of parallel lines. Four bosses.

Date: Western Han dynasty.

Condition: Chip and crack on side; azurite patination.

This mirror fits easily within the variations of Karlgren's type J; see Karlgren, "Huai and Han," pl. 73.

234. Mirror

1953.27.31

Hobart and Edward Small Moore Memorial Collection; gift of Mrs. William H. Moore

Bronze; D. 2¾″

Design based on volutes and curving lines. Four bosses.

Date: Western Han dynasty.

Condition: Chips on rim; minute area missing; malachite encrustation.

A mirror with similar design, but with a plain band connecting the four bosses, was found at Ch'êng-tu in 1954; see Ssŭ-ch'ûan shêng po-wu-kuan, *Ssŭ-ch'ûan shêng ch'u-t'u tung ching* (Bronze mirrors excavated in Ssŭ-ch'ûan province) (Peking, 1960), no. 10. Karlgren, "Huai and Han," notes another similar mirror (J–15) as coming from Hui-hsien in Honan.

235. Belt hook

1954.48.15

Hobart and Edward Small Moore Memorial Collection; gift of Mrs. William H. Moore

Bronze, gilt, and inlaid turquoise; L. 7½″, D. (max.) ⅜″

Two bands of chevron-shaped turquoise inlay on one side. Dragon head on both ends.

Date: Han dynasty.

Condition: Some areas rubbed smooth; some inlay and much gilt missing.

Provenance: Yamanaka, New York, 1918.

The belt hook is very similar to pl. 48, fig. K23W in Bernard Karlgren, "Chinese Agraffes in two Swedish Collection," *BMFEA, 38* (1967), 83–192.

236. Food vessel of type kuei

1954.26.1

Hobart and Edward Small Moore Memorial Collection; gift of Mrs. William H. Moore

Bronze; H. 12½″, D. 14″

Decorated with broad band of birds and spiral filling along top. Boss design protrudes from center; band of dragons around base. The four lobed handles have scroll pattern and are topped with animal heads. Each side of square base bears band of birds around ribbed panel. Bell suspended under base is old, but not necessarily originally associated with the piece.

Date: Sung dynasty or later.

Condition: Lightly covered with spots of olive and dark brown patination.

Provenance: C. T. Loo, New York.

Exhibition: Chinese Bronzes, Metropolitan Museum, 1938, no. 102.

Bibliography: Tch'ou Tö-yi, *Bronzes antiques de la Chine appartenant à C. T. Loo et Cie.,* pl. 4; Umehara, *Shina, 1, 2,* pl. 105; Ackerman, *Ritual Bronzes,* pl. 30.

There is a similar piece in the Freer Gallery of Art; see Freer Gallery of Art, *A Descriptive and Illustrative Catalogue of Chinese Bronzes* (Washington, 1946), pl. 28.

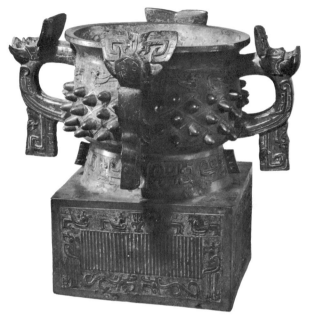

237. Vessel of type kuei

1954.26.2

Hobart and Edward Small Moore Memorial Collection; gift of Mrs. William H. Moore

Bronze; H. 8½″, D. (incl. handles) 13″

Both bowl and stem decorated with wide bands of conventionalized animal figures. Two lobed handles topped with bird heads, and two vertical ridges project from vessel.

Inscription: 104 character inscription of later date cut inside of bowl.

Date: Sung dynasty or later.

Condition: Covered with red brown patination.

Provenance: C. T. Loo, New York.

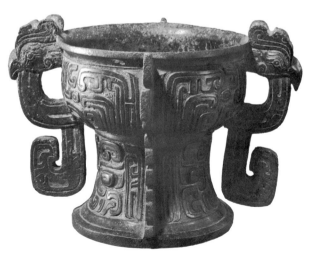

Exhibition: Chinese Bronzes, Metropolitan Museum, 1938, no. 131; Chinese Bronze Exhibition, Princeton, 1946.

Bibliography: Tch'ou Tö-yi, *Bronzes Antiques,* pl. 10; Max Loehr, "Beitrage zu chronologie der Alteren Chinesischen Bronzen," *Ostasiatisch Zeitschrift,* NF 12, Helf ½, Tafel 5, Abb. 14; J. LeRoy Davidson, "New Light on Middle Chou Bronzes," *Art Quarterly,* 1940, 93–106, ill. fig. 3; Ackerman, *Ritual Bronzes,* pl. 33.

The cut, rather than cast, inscription combined with the poor workmanship of the bronze detail suggests this to be an archaizing, rather than an archaic, piece.

238. Tripod

1954.49.5

Hobart and Edward Small Moore Memorial Collection; gift of Mrs. William H. Moore

Bronze; H. (excl. head) 5″, L. (incl. head) 10½″

Bowl-shaped vessel on three slender, curving legs. Small channeled spout, duck's neck and head, and flat, taillike ledge protrude from rim.

Inscription: Cast six character inscription on one of legs.

Date: Sung dynasty or later.

Condition: Spotted with olive brown and malachite patination.

The piece is similar to one shown in Karlgren, "Bronzes in the Hellstrom Collection," *BMFEA,* 20 (1948), pl. 45, no. 1. The Yale piece is dated late because the characters of a Han dynasty reign period are incompletely rendered.

239. Mirror

1952.52.26

Hobart and Edward Small Moore Memorial Collection; gift of Mrs. William H. Moore

Bronze; D. 6⅝″

Design of boat amid dragon waves.

Inscription: Four large seal type characters may be rendered, "All powerful ruler Tse

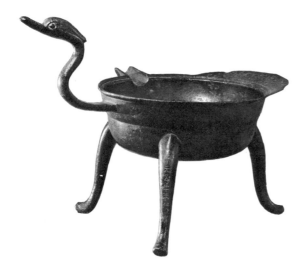

T'ien," presumably referring to Empress Wu of T'ang.

Origin: Korea.

Date: Koryō dynasty, eleventh–twelfth century.

Condition: Few surface areas lost; green patination.

Provenance: Ton-ying, New York, 1932.

An identical piece is in the Historical Museum, Kaesong; see G. J. Barinka and W. Forman, *The Art of Ancient Korea* (Prague and London, 1962), pl. 53.

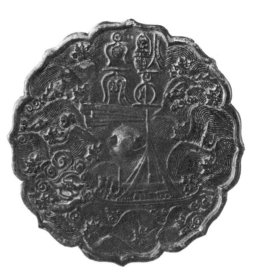

240. Recumbent horse

1954.2.2

Gift of Mrs. Paul Moore

Silver; H. 2″, L. 2⅞″

Solid cast with incising on mane and tail. Traces of red paint in crevices.

Date: Ming dynasty.

Condition: Some surface flaws due perhaps to casting problems.

The dating, at best provisional, seems logical in view of horses in jade often attributed to Ming.

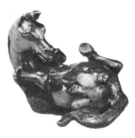

241. Censer

1955.4.148

Hobart and Edward Small Moore Memorial Collection; bequest of Mrs. William H. Moore

Bronze; H. 5¾″, W. 3¾″

Made in three separate parts: top, body, and base. Openwork top bears a dragon and cloud design; body has two dragons against a wave design; base and lower part of body decorated with gadroons. Splashes of gilt overall.

Date: Ch'ing dynasty, K'ang Hsi reign.

Condition: Complete.

A generally parallel censer has been found in a tomb dated in accordance with 1675; see Su T'ien-chün, "Pei-ching hsi-chiao hsiao-hsi t'ien ch'ing-tai mu-tsang fa-chüeh chien-pao" (Excavations of the Ch'ing dynasty tombs at Hsiao-hsi t'ien, Peking), fig. 18 on p. 57.

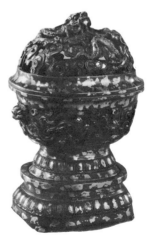

Jades

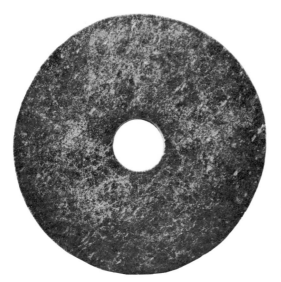

242. Disk of type *pi*

1940.160

Gift of J. Watson Webb, B.A. 1907, and Electra Havemeyer Webb

Nephrite; D. 8¼″, D. (of perforation) 1¾″

Heavy, plain disk of variegated brown. Surfaces and outer edge even, smooth, and polished. Perforation drilled from both sides, leaving uneven ridge inside.

Date: Western Chou or Eastern Chou dynasty, tenth–seventh century B.C.

Condition: Few very small chips on edge of outer rim.

Increase in thickness from ½″ along outer edge to ⅗″ along inner edge suggests cutting of slab by rotary disk, rather than by wire saw.

243. Ornament in shape of bovine head

1953.27.25

Hobart and Edward Small Moore Memorial Collection; gift of Mrs. William H. Moore

Nephrite; H. 1″, W. ⅞″

Rounded face incised with nostrils, eyes, eyeballs and decorative, curving lines. Pattern between horns carved straight through to back, which is nearly flat. Diagonal perforation from lower jaw to back, drilled from both sides. Creamy white.

Date: Western Chou or Eastern Chou dynasty, tenth–seventh century B.C.

Condition: Traces of calcification.

Provenance: R. Bensabott, Chicago, 1932.

For a parallel piece see Berthold Laufer, *Archaic Chinese Jades Collected by A. W. Bahr* (Chicago, 1927), pl. 21, no. 9.

244. Ornament in form of rhinoceros

1953.27.21

Hobart and Edward Small Moore Memorial Collection; gift of Mrs. William H. Moore

Nephrite; H. 1⅜″, W. (at ears) 1⅜″

Large rounded ears and two upward-curving projections of equal size on lower face. Diamond-shaped eyes. Front in the round, but back depressed inward, and plain. Pale green stone.

Date: Western Chou or Eastern Chou dynasty, tenth–seventh century B.C.

Condition: Complete.

Exhibition: Chinese Jades, Arden Gallery, 1939, no. 101.

Bibliography: Arden Gallery, *Chinese Jades,* p. 27, ill. on p. 70.

The rhinoceros appears to have existed in some areas of China through the Chou period; see Soame Jenyns, "The Chinese Rhinoceros and Chinese Rhinoceros Horn Carving," *TOCS, 29* (1954–55), 31–62.

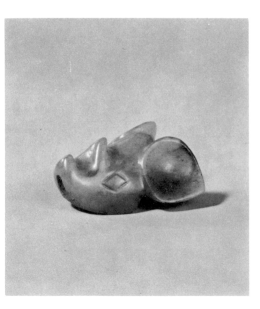

245. Appliqués in form of half-pi

1953.27.20a, b

Hobart and Edward Small Moore Memorial Collection; gift of Mrs. William H. Moore

Nephrite; (Each) L. 5½″, W. 1⅞″, T. (max.) ⅛″

Patterned fields of small, roughly hexagonal protuberances, formed by straight line cuts and incised with spirals; lightly incised border lines. Patterned incision on reverse sides mostly ground away. Small, evenly drilled holes along edges. Ivory and green mixture in color.

Date: Eastern Chou dynasty, fifth–third century B.C.

Condition: Small flaw on surface of stone; chip from outer edge of .20a.

The object was originally a complete pi decorated on both sides; then, possibly at a later date, cut in half, ground smooth on the backs, and drilled with holes for use as appliqués. The Sonnenschein Collection contains a similar piece which has undergone the same transformation; see Salmony, *Archaic Chinese Jades,* pl. 76, no. 3.

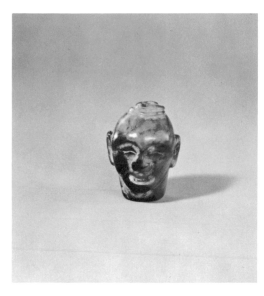

246. Pendant in form of male head

1953.27.22

Hobart and Edward Small Moore Memorial Collection; gift of Mrs. William H. Moore

Nephrite; H. 1⅛″, W. ⅞″

Face naturalistically modeled with broad, flat nose, grinning mouth, squinting eyes, long articulated ears, and coiled topknot. Hole drilled from both ends runs the length of head. Gray green with areas of dark brown.

Date: Eastern Chou dynasty, fifth–third century B.C.

Condition: Complete.

Provenance: R. Bensabott, Chicago, 1932.

For a parallel piece, see a jade head in *International Exhibition* (London, 1935–36), no. 689, dated T'ang. The possibility of a post-Chou date for the Yale piece may also be considered.

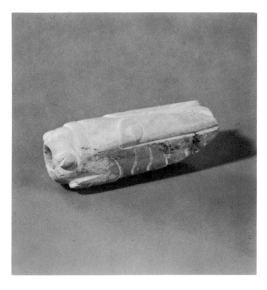

247. Ornament in form of mantis

1953.27.23

Hobart and Edward Small Moore Memorial Collection; gift of Mrs. William H. Moore

Nephrite; L. 2″, W. ¾″, T. ¾″

Made in the round with protruding eyes, band behind head, folded wings with spiral design, and pair of forelegs with claws, all in relief. Underside incised with scalloped lines extending up to wings. Large perforation, drilled from both ends, runs length of body. Creamy white stone.

Date: Han dynasty.

Condition: Calcination along a few cracks; chunk missing from underside of tail seems to have been a flaw in the stone before cutting.

Provenance: S. and G. Gump, San Francisco, 1930.

Alfred Salmony discusses a mantis which resembles the Yale piece in certain features: legs with claws, elongated breast, spirals on wings; see Salmony, "The Cicada in Ancient Chinese Art," *The Connoisseur, 91* (1933), 176, text fig. 6. The Yale piece is, however, far simpler.

248. Tongue amulet in form of cicada

1954.49.24

Hobart and Edward Small Moore Memorial
Collection; gift of Mrs. William H. Moore

Nephrite; L. 3¼″, T. ¼″

Thin and nearly flat. Incised with two parallel
curves behind protruding eyes; beveled
grooves mark wings. Underside incised with
long double V at head and with parallel curves
on tail. Perforation drilled between eyes, pos-
sibly at a later date for use as pendant. Pale
green in uncalcified areas.

Date: Han dynasty.

Condition: Most of surface calcified.

Provenance: A. W. Bahr, New York, 1930.

249. Tally in form of tiger

1955.4.193

Hobart and Edward Small Moore Memorial
Collection; bequest of Mrs. William H. Moore

Nephrite; L. 3⅛″, W. 1½″

Made in two halves which slide together on an
inside groove. Symmetrical except for tail
curled over left flank. Small, flamelike patterns
incised on body. Underside plain. Gray.

Date: Six Dynasties.

Condition: Complete.

Provenance: Otto Burchard, New York, 1931.

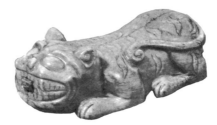

250. Camel with feline crawling up its side

1955.4.163

Hobart and Edward Small Moore Memorial
Collection; bequest of Mrs. William H. Moore

Nephrite; H. 4¼″, L. 9″

Surface naturalistically modeled, although un-
derside is flat, with legs in very low relief.
Striations indicate hair on neck, legs, and
humps. Feline creature holds branch in its
teeth. Black with areas of dark green.

Date: Sung dynasty.

Condition: Small losses and imperfections in
stone.

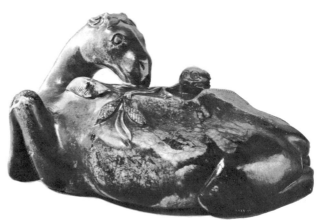

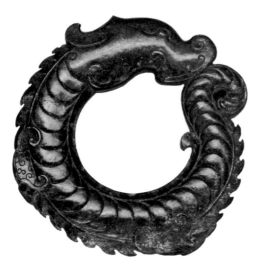

Exhibition: Chinese Jades, Arden Gallery, 1939, no. 249.

Similar camels, without the feline, are illustrated in Desmond Gure, "Jades of the Sung Group," no. 268, and in Henry Trubner, *The Arts of the T'ang Dynasty* (Los Angeles, 1957), no. 281, the latter dated T'ang, the former as possible T'ang or early Sung. The Yale camel is not as vigorous or athletic as the above two, which suggests the later date.

251. Ring in form of dragon

1940.161

Gift of J. Watson Webb, B.A. 1907, and Electra Havemeyer Webb

Nephrite; D. 6½″, T. ¾″

Dragon touches head to tail. Thick, swelling body covered with large scales; spiky backbone. Four little wings and head archaistically incised. Dark, variegated brown.

Date: Sung dynasty or later.

Condition: Chips off two wings.

A nearly identical piece is illustrated in Gure, "Jades of the Sung Group," no. 260.

252. Vessel in shape of chimera

1955.4.172

Hobart and Edward Small Moore Memorial Collection; bequest of Mrs. William H. Moore

Nephrite; H. 1¾″, L. 3½″

Small cavity inside body leads to cup at mouth. Archaistic features include flattened nose, small bifid horn between heart-shaped ears, and stiff, featherlike cheekpieces and shoulder wings. Spine edged with curling feathers. Stopper topped with bird. Gray white with brown spots.

Date: Ming dynasty.

Condition: Complete.

Similar vessel in bronze found in *Hsi-ch'ing shu-chien i-pien* (Supplement to illustrated catalogue of bronzes in Manchu imperial collection), p. 34.

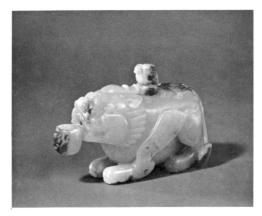

253. Jar in shape of hu

1954.49.29

Hobart and Edward Small Moore Memorial
Collection; gift of Mrs. William H. Moore

Nephrite; H. 5½", D. 6"

Oval body with finger and thumb marks
carved on either side into smooth, plain sur-
face. Slightly spreading foot archaistically in-
cised. Gray green stone.

Date: Ming dynasty.

Condition: Complete.

Exhibition: Chinese Jades, Arden Gallery,
1939, no. 239; Chinese Jade, China House,
1946.

Bibliography: Arden Gallery, *Chinese Jades,*
p. 47, pl. 84.

The same type in bronze is found in *Hsüan-ho
po-ku t'u-lu* (Illustrated catalogue of Sung
imperial bronzes), p. 20.

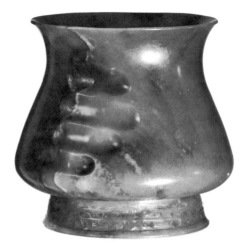

254. Feline in wrappings

1954.49.27

Hobart and Edward Small Moore Memorial
Collection; gift of Mrs. William H. Moore

Nephrite; H. 1", L. 2"

Feline, wrapped in material tied over center of
back and tucked under both ends in two point-
ed folds, leaving only head and question mark
tail visible. Pale green with brown on under-
side.

Date: Ming dynasty.

Condition: Irregular crack over back, edged
with brown.

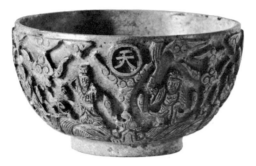

255. Bowl

1955.4.156

Hobart and Edward Small Moore Memorial Collection; bequest of Mrs. William H. Moore

Nephrite; H. 3″, D. 5″

Thick, buff bowl of burned jade, with large areas of pink. Exterior carved in high relief, showing the eight Taoist immortals with four medallions containing characters of good fortune and long life. Interior plain.

Date: Ming dynasty.

Condition: Long crack one side.

Provenance: Roland Moore, New York, 1916.

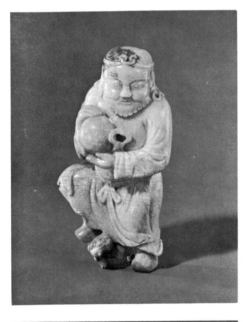

256. Lohan

1955.4.171

Hobart and Edward Small Moore Memorial Collection; bequest of Mrs. William H. Moore

Nephrite; H. 4¼″

Gray male figure holding a starry globe and standing with one foot on a *ch'i-lin*. Long curling hair and eyebrows show traces of black paint.

Date: Ming dynasty.

Condition: Complete except for paint.

Possibly a representation of the lohan Chu T'an-yu, the tiger tamer; similar figure in Stanley Nott, *Chinese Jade* (New York, 1937), pl. 147b.

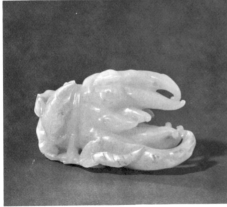

257. Flower

1954.49.31

Hobart and Edward Small Moore Memorial Collection; gift of Mrs. William H. Moore

Nephrite; L. 3½″

Carving of Buddha's Hand Citron, showing the tentacled flower on a cut branch with several leaves. White with traces of light brown.

Date: Ming dynasty or later.

Condition: Complete.

258. Cup with figures

1955.4.167

Hobart and Edward Small Moore Memorial Collection; bequest of Mrs. William H. Moore

Nephrite; (Incl. figures) H. 3⅛", D. 4¼"

Cup decorated in relief with flowers and tendrils. Handle is a boy clinging to side; another boy inside pushes head and hand through wall of cup. White stone.

Date: Ch'ing dynasty.

Condition: Long crack in cup; small hole in side.

Similar piece in Howard Hansford, "Jade and Jade Carvings in the Ch'ing Dynasty," *TOCS,* 35 (1963–64), no. 395.

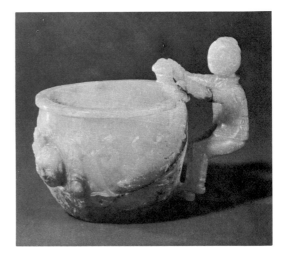

259. Cup with cover

1955.4.191

Hobart and Edward Small Moore Memorial Collection; bequest of Mrs. William H. Moore

Jadeite; H. ¾", W. 2"

Oblong and very narrow with handle and base of tendrils and leaves from which grow flowers that decorate sides. Cover topped by openwork of leaves and long, stylized feline. Pure, translucent white stone slightly tinged with gray green.

Date: Ch'ing dynasty.

Condition: Complete.

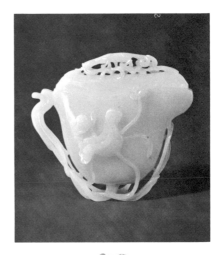

260. Covered tripod

1955.4.157

Hobart and Edward Small Moore Memorial Collection; bequest of Mrs. William H. Moore

Jadeite; H. 7", W. 7"

Plain, squat body on three mask and claw feet; large foliate dragon head handles with loose rings. Cover with three loose rings in branchlike attachments, surmounted by openworked dragon over hole in center. Blue gray with brown spots.

Date: Ch'ing dynasty.

Condition: Complete.

Provenance: Roland Moore, New York, 1920.

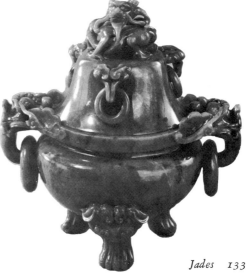

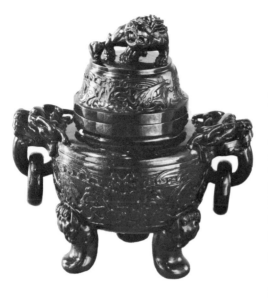

261. Covered tripod

1955.4.158
Hobart and Edward Small Moore Memorial
Collection; bequest of Mrs. William H. Moore
Jadeite; H. 7″, D. 7½″
Squat body on three feet has monster handles
with loose rings. Foliate t'ao t'iehs in relief in
central zone and on cover, which is topped by
leonine beast. Black with tiny flecks of white
and green.
Date: Ch'ing dynasty.
Condition: Complete.

262. Bowl

1955.4.186
Hobart and Edward Small Moore Memorial
Collection; bequest of Mrs. William H. Moore
Jadeite; H. 2″, D. 4¼″
White, mottled with emerald green, black,
and flecks of brown.
Date: Ch'ing dynasty.
Condition: Complete.

Ceramics

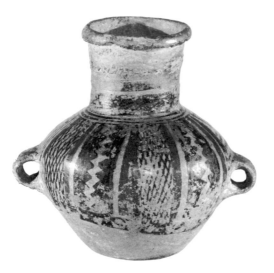

263. Jar

1955.4.204

Hobart and Edward Small Moore Memorial Collection; bequest of Mrs. William H. Moore

Earthenware; H. 6″, D. (excl. handles) 5″

Made of light brown clay with two appliquéd handles. Design area of alternating trellis and double dentated bands painted in red and black.

Origin: Kansu province.

Date: Late Neolithic period.

Condition: Some loss of painted surface.

This jar belongs to the Pan Shan style; see Nils Palmgren, *Kansu Mortuary Urns of the Pan Shan and Ma Chang Groups.* The form type is P.S. 27, and the decorative type 15P. Note especially pl. 15.

264. Libation cup

1950.158

Gift of John Hadley Cox, B.A. 1935

Earthenware; H. 4¼″, D. 3¾″

Wheel thrown of dark gray clay, then hand pressed to form spout. Handle and three legs appliquéd to create a chüeh form.

Origin: Honan province.

Date: Shang dynasty.

Condition: Rubbed and perhaps slightly ground at lip.

Provenance: Walter Hochstadter, New York, 1940.

Exhibition: Hochstadter Exhibition, Nierendorf Gallery, 1940, no. 1.

Parallel pieces include chüehs in the Museum of Far Eastern Antiquities, Stockholm (see *STZ, 8,* pl. 44) and the Ralph Chait Collection, New York (see Warren E. Cox, *The Book of Pottery and Porcelain, 1* fig. 32).

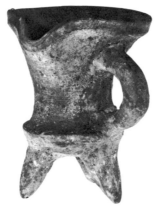

265. Bowl

1950.159
Gift of John Hadley Cox, B.A. 1935
Earthenware; H. 5¼″, D. 7¼″
Wheel made of dark gray clay. Single design band of triple chevrons, freely incised.

Origin: Honan province.

Date: Shang dynasty or slightly later.

Condition: Few rubbed areas on upper rim.

Provenance: Walter Hochstadter, New York, 1940.

Exhibition: Hochstadter Exhibition, Nierendorf Gallery, 1940, no. 4.

Similar pieces illustrated in *STZ, 8,* pl. 43, and in Max Loehr, "Neue Typen Grauer Shang-Keramik," *Sinologische Arbeiten des Deutschland-Institutes* (Peking, 1943), Abb. 12.

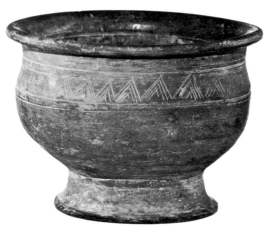

266. Tripod

1955.4.23
Hobart and Edward Small Moore Memorial Collection; bequest of Mrs. William H. Moore
Earthenware; H. 5¼″, D. 5¾″
Made of gray clay with parallel vertical impressed lines on main part of body.

Origin: Shensi province.

Date: Western Chou dynasty.

Condition: Large chip in upper rim.

Two rather similar tripods are reported from Shensi province. One, from P'u-tu village, Sian, is illustrated in *STZ, 8,* fig. 66. The other, also from the Sian district, was found at Chang-chia-p'o; see CPAM, Shensi province, "Shen-hsi Ch'ang-an Fêng-hsi Chang-chia-p'o hsi-chou i chih ti fa chüeh" (Excavations of a Western Chou site at Chang-chia-p'o, Fêng-hsi, Ch'ang-an county, Shensi province), pl. 5, no. 6.

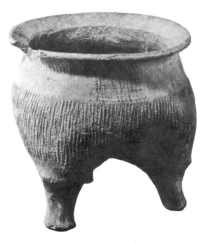

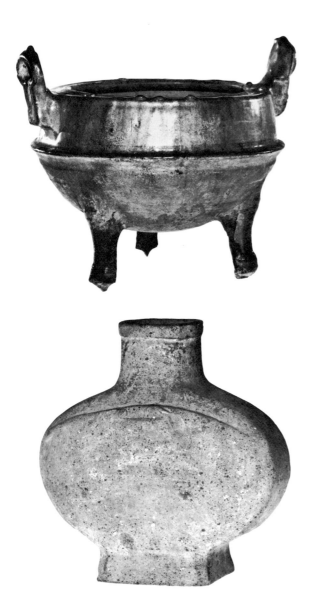

267. Tripod

1955.4.66

Hobart and Edward Small Moore Memorial Collection; bequest of Mrs. William H. Moore

Earthenware; H. 7″, D. 8½″

Made of red clay, wheel thrown with horizontal ridge on body. "Keyhole" design handles and three plain legs appliquéd. Green lead glaze with silvery iridescence. Fired upside down.

Date: Han dynasty.

Condition: Few minute areas of glaze missing.

268. Flask

1949.282

Collection of Wayland Wells Williams, B.A. 1910; gift of Mrs. Frances Wayland Williams

Earthenware; H. 7⅝″, D. 7¼″

Rectangularly made of bluish gray clay. Raised oval panels project slightly from each flattened side.

Date: Han dynasty.

Condition: Small surface losses.

Provenance: Mathias Komor, New York, 1943.

A generally similar piece, called a *kê-hsing hu* (a hide stretched hu), was found in tomb 159 at Chêng-chou in 1959; see *Wên-wu*, 1960, no. 8, p. 24, text ill. 14. This tomb contained architectural model, mortuary stove, and *wushu* coins.

269. Model of a rooster

1949.281

Collection of Wayland Wells Williams, B.A. 1910; gift of Mrs. Frances Wayland Williams

Earthenware; H. 3⅞″, L. 4″

Made of light buff clay in a two-part mold. Green lead glaze has turned to silvery iridescence.

Date: Han dynasty.

Condition: Minor chips on foot; glaze missing in a few areas.

Provenance: M. J. Maclay, 1943.

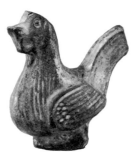

270. Hill jar of type *lien*

1948.44

Collection of Wayland Wells Williams, B.A.
1910; gift of Mrs. Frances Wayland Williams

Earthenware; H. 5⅛″, D. 6¼″

Made of brick red clay. Sits on three bear feet;
band of molded design includes mounted
huntsmen, boars, tigers, deer, monkey, and
t'ao t'iehs. Lead glaze of cucumber green on
exterior, brown yellow in interior.

Date: Han dynasty.

Condition: Chip on upper rim.

Provenance: C. E. Wells, 1941.

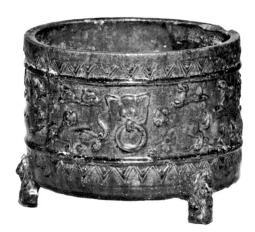

271. Hill jar of type lien

1940.146

Gift of J. Watson Webb, B.A. 1907, and
Electra Havemeyer Webb

Earthenware; H. 5¾″, D. 8″

Made of light buff clay in two-part mold. Sits
on three bear feet; band of molded design
consists of confronting tigers, mountains, and
t'ao t'iehs. Covered with lead glaze of varying
green hues. Fired upside down.

Date: Han dynasty.

Condition: Few rim chips.

Provenance: Horace O. Havemeyer Collection.

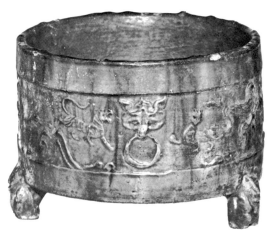

272. Tripod

1947.60

Collection of Wayland Wells Williams, B.A.
1910; gift of Mrs. Frances Wayland Williams

Earthenware; H. 3″, D. 3¾″

Made of orange buff clay. Three lion masks
appliquéd. Green lead glaze has silvery iri-
descence.

Date: Han dynasty–Six Dynasties, first–fifth
century.

Condition: Few small areas where glaze fails
to adhere.

Provenance: C. E. Mills Sale, American Art
Association, Anderson Galleries, May 11,
1939, lot 21.

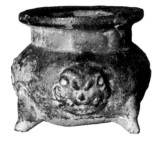

Pre-T'ang and T'ang

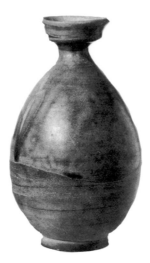

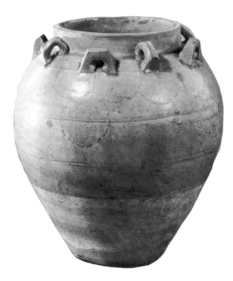

273. Vase

1947.76

Collection of Wayland Wells Williams, B.A.
1910; gift of Mrs. Frances Wayland Williams

Stoneware; H. 7″, D. 4″

Made of fine-grained gray clay which turns
reddish on exposure to kiln. Finely crackled,
olive green glaze, applied in a double dipping,
covers upper two-thirds of body.

Date: Six Dynasties, sixth century.

Condition: Glaze worn on upper lip; chip on
footrim.

Provenance: Walter Hochstadter, New York,
1940.

Using the stylistic criteria of Chow and Drake,
"Sui-T'ang," p. 357, one can attribute a pre-
T'ang date to this vase.

274. Jar

1950.163

Gift of John Hadley Cox, B.A. 1935.

Porcelaneous stoneware; H. 7¾″, D. 7″

Roughly thrown of grayish clay and mostly
covered with white slip. Incised petals on
upper body; eight appliquéd handles. Thin,
finely crackled, gray green glaze covers upper
two-thirds of body exterior.

Date: Six Dynasties, sixth century.

Condition: Firing imperfections of glaze.

A jar with incised designs and six handles (two
are double lugs, thus making eight) has been
reported in a find dated in accordance with
576; see Chou Tao, "Ho-nan P'u-yang pei-ch'i
li-yun-mu ch'u-t'u ti tz'u-ch'i ho mu chih"
(Porcelain objects and burial records from the
Li and other graves of Northern Ch'i times at
P'u-yang, Honan), pp. 482–84, esp. pl. 10.

275. Amphora-shaped vase

1950.166

Gift of John Hadley Cox, B.A. 1935

Stoneware; H. 9″, D. 5″

Heavily potted of gray clay with neck cut and twisted. Two double loop handles appliquéd to neck. White slip applied to upper part of body; irregularly crackled glaze covers upper three-fourths of body, greenish yellow over slipped area and more solidly green over clay.

Date: Sui dynasty.

Condition: Two substantial areas of repair on shoulder.

A similar piece, black glazed and a little later in date, belongs to Mr. and Mrs. Myron S. Falk of New York; see Trubner, *Chinese Ceramics,* no. 60.

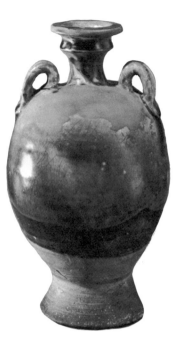

276. Cup

1950.168

Gift of John Hadley Cox, B.A. 1935

Porcelaneous stoneware; H. 2⅛″, D. 2¾″

Made of very fine grained, gray clay with incised line running below lip. Slightly concave base beveled at outer edge. Thin, crackled, pale gray green glaze is more intense green where thick.

Date: Sui dynasty.

Condition: Firing crack on upper rim; glaze imperfections from firing.

This piece exhibits practically all of the Sui characteristics enunciated by Chow and Drake, "Sui-T'ang, p. 357.

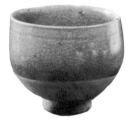

277. Jar

1950.164

Gift of John Hadley Cox, B.A. 1935

Stoneware; H. 7″, D. 5¾″

Made of fine-grained, whitish clay with flat foot and beveled rim. Pair of incised parallel lines on shoulder, partly covered by four appliquéd double loop handles. Finely crackled, gray green glaze covers upper half of body.

Date: T'ang dynasty, seventh century.

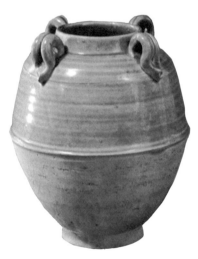

Provenance: Walter Hochstadter, New York, 1946.

Exhibition: Hochstadter Exhibition, Nierendorf Gallery, New York, 1940, no. 11.

The jars found in the tomb of Pu Jên (d. 603) at An-yang give general dating for this piece; see *STZ, 9,* 171–72, pl. 37.

278. Bowl

1950.169
Gift of John Hadley Cox, B.A. 1935
Stoneware; H. 2⅜", D. 4⅝"

Sturdily potted of gray clay with flat base. Incised and cut lotus petal design covers exterior. Glassy, gray green glaze assumes a more intense green hue where thick.

Date: Probably before T'ang dynasty, seventh century.

Condition: Patches of white clay adhered to bowl during firing; inside, another bowl's supporting spurs and glaze have also adhered.

Provenance: Walter Hochstadter, New York, 1940.

Stylistic criteria enunciated by Chow and Drake, "Sui-T'ang," p. 357, fail to provide a precise date for this bowl.

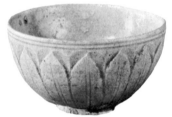

279. Globular vase

1950.170
Gift of John Hadley Cox, B.A. 1935
Stoneware; H. 5⅜", D. 5⅛"

Made of fine, gray white clay with flat base beveled on edge. White slip extends below glaze line. Thin neutral glaze takes a greenish hue where thick.

Date: Probably before T'ang dynasty, seventh century.

Condition: Glaze irregular and speckled from firing.

Provenance: Walter Hochstadter, New York, 1940.

Exhibition: Hochstadter Exhibition, Nierendorf Gallery, New York, 1940.

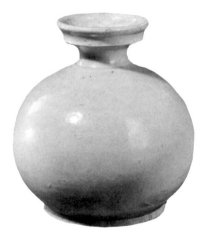

The dividing line between Sui and T'ang, especially in white wares, is still somewhat obscure. Following the stylistic criteria of Chow and Drake, "Sui-T'ang," p. 357, one sees elements of both periods in this jar but may argue that it is more likely T'ang than Sui.

280. Vase

1950.167

Gift of John Hadley Cox, B.A. 1935

Porcelaneous stoneware; H. 9″, D. 4½″

Heavily potted of gray white clay. Three deeply incised horizontal lines on body. Thin, finely crackled, gray green glaze covers upper three-fourths of body.

Date: Probably before T'ang dynasty, seventh century.

Condition: Imperfect maturing of glaze in one area.

This vase demonstrates elements of both Sui and T'ang, as judged by the criteria of Chow and Drake, "Sui-T'ang," p. 357.

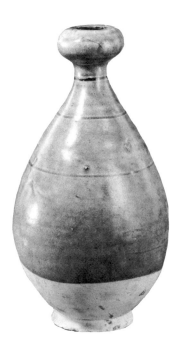

281. Ewer

1950.165

Gift of John Hadley Cox, B.A. 1935

Stoneware; H. 6¾″, D. 4¾″

Made of fine-grained, but impure, clay with appliquéd spout and handle. Impressed herringbone design on body probably done by rollers. White slip covers upper two-thirds of body. Thin glaze, light yellow over slip and yellow brown over body, stops irregularly short of footrim.

Date: T'ang dynasty, seventh century.

Condition: Complete.

Ewers of this general type and glaze, but with two additional handles, are published by William Willetts, *Chinese Art,* 2 (London, 1958), pl. 33, and Tseng and Dart, *Hoyt Collection, 1,* no. 82, as T'ang. The possibility of an early T'ang date for the Yale piece is strengthened by the finding in a tomb dated in accordance with 576 of a jar with *mi-huang* (rice yellow) glaze; see Chou Tao, "Honan P'u-yang," pl. 10.

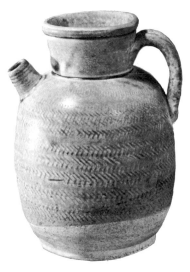

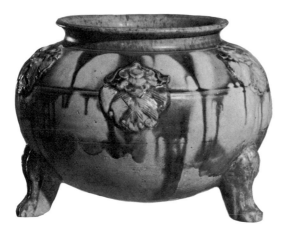

282. Tripod vessel

1955.51.2
Gift of Mr. and Mrs. Fred Olsen
Stoneware; H. 5⅞", D. 8½"
Made of whitish clay which turns pinkish on exposure to kiln. Six floral medallions and three animal feet appliquéd. Mouth rim and feet covered with amber glaze; neutral glaze with metallic oxides applied in streaks to body, firing green and amber.
Date: T'ang dynasty.
Condition: Complete.
Provenance: Swiss collection, 1953.

283. Ewer

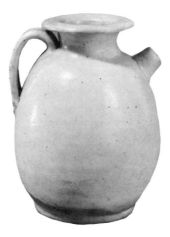

1948.54
Collection of Wayland Wells Williams, B.A. 1910; gift of Mrs. Frances Wayland Williams
Stoneware; H. 5½"
Made of light gray clay with appliquéd spout and wide flat handle. Covered with white slip and cream glaze, now ivory, stopping unevenly short of flat base.
Origin: Probably Honan province.
Date: T'ang dynasty.
Condition: Surface covered with pitting and minor abrasions.
Provenance: Walter Hochstadter, New York, 1942.

284. Ewer

1947.73
Collection of Wayland Wells Williams, B.A. 1910; gift of Mrs. Frances Wayland Williams
Stoneware; H. 3¾"
Made of light gray clay with appliquéd rib handle and spout and covered with a brown black glaze which stops short of base.
Origin: Probably Honan province.
Date: T'ang dynasty.
Condition: Large imperfections in side, near spout.

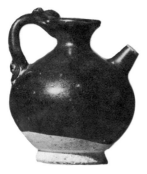

Provenance: Walter Hochstadter, New York, 1940.

Parallel piece, with white glaze, illustrated in *Hoyt Memorial,* no. 140.

285. Bowl

1954.49.51

Hobart and Edward Small Moore Memorial Collection; gift of Mrs. William H. Moore

Porcelaneous stoneware; H. 1⅝", D. 4"

Made of white and brown marbleized clay, the pattern the same on interior and exterior, and covered with transparent amber glaze to edge of footrim.

Date: T'ang dynasty.

Condition: Pitting of surface, occasionally deeply.

Marble ware bowl of this general shape recovered at Sian, Shensi province, in 1953; see CPAM, Shensi province, "Si-an Wang-chia-fên ts'un ti 90 hao t'ang-mu ch'ing-li chien-pao" (Excavation report of T'ang tomb designated no. 90 at Wang-chia-fên, Sian), ill. on p. 30, fig. on lower right. A parallel piece, somewhat larger, is owned by Howard C. Hollis, illustrated in Trubner, *Arts of T'ang,* no. 263.

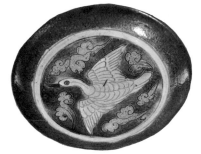

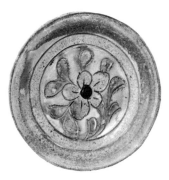

286. Dish

1949.279
Collection of Wayland Wells Williams, B.A.
1910; gift of Mrs. Frances Wayland Williams
Stoneware; H. 1″, D. 5 7/8″
Made of buff clay and incised with duck and
cloud forms within a circular border. White
glaze covers bird and border, amber glaze the
clouds, and a green glaze covers the rest, stop-
ping short of foot on underside.
Origin: Honan province.
Date: Sung dynasty.
Condition: Complete.
Provenance: Yamanaka, New York, 1943.
Closest excavated parallel is a fragment in
Chūgoku, no. 440, recovered in village of P'a
ts'un in Yü hsien, Honan province.

287. Dish

1955.4.17
Hobart and Edward Small Moore Memorial
Collection; bequest of Mrs. William H. Moore
Porcelaneous stoneware; H. 5/8″, D. 4 1/2″
Made of clay which fires buff on exposure to
kiln. Interior and part of exterior covered with
white slip. Incised design of single flower and
leaves within ring. Thin glazes of green,
brown, and yellow hues.
Date: Liao dynasty.
Condition: Some surface deterioration of glaze.

288. Dish

1950.171
Gift of John Hadley Cox, B.A. 1935
Porcelain; H. 1 3/8″, D. 5 1/4″
Made of fine-grained, whitish clay. Covered
with a flat white glaze, soft to the touch, which
stops unevenly near footrim.
Date: Five Dynasties.
Condition: Repaired chip on upper rim.
Provenance: Walter Hochstadter, New York,
1941.

A dish of this shape but with slightly foliate rim has been recovered at Chien-tz'ŭ village near Ting-chou and attributed to the Five Dynasties period; see Hopei Bureau of Culture Archaeological Team, "Ho-pei Ch'ü-yang hsien," fig. 9, no. 10.

289. Small bottle

1954.49.42

Hobart and Edward Small Moore Memorial Collection; gift of Mrs. William H. Moore

Porcelain; H. 4½", D. 2¼"

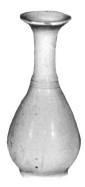

Made of a grayish white, extremely fine-grained porcelain clay. Three raised rings on neck and six vertical indentations on body. All except base of footrim and a few body areas covered by a flat white glaze.

Date: Ninth–tenth century.

Condition: Firing cracks near base.

A slightly smaller bottle is illustrated in R. L. Hobson and A. L. Heatherington, *The Art of The Chinese Potter* (London, 1923), pl. 29, fig. 1.

290. Jar cover

1954.49.40

Hobart and Edward Small Moore Memorial Collection; gift of Mrs. William H. Moore

Porcelain; H. 2¼", D. 5"

Made of fine-grained, grayish white porcelain clay. Interior and exterior bear incised curving radial designs. Two incised lines encircle exterior. All except lower rim covered with thin, neutral, warm-toned glaze. Rim bound with copper.

Origin: Ting ware, Hopei province.

Date: Sung dynasty.

Condition: Button top of cover ground down; chip on rim; small firing imperfections.

A cover with similar designs, but somewhat different shape, has been uncovered on the mainland and attributed to Northern Sung;

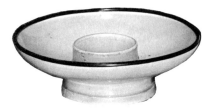

see Hopei Bureau of Culture Archaeological Team, "Ho-pei Ch'ü-yang hsien," text fig. 10, no. 13.

291. Cup stand

1954.49.62

Hobart and Edward Small Moore Memorial Collection; gift of Mrs. William H. Moore

Porcelain; H. 1⅝", D. 5"

Made of fine-grained, grayish white porcelain clay. Reinforced footrim. All but a few minor areas covered with thin, warm-toned neutral glaze. Rim bound with copper.

Origin: Ting ware, Hopei province.

Date: Sung dynasty.

Condition: Complete.

292. Bowl

1947.67

Collection of Wayland Wells Williams, B.A. 1910; gift of Mrs. Frances Wayland Williams

Porcelain; H. 2½", D. 8"

Made of fine-grained, grayish white porcelain. Incised design of two fish among the waves. Covered, except for certain areas of the foot, with a thin, neutral, warm-toned glaze. Rim bound with copper.

Origin: Ting ware, Hopei province.

Date: Sung dynasty.

Condition: Few small firing imperfections.

Provenance: Vetlesen Sale, Parke-Bernet Galleries, May 11–12, 1939, lot no. 215.

A bowl of this shape, but with foliate rim, and with similar incised fish, has been found on the mainland; see Hopei Bureau of Culture Archaeological Team, "Ho-pai Ch'ü-yang hsien," text fig. 10, no. 2.

293. Dish

1947.74
Collection of Wayland Wells Williams, B.A.
1910; gift of Mrs. Frances Wayland Williams
Porcelain; H. ¾", D. 4½"

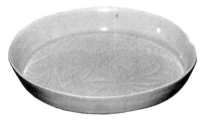

Made of fine-grained white porcelain with in-
cised lotus pattern. Nearly covered with thin,
neutral, warm-toned glaze. Small spur marks
on base.

Origin: Ting ware, Hopei province.

Date: Sung dynasty.

Condition: Part of upright side warped in
firing; few small firing imperfections char-
acteristic of Ting ware.

Provenance: Walter Hochstadter, New York,
1940.

A piece of this general size and shape, but with
a simpler lotus pattern, has been reported
from mainland digging; see Hopei Bureau of
Culture Archaeological Team, "Ho-pei Ch'ü-
yang hsien," text fig. 17, no. 18.

294. Bowl

1952.52.34
Hobart and Edward Small Moore Memorial
Collection; gift of Mrs. William H. Moore
Stoneware; H. 1½", D. 3½"

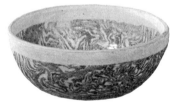

Made of marbleized white and brown clay,
the pattern the same on interior and exterior.
White mouth rim luted on; no footrim on flat
base. Covered with transparent, slightly cream
glaze except for lip.

Origin: Honan province.

Date: Sung dynasty.

Condition: Complete.

Parallel piece recovered at Chiao-tso; see
Orvar Karlbeck, "Notes on the Wares from
the Chiao-tso Potteries," *Ethnos, 8,* no. 3
(1943), fig. 6.

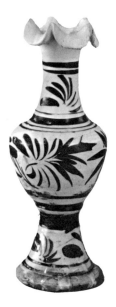

295. Vase with foliate lip

1950.216

Gift of John Hadley Cox, B.A. 1935

Stoneware; H. 8¼″, D. 3¼″

Made of light buff clay, mainly covered with white slip. Floral designs painted in brown slip between parallel horizontal bands. Neutral exterior glaze runs unevenly onto footrim.

Origin: Tz'ŭ-chou type, Honan province.

Date: Sung dynasty.

Condition: Multiple firing imperfections occur in slip and glaze.

A vase of similar shape with divisions into design bands and parallel design elements has been found at P'a ts'un near Yü hsien, Honan; see Yeh Chê-min, "Ho-nan shêng Yü hsien ku-yao chih tiao-ch'a" (Reconnaissances of ancient kiln sites at Yü hsien, Honan province), p. 33, fig. 12.

296. Bottle

1947.59

Collection of Wayland Wells Williams, B.A. 1910; gift of Mrs. Frances Wayland Williams

Stoneware; H. 6″, D. 2⅝″

Made of light buff clay, upper three-fourths covered with white slip. Floral designs painted in brown slip between parallel horizontal bands. Exterior covered with neutral glaze which extends below slip.

Origin: Tz'ŭ-chou type, probably Honan province.

Date: Sung dynasty.

Condition: Minor firing flaws.

Provenance: Charles C. Mills Sale, lot no. 21, 1939.

Parallels in body clay, painted design, and glaze character between this piece and no. 295 suggest the bottle can be tentatively attributed to Honan province, and possibly to Yü hsien.

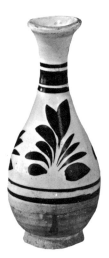

297. Pillow

1950.196
Gift of John Hadley Cox, B.A. 1935
Stoneware; H. 3⅞″, L. 10⅝″, W. 7″

Molded of buff white clay with single back hole and mainly covered with white slip on exterior. Thick outer and thin inner border plus central floral pattern are painted in brown slip. Exterior covered with neutral glaze which stops short of base.

Origin: Tz'ŭ-chou type, Hopei province.

Date: Sung dynasty.

Condition: Parts of two side panels missing.

Exhibition: Painting, Yale, 1963, no. 7.

Two pillow fragments of this shape, with similar double borders have been recovered at Han-tan in the Tz'ŭ-chou district; see Li Hui-ping, "Tz'ŭ-chou yao i chih tiao-ch'a" (Reconnaissances of the remains of the Tz'ŭ-chou kilns), pl. 6, fig. 4.

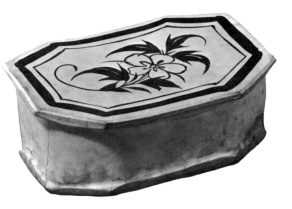

298. Jar

1954.49.47
Hobart and Edward Small Moore Memorial Collection; gift of Mrs. William H. Moore
Porcelaneous stoneware; H. 3″, D. 4¾″

Made of gray clay. Partially covered with slip on exterior, incised with band of floral design and combing. Translucent creamy glaze of varying crackle covers slipped area and part of interior.

Origin: Tz'ŭ-chou type, probably Hopei province.

Date: Sung dynasty.

Condition: Complete.

Several shards with closely parallel design markings have been found at Ch'ing-ho hsien, Hopei province; see Palmgren, *Sung Sherds,* pl. on p. 303, nos. 365, 382.

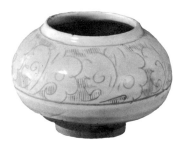

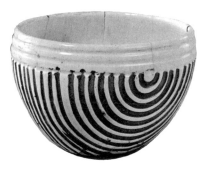

299. Bowl

1954.49.53

Hobart and Edward Small Moore Memorial Collection; gift of Mrs. William H. Moore

Stoneware; H. 3¼″, D. 5″

Made of gray clay which turns brown on exposure to kiln and slipped. Stripes in concentric semicircles carved through white slip. Entirely covered with transparent glaze which stops just short of recessed foot.

Origin: Honan province:

Date: Sung dynasty.

Condition: Firing accidents; vertical cracks in rim; pitting of interior surface, flaws on exterior.

Close parallel, differing mainly in cut design, was recovered in Têng-fêng hsien, Honan and is called Ch'ü-ho yao; see *Chūgoku,* no. 75. Closer in design is a piece in *Hoyt Memorial* no. 280.

300. Bowl

1947.58

Collection of Wayland Wells Williams, B.A. 1910; gift of Mrs. Frances Wayland Williams

Porcelaneous stoneware; H. 2⅛″, D. 4⅞″

Made of buff clay and covered except for base with iridescent black glaze which has turned almost completely rust brown in hare's fur patterns during firing. Glaze stops unevenly at footrim.

Origin: Northern brown ware, probably Honan province.

Date: Sung dynasty.

Condition: Crack in rim; three protuberances of body clay on interior.

Provenance: Frank's, London, 1936.

301. Jar

1950.217

Gift of John Hadley Cox, B.A. 1935

Porcelaneous stoneware; H. 3¾″, D. 5⅛″

Made of buff clay and given small, ribbed handles. Brown glaze partially covers interior and on exterior combines with a line of black glaze on the shoulder to end unevenly in several long drips short of foot.

Origin: Northern brown ware, probably Honan province.

Date: Northern Sung dynasty.

Condition: Many firing flaws.

Provenance: Walter Hochstadter, New York.

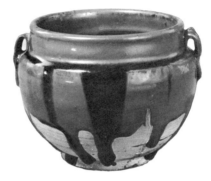

302. Bowl

1955.4.9

Hobart and Edward Small Moore Memorial Collection; bequest of Mrs. William H. Moore

Porcelaneous stoneware; H. 2½″, D. 5⅛″

Sturdily made of coarse, dark gray clay and covered with thick black glaze which stops unevenly short of base and is streaked with brown hare's fur markings descending from the lip, where glaze is thinnest. Lip bound with silver.

Origin: Chien ware, Fukien province.

Date: Sung dynasty.

Condition: Worn from use.

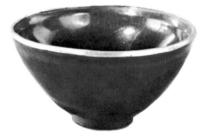

303. Bowl

1948.59

Collection of Wayland Wells Williams, B.A. 1910; gift of Mrs. Frances Wayland Williams

Porcelaneous stoneware; H. 2½″, D. 5″

Made of coarse, dark brown clay and covered with thick black glaze which has turned brown on rim and rust brown in hare's fur markings on rest of body. Glaze stops unevenly short of foot.

Origin: Chien ware, Fukien province.

Date: Sung dynasty.

Condition: Slightly worn from use.

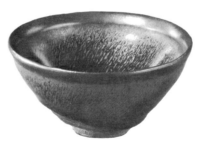

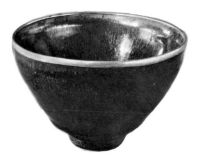

304. Bowl

1947.78
Collection of Wayland Wells Williams, B.A.
1910; gift of Mrs. Frances Wayland Williams.

Porcelaneous stoneware; H. 2⅞″, D. 4¾″

Sturdily made of coarse, dark gray clay and covered with thick black glaze which stops evenly short of base. Glaze streaked with silvery hare's fur markings and acquired a purplish blue iridescence in firing. Lip bound with silver.

Origin: Chien ware, Fukien province.

Date: Sung dynasty.

Condition: Breaks through center and at rim repaired.

Provenance: Saltig, New Haven.

305. Bowl (one of a pair)

1947.66a
Collection of Wayland Wells Williams, B.A.
1910; gift of Mrs. Frances Wayland Williams

Porcelaneous stoneware; H. 2⅛″, D. 5½″

Made of fine-grained gray clay which turns brown on exposure to kiln. Interior decorated with carved lotus plant and combing. Covered with olive green glaze to edge of footrim.

Origin: Northern celadon ware.

Date: Sung dynasty.

Condition: Complete.

Provenance: Vetlesen Sale, Parke-Bernet Galleries, May 11–12, 1939, lot no. 210.

Parallel piece in the collection of Sir George Labouchere, illustrated in "Sung," *TOCS, 32,* no. 144.

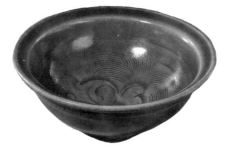

306. Bowl

1950.192

Gift of John Hadley Cox, B.A. 1935

Porcelaneous stoneware; H. 3″, D. 8¼″

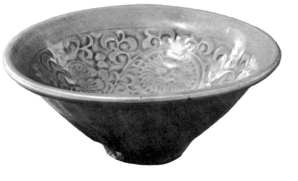

Sturdily made of gray clay which turns reddish brown on exposure to kiln. Molded peony pattern on interior; carved vertical lines on exterior. Covered with gray green celadon glaze except for several patches on exterior.

Origin: Northern celadon ware.

Date: Sung dynasty.

Condition: Slightly worn on interior from use.

Provenance: Walter Hochstadter, New York.

Exhibition: Hochstadter Exhibition, Nierendorf Gallery, New York, 1940.

Shards found at Ch'ing-ho hsien match Yale piece in interior and exterior design; see Palmgren, *Sung Sherds,* pl. on. p. 319, Ch. 56, pl. on p. 277, Ch. 4:335—and fig. pl. 65. This ware was, however, made in several northern provinces; see *Chūgoku,* nos. 256–66.

307. Bowl

1947.72

Collection of Wayland Wells Williams, B.A. 1910; gift of Mrs. Frances Wayland Williams

Porcelaneous stoneware; H. 1¾″, D. 6″

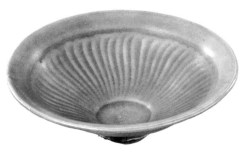

Made of gray clay which fires buff on exposure to kiln. Cut pattern of curving radiants. Covered except for footrim with an olive green glaze.

Origin: Northern celadon ware, perhaps Honan province.

Date: Sung dynasty.

Condition: Complete.

Provenance: Walter Hochstadter, New York, 1940.

While bowls of this simple design may have been made in many sections of Sung China, it remains worth noting that a fragment bearing precisely this pattern has been recovered at Lin-ju, Honan province; see Fêng, "Ho-nan shêng Lin-ju hsien," p. 18, fig. 7.

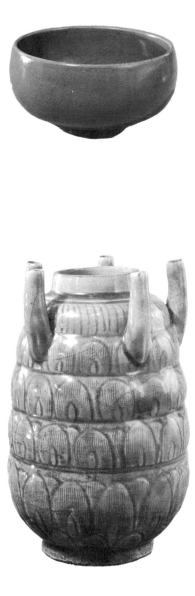

308. Bowl

1955.4.14

Hobart and Edward Small Moore Memorial Collection; bequest of Mrs. William H. Moore

Porcelaneous stoneware; H. 2⅛″, D. 4¼″

Made of dark gray clay which turns dark brown on exposure to kiln. Covered with green chün glaze except for footrim, parts of base, and a large area on bottom of interior. Glaze, irregularly crackled, approaches millet in color at lip, where thinnest.

Origin: Chün ware, probably Honan province.

Date: Sung dynasty.

Condition: Complete.

309. Terraced jar with five spouts

1959.64.3

Gift of Mr. George H. Fitch, B.A. 1932, and Mrs. Fitch

Stoneware; H. 9½″, D. 5¼″

Made of whitish clay with incised design of lines on uppermost band; lotus leaves with combing on four lower bands. Covered with gray green celadon glaze except for base. Some glaze areas crackled, and some oxidized into olive brown tones.

Origin: Southern celadon ware.

Date: Sung dynasty, probably tenth–eleventh century.

Condition: Some severe firing cracks, especially near base.

Parallel piece in Michael Sullivan, *Chinese Ceramics, Bronzes and Jades in the Collection of Sir Alan and Lady Barlow* (London, 1963), pl. 74b.

310. Bowl

1954.49.45
Hobart and Edward Small Moore Memorial Collection; gift of Mrs. William H. Moore

Porcelaneous stoneware; H. 1⅞″, D. 5⅛″

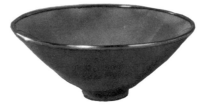

Made of reddish clay which turns reddish brown on exposure to kiln. Covered except for base of footrim with pale green celadon glaze; pinkish tones near base and lip on interior and exterior probably the body clay showing through where glaze runs thinnest. Lip bound with silver.

Origin: Lung-ch'üan kilns, Chekiang province.
Date: Sung dynasty.
Condition: Complete.

311. Bowl with everted rim

1948.49
Collection of Wayland Wells Williams, B.A. 1910; gift of Mrs. Frances Wayland Williams

Porcelaneous stoneware; H. 1⅝″, D. 5⅛″

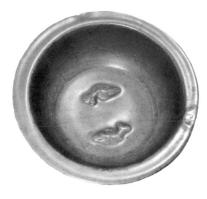

Made of gray white clay which turns red on exposure to kiln. Two fish appliquéd to center of bowl; exterior fluted. All except base of footrim covered with a blue gray glaze of random crackle.

Origin: Lung-ch'üan kilns, probably Ta-yao site, Chekiang province.
Date: Southern Sung dynasty.
Condition: Repair on rim.
Provenance: Walter Hochstadter, New York, 1941.

Closest parallel is a fragment recently recovered at Ta-yao, Lung-ch'üan: see *Chūgoku,* no. 141.

312. Bowl

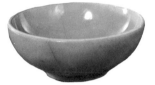

1949.272
Collection of Wayland Wells Williams, B.A.
1910; gift of Mrs. Frances Wayland Williams
Porcelaneous stoneware; H. 1⅜″, D. 3½″
Made of fine gray clay and covered with a
thick, blue green celadon glaze except for foot-
rim.
Origin: Lung-ch'üan kilns, Ta-yao site, Cheki-
ang province.
Date: Southern Sung dynasty.
Condition: Large firing cracks; lip ground
down.
Provenance: Mathias Komor, New York,
1942.
Bowl of the same shape was found at Ta-yao,
illustrated in a drawing in Palmgren, *Sung
Sherds,* fig. pl. 18, no. 145.

313. Tripod waterpot

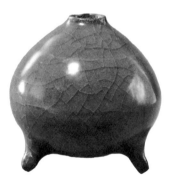

1952.52.33
Hobart and Edward Small Moore Memorial
Collection; gift of Mrs. William H. Moore
Porcelaneous stoneware; H. 2⅝″, D. 2¾″
Made of fine gray clay which turns brown on
exposure to kiln. Covered with thick, gray
green glaze of regular crackle.
Origin: Kuan type, Lung-ch'üan kilns, Che-
kiang province.
Date: Southern Sung dynasty.
Condition: One leg missing.
Provenance: Mathias Komor, New York,
1943.
A shard of this glaze type (with slightly larger
bubbles) was recovered near the Altar of
Heaven, close to the Wu–kuei hill at Hang-
chou; see Palmgren, *Sung Sherds,* pl. on p.
153, no. 114. A piece similar in form is in the
Buffalo Museum of Science, illustrated in *Hob-
bies, 26,* 5, no. 63.

314. Candlestick

1949.269
Collection of Wayland Wells Williams, B.A.
1910; gift of Mrs. Frances Wayland Williams
Stoneware; H. 5¾″, D. (of base) 5½″
Made of whitish clay which turns reddish on
exposure to kiln; made in three parts luted
together. Incised with two rings around stem
and covered except for base with pale gray
blue, finely crackled ch'ing-pai glaze. Hole in
top for point; foot lightly ground down.
Date: Five Dynasties.
Condition: Complete.
Provenance: Wells, New York, 1942.

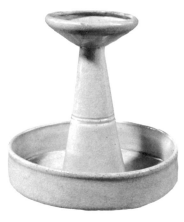

315. Bowl

1954.49.48
Hobart and Edward Small Moore Memorial
Collection; gift of Mrs. William H. Moore
Porcelaneous stoneware; H. 2⅛″, D. 5¼″
Made of fine-grained white clay with casually
finished foot. Interior design of five petal flow-
er and leaves executed in heavily incised and
lightly combed lines. Combing also on exte-
rior. Covered almost to foot with a ch'ing-pai
glaze.
Date: Sung dynasty.
Condition: Firing imperfections and chips on
upper rim.

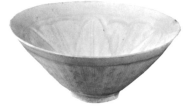

316. Bowl

1954.49.46
Hobart and Edward Small Moore Memorial
Collection; gift of Mrs. William H. Moore
Porcelaneous stoneware; D. 4½″, H. 1¾″
Thinly made of sugary white clay which fires
buff to dark brown on exposure to kiln. Fluted
sides, scalloped lip, and small flower in center
in slip; ribs on interior heightened with slip.
Covered to base of footrim with thin, pale
blue ch'ing-pai glaze which leaves slip-height-
ened areas white.

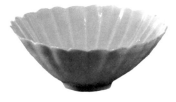

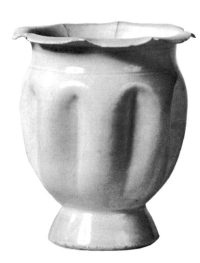

Date: Sung dynasty.

Condition: Minor cracks; small chip on lip.

Provenance: N. E. Montross, New York, 1916.

Parallel piece in *Hoyt Memorial,* no. 372.

317. Vase

1955.4.8

Hobart and Edward Small Moore Memorial Collection; bequest of Mrs. William H. Moore

Porcelaneous stoneware; H. 5¾″, D. (at lip) 5¼″

Made of fine white clay, the body molded into eight deep lobes and the lip with eight scallops. Completely covered with pale blue ch'ing-pai glaze.

Date: Sung dynasty.

Condition: One large and several small chips from lip; adhesions on base from firing support.

Generally similar piece in the collection of Mrs. C. G. Seligman is illustrated in "Sung," *TOCS, 32,* no. 205.

318. Dish

1949.275

Collection of Wayland Wells Williams, B.A. 1910; gift of Mrs. Frances Wayland Williams

Porcelaneous stoneware; H. 1¾″, D. 5⅜″

Made of clay which fires light buff on exposure to kiln. Molded designs on interior include a band of chrysanthemum flowers and leaves, and in the center a three-clawed dragon. Covered with the opaque, blue white glaze characteristic of *shu-fu* ware.

Date: Yüan dynasty.

Condition: Several small cracks and other firing imperfections, mainly on upper rim.

Provenance: Walter Hochstadter, New York, 1942.

319. Bowl

1948.42

Collection of Wayland Wells Williams, B.A.
1910; gift of Mrs. Frances Wayland Williams

Porcelaneous stoneware; H. 3″, D. 7⅛″

Made of clay which fires buff yellow on expo-
sure to kiln. Gray blue glaze turns millet color
where thin; splashes of purple where daubed.

Origin: Chün ware, Honan province.

Date: Yüan dynasty.

Condition: Imperfection of footrim.

Provenance: Eumorfopoulos Collection, Lon-
don; purchased Sotheby and Co., London, May
29, 1940, lot no. 170.

Bibliography: Hobson, *Eumo. Cat., 3,* 10 and
pl. 15 (C47).

An almost identically shaped bowl, with ap-
parently similar body clay color and glaze col-
or, was recovered at Ho-pi-chi and dated Yüan;
see Archaeological Team, Bureau of Culture,
Honan province, "Ho-nan shêng Ho-pi-chi,"
pl. 3, fig. 2, and p. 9.

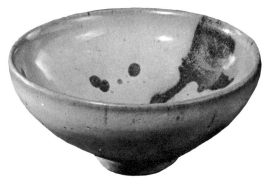

320. Dish

1948.41

Collection of Wayland Wells Williams, B.A.
1910; gift of Mrs. Frances Wayland Williams

Porcelaneous stoneware; H. 1½″, D. 7¾″

Dish made of impure clay which fires buff
where exposed to kiln. Gray glaze, millet toned
where thin, touched with pale purple daub
near rim.

Origin: Chün ware, Honan province.

Date: Yüan dynasty.

Condition: Small firing imperfections in glaze.

Provenance: Eumorfopoulos Collection, Lon-
don; purchased Sotheby and Co., London, May
1940, lot no. 170.

Bibliography: Hobson, *Eumo. Cat., 3,* 12 and
pl. 18.

Rim shard of a Chün dish shaped like the Yale
piece, except for a slightly more recessed un-
derbase, has been recovered at Lin-ju; see
Fêng, "Ho-nan shêng Lin-ju hsien," fig. 11,
no. 7 on p. 20.

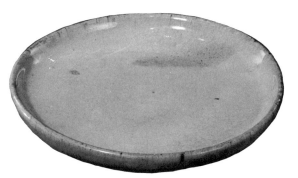

Ming

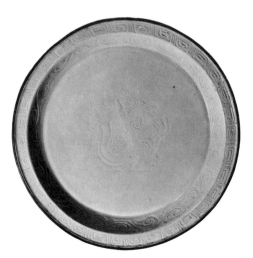

321. Dish

1954.49.55

Hobart and Edward Small Moore Memorial Collection; gift of Mrs. William H. Moore

Porcelaneous stoneware; H. ⅝″, D. 6⅞″

Made of white clay. Decorated with incised dragon in slight relief in center, floral scroll pattern around sides, and fretwork around flat rim. Entirely covered with creamy white glaze. Rim bound in copper.

Origin: Ting ware, Hopei province.

Date: Yüan-Ming dynasty, thirteenth–fourteenth century.

Condition: Imperfections in surface.

One may note that dishes with rims were, according to the author of the *Ko-ku Yao-lun,* introduced into China by foreigners (i.e., the Mongols).

322. Bowl

1955.4.88

Hobart and Edward Small Moore Memorial Collection; bequest of Mrs. William H. Moore

Porcelaneous stoneware; H. 2⅛″, D. 8″

Finely potted of fine white clay and completely covered with black glaze. Lip bound with copper.

Origin: Black ting ware, Hopei province.

Date: Ming dynasty, probably fourteenth–fifteenth century.

Condition: Complete.

Provenance: S. and G. Gump, San Francisco, 1939.

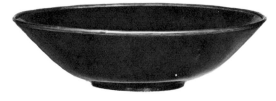

323. Tall vase

1955.4.78

Hobart and Edward Small Moore Memorial Collection; bequest of Mrs. William H. Moore

Porcelaneous stoneware; H. 15½″, D. 5¼″

Wheel made of light gray clay. Thin wash of glaze on interior; exterior covered with a creamy white glaze with small, brownish crackle.

Origin: Tung-ch'i (Dong-khe) ware, Fukien province.

Date: Ming dynasty.

Condition: One circular firing flaw.

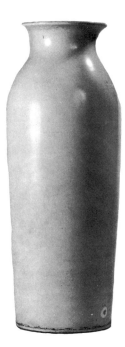

324. Incense burner

1949.280

Collection of Wayland Wells Williams, B.A. 1910; gift of Mrs. Frances Wayland Williams

Porcelain; H. 2¼″, D. 3⅝″

Made of *Blanc de Chine* porcelain clay. Three raised bands, with the area between the two center ones filled with incised fret design. Three cloud-scroll feet support an unglazed base. Remainder, except for parts of base interior, covered with a creamy white glaze.

Origin: Tê-hua ware, Fukien province.

Date: Late Ming dynasty.

Condition: Wear on interior; few firing imperfections on exterior.

Provenance: Mathias Komor, New York, 1943.

A very similar piece is illustrated by Malcolm Farley in "The White Wares of Fukien and the South China Coast (second half)," no. 9 (Mar. 1950), pl. 7, no. 2.

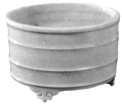

325. Bowl

1960.25.6

Gift of Mrs. Dewees W. Dilworth

Porcelaneous stoneware; H. 3″, D. 7″

Wheel made of clay which fires to chocolate brown. Crackled and pitted blue gray Chün glaze.

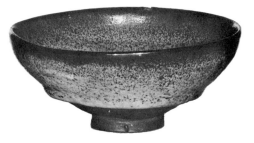

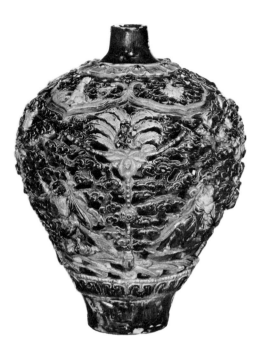

Origin: Chün ware, Honan province.

Date: Ming dynasty, fourteenth–fifteenth century.

Condition: Few small chips on lip.

326. Jar of hu shape

1955.4.53

Hobart and Edward Small Moore Memorial Collection; bequest of Mrs. William H. Moore

Stoneware; H. 14″, D. 10¼″

Mold made with inner jar and reticulated outer surface, which is decorated with cloud forms, animals, and birds. Appliqués of four equestrian figures and a single deity. Glazed in turquoise, deep blue, and white.

Date: Ming dynasty.

Condition: Small areas of glaze missing.

Many *san-ts'ai* pieces are attributed to the sixteenth century, and it is probable that the current piece eventually will be included among them.

327. Miniature jar

1949.285

Collection of Wayland Wells Williams, B.A. 1910; gift of Mrs. Frances Wayland Williams

Porcelain; H. 2″, D. 2¼″

Made of coarse whitish clay with a roughly fashioned foot. Outline of horses and clouds drawn in underglaze blue. All except footrim covered with transparent glaze of bluish tint.

Date: Ming dynasty, sixteenth century.

Condition: Few areas of cobalt painting have burned through to surface of glaze.

Provenance: Mathias Komor, New York, 1943.

A pair of small jars with similarly drawn horses is in the collection of Mrs. John M. Allison; see an exhibition catalogue of her collection displayed at International House, Tokyo, Jan. 26–27, 1957, no. 21.

328. Squat jar

1940.242

Bequest of Florence Baiz Van Volkenburgh in memory of her husband, Thomas Sedgwick Van Volkenburgh, B.A. 1866

Porcelain; H. 3¼″, D. 3¼″

Made of coarse porcelain which turns brown on exposure to kiln. Decorated with four panels, each containing a deer, both outline and wash rendered in underglaze blue. Thick, heavily crackled, transparent glaze, stained brown in some areas and in crackle.

Date: Ming dynasty, probably sixteenth–seventeenth century.

Condition: Some glaze imperfections on upper and lower rims.

Provenance: Charles A. Dana Collection; sold American Art Gallery, Feb. 24, 1898.

This piece was supposed to have been found in Java and bore an attribution to that area for some years. It is, in fact, one of the common types of late Ming export wares. To support this contention, one may note two pieces reportedly found in Bali, from the Von Plessen collection; see Der Preukischen Akademie der Künste, *Ausstellung Chinesischer Kunst,* no. 686–87. See also John A. Pope, "The Princessehof Museum in Leeuwarden," *ACASA, 5* (1951), 36, and Michael Sullivan, "Export Wares in Southeast Asia," *TOCS, 33,* pl. 47a.

329. Tea bowl

1949.286

Collection of Wayland Wells Williams, B.A. 1910; gift of Mrs. Frances Wayland Williams

Porcelain; H. 2″, D. 3½″

Thinly potted of fine-grained clay. Decorated in pale underglaze blue with a plum branch and ten characters of a poem. Thin neutral glaze covers all except footrim.

Inscription: The ten characters are the second half of a famous poem by Lu K'ai of the Six Dynasties period. A rough translation: "There are no important causes in Chiang-nan, so I press on you a single branch of spring."

Date: Ming dynasty, probably seventeenth century.

Condition: Few small glaze flaws from firing.

Provenance: Mathias Komor, New York, 1943.

This bowl is similar in many ways to numerous pieces of *kraakporselein* (sixteenth century blue and white export ware).

330. Bowl

1949.284

Collection of Wayland Wells Williams, B.A. 1910; gift of Mrs. Frances Wayland Williams

Porcelain; H. 2¼″, D. 4″

Made of sugary white porcelain. Design of fish and water plants painted in watery underglaze cobalt blue. Underbase bears interlocking lozenge design in similar blue. Covered except for footrim with a neutral, warm-toned glaze.

Date: Ming dynasty, perhaps seventeenth century.

Condition: Firing flaws on upper and lower rims; glaze stained, especially on interior.

Provenance: Mathias Komor, New York, 1943.

A series of five bowls of this shape, and with similar watery blue drawing, is to be found in the David Collection, University of London. They are, however, smaller in diameter and bear the mark of Ch'êng Hua; see Margaret Medley, *Illustrated Catalogue of Porcelains Decorated in Underglaze Blue and Copper Red in the Percival David Foundation of Chinese Art* (London, 1965), no. 602.

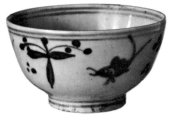

331. Vase of *mei-p'ing* type

1960.25.9

Gift of Mrs. Dewees W. Dilworth

Porcelaneous stoneware; H. 11¾", D. 6½"
Heavily potted of gray clay. Main design of
appliquéd flowers and leaves, with incised de-
sign of leaves below and waves above. Cov-
ered with a thick, glassy, green celadon glaze
of heavy crackle.

Origin: Chekiang province.

Date: Ming dynasty, probably sixteenth cen-
tury.

Condition: Complete.

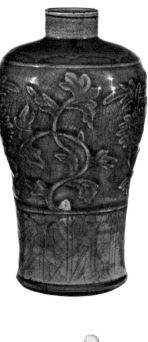

332. Covered bowl

1955.4.95

Hobart and Edward Small Moore Memorial
Collection; bequest of Mrs. William H. Moore

Porcelain; H. 5¾", D. 4½"

Wheel made of whitish clay with appliqués of
eight Taoist immortals, lion masks, and orna-
ments on body. Deity, perhaps Lao-tzǔ, sits in
full round on cover. Primarily glazed in yel-
low, with details in aubergine, green, and
white.

Date: Ming dynasty.

Condition: Large chip on upper rim.

Provenance: George R. Davies Collection;
purchased through Dreicer and Co., New
York, 1914.

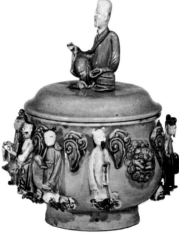

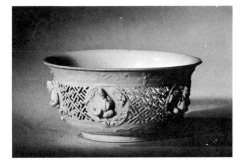

333. Bowl

1955.4.102

Hobart and Edward Small Moore Memorial
Collection; bequest of Mrs. William H. Moore

Porcelain; H. 2¼", D. 4⅝"

Made of fine-grained white clay. Five open
fret panels alternate with medallions, each
containing appliquéd figure of a sage. Bands
of floral and cloud forms painted in slip. All
covered with a thin neutral glaze.

Date: Ch'ing dynasty, seventeenth century.

Condition: Losses in fret pattern; small chips
on lip.

The rounded footrim and the freely written six
character Ch'êng Hua mark (in underglaze
blue on base) suggest a date slightly later than
Ming.

334. Figure of Ts'ao Kuo-chiu, Taoist immortal

1958.88.42

Gift of Dr. Yale Kneeland, Jr., B.A. 1922

Porcelain; H. 9½", W. 4"

Made in two-part mold of off-white Blanc de
Chine clay and covered with a clear glaze
which thickens into pools in deep crevices.
Ts'ao Kuo-chiu is wearing a court headdress
and official robes; his emblem, a pair of cas-
tanets, is held in his right hand.

Origin: Tê-hua ware, Fukien province.

Date: Ch'ing dynasty, eighteenth century or
earlier.

Condition: Many fine cracks and a deep split
on underside of figure where sections of two-
part mold originally joined.

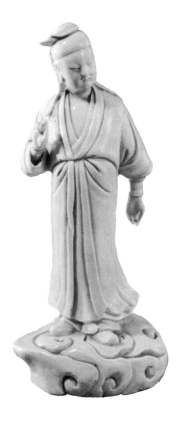

335. Kuan-yin

1956.42.12

Gift of Dr. Yale Kneeland, Jr., B.A. 1922

Porcelain; H. 9½″, D. 5⅞″

Made in two-part mold of off-white Blanc de Chine clay. Entirely covered except for base with a glaze which fires to a lustrous ivory hue.

Inscription: Potter's mark, probably that of Ho Chao-tsung (eighteenth century), impressed in seal characters on back of figure.

Origin: Tê-hua ware, Fukien province.

Date: Ch'ing dynasty, eighteenth century.

Condition: Several hairline cracks at front edge of robe, and another crack, more visible, in lap area.

For parallel pieces, see Cox, *The Book of Pottery and Porcelain, 1,* pl. 133, and Daisy Lion-Goldschmidt and Jean-Claude Moreau-Gobard, *Chinese Art* (New York, 1960), p. 344, pl. 153.

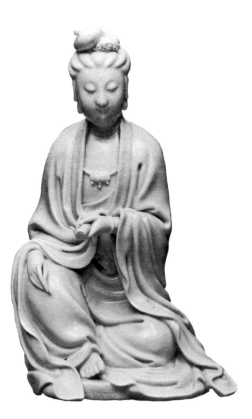

336. High-shouldered vase

1940.154

Gift of J. Watson Webb, B.A. 1907, and Electra Havemeyer Webb

Porcelaneous stoneware; H. 5⅞″, D. 2¾″

Made of fine, whitish porcelain. Wheel thrown in two sections and horizontally joined. Thin, warm-toned glaze crackled where directly exposed to firing.

Origin: Tung-ch'i (Dong-khe) ware, Fukien province.

Date: Ch'ing dynasty, probably K'ang Hsi reign.

Condition: Substantial chip on upper rim.

The strength of the shape, the crackle, and the glaze pitting under the base suggest a K'ang Hsi date.

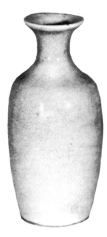

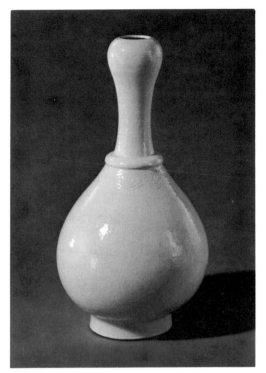

337. Bottle

1955.1.15

Hobart and Edward Small Moore Memorial Collection; gift of Mrs. William H. Moore

Stoneware; H. 8½" D. 4½"

Made of whitish stoneware. Carved and incised designs include three dragon medallions plus leaf and cloud forms. Exterior covered with a neutral glaze of creamy hue.

Date: Ch'ing dynasty, K'ang Hsi reign, eighteenth century.

Condition: Few small firing imperfections.

This piece appears to be an interesting continuation of Sung Ting ware with modified shape and different designs.

338. Reticulated bowl

1956.42.1

Gift of Dr. Yale Kneeland, Jr., B.A. 1922

Porcelain; H. 2⅜", D. 4½"

Made of fine-grained white clay with five delicately cut-out circular panels composed of radiating lines enclosing the ideographs for the Five Blessings *(wu fu)*. Lower body decorated with incised lines of basketwork pattern. Entirely covered with a bluish white glaze except for recessed foot and circular band below lip.

Origin: Ching-tê Chên kilns, Kiangsi province.

Date: Ch'ing dynasty, K'ang Hsi, eighteenth century.

Condition: Two fine cracks at lip from age.

A close parallel to this piece was in the Bushell Collection; see Cosmo Monkhouse, *A History and Description of Chinese Porcelain* (London, 1901), fig. 18 opp. p. 53.

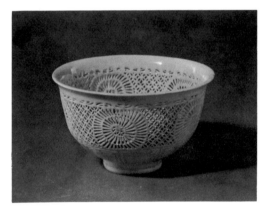

339. Vase

1957.41.1a,b

Gift of Dr. Yale Kneeland, Jr., B.A. 1922

Porcelain; H. 10¼″, D. 5½″

Made of fine-grained white porcelain. Main design of dragon in the clouds and wave design below molded and touched up with slip. Design band on shoulder of bats in clouds may be entirely slip painted. Neutral glaze covers exterior except base of footrim.

Date: Ch'ing dynasty, eighteenth century.

Condition: Horizontal firing crack near base plus small firing imperfections; chip on lower rim.

This piece has had a cover associated with it in the past. The cover fits well in design, fairly well in size, but matches badly in color.

340. Bowl

1956.42.2

Gift of Dr. Yale Kneeland, Jr., B.A. 1922

Porcelain; H. 2⅛″, D. 4½″

Made of fine eggshell porcelain, in a deep lotus shape with foliate rim and short foot. Slightly molded petals accented with thin vertical, incised lines on exterior. Covered except for narrow edge on foot with a brilliant, soft-textured, milk white glaze.

Inscription: Yung Chêng mark enclosed in two circles, six characters in blue, on bottom of bowl.

Origin: Ch'ing-tê Chên kilns, Kiangsi province.

Date: Ch'ing dynasty, Yung Chêng reign.

Condition: Tiny pinhole in bottom of bowl; several minute stains in glaze.

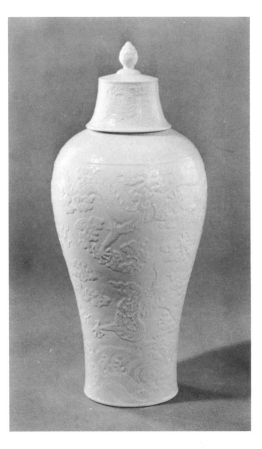

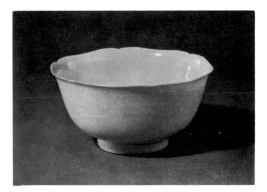

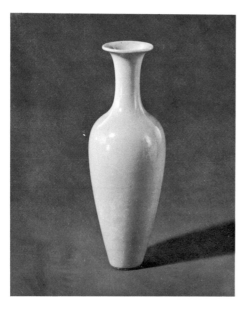

341. Small amphora vase

1954.48.5

Hobart and Edward Small Moore Memorial Collection; gift of Mrs. William H. Moore

Porcelain; H. 6¼″, D. 2¼″

Fine-grained porcelain covered with a monochrome clair de lune glaze. Underbase covered with a neutral glaze.

Inscription: Six character K'ang Hsi mark in underglaze blue on base.

Origin: Ching-tê Chên kilns, Kiangsi province.

Date: Ch'ing dynasty, K'ang Hsi reign.

Condition: Repair on lip.

Provenance: Prince Kung Collection, 1913. For parallel piece see Christensen, *Widener Collection,* p. 33.

342. Small jar

1954.48.6

Hobart and Edward Small Moore Memorial Collection; gift of Mrs. William H. Moore

Porcelain; H. 2¾″, D. 3¾″

Fine porcelain body uniformly covered with a monochrome blue clair de lune glaze. Foot glazed in white.

Inscription: Six character K'ang Hsi mark in underglaze blue on base.

Origin: Ching-tê Chên kilns, Kiangsi province.

Date: Ch'ing dynasty, K'ang Hsi reign.

Condition: Complete.

For a parallel piece see Christensen, *Widener Collection,* p. 33.

343. Water jar

1940.196

Bequest of Florence Baiz Van Volkenburgh in memory of her husband, Thomas Sedgwick Van Volkenburgh, B.A. 1866

Porcelain; H. 2″, D. 3½″

Made of fine-grained, whitish porcelain. Upper lip and footrim covered with wash of ferruginous slip glaze; interior with a pale green

glaze of brownish crackle. Exterior bears a crackled glaze of brilliant sapphire blue.

Origin: Ching-tê Chên kilns, Kiangsi province.

Date: Ch'ing dynasty, K'ang Hsi reign.

Condition: Complete.

344. Vase of mei-p'ing shape

1958.89.1

Gift of Winston F. C. Guest, B.A. 1927

Porcelain; H. 14½", D. 9½"

Massively made of grayish white porcelain. Exterior and underbase covered with a crackled sapphire blue glaze. Interior covered with a crackled, whitish glaze.

Date: Ch'ing dynasty, eighteenth century.

Condition: Complete.

Provenance: Edward I. Farmer Collection, New York; sold at Sotheby and Co., London, Nov. 20, 1936, lot no. 51.

Excellent color control manifest in the glaze handling.

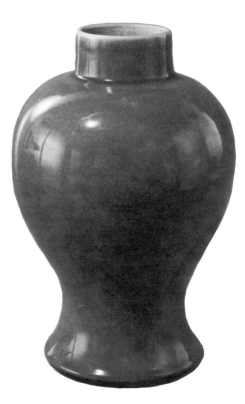

345. Bottle

1958.88.11

Gift of Dr. Yale Kneeland, Jr., B.A. 1922

Porcelain; H. 7½", D. 2¾"

Made of grayish white porcelain. Interior and underbase covered with a neutral glaze, while a monochrome glaze of sapphire blue covers exterior, stopping, with excellent control, just short of base of foot.

Origin: Ching-tê Chên kilns, Kiangsi province.

Date: Ch'ing dynasty, eighteenth century.

Condition: Few small surface imperfections in glaze.

For a bottle generally parallel in size and shape, see *International Exhibition* (London, 1935–36), no. 2590.

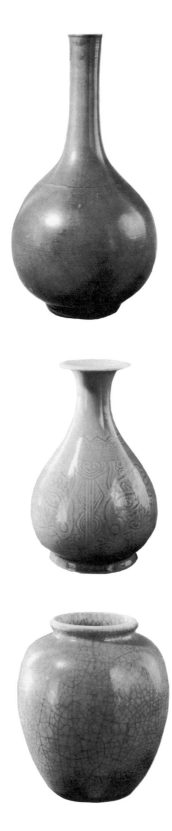

346. Bottle-shaped vase

1955.4.70
Hobart and Edward Small Moore Memorial Collection; bequest of Mrs. William H. Moore
Porcelain; H. 16½", D. 9½"
Made of fine white porcelain, with long neck thrown separately and added to body. Interior and underbase covered with neutral glaze. Remainder except footrim bears a high-fired monochrome green glaze.
Origin: Ching-tê Chên kilns, Kiangsi province.
Date: Ch'ing dynasty, K'ang Hsi reign.
Condition: Neck tilted during firing.
Provenance: Thomas B. Clarke, New York, 1903.

347. Vase

1955.4.87
Hobart and Edward Small Moore Memorial Collection; bequest of Mrs. William H. Moore
Porcelain; H. 11½", D. 7½"
Made of grayish white porcelain. Incised and cut underglaze designs: main design, twice repeated, may be fanciful rendering of a t'ao t'ieh. Exterior covered with a high-fired light green celadon glaze; interior and underbase covered with a neutral glaze.
Date: Ch'ing dynasty, eighteenth century.
Condition: Some small firing imperfections and later glaze wear.

348. Jar

1955.4.85
Hobart and Edward Small Moore Memorial Collection; bequest of Mrs. William H. Moore
Porcelain; H. 8¼", D. 7"
Made of grayish white porcelain. Exterior bears a crackled apple green glaze which, with fine control, stops just short of foot. Base covered with a wash of ferruginous slip glaze; interior probably covered with a thin wash of the same, and with a whitish glaze which shows brown crackle.

Origin: Ching-tê Chên kilns, Kiangsi province.
Date: Ch'ing dynasty, K'ang Hsi reign.
Condition: Complete.

349. High-shouldered vase

1959.18
Gift of Mrs. Howell H. Howard for the
Wilson P. Foss Collection
Porcelain; H. 16⅞", D. 6¼"
Made of fine-grained white porcelain. Interior
and underbase covered with a neutral glaze.
Remainder except footrim covered with a red
monochrome glaze of *sang de boeuf* family.
Glaze has not matured completely on one area
near footrim.
Origin: Ching-tê Chên kilns, Kiangsi province.
Date: Ch'ing dynasty, K'ang Hsi reign.
Condition: Complete.
For a slightly smaller piece, see "Ch'ing," no.
260, pl. 89.

350. Vase

1956.40.2
Gift of Wilson P. Foss, Jr., Ph.B. 1913
Porcelain; H. 19", D. 8¾"
Made of fine-grained white porcelain. Lower
part of interior and underbase covered with a
neutral glaze. Remainder except footrim cov-
ered with a monochrome red sang de boeuf
glaze.
Origin: Ching-tê Chên kilns, Kiangsi province.
Date: Ch'ing dynasty, K'ang Hsi reign.
Condition: Repair on lip.
Provenance: J. Pierpont Morgan Collection.

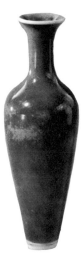

351. Amphora vase

1954.48.1a

Hobart and Edward Small Moore Memorial Collection; gift of Mrs. William H. Moore

Porcelain; H. 6¼″, D. 2″

Made of fine-grained porcelain and covered with a peach bloom glaze. Interior of neck shows a blending of green and ash-colored tones.

Inscription: Six character K'ang Hsi mark in underglaze blue on base.

Origin: Ching-tê Chên kilns, Kiangsi province.

Date: Ch'ing dynasty, K'ang Hsi reign.

Condition: Lower edge ground to accommodate stand; several small chips on lower edge.

Bibliography: Margaret T. J. Rowe, "The Moore Collections at Yale," *BAFAYU, 22,* no. 2 (1956), fig. 4.

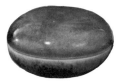

352. Covered box

1954.48.2a,b

Hobart and Edward Small Moore Memorial Collection; gift of Mrs. William H. Moore

Porcelain; H. 1⅜″, D. 2⅞″

Made of fine-grained white porcelain. Interior and underbase covered with neutral glaze. Exterior covered with a peach bloom glaze which has mostly oxidized, primarily green with a few patches of reduced red.

Inscription: Six character K'ang Hsi mark in underglaze blue on base.

Origin: Ching-tê Chên kilns, Kiangsi province.

Date: Ch'ing dynasty, K'ang Hsi reign.

Condition: Few chips on lower rim.

For a close parallel see "Ch'ing," no. 258, pl. 87.

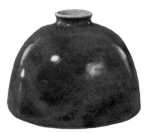

353. Brush washer

1958.88.24

Gift of Dr. Yale Kneeland, Jr., B.A. 1922

Porcelain; H. 3¼″, D. 4½″

Made of fine white porcelain with three dragon medallions incised on body. Covered with a

mottled peach bloom glaze which varies from lavender to deep rose. Interior and underbase covered with a glaze which is neutral or slightly bluish.

Inscription: Six character K'ang Hsi mark in underglaze blue on base.

Origin: Ching-tê Chên kilns, Kiangsi province.

Date: Ch'ing dynasty, K'ang Hsi reign.

Condition: White glazed areas slightly pinholed.

354. Brush washer

1958.88.25

Gift of Dr. Yale Kneeland, Jr., B.A. 1922

Porcelain; H. 3½″, D. 4¼″

Made of fine white porcelain with three dragon medallions incised on body. Covered with an even-toned peach bloom glaze, but white shows through on lip and at footrim. Interior and underbase covered with a neutral glaze.

Inscription: Six character K'ang Hsi mark in underglaze blue on base.

Origin: Ching-tê Chên kilns, Kiangsi province.

Date: Ch'ing dynasty, K'ang Hsi reign.

Condition: White glazed areas slightly pinholed.

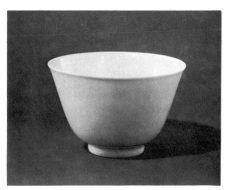

355. Bell-shaped bowl

1955.4.48

Hobart and Edward Small Moore Memorial Collection; bequest of Mrs. William H. Moore

Porcelain; H. 2½″, D. 4¼″

Made of semitranslucent porcelain. Exterior covered with an opaque, lemon yellow glaze. Interior covered with a pure white glaze.

Inscription: Six character Yung Chêng mark in blue enclosed in two rings on bottom of foot.

Origin: Ching-tê Chên kilns, Kiangsi province.

Date: Ch'ing dynasty, Yung Chêng reign.

Condition: Fine crack running down from rim.

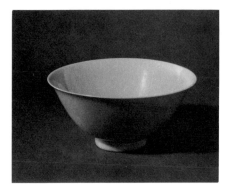

356. Bowl

1958.88.35

Gift of Dr. Yale Kneeland, Jr., B.A. 1922

Porcelain; H. 2¼", D. 5⅜"

Thinly made of fine porcelain. A monochrome yellow glaze, tending toward brown, covers exterior, stopping just short of base. Interior and underbase covered with neutral glaze.

Inscription: Six character Yung Chêng mark in underglaze blue on base.

Origin: Ching-tê Chên kilns, Kiangsi province.

Date: Ch'ing dynasty, Yung Chêng reign.

Condition: Few minute firing imperfections.

357. Vase

1955.4.142

Hobart and Edward Small Moore Memorial Collection; bequest of Mrs. William H. Moore

Porcelain; H. 5⅛", D. 2¾"

Wheel made of grayish white clay with well-turned lip and footrim. Design of so-called tiger lily pattern painted in underglaze blue. Glaze is neutral, and cobalt fires to a sapphire blue.

Inscription: Double circle and leaf in underglaze blue on base.

Origin: Ching-tê Chên kilns, Kiangsi province.

Date: Ch'ing dynasty, K'ang Hsi reign.

Condition: Has nonmatching cover.

Provenance: Richard Bennett Collection; purchased Dreicer, New York, 1915.

Bibliography: Osgood, *Blue-and-White Chinese Porcelain,* pl. 34.

A pair of larger vases, but similar in form and design, is in the collection of the Victoria and Albert Museum; see W. B. Honey, *Guide to the Later Chinese Porcelain Periods of K'ang Hsi, Yung Chêng and Ch'ien Lung,* pl. 25A.

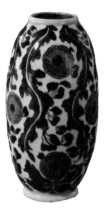

358. Vase

1940.208a

Bequest of Florence Baiz Van Volkenburgh in memory of her husband, Thomas Sedgwick Van Volkenburgh, B.A. 1866

Porcelain; H. 17¾″, D. 6¾″

Wheel made of grayish white porcelain. Exterior decorated with figures in a landscape in underglaze sapphire blue. Entirely covered except base of footrim with a neutral glaze.

Origin: Ching-tê Chên kilns, Kiangsi province.

Date: Ch'ing dynasty, K'ang Hsi reign.

Condition: Few small firing flaws.

359. Vase

1940.208b

Bequest of Florence Baiz Van Volkenburgh in memory of her husband, Thomas Sedgwick Van Volkenburgh, B.A. 1866

Porcelain; H. 17½″, D. 6¾″

Wheel made of fine-grained white clay. Exterior decorated with landscape with deer and cranes in underglaze sapphire blue. Entirely covered except base of footrim with thick neutral glaze.

Origin: Ching-tê Chên kilns, Kiangsi province.

Date: Ch'ing dynasty, K'ang Hsi reign.

Condition: Crack on lip plus a few other minor firing flaws.

For a close parallel piece, see Honey, *Guide,* p. 34, pl. 29.

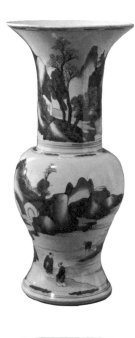

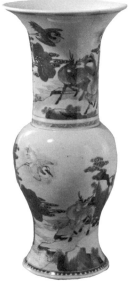

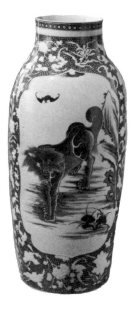

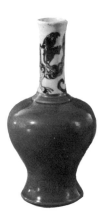

360. Vase

1955.4.74
Hobart and Edward Small Moore Memorial Collection; bequest of Mrs. William H. Moore
Porcelain with steatite; H. 16½″, D. 7″
Made of steatitic porcelain, thrown in two sections and joined horizontally. Molded and incised design of bats and flowers against a blue ring-matted background. Two large quatrefoil lozenges filled with lion dogs (or temple dogs), rocks, foliage, and bats in underglaze blue. Mainly covered with a neutral glaze.
Date: Ch'ing dynasty, eighteenth century.
Condition: Complete.

361. Long-necked vase

1958.88.16
Gift of Dr. Yale Kneeland, Jr., B.A. 1922
Porcelain; H. 8″, D. 3¾″
Made of fine-grained porcelain with two bands of incised design on body, which is covered with blue glaze. Neck bears a dragon design in underglaze blue and red beneath neutral glaze. A band of brown at base of neck.
Origin: Ching-tê Chên kilns, Kiangsi province.
Date: Ch'ing dynasty, K'ang Hsi reign.
Condition: Small chip on upper rim.

A larger vase with generally similar decorative components is in the collection of Mr. G. de Menasce; see "Ch'ing," no. 101, pl. 38.

362. Wide-mouthed jar

1954.49.35
Hobart and Edward Small Moore Memorial Collection; gift of Mrs. William H. Moore
Porcelain; H. 6⅞″, D. 7¾″
Sturdily potted of white porcelain. Interior covered with a neutral glaze. Exterior decorated with enamels on the biscuit: Buddhist eight precious things in emerald and leaf greens, pale turquoise, yellows, and white against a wave pattern in aubergine.

Origin: Ching-tê Chên kilns, Kiangsi province.

Date: Ch'ing dynasty, seventeenth century.

Condition: Two holes high on each shoulder; crack on neck.

Provenance: Larkin, New York, 1904.

This design was known in late Ming. The freedom with which it is here applied, plus the vigor of shape, suggests a date perhaps pre-K'ang Hsi. A similar piece is illustrated by Hobson, *Chinese Pottery and Porcelain, 2,* fig. 3 opp. p. 80.

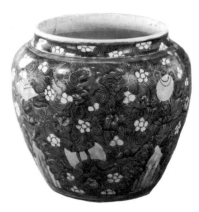

363. Quadrilateral vase

1954.36.2

Gift of Wilson P. Foss, Jr., Ph.B. 1913

Porcelain; H. 20″, W. 5¾″

Made of grayish white porcelain. Interior of neck and part of underbase covered with neutral glaze. Exterior decorated with enamels on biscuit: the panels include prunus (winter), lotus with cranes (spring), camellias and rocks (summer), and chrysanthemums (fall) in black outlines and several shades of green, yellow, aubergine, and white against a green background.

Inscription: Six character Ch'êng Hua mark in underglaze blue on base.

Origin: Ching-tê Chên kilns, Kiangsi province.

Date: Ch'ing dynasty, K'ang Hsi reign.

Condition: Two cracks on neck, small repairs on two vertical edges.

A piece, formerly shown anonymously, matches the Yale vase in size, shape, background, color, and design; see *International Exhibition* (London, 1935–36), no. 1681.

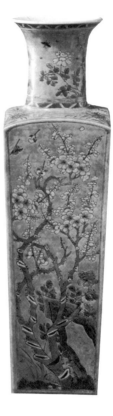

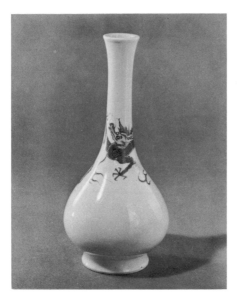

364. Long-necked vase

1954.49.52

Hobart and Edward Small Moore Memorial Collection; gift of Mrs. William H. Moore

Porcelain; H. 9″, D. 4⅜″

Made of fine porcelain clay and entirely covered except for footrim with a neutral glaze. Design of a five-clawed dragon chasing a flaming pearl is painted in deep coral red enamel.

Origin: Ching-tê Chên kilns, Kiangsi province.

Date: Ch'ing dynasty, K'ang Hsi reign.

Condition: Complete.

Provenance: Yamanaka, New York, 1917.

365. Five-piece garniture (two shown)

1955.4.92a–e

Hobart and Edward Small Moore Memorial Collection; bequest of Mrs. William H. Moore

Porcelain; H. 6¼″, D. 4½″

Three pear-shaped bottles and two ovoid jars with dome covers. Fine, white body clay decorated with famille verte enamels. Four panels, outlined in rust red, filled with flowering plants in green, rust red, pale yellow, and aubergine.

Inscription: Double blue ring on base of all five.

Origin: Ching-tê Chên kilns, Kiangsi province.

Date: Ch'ing dynasty, K'ang Hsi reign.

Condition: Repair on lip and two cracks on base of 1955.4.92c.

Provenance: Parish-Watson, New York, 1918.

These five pieces, made for export, bear a close family resemblance, but when examined closely, differences in proportion, design, and color become noticeable. For a close parallel in decoration, however, see a tankard in the collection of Anthony De Rothschild, illustrated in R. L. Hobson, *The Later Ceramic Wares of China* (London, 1925), pl. 44, fig. 2.

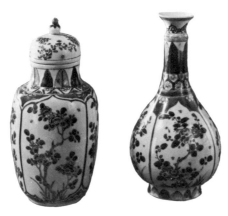

366. Temple jar

1952.14.1a

Gift of Mrs. Mellon Bruce

Porcelain; H. (with cover) 24¼″, D. 10″

Made of whitish porcelain, covered with neutral glaze except for foot and base, and decorated with birds, flowers, rocks, and patterns in full palette of famille rose enamels.

Origin: Ching-tê Chên kilns, Kiangsi province.

Date: Ch'ing dynasty, Yung Chêng reign.

Condition: Crack on lower body; cover damaged; few enamel imperfections.

Provenance: Parish-Watson, New York, 1920.

A similar piece is illustrated in Soames Jenyns, *Later Chinese Porcelains,* pl. 53, from the collection of John Morrison.

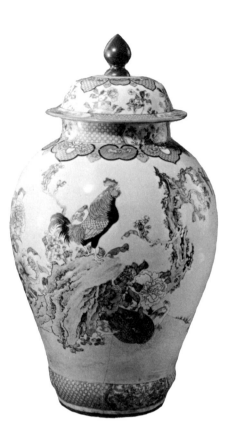

367. Dish

1928.235.9

S. Wells Williams Collection; bequest of F. Wells Williams, B.A. 1879

Porcelain; H. 1⅝″, D. 8″

Made of fine white porcelain, entirely covered with a neutral glaze except for part of footrim. Design of deer, trees, grasses, and rocks outlined in underglaze blue and filled in with overglaze enamels of greens, red, yellow, and aubergine.

Inscription: Six character Ch'êng Hua mark in underglaze blue on base.

Origin: Ching-tê Chên kilns, Kiangsi province.

Date: Ch'ing dynasty, eighteenth century.

Condition: Few small firing flaws on upper rim.

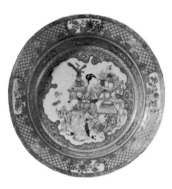

368. Plate

1955.1.22

Hobart and Edward Small Moore Memorial Collection; gift of Mrs. William H. Moore

Porcelain; H. 1¼″, D. 8¼″

Made of eggshell porcelain and decorated in Canton enamels. Ruby backed with domestic scene in the center against a gold background with pink flowers and curling vines.

Origin: Ching-tê Chên kilns, Kiangsi province; enamels applied in Canton.

Date: Ch'ing dynasty, eighteenth century, probably Yung Chêng reign.

Condition: Slight enamel losses on front.

Provenance: Trapnell Collection.

See Hobson, *Chinese Pottery and Porcelain, 2,* pl. 119, fig. 1 (British Museum). The probable attribution of the Yale piece to the Yung Chêng period is based on this dated piece. Other parallels are in: Honey, *Guide,* pl. 88 (Salting Collection); Trubner, *Chinese Ceramics,* pl. 334, p. 110 (Lent by Li Ch'ing-wa, San Francisco); Lady David, *Illustrated Catalogue of Ch'ing Enamelled Wares,* A 811.

369. Vase

1955.4.58

Hobart and Edward Small Moore Memorial Collection; bequest of Mrs. William H. Moore

Porcelain; H. 30½″, D. 8″

Made of whitish porcelain in three sections, horizontally joined: Interior and underbase covered with a neutral glaze. Exterior decorated with blown cobalt ("powder blue") and covered with a neutral glaze. A design of tree peonies and rocks is painted in overglaze gold and low fired.

Origin: Ching-tê Chên kilns, Kiangsi province.

Date: Ch'ing dynasty, K'ang Hsi reign.

Condition: Slight wearing of gold in some areas.

Provenance: Ton-ying, New York, 1919.

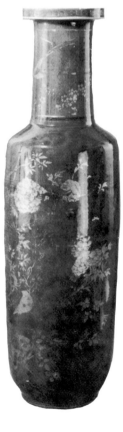

370. Club-shaped vase

1955.4.69

Hobart and Edward Small Moore Memorial Collection; bequest of Mrs. William H. Moore

Porcelain; H. 18″, D. 7″

Sturdily made of whitish porcelain. Interior and underbase covered with a neutral glaze. Exterior bears layered glaze known as mirror black. Design in overglaze gold of large panels of dragons and small panels of flowers and poetry against an over-all floral pattern.

Origin: Ching-tê Chên kilns, Kiangsi province.

Date: Ch'ing dynasty, K'ang Hsi reign.

Condition: Small areas of gilt design worn away.

Provenance: Rufus E. Moore, New York, 1906.

A piece similar in size, shape, and technique, but different in decoration, is in the Seattle Art Museum; see Trubner, *Chinese Ceramics,* no. 359.

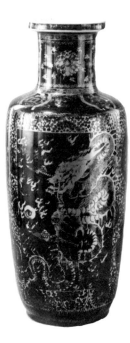

371. Vase

1955.4.71

Hobart and Edward Small Moore Memorial Collection; bequest of Mrs. William H. Moore

Porcelain; H. 10½″, D. 4¼″

Made of fine-grained white clay, covered with a heavy mirror black glaze which stops short of base line. Interior and recessed foot covered with transparent glaze. Tracings on body from now-missing gilt designs depict lotus rising from water, with four medallions around collar, each filled with Buddhist happy omen *(pa-chi-hsiang)*.

Origin: Ching-tê Chên kilns, Kiangsi province.

Date: Ch'ing dynasty, probably K'ang Hsi reign, eighteenth century.

Condition: Small scratches in black glaze; white areas slightly pinholed.

Provenance: Thomas B. Clarke, New York, 1910.

372. Gourd-shaped vase

1956.42.8
Gift of Dr. Yale Kneeland, Jr., B.A. 1922
Porcelain; H. 7¾", D. 4⅛"
Made of fine white porcelain and covered with a dense mirror black glaze which pales to brown below white mouth rim. Interior and recessed foot covered with a transparent glaze.
Origin: Ching-tê Chên kilns, Kiangsi province.
Date: Ch'ing dynasty, K'ang Hsi reign, eighteenth century.
Condition: Few firing imperfections in glaze; hairline crack at mouth.
Provenance: J. Pierpont Morgan Collection.
Bibliography: Morgan, *Morgan Collection, 2,* no. 1411, p. 95.

373. Vase

1960.25.8
Gift of Mrs. Dewees W. Dilworth
Porcelain; H. 8", D. 4½"
Made of grayish white clay. Covered with a mirror black glaze, the edges of which are brown. Inside of mouth and recessed foot covered with a transparent glaze.
Origin: Ching-tê Chên kilns, Kiangsi province.
Date: Ch'ing dynasty, eighteenth century.
Condition: Footrim ground; few firing imperfections in glaze.

374. Vase

1958.88.13
Gift of Dr. Yale Kneeland, Jr., B.A. 1922
Porcelain; H. 4¾", D. 3"
Made of gray white clay and covered with "Kuan yao" glaze of pale blue green, irregularly crackled with brown. Footrim dressed with ferruginous clay.
Origin: Ching-tê Chên kilns, Kiangsi province.
Date: Ch'ing dynasty, K'ang Hsi reign or later, eighteenth century.
Condition: Complete.
This piece seems to be a deliberate imitation of the famous Sung kuan ware.

375. Bottle vase

1956.42.9a

Gift of Dr. Yale Kneeland, Jr., B.A. 1922

Porcelain; H. 5⅝″, D. 4″

Pure white porcelain uniformly covered with a delicate pearl gray glaze. Neutral glaze covers interior and inner part of lip.

Inscription: Six character Ch'ien Lung mark in seal characters in underglaze blue on base.

Origin: Ching-tê Chên kilns, Kiangsi province.

Date: Ch'ing dynasty, Ch'ien Lung reign.

Condition: Tiny stain, small chip, and slight scratching in glaze; evidence of grinding on feet.

Provenance: Emil Baerwald Collection, Berlin.

Exhibition: Chinesische Kunst, Berlin, 1929, no. 858.

Bibliography: Schmidt, *Chinesische Keramik,* pl. 103A.

376. Bottle vase

1956.42.9b

Gift of Dr. Yale Kneeland, Jr. B.A. 1922

Porcelain; H. 5½″, D. 3⅞″

Pure white porcelain uniformly covered with a delicate pearl gray glaze. Neutral glaze covers interior and inner part of lip.

Inscription: Ch'ien Lung mark, six seal characters, in blue on base.

Origin: Ching-tê Chên kilns, Kiangsi province.

Date: Ch'ing dynasty, Ch'ien Lung reign.

Condition: Small dark stain on onion-top; evidence of grinding and wear on feet.

Provenance: Emil Baerwald Collection, Berlin.

Exhibition: Chinesische Kunst, Berlin, 1929, no. 858.

Nos. 375–76 are similar in terms of size, shape, and color. Close examination, however, brings out some differences: 375 is slightly taller and broader than 376, and grayer in tone, 376 being of a bluer shade.

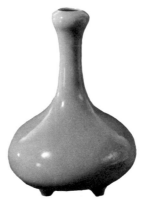

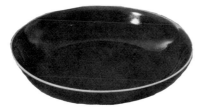

377. Dish

1928.190

S. Wells Williams Collection; bequest of F. Wells Williams, B.A. 1879

Porcelain; H. 1¾″, D. 8¼″

Sturdily potted of grayish white porcelain. Underbase covered with neutral glaze. Remainder, except footrim, glazed in monochrome sang de boeuf red. Glaze thins, showing bands of white at upper lip and edge of footrim.

Inscription: Six character mark of Ch'ien Lung in underglaze blue, written in seal characters.

Origin: Ching-tê Chên kilns, Kiangsi province.

Date: Ch'ing dynasty, Ch'ien Lung reign.

Condition: Complete.

378. Vase of ku shape

1955.44.16

Gift of Mrs. C. Sanford Bull

Porcelain; H. 10⅝″, D. 7″

Made of fine-grained, grayish white porcelain, molded with four projecting ridges on lower part of body. Wash of dark clay on footrim. Remainder covered with a thick "tea dust" green glaze.

Inscription: Six character mark of Ch'ien Lung stamped in seal characters on base beneath wash of glaze.

Origin: Ching-tê Chên kilns, Kiangsi province.

Date: Ch'ing dynasty, Ch'ien Lung reign.

Condition: Complete.

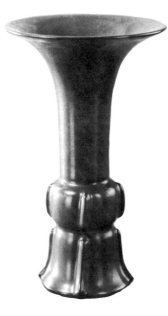

379. Vase of mei-p'ing shape

1954.49.36

Hobart and Edward Small Moore Memorial
Collection; gift of Mrs. William H. Moore

Porcelain; H. 12½″, D. 8¾″

Whitish porcelain, made in two sections and
joined horizontally. Interior and underbase
covered with neutral glaze; exterior with var-
iegated green brown "tea dust" green glaze.

Inscription: Six character mark of Ch'ien Lung
in seal characters in underglaze cobalt blue on
base.

Origin: Ching-tê Chên kilns, Kiangsi province.

Date: Ch'ing dynasty, Ch'ien Lung reign.

Condition: Complete.

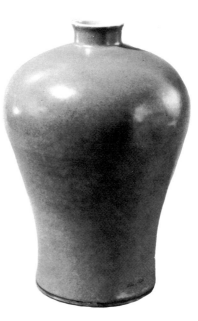

380. Vase

1955.4.83

Hobart and Edward Small Moore Memorial
Collection; bequest of Mrs. William H. Moore

Porcelain; H. 9⅜″, D. 5½″

Made of gray porcelain, entirely covered ex-
cept for footrim with a lightly crackled, tur-
quoise blue glaze.

Inscription: Six character Ch'ien Lung mark
in seal characters incised.

Origin: Ching-tê Chên kilns, Kiangsi province.

Date: Ch'ing dynasty, Ch'ien Lung reign.

Condition: Some imperfections of glaze surface
near footrim.

Provenance: Thomas B. Clarke, New York.

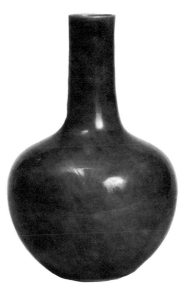

381. Stemcup

1958.88.31

Gift of Dr. Yale Kneeland, Jr., B.A. 1922

Porcelain; H. 3⅞″, D. 5¾″

Made of thin, semieggshell porcelain, deco-
rated with an incised design of lotus blossoms
and leaf scrolls. Covered with a clear glaze of
greenish tint, which deepens in tone over in-
cised lines.

Inscription: Incised six character Ch'ien Lung
mark enclosed in a medallion in the center of
the bowl.

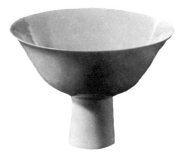

Origin: Ching-tê Chên kilns, Kiangsi province.
Date: Ch'ing dynasty, Ch'ien Lung reign.
Condition: Two fine cracks running down from lip.

For a parallel piece, see Hobson, *Eumo. Cat.,* 5, E 352, pl. 60 (Hsüan Tê mark, Ch'ien Lung period).

382. Bowl

1928.209
S. Wells Williams Collection; bequest of F. Wells Williams, B.A. 1879
Porcelain; H. 1⅞″, D. 4¼″

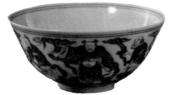

Whitish porcelain body decorated in underglaze blue and covered with a transparent glaze. In center of bowl is the Taoist triad: Shou-hsing, Lu-hsing, and Fu-hsing. Around outside are the eight Taoist immortals.

Inscription: Six character Tao Kuang mark in seal characters in underglaze blue on base.
Origin: Ching-tê Chên kilns, Kiangsi province.
Date: Ch'ing dynasty, Tao Kuang reign.
Condition: Complete.

383. Dish

1928.235.15
S. Wells Williams Collection; bequest of F. Wells Williams, B.A. 1879
Porcelain; H. 1½″, D. 6¾″

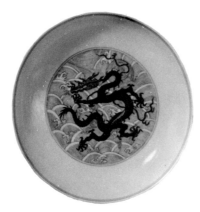

Made of whitish porcelain clay. Interior decorated with an iron red overglaze-enameled dragon in underglaze blue waves; outside decorated with nine red dragons with blue claws in blue waves done in the same manner. Neutral glaze.

Inscription: Ch'ien Lung mark in six seal characters in blue on base.
Origin: Ching-tê Chên kilns, Kiangsi province.
Date: Ch'ing dynasty, Ch'ien Lung reign.
Condition: Complete.

For a parallel piece, see Schmidt, *Chinesische Keramik,* pl. 126d.

384. Ginger jar (one of a pair)

1958.88.23a
Gift of Dr. Yale Kneeland, Jr., B.A. 1922
Porcelain; H. 7½″, D. 6¾″

Made of grayish white porcelain, entirely covered except for base of footrim with a neutral glaze. Main design of dragons chasing flaming pearls is executed in underglaze blue and overglaze green enamel.

Inscription: Six character Ch'ien Lung mark in seal characters in underglaze blue on base.

Origin: Ching-tê Chên kilns, Kiangsi province.

Date: Ch'ing dynasty, probably late Ch'ien Lung reign.

Condition: A firing flaw on shoulder of jar.

For another jar, generally like nos. 384–85, see Jenyns, *Later Chinese Porcelain,* pl. 91. Also, see commentary for no. 385.

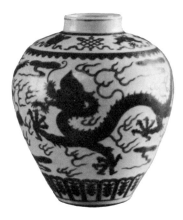

385. Ginger jar (one of a pair)

1958.88.23b
Gift of Dr. Yale Kneeland, Jr., B.A. 1922
Porcelain; H. 7½″, D. 7″

Same as no. 384.

Inscription: Six character Ch'ien Lung mark in seal characters in underglaze blue on base.

Origin: Ching-tê Chên kilns, Kiangsi province.

Date: Ch'ing dynasty, Ch'ien Lung reign.

Condition: Chip on lip and crack on neck.

While theoretically a pair, no. 385 differs sharply from no. 384 in shape and design, drawing, and execution. On all accounts, no. 385 is superior to no. 384. The form of no. 385 is far better balanced, and the dragon designs are better drawn and more successfully spaced. The enamel green is deeper in hue and more evenly applied than on no. 384. Also, see commentary of no. 384.

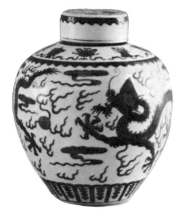

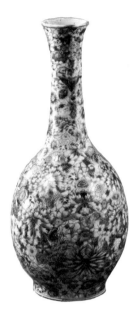

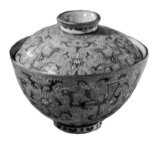

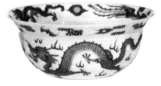

386. Vase

1955.1.13

Hobart and Edward Small Moore Memorial Collection; gift of Mrs. William H. Moore

Porcelain; H. 9½″, D. 4½″

Made of fine-grained white clay. Neutral glaze on exterior, turquoise glaze on neck interior and underbase. Exterior decorated with *mille fleurs* pattern in a profusion of enamels.

Inscription: Six character Ch'ien Lung mark in overglaze enamel on base.

Origin: Ching-tê Chên kilns, Kiangsi province.

Date: Ch'ing dynasty, Ch'ien Lung reign.

Condition: Complete.

387. Covered bowl (one of a pair)

1958.88.36a

Gift of Dr. Yale Kneeland, Jr., B.A. 1922

Porcelain; H. (incl. cover) 3¼″, D. 4¼″

Made of fine white porcelain. Design of dragons and lotus in overglaze enamels of many hues against a rose graviata background. Interior, interior of cover, and underbase covered with a blue glaze.

Inscription: Six seal character mark of Ch'ien Lung in overglaze red on cover and base.

Origin: Ching-tê Chên kilns, Kiangsi province.

Date: Ch'ing dynasty, Ch'ien Lung reign.

Condition: Complete.

388. Bowl (one of a pair)

1928.200

S. Wells Williams Collection; bequest of F. Wells Williams, B.A. 1879

Porcelain; H. 1¾″, D. 4½″

Made of eggshell porcelain entirely covered except for small lower rim by a neutral glaze. Decorated with painted dragons and phoenixes in translucent red enamel and flowers on interior in opaque white enamel.

Inscription: Inscription in red on base: *Chia Ch'ing wu wu shih ching t'ang chih* (The *wu wu* year of the Chia Ch'ing period [1798] made for the Hall of Respectful Matters).

Origin: Ching-tê Chên kilns, Kiangsi province.

Date: Ch'ing dynasty, Chia Ch'ing reign, dated in accordance with 1798.

Condition: Small firing flaws; repair on upper rim.

See commentary for no. 52.

389. Peking bowl (one of a pair)

1928.220

S. Wells Williams Collection; bequest of F. Wells Williams, B.A. 1879

Porcelain; H. 2⅝", D. 5⅞"

Made of whitish porcelain and covered with neutral glaze. Decorated in overglaze famille rose enamels on exterior and underglaze blue on interior. Exterior design of four medallions reserved on a field of pink graviata ground over which are groupings of stylized flowers.

Inscription: Six character Tao Kuang mark in seal characters in underglaze blue on base.

Origin: Ching-tê Chên kilns, Kiangsi province.

Date: Ch'ing dynasty, Tao Kuang reign.

Condition: Complete.

Bibliography: L. R., "Williams Collection," *BAFAYU, 3, 9.*

For a parallel piece, see Daisy Lion-Goldschmidt, *Les Poteries et Porcelaines Chinoises* (Paris, 1957), pl. 28(d), from the Musée Guimet, Collection Grandidier, no. 1391.

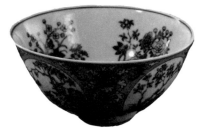

390. Bowl

1928.216

S. Wells Williams Collection; bequest of F. Wells Williams, B.A. 1879

Porcelain; H. 2¼", D. 4½"

Eggshell porcelain covered with neutral glaze, except footrim, with design of fruiting tree painted in red, brown, blue, and green enamels.

Inscription: Six character mark of Tao Kuang in seal characters in overglaze red on base.

Date: Ch'ing dynasty, Tao Kuang reign.

Condition: Complete.

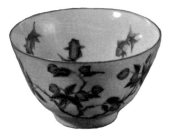

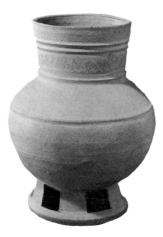

391. Pedestaled jar

1968.27
Gift of Mr. and Mrs. Cho Duck-whan
Earthenware; H. 8″
Made of coarse gray clay, decorated with ridge around shoulder and band of lightly combed zigzag pattern between ridges around neck.
Origin: Talsong type, Silla area, Korea.
Date: Three Kingdoms period, fifth–sixth century.
Condition: Complete.
General parallel piece in *Hoyt Memorial,* no. 570. Precise parallels for all shape and design elements will be found on one of two hus in the collection of the Tenri Museum; see *STZ, 13,* 209, fig. 64. nos. 4, 9.

392. Cup stand

1954.49.57
Hobart and Edward Small Moore Memorial Collection; gift of Mrs. William H. Moore
Porcelaneous stoneware; H. 1½″, D. 5½″
Fashioned of gray clay into ten lobes on rim, parallel lobing and scalloping on base. Cut lotus leaves around pedestal; center contains an incised chrysanthemum design. Other incised designs include waves in the depression, chrysanthemums on the rim lobes, and floral patterns on the base lobes. All covered with a crackled gray green glaze. Fired on three spurs.
Origin: Korea.
Date: Koryō dynasty, twelfth century.
Condition: Complete:
A generally similar stand (with cup), but divided into eight lobes, belongs to the National Museum of Korea; see Kim Chewon and G. St. G. M. Gompertz, *The Ceramic Art of Korea* (New York, 1961), pl. 26.

393. Globular jar

1949.276
Collection of Wayland Wells Williams, B.A.
1910; gift of Mrs. Frances Wayland Williams
Porcelain; H. 3″, D. 3¾″

Made of coarse porcelain which fires buff on exposure to kiln. Main body of design consists of flowers and floral scrolls boldly painted in underglaze blue. Neutral glaze covers body except for footrim and underbase, producing a dense, milky white surface.

Origin: Annam.

Date: Fifteenth century.

Condition: Small chip on lip; minute glaze flaws.

Provenance: Mathias Komor, New York, 1942.

This piece is reported to have been found on the island of Java. Stylistically it fits current concepts of Annamese ware. For a summary of the knowledge about such ware, see John A. Pope, *Chinese Porcelains from the Ardebil Shrine,* pp. 103–04.

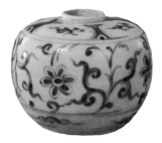

394. Vase

1951.10.14
Gift of Mrs. Charles J. Morse in honor of Charles J. Morse, Ph.B. 1874 and Jared K. Morse, Ph.B. 1908
Stoneware; H. 9½″

Roughly wheel made of chocolate brown clay with finished foot, slightly ribbed surface, and irregularities in upper body, neck, and lip. Several glazes applied: first a patch of white glaze, then large, irregular areas of blue black, then daubs of thick white, which run with the blue black, all under a transparent glaze which stops irregularly short of base.

Origin: Chōsengaratsu, Korean type *Karatsu* ware, Saga and Nagasaki prefectures, Japan.

Date: Momoyama period, perhaps seventeenth century.

Condition: Lip shattered, repaired with original fragments.

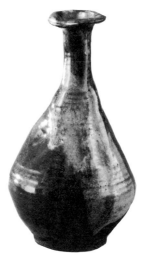

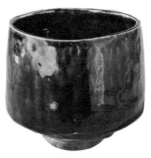

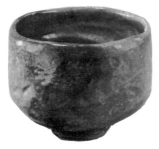

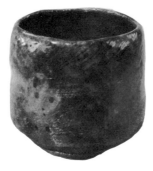

395. Tea bowl

1951.51.40
Gift of Mrs. William H. Moore
Stoneware; H. 3½", D. 4"
Wheel made of light gray clay and then given irregular footrim and sides. Covered with thin dark brown glaze, turning amber where thinnest and stopping irregularly well short of base.

Inscription: Sei, mark of first generation *Rokubei* ware potter, Kiyomizu Rokubei, impressed near footrim.

Origin: Kyoto, Japan.

Date: Edo period, mid-eighteenth century.

Condition: Complete.

396. Tea bowl

1951.51.47
Gift of Mrs. William H. Moore.
Stoneware; H. 3", D. 4½"
Made by hand of white clay which turns brown on exposure to kiln, with irregularities of rim, surface, foot, and shape. Covered with brushed on salmon ochre slip of varying shades, spotted with two areas of greenish black slip on exterior, all under a thin, transparent, crackled lead glaze, the crackle more evident on interior. Slip and glaze stop irregularly short of base.

Inscription: Mark of ninth generation *Raku* potter, Riyōnyū (1756–1834), impressed near footrim.

Origin: Kyoto, Japan.

Date: Edo period, late eighteenth century.

Condition: Complete.

397. Tea bowl

1951.10.5
Gift of Mrs. Charles J. Morse in honor of Charles J. Morse, Ph.B. 1874 and Jared K. Morse, Ph.B. 1908
Stoneware; H. 3¾", D. 3⅞"

Hand made of buff clay, with aid of spatula, showing the usual irregularities of Raku ware. Covered with brushed on salmon red ochre slip, the body occasionally showing through; interior and exterior spotted with large areas of variegated black green slip, all under a thin, transparent, crackled lead glaze. Footrim partially slipped and glazed.

Inscription: Mark of eleventh generation Raku potter, Keinyū (1817–1902), impressed on inside; mark of twelfth generation Raku potter, Kōnyū (1857–1932), impressed near footrim.

Origin: Kyoto, Japan.

Date: Meiji period, probably 1880s.

Condition: Complete.

This is probably an apprentice piece because of two generations' marks.

398. Tea bowl

1951.51.41
Gift of Mrs. William H. Moore
Stoneware; H. 3″, D. 4⅜″

Wheel made of brown clay with a finished footrim and the sides somewhat regularly indented. Covered with purplish red brown slip glaze and irregularly dappled with thick ochre glaze which did not run in firing. Glaze stops short of base.

Inscription: *Shidoro* mark impressed in base.

Origin: Shidoro ware, Shizuoka prefecture, Japan.

Date: Edo period, ninteenth century.

Condition: Break in rim repaired.

399. Bottle vase

1951.51.49
Gift of Mrs. William H. Moore
Stoneware; H. 9″

Made of buff clay, incised with rings around neck, shoulder, and mid-body; incised band of V-shaped pattern on upper body. Covered to footrim with dark molasses-colored glaze.

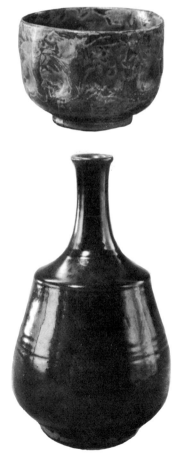

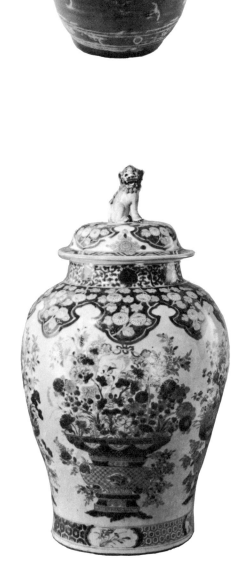

Origin: Bizen ware, Okayama prefecture, Japan.

Date: Edo period, nineteenth century.

Condition: Small firing crack in footrim.

400. Bowl

1951.10.8

Gift of Mrs. Charles J. Morse in honor of Charles J. Morse, Ph.B. 1874 and Jared K. Morse, Ph.B. 1908

H. 4⅜", D. 5⅞"

Made of reddish clay with flattened footrim and decorated with stamped and inlaid cranes, rosettes, and borders in white and black slip (*mishima* technique). Covered with transparent, slightly gray green glaze stopping at footrim.

Inscription: Mark of first generation *Zōroku* potter, Kiyomizu Genemon, impressed in base.

Origin: Bizen ware, Okayama prefecture, Japan.

Date: Edo period, 1841–78.

Condition: Complete.

401. Temple jar (one of a pair)

1940.302a,b

Gift of Mrs. Howard Hanna, Mrs. Paul Moore, and Leonard C. Hanna, Jr.

Porcelain; H. (with covers) 26¼", D. 14"

Made of coarse white porcelain. Main design consists of floral sprays in a vase, repeated four times, in underglaze enamels including rose and gold. Covered with neutral glaze except for base.

Origin: Japan.

Date: Edo period, nineteenth century.

Condition: Complete.

Later Japanese copies after K'ang Hsi export designs are relatively rare in America. These jars must date relatively late for the Japanese to have mastered the famille rose palette.

Sculpture

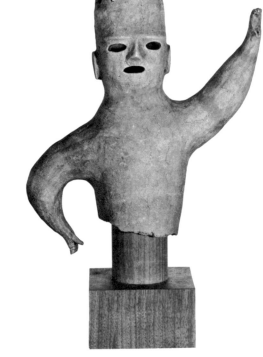

402. Miniature owl

1949.268

Collection of Wayland Wells Williams, B.A.
1910; gift of Mrs. Frances Wayland Williams
Stoneware; H. 2¼″

Made of gray clay, perhaps in two sections,
with appliqués of lower feet. Crisply cut de-
tails on front and back.

Date: Eastern Chou dynasty, probably fifth-
third century B.C.

Condition: Complete.

Provenance: Meerkert, New York, 1942.

At present, it seems difficult to find a precise
parallel for this owl with a man's legs. Styl-
istically, the Yale piece fits between the Shang
marble owl recovered at Anyang and the much
later pottery form as represented by a Han
owl in the Eumorfopoulos Collection; see
Hobson, *Eumo. Cat.,* 6, pl. 2, F2.

403. *Haniwa* male bust

1967.64.1

Gift of Mr. and Mrs. Fred Olsen, Mr. and Mrs.
Laurens Hammond, and Mr. and Mrs. Knight
Woolley, B.A. 1917.

Terra-cotta; H. 11¾″, W. 11¼″, D. 4¼″

Made of coarse orange clay. Hollow body and
head with circular ears and crownlike head-
gear.

Origin: Japan.

Date: Late Tomb period.

Condition: Broken off at waist; back of crown
and fingers on both hands missing; repairs.

Similarly postured figure, a groom reaching
up to a horse, is in the Shibayama Haniwa
Museum, illustrated in J. E. Kidder, *The Birth
of Japanese Art,* fig. 88.

404. Haniwa male head

1967.64.2

Gift of Mrs. and Mrs. Fred Olsen, Mr. and Mrs. Laurens Hammond, and Mr. and Mrs. Knight Woolley, B.A. 1917

Terra-cotta; H. 8″, W. 6″, D. 5½″

Made of coarse red clay. Hollow head given masklike face, protruding ears, combing for hair, bead necklace, and circular earrings, now lost.

Origin: Japan.

Date: Late Tomb period.

Condition: Broken off at neck; top of head, earrings, and some of necklace lost.

Similar head, complete and without necklace, from Takigawa, Gunma county and prefecture, is in the Institute of Archaeology, Tokyo University; see Kidder, *The Birth of Japanese Art,* cat. 94.

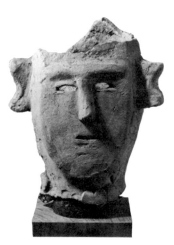

405. Mortuary model of a court lady

1928.382

Gift of Maitland F. Griggs, B.A. 1896

Earthenware; H. 23½″, W. 4″

Made of dark gray clay in a two-part mold, covered with white slip and polychrome.

Date: Six Dynasties, probably sixth century.

Condition: Much of polychrome missing or encrusted; repair on lower skirt and at elbows; head once separated from body.

Provenance: C. T. Loo, New York, 1928.

Numerous examples of this type have been published. One suggested place attribution is to be found in Ch'in Ting-yü, *Chung-kuo ku-tai t'ao-su i-shu* (A study of Chinese ancient clay-modeling art), pls. 13–14, who gives similar pieces to the Loyang area.

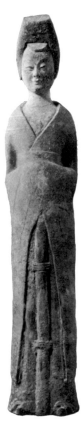

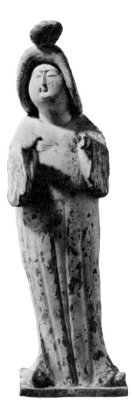

406. Mortuary model of a standing lady

1930.250
Gift of the Associates in Fine Arts
Earthenware; H. 17⅝", W. 5¼"
Mold made of reddish paste, slipped, and polychromed.

Date: T'ang dynasty.

Condition: Much of polychrome missing; figure may originally have held something in the hands.

Provenance: Yamanaka, New York, 1930.

Many undocumented examples exist in Eastern and Western collections. One documented figure of this type has, however, been reported from the Kao-lu district, east of Sian in Shensi province; see *Wên-wu*, 1955, no. 7, p. 107, fig. 9.

407. Figure of a lady

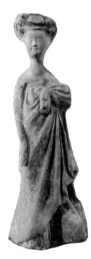

1948.51
Collection of Wayland Wells Williams, B.A. 1910; gift of Mrs. Frances Wayland Williams
Earthenware; H. 7⅝"
Made of orange red clay, over which white slip was applied.

Date: T'ang dynasty.

Condition: White slip almost completely gone; soil adhesions.

Provenance: C. T. Loo, New York, 1941.

Bibliography: C. T. Loo and Co., *Exhibition of Chinese Art,* special sale (New York, 1942), no. 429.

Parallel piece in the Collection Rousset, Paris, illustrated, as Sui dynasty, in J. P. van Goidsenhoven, *La Ceramique Chinoise,* pl. 13.

408. Mortuary model of an ox

1955.4.91

Hobart and Edward Small Moore Memorial Collection; bequest of Mrs. William H. Moore

Earthenware; H. 7⅝", L. 10"

Made of dark gray clay in a two-piece mold, white slipped, with areas painted in red.

Date: T'ang dynasty.

Condition: Much of slip turned buff color during burial; breaks in legs and tail.

Provenance: A. W. Bahr Collection, New York; sold through N. E. Montross, New York, 1920.

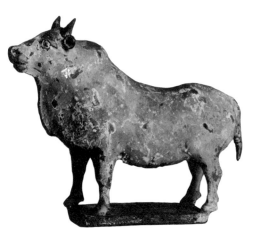

Generally similar pieces in Eumorfopoulos Collection (Hobson, *Eumo. Cat., 1*, pl. 34, no. 254) and in the Tenri Museum *(STZ, 8,* 269, fig. 308). Recent dating evidence includes an ox with cart recovered from a T'ang tomb at Ch'ang-an; see *Wên-wu,* 1959, no. 8, p. 17, fig. 27.

409. Mortuary model of horse and rider

1957.43

Gift of Samuel W. Meek, B.A. 1917

Stoneware; H. 14½", L. 13¼"

Molded of gray white clay in two pieces and luted together vertically. Mostly covered with a white slip and lead glaze of amber, green, and neutral tones. Face and hat of rider unglazed; details painted in red and black.

Origin: Reputedly found near Lo-yang, Honan province, before 1943.

Date: T'ang dynasty.

Condition: Base slightly warped in firing.

Provenance: C. T. Loo, New York.

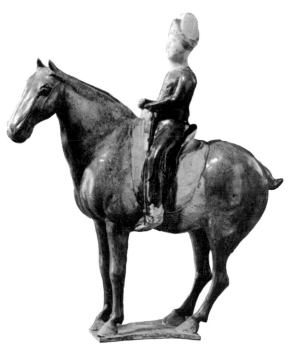

The Yale piece is apparently one of a group of sixteen. Other figures from this lot now in public collections include two at the Freer Gallery, two at the Nelson Gallery, and one each at the Fogg Museum, the Guimet, Oberlin, and the Royal Ontario Museum.

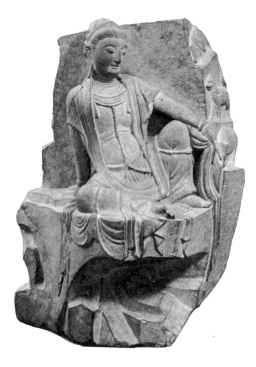

410. Kuan-yin

1930.246

Gift of the Associates in Fine Arts

Stone; H. 17½″, W. 12″, T. 9″

Kuan-yin seated on rocky ledge in posture of royal ease (mahârâjalîla); plain crown, usual Indian garb. Five various animals on sides of rock. Traces of pigment over all: possibly rock was blue, flesh gold, and draperies gold, lined with red and green.

Date: Liao-Chin dynasty.

Condition: Stone broken off at top; large chip off right shoulder glued back on.

Provenance: Yamanaka, New York.

Bibliography: BAFAYU, 5, nos. 1–3 (1931), p. 23; Osvald Sirén, "Chinese Sculptures of the Sung, Liao and Chin Dynasties," pl. 6:1; Osvald Sirén, "The Chinese Marble Bust in the Rietberg Museum," fig. 8.

Similar piece in Sirén, *Chinese Sculpture*, pl. 568.

411. Sakyamuni Votive Stele

1955.57.1

Gift of Winston F. C. Guest, B.A. 1927

Micaceous white marble with polychrome; H. 60″, W. 26″

Sakyamuni Buddha stands on a fully round lotus against incised nimbus which is slightly concave and plain on back. Head connected to nimbus by bridge of marble. Red and green polychrome on nimbus and base; figure bears remnants of gilding.

Origin: Probably Chili province.

Date: Chin dynasty.

Condition: Losses of polychrome, especially on figure; marble patinated.

Provenance: Yamanaka, Kyoto, 1907; the Reverend Theodore Pitcairn, Philadelphia.

Bibliography: Alfred Salmony, *Chinese Sculpture*, pp. 52–53, pls. 25–26.

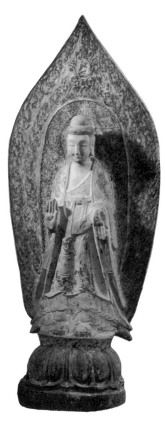

412. Recumbent dragon

1954.48.13

Hobart and Edward Small Moore Memorial Collection; gift of Mrs. William H. Moore

Bronze with polychrome; H. 13¼", L. 18"

Animal with details cast as if incised and in relief. Hair details heightened by cinnabar red; green on body may be polychrome or patination.

Date: Ming dynasty, perhaps seventeenth century.

Condition: Few small casting flaws on base.

Provenance: Tuan Fang collection, 1910; Lee Van Ching; P. Jackson Higgs, New York, 1926.

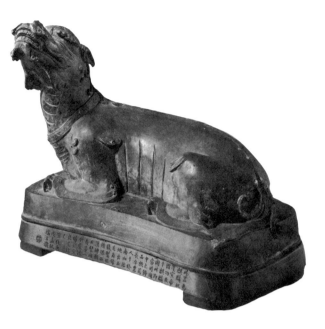

Painting

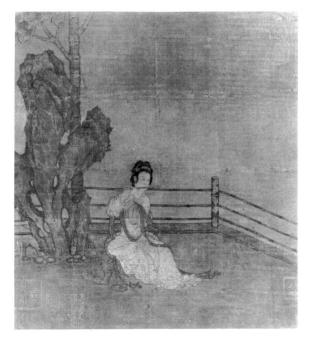

嘉祐元年三月二四日

敕門左司諫唐介

誰善人能受盡言

故昔士諫者章

臣有不容之憂然

寫志古惟擢且不能

志養阿激裏是可

忘乎

臣恭乙無虛處心以懇

名河謹筆無為也

臨求有拒如如不聽也

卯不用者半宜服

新令書而臣言

而不濟

臨近日愧知命不言泳知

留後可不知對

敕

敕如右符到奉行

奉行

413. Calligraphy (imperial decree)

1952.52.15b

Hobart and Edward Small Moore Memorial Collection; Gift of Mrs. William H. Moore

Ink on paper; H. 14¾″, W. 33″

Decree to T'ang Chieh, Chief Censor. Unsigned attribution to Ou-yang Hsiu (1007–72) added after decree. Imperial seal affixed at beginning and end. Translated Hackney and Yau, p. 39.

Date: Northern Sung dynasty, dated in accordance with 1056.

Condition: Paper thin and worn; holes.

Bibliography: Hackney and Yau, p. 39.

Mounted as a colophon to the T'ang family portrait scroll.

414. Lady playing a flute

1952.52.25m

Hobart and Edward Small Moore Memorial Collection; gift of Mrs. William H. Moore

Ink and color on silk; H. 10″, W. 9¼″

Surroundings in green; lady in white with touches of red and blue. Seals are all of Kêng Chao-chung except for the seal fragment in extreme lower right, which belongs to Chao Mêng-fu.

Date: Southern Sung dynasty, probably thirteenth century.

Condition: Cut on all four sides; right third of painting on different, coarser silk and painted by another hand.

Provenance: Ton-ying, New York, 1926.

Bibliography: Hackney and Yau, no. 30, p. 13.

A related painting is illustrated in Cahill, *The Art of Southern Sung China*, no. 10.

415. Bodhisattvas of the Ten Cardinal Points (detail shown)

1952.52.22
Artist: Lü T'ien-ju
Dates: Active c. 1427
Hobart and Edward Small Moore Memorial Collection; gift of Mrs. William H. Moore
Ink, color, and gold on blue paper; H. 11⅞″, L. (incl. inscriptions) 78⅞″
Ten identical Bodhisattvas, each identified by symbol and by inscription above and below.
Inscription: Two inscriptions at end; by Li O, dated in accordance with 1743, and by Ch'i Chao-nan, dated in accordance with 1747, translated Hackney and Yau, pp. 156–57.
Date: Ming dynasty, dated in accordance with 1427.
Condition: Repeated stains near beginning.
Provenance: A. W. Bahr Collection, New York; sold through N. E. Montross, New York, 1920.
Exhibition: Sterling Library, Yale University, 1956; Paintings, Yale, 1963, no. 17.
Bibliography: Hackney and Yau, no. 32.

416. Calligraphy (poems)

1954.40.3
Artists: Tu Mu (left) and Ku Lin (right)
Dates: 1458–1525 and 1476–1545
Hobart and Edward Small Moore Memorial Collection; gift of Mrs. William H. Moore
Ink on silk; H. 12½″, W. 11¾″
Two poems on two pieces of silk which form part of the border of painting no. 417. Poems and seals translated Hackney and Yau, pp. 120–21.
Date: Ming dynasty.
Condition: A few cracks.
Provenance: See no. 417.
Exhibition: See no. 417.
Bibliography: Hackney and Yau, pp. 120–21.

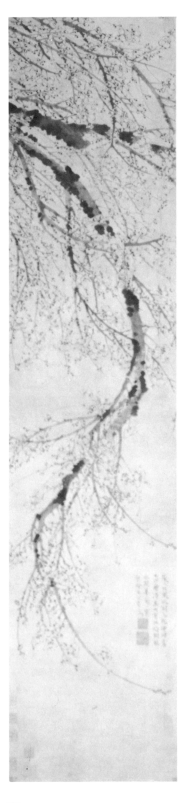

417. Prunus in bloom

1954.40.3

Hobart and Edward Small Moore Memorial Collection; gift of Mrs. William H. Moore

Ink on paper; H. 45″, W. 10½″

A hanging branch of flowering prunus. Traditionally ascribed to and signed by Wang Mien (1335–1407).

Inscription: Trans. Hackney and Yau, p. 119; inscription now believed fraudulent.

Date: Ming dynasty, possibly fifteenth century.

Condition: Creases and small surface losses of paper.

Provenance: Chang Jo-ai, eighteenth century; P'ang Lai-ch'ên, twentieth century; Ton-ying, 1932.

Exhibition: International Exhibition, London, 1935–36, no. 300.

Bibliography: Hackney and Yau, no. 29.

Has small sense of structure and little vitality of brushwork in comparison with the best surviving work of Wang Mien, such as the flowering prunus in the collection of Shao Fu-ying. The calligraphy is doubtful on much the same bases in comparison with surviving material in the Palace Collection. The seals of Chang Jo-ai seem proper, and the painting has been cut, reducing seemingly older seals to small fragments. It is possible that we are dealing with a work of Ch'en Hsien-chang (1428–1500), who painted in Wang Mien style but with delicacy rather than vigor. The seal fragments, currently indecipherable, are also in Ch'en style. It remains only theory, but perhaps we have a Ch'en painting, cut and equipped with a Wang Mien inscription before it reached the eighteenth century collection of Chang Jo-ai.

418. Calligraphy (comment)

1954.40.2
Artist: Wên Chêng-ming
Dates: 1470–1559
Hobart and Edward Small Moore Memorial Collection; gift of Mrs. William H. Moore
Ink on paper; H. 12⅝″, W. 12¼″
Colophon belonging to painting of three horses (no. 429). Comment and seals translated Hackney and Yau, p. 110.
Date: Ming dynasty, dated in accordance with 1532.
Condition: Complete.
Provenance: Ton-ying, New York, 1931.
Bibliography: Hackney and Yau, p. 110; Laurence Sickman, ed., *Chinese Calligraphy and Paintings in the Collection of John M. Crawford, Jr.,* p. 103.
See commentary for no. 429.

419. Landscape (detail shown)

1966.134
Artist: Chiang Ch'ien
Dates: Active 1540–60
Gift of Wango H. C. Wêng
Ink and color on paper; H. 9⅜″, L. 88½″
Scholars seated in discussion under the trees; rendered in washes of pale blues, red, and brown.
Inscription: Trans. "On a spring day of the *wu-shen* year (1548) painted by Chiang Ch'ien." Seal reads Chiang Shih (the teacher Chiang). Colophons by Wêng Tung-ho.
Date: Ming dynasty, dated in accordance with 1548.
Condition: Worn and repaired.
Bibliography: Sirén, *Chinese Painting,* 7, 171.
Provenance: Wêng Tung-ho Collection.

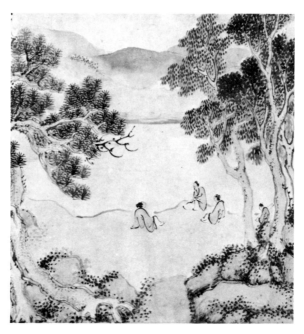

420. Yangtse River Landscape (detail shown)

1957.51.1
Artist: Wên Chia
Dates: 1500–82 or 1501–83
Gift of Wango H. C. Wêng

Ink and color on paper; H. 11⅜″, L. 123½″
River, rocks, and trees are shades of blue, with a few details picked out in delicate red, yellow, and brown.

Inscription: "In the fifth month of the *kuei-hai* year of Chia Ching (1563), identical, Mr. Wu Chih crossed the river north of the worthy Chin and Chiao. A substantial reason to sketch this off personally. Wên Chia." Followed by two seals of the artist: Wên Chia Hsiu-ch'êng and Wen Shui-tao-jên.

Date: Ming dynasty, dated in accordance with 1563.

Condition: Tears along upper edge.

Provenance: Chang Hsiung (Chang I-kou), late Ming; Sung Lo, early Ch'ing; Liang Chang-chu, middle Ch'ing; Wêng Tung-ho collection.

Another version of this subject by Wên Chia was lent by Li Hsüan-chou to an exhibition of Chinese paintings in Tokyo, 1929 and is published in *Tōsō genmin meiga taikan* (Catalogue of famous paintings of T'ang, Sung, Yüan, and Ming, 2 (Tokyo, 1929), pl. 300, and in Harada Bizen, *Pageant of Chinese Painting*, 2, 524.

The character *t'ung* (alike, identical) following the date raises the possibility that this copy may have been made by the artist. There is a fan painting of rocky islands in a river, dated 1562, preserved in the Köln Museum. This suggests a preoccupation of Wên Chia with the subject. The seals of Wên Chia and of the collector Sung Lo have been taken from the Yale painting and published in the revised edition of Wang and Contag. Of course, two, one, or none of these versions may be genuine.

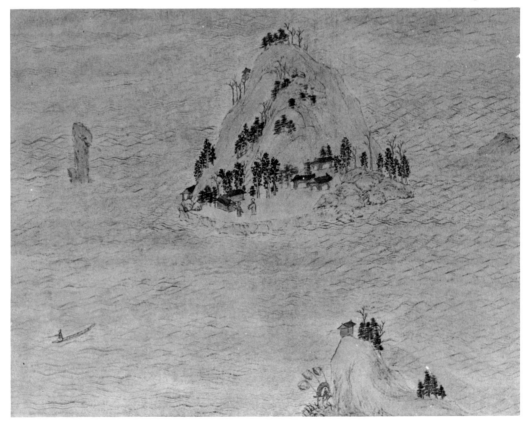

421. Mountain landscape

1956.38.5d

Gift of Mrs. Arthur Davison Ficke

Ink on silk; H. 50⅛″, W. 28½″

A man, accompanied by his servant, gazes at distant peaks.

Date: Ming dynasty, probably sixteenth century.

Condition: Cut on all four sides.

Provenance: Arthur Davison Ficke Collection.

Exhibition: Paintings, Yale, 1963, no. 21.

The picture is in a Japanese mount. A fragment of an unidentifiable seal can be found on the lower right edge.

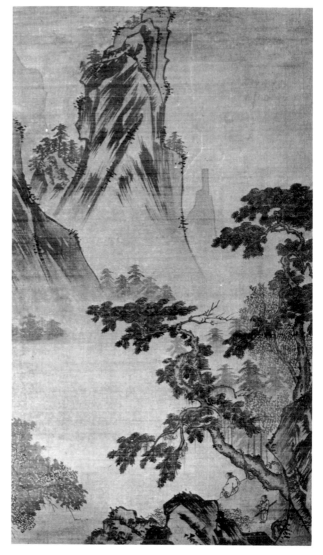

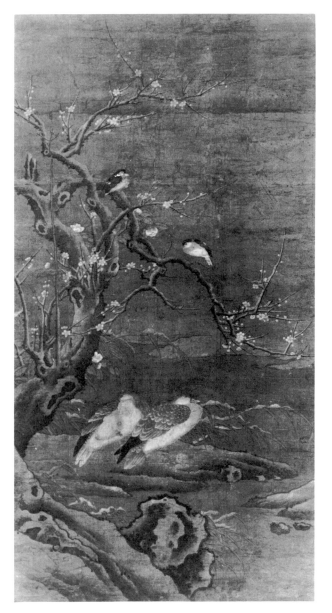

422. Snow-laden tree with birds

1954.40.12

Hobart and Edward Small Moore Memorial
Collection; gift of Mrs. William H. Moore

Ink and color on silk; H. 70½″, W. 39″

Shown in a variety of ink tones and strokes.
Color mainly restricted to floral details.

Date: Ming dynasty, probably sixteenth century.

Condition: Cracks and repairs.

Exhibition: Paintings, Yale, 1963, no. 20.

Bibliography: Hackney and Yau, suppl. no. 7.

423. Fishermen conversing

1953.27.9

Hobart and Edward Small Moore Memorial Collection; gift of Mrs. William H. Moore

Ink on silk; H. 83½", W. 54½"

Fishermen sit in conversation under a pine tree, backed by cliffs and mountains.

Date: Ming dynasty, sixteenth–seventeenth century.

Condition: Modest areas of loss and repair; one vertical seam in silk.

Provenance: P'ang Lai-ch'ên, Shanghai; Arden Gallery, New York, 1917.

Bibliography: Antique Famous Chinese Paintings Collected by P'ang Lai Ch'ên (Shanghai, 1916), no. 47; Hackney and Yau, no. 15.

This appears to be a large late Ming academy painting, casually inscribed with the characters "Ma Yüan" (a Sung artist). The interest in such subjects in late Ming is exemplified by three paintings of the Fishermen's Pleasures by Ch'ien Ku (1508–72) and illustrated in *Sōgen minshin meiga taikei* (Catalogue of famous Sung, Yüan, Ming, Ch'ing Paintings) (Tokyo, 1931), pp. 126–28.

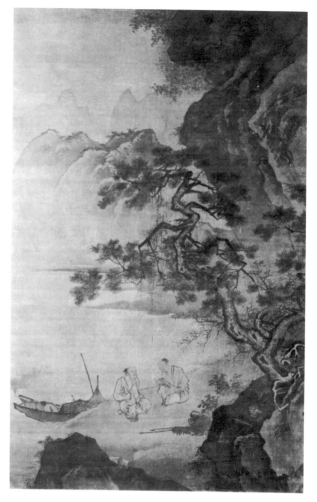

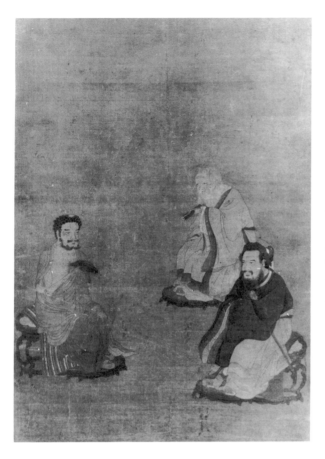

424. The Three Religions

1952.52.23

Hobart and Edward Small Moore Memorial Collection; gift of Mrs. William H. Moore

Color and ink on silk; H. 23", W. 16½"

Three figures, Confucius, Lao-tzǔ, and Buddha, are seated together. They are depicted with outline and detail in ink, their robes in light washes of red, blue, and brown with an occasional detail in bright red.

Date: Ming dynasty, seventeenth century.

Condition: Complete.

Exhibition: Bronzes and Paintings, Wellesley College, 1943, no. 28; Paintings, Yale, 1963, no. 23.

Bibliography: Hackney and Yau, no. 34.

425. The Gentlemanly Recreations (one shown)

1954.40.20a,b,c

Hobart and Edward Small Moore Memorial Collection; gift of Mrs. William H. Moore

Ink and color on silk; (Each approx.) H. 37¾″, W. 22¾″

Set of three paintings showing gentlemen writing, examining paintings, and playing chess.

Date: Ming dynasty.

Condition: Cracks.

Exhibition: Paintings, Yale, 1963, no. 19.

Bibliography: Hackney and Yau, suppl. no. 17.

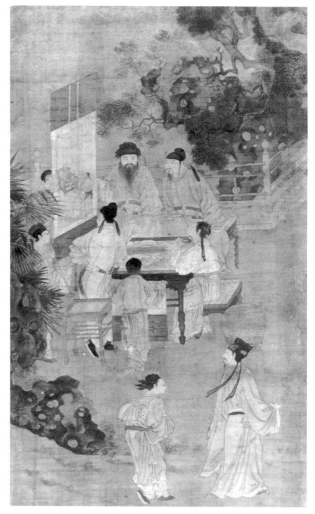

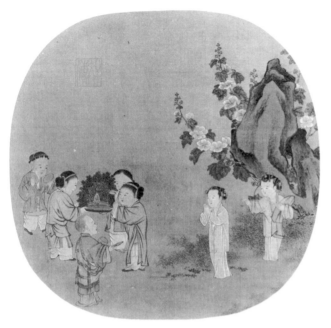

426. Children at play

1952.52.25h

Hobart and Edward Small Moore Memorial Collection; gift of Mrs. William H. Moore

Ink and color on silk; H. 8½″, W. 8½″
Painted in gentle tones of many colors.

Date: Ming dynasty.

Condition: Complete.

Provenance: Ton-ying, New York, 1926.

Exhibition: Paintings, Yale, 1963, no. 12.

Bibliography: Hackney and Yau, no. 30, 8 (as Sung); Institute of Chinese Culture, *Wên-wu ching-hua,* 5, pl. 26 (as Northern Sung).

An archaizing picture, close parallels can be seen between this picture and certain works signed by Ting Yün-p'êng (early seventeenth century).

427. Eighteen Lohans (detail shown)

1954.40.14

Hobart and Edward Small Moore Memorial
Collection; Gift of Mrs. William H. Moore

Gold and ink on blue paper; H. 11⅞", L. 157"

Painted in gold, with black ink for features
and hands. The area of the last seven lohans,
including the signature of Ting Yün-p'êng,
appears to be by a different hand than the first
part of the scroll.

Date: Ming dynasty.

Condition: Gold slightly worn.

Provenance: A. W. Bahr Collection, New
York; sold through N. E. Montross, New
York, 1920.

Exhibition: Paintings, Yale, 1963, no. 22.

Bibliography: Hackney and Yau, suppl. no. 10.

A close parallel scroll in this style of Ting
Yün-p'êng's painting is in the collection of the
Honolulu Academy of Art; see Sirén, *Chinese
Painting,* 7, pl. 310.

428. Mountain landscape

1952.52.25k

Hobart and Edward Small Moore Memorial Collection; gift of Mrs. William H. Moore.

Ink and color wash on silk; H. 8¼", W. 9¼"

The distant hills are tinged with blue, and the building with red.

Date: Ming dynasty.

Condition: Lower half inch a replacement; small fill-ins.

Provenance: Ton-ying, New York, 1926.

Exhibition: Paintings, Yale, 1963, no. 15.

Bibliography: Hackney and Yau, no. 30, 11.

A standard Ming academy continuation of Sung elements.

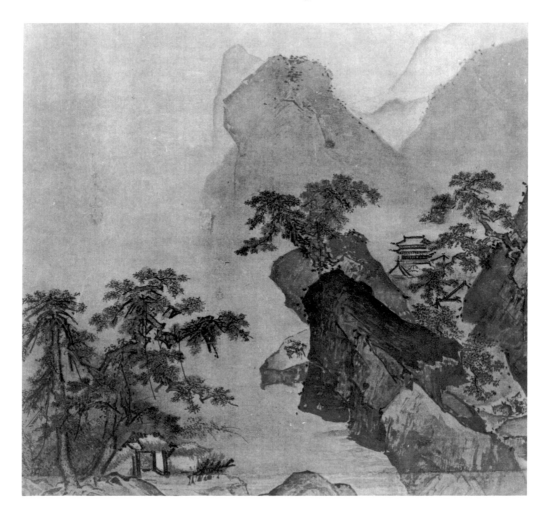

429. Three Horses (one shown)

1954.40.2

Hobart and Edward Small Moore Memorial
Collection; gift of Mrs. William H. Moore

Ink and color on paper; H. 12⅜″, W. 26¼″

Traditionally attributed to Chao Lin. Part of
handscroll containing three paintings tradi-
tionally attributed to various members of the
Chao family. Numerous colophons.

Date: See commentary.

Condition: Complete.

Provenance: Ton-ying, New York, 1931.

Exhibition: Paintings, Yale, 1963, no. 15.

Bibliography: Hackney and Yau, no. 27.

Opinion on the *Three Horse* scroll ranges
from complete acceptance in the publication
of the Institute of Chinese Culture, *Wên-wu
ching-hua,* 7, pls. 12–14, to substantial con-
demnation as late Ch'ing copies by several
Western critics. The one area which seems un-
questionably authentic by standards of callig-
raphy, seals, and paper is the colophon by
Wên Chêng-ming. This colophon, as discussed
by Sickman, *Crawford Collection,* p. 103,
seems to have been attributed by the *P'ei-wên-
chai shu-hua p'u* of 1708 to another version of
three horses in the Crawford collection. Sick-
man indicates that the colophon belongs to the
Moore scroll. In fact, the Wên Chêng-ming
colophon is tacked on, out of chronological
order, to the Moore scroll and may be its old-
est section.

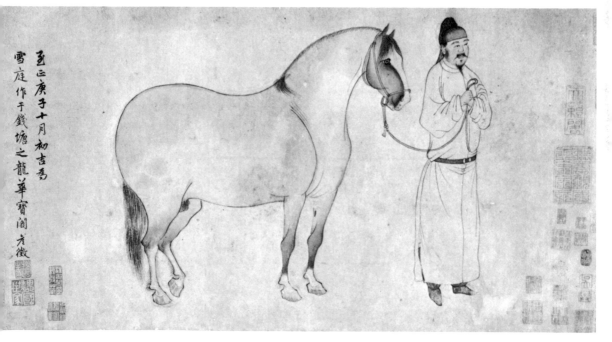

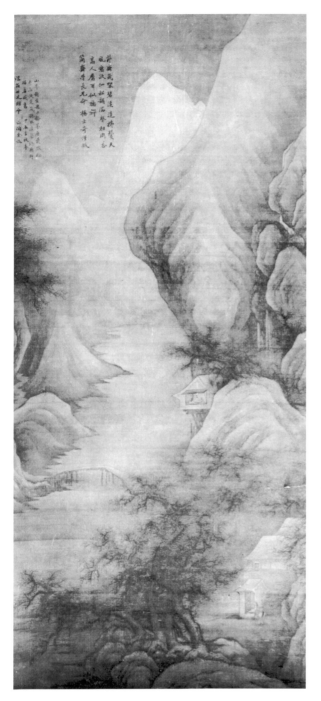

430. Landscape

1930.30

Artist: Chin K'an

Dates: Died 1703

Gift of T. Lawrason Riggs, B.A. 1910

Ink on silk; H. 100½″, W. 40⅛″

This dark, towering, moody landscape has light color washes used in depicting the humans, horse, and the roofs of the buildings.

Inscription: Poem on left by the artist:

> "A pavilion standing opposed to the mountain stimulates the three periods of leisure*
>
> The house of the chestnut oak, a loyal but mourning place, exudes its influence
>
> Convenient and appropriate-but is it sound in time and rhythm? The concealed legacy
>
> Holds no official standing to one's descendants, and the bequest thus usurps fulfillment
>
> In the half-cleared spring of the *chia-ch'en* year (1664) a very confused society follows a sacrifice-oriented leader."

Signed "I-t'ao Chin K'an."

*The three periods of leisure (for study) are winter, evening and wet days.

Seven character poem and undated inscription by Yang Shih-ch'i.

Date: Ch'ing dynasty, dated in accordance with 1664.

Condition: Several large cracks, small losses.

Provenance: Matsuke Bunkio, Boston, 1915.

Exhibition: Paintings, Yale, 1963, no. 27.

431. Woodcutter in the Early Morning (detail shown)

1958.5

Artist: Ch'a Shih-piao

Dates: 1615–98

Gift of Mrs. John A. Gee

Ink and color on paper; H. 10″, L. 91¼″

Landscape with woodcutter leaving cottage and wife in the morning. Faint washes of blue and beige.

Inscription: By the artist (trans. Li T.Y.):

> "The husband stands listening as his wife cautions,
>
> Gather but a light bundle of wood,
>
> The moss is yet slippery from last night's rain
>
> Tread not upon the dangerous peaks and cliffs."

"These lines accompanying a painting were composed by Shih-t'ien (Shên Chou). The meaning contained within is wide and deep and serves as an urgent message to the world. I spoke of it to a friend and we began to chant the poem repeatedly. He then asked me to supplement it with a painting. But how can the vitality of the master's brush-work be approximated? I use only his poem in acquiescence to my friend's wishes and to point out to later generations the import of the message contained here, which is beyond either poem or painting. September 26, 1687, the traveler in Han, Ch'a Shih-piao." Two seals of the artist follow: Êrh-chan and Shih-piao. Colophons by Shih T'ao (Tao-chi), dated in accordance with 1700 and by Hu Ching.

Date: Ch'ing dynasty, dated in accordance with 1687.

Condition: Many small losses of paper surface; horizontal banding from remounting.

Provenance: Chang Ta-ch'ien collection (nine seals on scroll).

Exhibition: Paintings, Yale, 1963, no. 29; The Arts of China and Japan, Colby College, Watersville, Maine, 1968.

Bibliography: Ta-fêng t'ang ming-chi (Famed addenda to the Ta fêng collection), 4 (Kyoto, 1956), no. 40; Sirén, *Chinese Painting*, 7, 284.

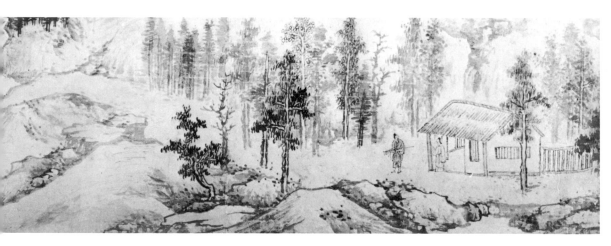

432. Leaf from Album of Landscapes

1965.130f

Artist: Yang Chin

Dates: 1644–after 1726

Gift of Wango H. C. Wêng

Ink and color on gold-flecked paper; H. 12⅛″, W. 13″

Landscape depicted in intense blues, green, and violet reds. It may be considered a very personal interpretation of the blue green pictures with which the name Chao Po-chü is often associated.

Inscription: "A personal attempt to seek the manner of Chao Po-chü. Spring of the *ping-wu year* (1696). Lu-hsi, Yang Chin." Two seals of the artist follow: Yang Chin chih yin and Tzŭ-hao.

Date: Ch'ing dynasty, dated in accordance with 1696.

Condition: Long tear near bottom.

Provenance: Wêng Tung-ho Collection.

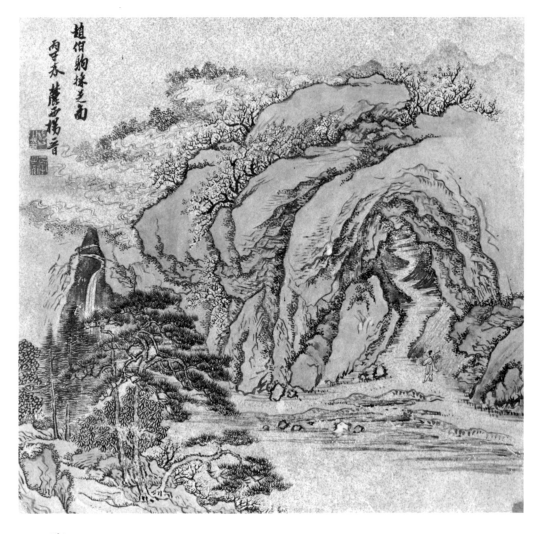

433. Buffalo on Willow Bank

1956.41.6

Artist: Yang Chin

Dates: 1644–after 1726

Gift of Wango H. C. Wêng

Color on paper; H. 39″, W. 18¼″

The colors used are primarily a variety of blues to suggest recession in depth, as in grasses and tree leaves.

Inscription: A five character poem followed by: "In the fourth month of the *ting-yu* year (1717) Hsi-t'ing Yang Chin painted." Two seals of the artist: Yang and Chin.

Date: Ch'ing dynasty, dated in accordance with 1717.

Provenance: Wêng Tung-ho Collection.

Exhibition: Paintings, Yale, 1963, no. 37.

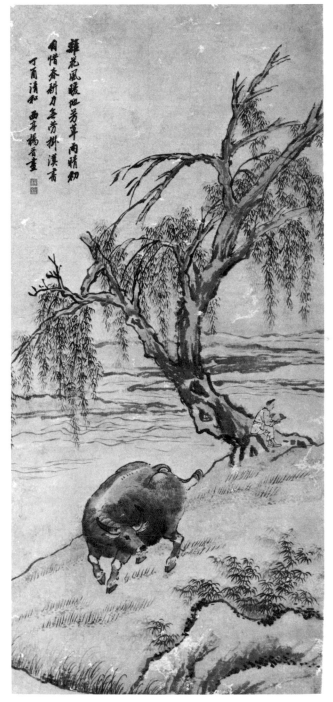

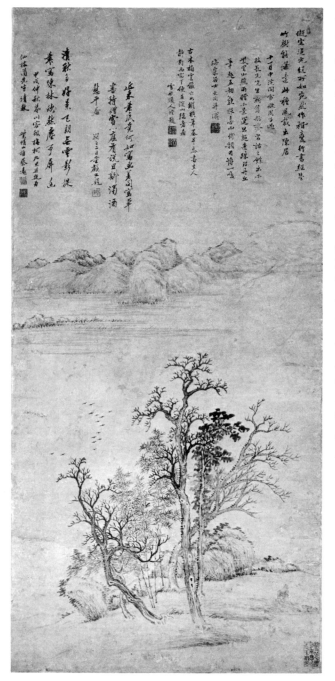

434. Landscape

1956.41.2

Artist: Ts'ai Yüan

Dates: c. 1680–1760

Gift of Wango H. C. Wêng

Ink on paper; H. 40⅝", W. 19⅝"

Foreground trees are painted with an interest in brush stroke variation. Distant hills rendered in very light ink tones.

Inscription: Artist's poem and commentary in upper left include date, followed by two seals of Ts'ai Yüan. Poem in left center by the artist is dated by month, not year, and is followed by one of his seals. In right center is a poem by Hsüeh-hang-tao-jên, the painter Chou K'ai, with two of his seals. Poem and commentary in upper right are by Hai-su-chu-shih, the painter Ku Wên-yüan with one of his seals. Single seal in lower right apparently belongs to Shên Yu-chih.

Date: Ch'ing dynasty, probably dated in accordance with 1694.

Condition: Repairs, fill-ins, cracks, and waterstains.

Provenance: Wên Tung-ho Collection.

Exhibition: Paintings, Yale, 1963, no. 33.

435. Leaf from Album of Landscapes

1965.130j

Artist: Ts'ai Yüan

Dates: c. 1680–1760

Gift of Wango H. C. Wêng

Ink and color on gold-flecked paper; H. 12⅜",
W. 13"

Landscape dominated in foreground by twist-
ing trees and swirling stream. The distant river
and hills provide a peaceful contrast.

Inscription: "In the manner of Li Hsi-ku. A
landscape done in early spring of the *ping-wu*
year (1696). A visitor to Chien-men respect-
fully involved. To Chiang Mu, a very elegant
lady, fifty shou (long life) are submitted. Tzŭ-
mao-shan-sui, Ts'ai Yüan." Two seals of the
artist follow: Ts'ai and Yüan.

Date: Ch'ing dynasty, dated in accordance with
1696.

Condition: Color seems somewhat oxidized
(probably was *ts'ang lü,* gray green); horizon-
tal scratch upper half.

Provenance: Wêng Tung-ho Collection.

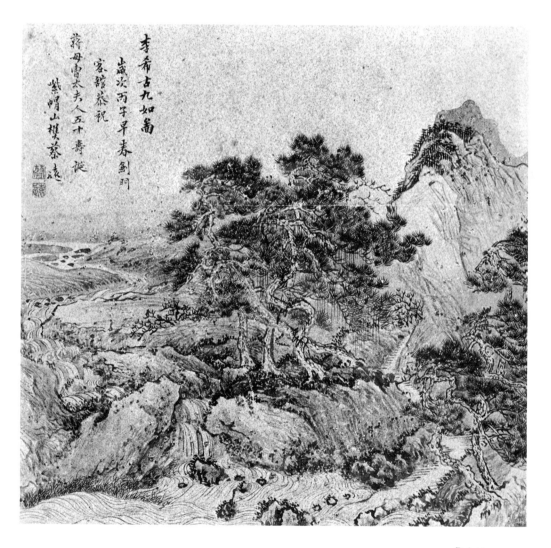

436. Winter landscape

1952.52.25i
Hobart and Edward Small Moore Memorial
Collection; gift of Mrs. William H. Moore
Ink on silk; H. 10½″, W. 10½″

Ink washes create the sky and the water. The
house and trees are done with a tight brush.
Illegible traces of a corner of a seal lower
right; signed Ta-nien.

Date: Ch'ing dynasty, perhaps seventeenth
century.
Condition: A few little cracks and silk fill-ins;
right side and bottom cut.
Provenance: Ton-ying, New York, 1926.
Exhibition: Paintings, Yale, 1963, no. 36.
Bibliography: Hackney and Yau, no. 30, 9.

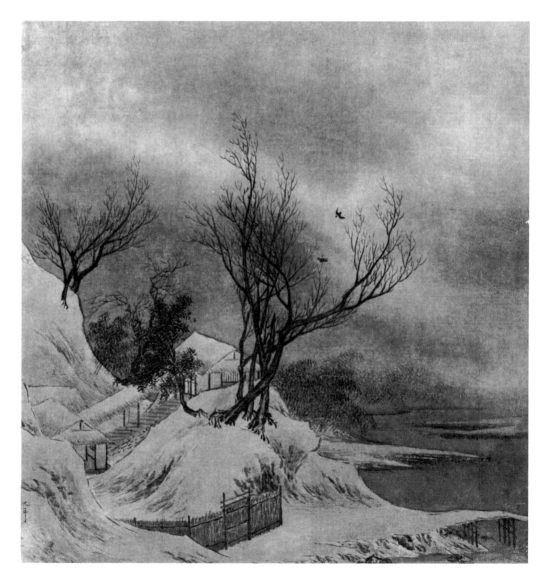

437. Travelers on a mountain path

1952.52.12

Hobart and Edward Small Moore Memorial Collection; gift of Mrs. William H. Moore

Ink and color on silk; H. 56¼″, W. 18″

The sky and the gorges are created by dark ink washes. Light colors are used primarily on the clothes of the travelers.

Inscription: Dubious.

Origin: Perhaps Yang-chou district.

Date: Ch'ing dynasty, seventeenth–early eighteenth century.

Condition: Surface rubbed; many small areas lost.

Provenance: Chang Yin-ch'un, twentieth century.

Bibliography: Hackney and Yau, no. 4.

This painting, despite an earlier attribution to Sung, is clearly derived from the work of Wu Pin of the early seventeenth century, although one cannot say with accuracy when it was painted or by whom.

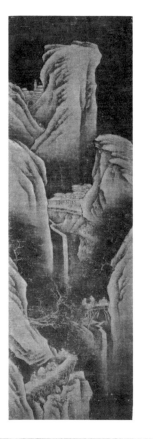

438. Wisteria and Roses (detail shown)

1956.41.3

Artist: Ch'ên Shu

Dates: 1660–1736

Gift of Wango H. C. Wêng

Color on paper; H. 11¼″, L. 108¼″

Pink roses, purple wisteria, and a predominance of green leaves.

Inscription: At beginning of painting: "In the spring, on the fourth day of the second month of the *hsin-mao* year (1711), the Nan-lou-lao-jên, Ch'ên Shu." Her seal follows: Ch'ên Shu chih yin. Seals at end of painting: Shang-yüan-ti-tzu (a name of Ch'ên Shu), Wei-kuan-fu-jên (currently unidentified, perhaps another name of the artist).

Date: Ch'ing dynasty, dated in accordance with 1711.

Condition: Repeated wormholes.

Provenance: Wêng Tung-ho Collection.

Exhibition: Paintings, Yale, 1963, no. 35.

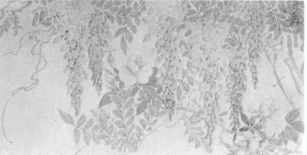

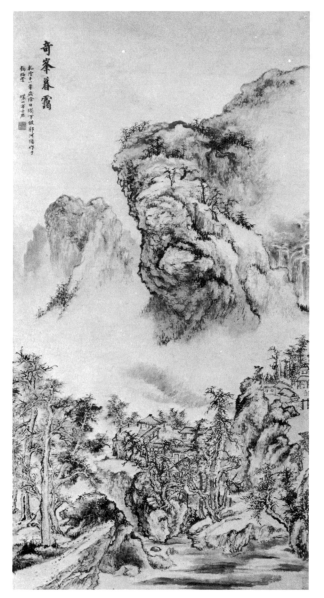

439. Cloudy Sunset on a Strange Mountain Peak

1959.40

Artist: Fang Shih-shu

Dates: 1692–1751

Hobart and Edward Small Moore Memorial Collection Fund

Ink and color on paper; H. 48¾″, W. 26″

Mostly in ink, with light washes of yellow brown to indicate the building roofs and dots of orange in the foliage.

Inscription: "Ch'ien Lung, eleventh year (1746) at the time of New Year's Eve. Illumination falling as at Ch'ou, north of the Yellow River. Painted from the Hsi-fu pavilion. Huan-shan, Fang Shih-shu." Followed by seal of the artist: Hsiao-shih-tao-jên.

Date: Ch'ing dynasty, dated in accordance with 1746.

Condition: Many small fill-ins, losses, and cracks.

Exhibition: Paintings, Yale, 1963, no. 34.

Provenance: Yamamoto Teijirō collection, Tokyo; purchased Eda, Tokyo, 1959.

Bibliography: Yamamoto Teijiro, *Chōkai-dō shoga mokuroku* (Catalogue of Chinese calligraphy and painting), 7 (Tokyo, 1932), 119.

440. Flowers and Insects (detail shown)

1944.109

Bequest of T. Lawrason Riggs, B.A. 1910

Ink and color on silk; H. 15½", L. 128"

Many flowers, bamboo, and insects scattered through the long scroll. Forged signature of Hsü Hsi.

Date: Ch'ing dynasty, probably first half eighteenth century.

Condition: Some cracks and fill-ins in silk.

Provenance: Prince Kung; J. H. Shinn, 1930.

This picture is very much in the style of Chiang Ting-hsi (1669–1732). One may consider the possibility that the end with his signature has been cut off, especially since the scroll terminates abruptly.

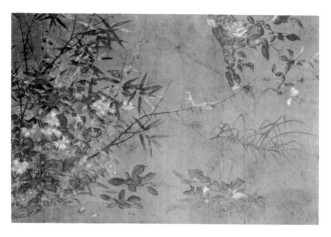

441. Tao Yüan-ming and Pine Tree

1955.38.2

Gift of Earl Morse

Ink and color on silk; H. 60½", W. 37½"

Poet stands by pine tree while servant approaches with musical instrument. Green is used on the near rocks, the pine, and, in pale washes, on the robes of the figures.

Date: Ch'ing dynasty.

Condition: Many loses, repairs, cracks.

Provenance: Owen Roberts Collection.

Exhibition: Chinese Paintings, Walker Art Center, Minneapolis, 1942; no. 12; Paintings, Yale, 1963, no. 28.

Bibliography: J. LeRoy Davidson, *Chinese Paintings* (Minneapolis, 1942), no. 12, pl. 4.

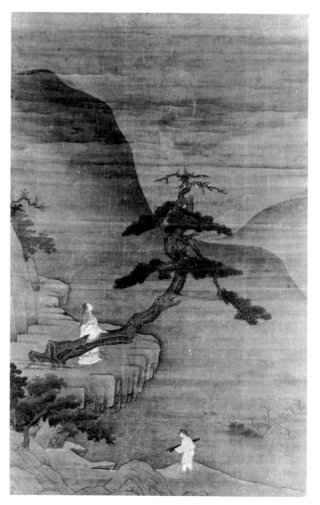

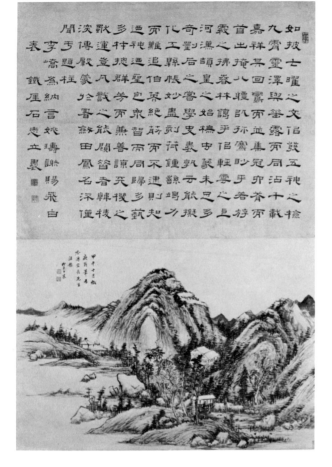

442. Landscape after Huang Kung-wang with calligraphy by Shih Chih-li

1965.131

Artist: Wang Ch'ên

Dates: 1720–97

Gift of Leopold Steiner

Ink on paper; H. 47½″, W. 32¾″

Painting done with a "dry" brush and thinned ink to give an almost brownish cast. Few scattered details in black ink tie the landscape together. Calligraphy written in *li-shu* style.

Inscription: On painting: "In the tenth month of the *chia-wu* year (1774). Frugality of essentials leads into the proper way of painting. Now, salutations to the Ts'ung-ch'ang scholar, Fa Tzǔ. Following Huang (Kung-wang), Wang Ch'ên." Followed by two seals of the artist: Ch'ên and P'êng-hsin. Third seal of the artist on right: Liu-tung-chü-shih.

Concluding part of calligraphy inscription: "Li Sung was able to receive lofty and beautiful salutations, gratefully bestowed, for demonstrating how to write *fei pei* (as if with insufficient ink in brush). Written by T'ieh Yai, Shih Chih-li." Two seals of calligrapher follow: Shih Chih-li and T'ieh Yai.

Date: Ch'ing dynasty, dated in accordance with 1774.

Condition: Painting: several large repairs on left; calligraphy: tears and losses.

Provenance: Wêng Tung-ho Collection; Wango H. C. Wêng Collection.

443. Pomegranate Flowers

1967.81.3

Artist: Ch'ien Tsai

Dates: 1708–93

Gift of Wango H. C. Wêng

Ink and color on paper; H. 48½″, W. 12″

The flowers in red, and many leaves in blue, are created by wash or the individual strokes of a broad brush, without outline.

Inscription: "In the fifth month, the eighty year old lao-jên (term of respect) sketched these stone pomegranate flowers." Three seals of the artist: Ch'ien Tsai, Wan-sung-chü-shih, and T'o-shih Shu Hua.

Date: Ch'ing dynasty, dated in accordance with 1787.

Condition: Small repairs.

Provenance: Wêng Tung-ho Collection.

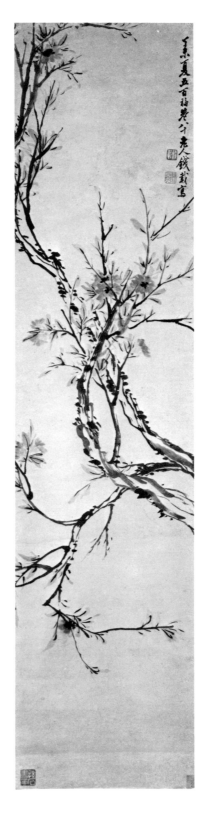

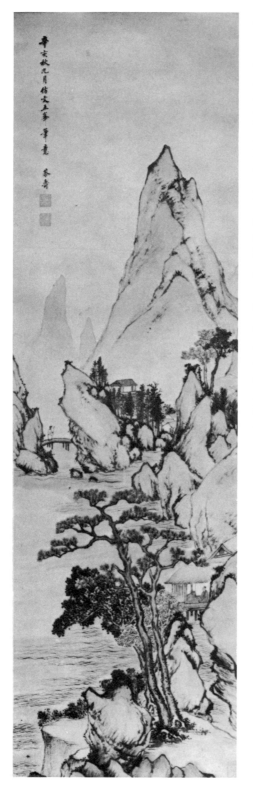

444. Landscape

1956.41.8

Artist: P'an Kung-shou

Dates: 1741–94

Gift of Wango H. C. Wêng

Ink and color on paper; H. 40⅝", W. 12¼"

A scholar sits in a pavilion surrounded by trees, mountains, and water. Ink with washes of blue and tan, and a touch of red.

Inscription: "Quietly drawn in the manner of Wên Wu-fêng (Wên Po-jên) in the ninth month of the *hsin-hai* year (1791), Kung-shou." Two seals of the artist follow: P'ang Shên-fu shih and Kuei Ch'ien Ching shê.

Date: Ch'ing dynasty, dated in accordance with 1791.

Condition: Few minor surface losses.

Provenance: Wêng Tung-ho Collection.

Exhibition: Paintings, Yale, 1963, no. 38; East Asian Landscape Painting, Dartmouth College, Hanover, New Hampshire, 1968.

Bibliography: Nelson Wu, "Additions to the Oriental Collections," *BAFAYU,* 22, no. 3 (1956), pp. 22–25.

445. Orchids

1960.10

Artist: Ch'ên Hung-shou

Dates: 1768–1822

Hobart and Edward Small Moore Memorial Collection Fund

Ink on paper; H. 11⅞", W. 16⅛"

One of eight album leaves depicting flowers and branches. Seal of the artist.

Date: Ch'ing dynasty, dated in accordance with 1799.

Condition: Once folded in middle.

Provenance: Eda Yūji Gallery, Tokyo, 1960.

Exhibition: Paintings, Yale, 1963, no. 39; University of New Hampshire, 1964.

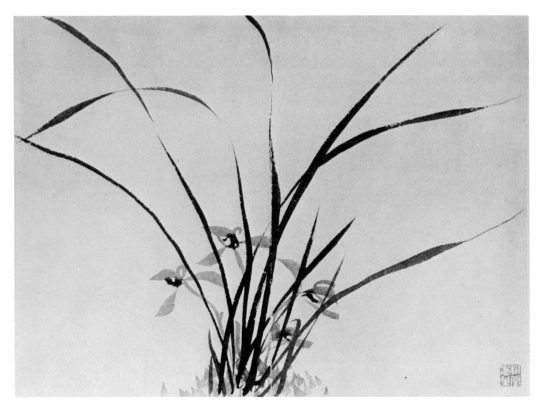

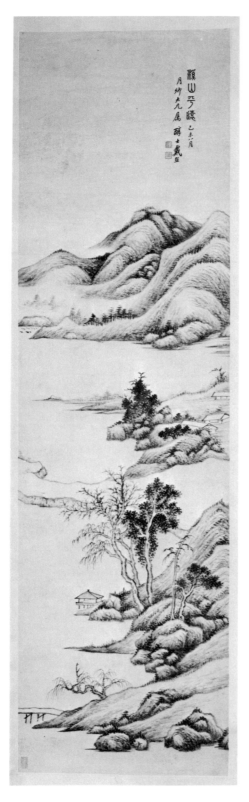

446. Streams and Mountains from a Distance

1967.81.2
Artist: Tai Hsi
Dates: 1801–60
Gift of Wango H. C. Wêng
Ink on paper; H. 51½″, W. 15″
The major variant in this picture is the depth of ink tonality. The brushwork is loosely consistent.
Inscription: "Streams and mountains from a distance." Followed by two seals of the artist: Tai Hsi and Ch'un-shih.
Date: Ch'ing dynasty, dated in accordance with 1859.
Condition: Some areas of foxing.
Provenance: Wêng Tung-ho Collection.

447. Cloudy Mountains

1951.51.18
Artist: Kanō Tanyū
Dates: 1602–74
Gift of Mrs. William H. Moore
Ink on paper; H. 12¼", W. 13¾"
Mountaintops created by ink washes, while brush daubs suggest vegetation.

Inscription: Trans.: "Hō-in (a priestly title Tanyū received at age 64) Tanyū painted this in his sixty-fifth year at the country place of the Imperial Household." Seal of the artist follows: "Hippō" (a part of another title Tanyū received).

Origin: Japan.

Date: Tokugawa period, dated in accordance with 1666.

Condition: Several ridges in paper from past remounting, and one small tear.

Provenance: Tsuchiya Collection; Matsudaira Collection; sold through Yamanaka, Kyoto.

The picture is a copy after a painting by Sesshū, which Tanyū's brother Tsunenobu authenticated.

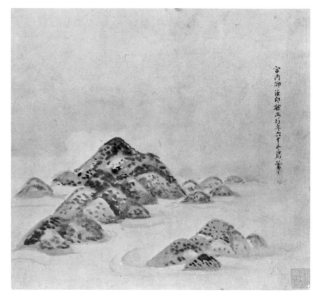

448. Courtesans' Diversions on a Snowy Day

1967.64.4
Artist: Isoda Kōryūsai
Dates: Active 1766–88
Gift of Mr. and Mrs. Fred Olsen, Mr. and Mrs. Laurens Hammond, and Mr. and Mrs. Knight Wooley, B.A. 1917
Color on silk H. 27", W. 13¾"
One courtesan holds a shamisen, the other paints a model of a rabbit. Many colors, but main scheme is shades of green and olive green with spots of red throughout. Signed Kōryūsai *zu* (picture), followed by seal, Kōryūsai.

Origin: Edo, Japan.

Date: Edo period, 1766–88.

Condition: Complete.

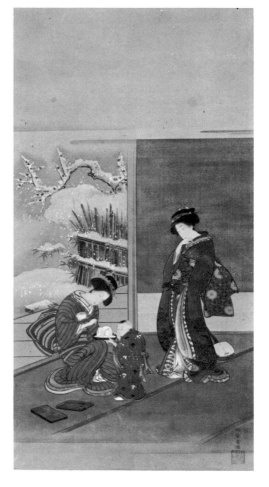

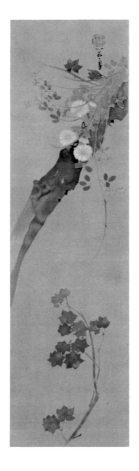

449. Maple and Flowers

1952.40.14
Artist: Suzuki Kiitsu
Dates: 1796–1858
Gift of Mrs. Jared K. Morse
Color on silk; H. 40″, W. 11½″
Gray tree trunk with softly colored flowers at base; tree leaves above and below bright red. Signed Seisei Kiitsu (two personal names); seal Suzuki Motonaga (family name).
Origin: Edo, Japan.
Date: Edo period, first half nineteenth century.
Condition: Complete.

Prints

450. Stamped Buddhist print

1967.71

Elisabeth Achelis Fund

Hand stamped on mulberry paper; H. 10″, W. 24″

An eleven-headed Kannon repeated five times by hand stamp in black ink.

Origin: Said to have come from Hōryū-ji, Nara, Japan.

Date: Heian period.

Condition: Numerous small paper losses; paper joining (before stamping) is evident.

Ishida Mosaku, *Japanese Buddhist Prints,* illustrates a very similar eleven-headed Kannon repeat print, owned by Hōryū-ji, on pl. 55.

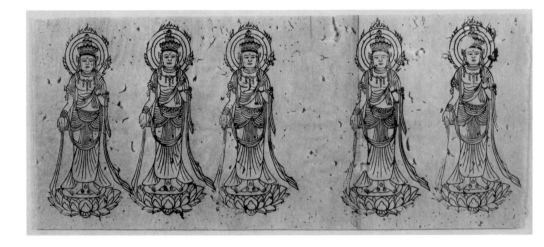

451. Fragment of printed cloth

1937.5623

Hobart and Edward Small Moore Memorial Collection; gift of Mrs. William H. Moore

Silk, cloth woven; H. 11¾", W. 12⅜"

Head and front half of lion within half circle of cloud forms, printed in black with details painted in red and white; yellow silk cloth.

Date: Kamakura period.

Condition: Many small areas lost within fragment.

Provenance: Yamanaka, Kyoto, 1932.

Bibliography: BAFAYU, 16, no. 2 (1948), p. 26.

A composite fragment showing this lion design complete is owned by the Kanegafuchi Spinning Company Ltd., Osaka. Another example of the lion design is at Hōryū-ji; see Ishida Mosaku, *Japanese Buddhist Prints,* pls. 175, 178. Fragments related to the Yale piece are also in the Fogg Museum (1934.8) and in the Nelson Gallery (1935.333).

452. Print of a foreigner

1950.409

Hobart and Edward Small Moore Memorial Collection; gift of Mrs. William H. Moore

Wood-block print, black ink on grayish paper; H. 12¼", W. 6¾"

Single figure with block of characters and *hiragana* (system of Japanese symbols).

Inscription: The characters may be rendered: "The fourth year of Tenshō at Azuchi in Ōmi" (the year and the place are repeated). The hiragana may be rendered: "Welcome foreigner."

Origin: Azuchi, Japan.

Date: Momoyama period, dated in accordance with 1576.

Condition: Short crease and surface imperfections; printing slightly incomplete.

Provenance: Yamanaka, New York, 1920.

One might anticipate a foreigner print from Azuchi, for this place was fortified by a great

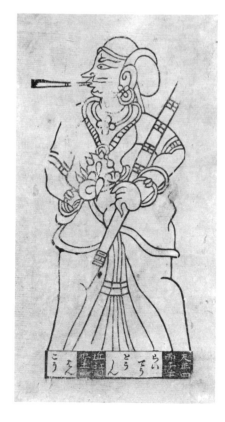

castle built by Oda Nobunaga, who at least tolerated the presence of Catholic missionaries in Japan.

453. Scene from drama "Ōeyama"

1950.564
Artist: Hishikawa Moronobu
Dates: 1618–95
Gift of Mrs. William H. Moore
Wood-block print *(sumizuri-e)*; H. 12″, W. 21½″
No signature or publisher's seals, but attributed to Moronobu.
Date: Edo period, probably 1680s.
Condition: A few stains left half.

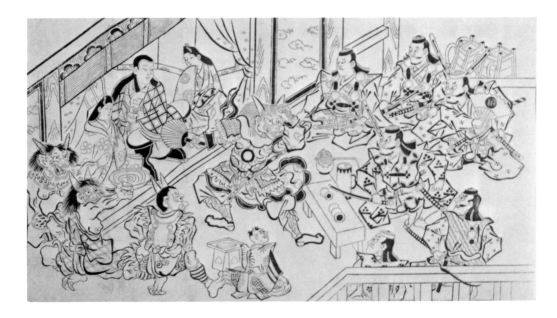

454. Courtesan, Lover, and Attendant
by the Sea from series "Ukiyo-e Genji"
(Tales from the *Genji Monogatari*)

1953.1.45
Artist: Okumura Masanobu
Dates: 1686–1764
Gift of Mrs. Jared K. Morse
Wood-block print (sumizuri-e); H. 11½",
W. 17"
Signed Okumura Masanobu zu. Seal of Masa-
nobu. Published Motohama-chō, Iga-ya han-
moto.
Date: Edo period, c. 1715.
Condition: A few printing flaws.

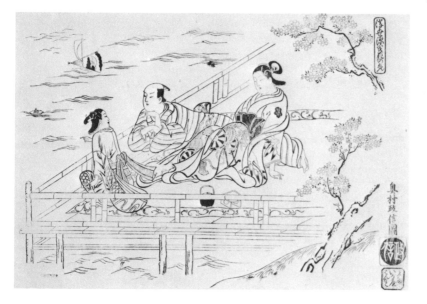

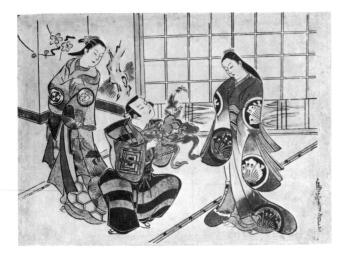

455. Actors Ichimura Tamagashiwa, Ichikawa Danzō I, and Sanjō Kantarō II

1959.2.15
Artist: Torii Kiyonobu, attributed to
Dates: 1664–1729
Gift of Walter Bareiss, B.A. 1940
Wood-block paint, hand lacquered *(urushi-e)* and hand colored; H. 8½″, W. 12″
Orange, blue, yellow, and beige in costumes; sprinkling of metal dust in areas. Signed Torii Kiyonobu *hitsu* (painted by).
Date: Edo period, c. 1718.
Condition: Signature partially worn away, possibly added at a later date.
Provenance: Garland Collection.

456. Scene from a *shosa* (dancing act)

1950.546
Artist: Torii Kiyohiro
Dates: Active 1751–65
Gift of Mrs. William H. Moore
Two-color *(benizuri-e)* wood-block print; H. 12″, W. 5½″
Black, red, and two shades of green. Signed Torii Kiyohiro hitsu. Publisher Abura-chō. Seal Yama, Maru Kō (Yamamoto Kōhei of Maruya).
Date: Edo period, c. 1755.
Condition: Slightly trimmed on left.

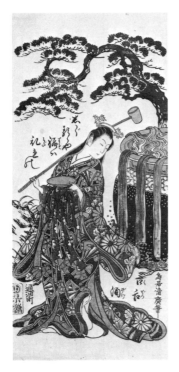

457. Mitate gensō Kotei (Analogue of the romance of the Chinese emperor Hsüan Tsung and the lady Yang Kuei-fei)

1950.426

Artist: Suzuki Harunobu

Dates: 1703–70

Gift of Mrs. William H. Moore

Color wood-block print; H. 11″, W. 8″

Pale green ground and orange bench; kimonos gray, brown, and pink. Signed Suzuki Harunobu *ga* (to paint).

Date: Edo period, c. 1766.

Condition: Complete.

Provenance: Fukushima Co., New York, 1919.

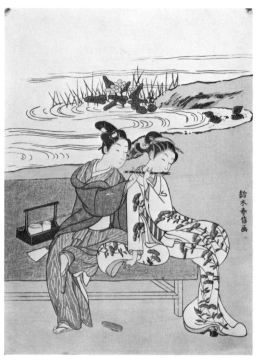

458. Actor Ichikawa Danjūrō V

1950.578

Artist: Katsukawa Shunshō

Dates: 1726–93

Gift of Mrs. William H. Moore

Color wood-block print; H. 12″, W. 5″

Costume pink, blue gray, ochre, beige, and white. Grass and leaves ochre; tree trunk blue gray. Blue lacquer applied by hand. Signed Katsu Shunshō ga.

Date: Edo period, late 1770s.

Condition: Complete.

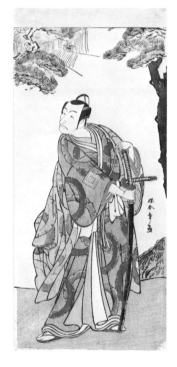

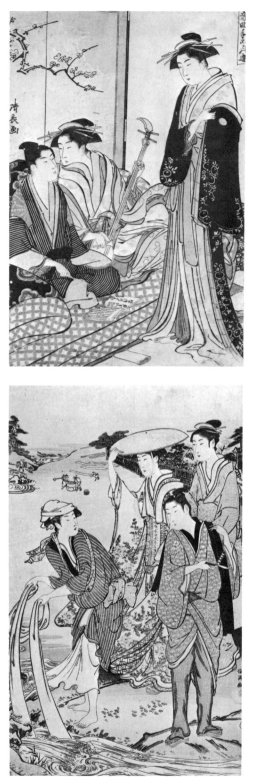

459. Teaching a Song of Katō-bushi from series "Ongyoku Tegoto no Asobi" (Musical Pastimes)

1953.1.30
Artist: Torii Kiyonaga
Dates: 1752–1815
Gift of Mrs. Jared K. Morse
Color wood-block print; H. 12¼", W. 8¼"
Singing youth and standing figure in yellow and black. Woman with shamisen in white, figured kimono. Song book before them is "Matsu no Uchi." Signed Kiyonaga ga.
Date: Edo period, 1785.
Condition: Touches of blue and purple now faded; trimmed on right and top.
Parallel print illustrated in Hirano Chie, *Kiyonaga,* no. 711, pl. 50.

460. Tazukuri no Tamagawa, province of Musashi, fourth print from hexaptych, Mu Tamagawa (Six Tama Rivers)

1950.571
Artist: Kubo Shunman
Dates: 1757–1820
Gift of Mrs. William H. Moore
Color wood-block print; H. 14½", W. 9⅛"
Costumes in gray tones with touches of black. Surroundings pale green with touches of yellow and pink. Signed Shunman ga. Seal of Shunman. Publisher Fushimiya Zenroku.
Date: Edo period, c. 1787.
Condition: Slightly trimmed on right.
Provenance: Arthur Davison Ficke Collection.
Parallel print illustrated in Louis Ledoux, *Bunchō to Utamaro,* no. 26D. First two prints of the hexaptych are also at Yale (1950.572).

461. Collecting Shells, first illustration from book *Shiohi no Tsuto* (Souvenirs from Ebb Tide)

1967.64.3
Artist: Kitagawa Utamaro
Dates: 1753–1806

Gift of Mr. and Mrs. Fred Olsen, Mr. and Mrs. Laurens Hammond, and Mr. and Mrs. Knight Woolley, B.A. 1917

Color wood-block print; H. 9″, W. 14¾″

Double page book illustration: gathering shells at Shinagawa bay at ebb tide. Sand gray, leaves and grass olive green, wave patterns in water embossed *(karazuri)*. Costumes mostly pink, red, and purple, with touches of blue, black, and olive green. Poem above from circle of poets called Yaegaki-ren. Publisher Tsutaya.

Date: Edo period, c. 1790.
Condition: Book complete.

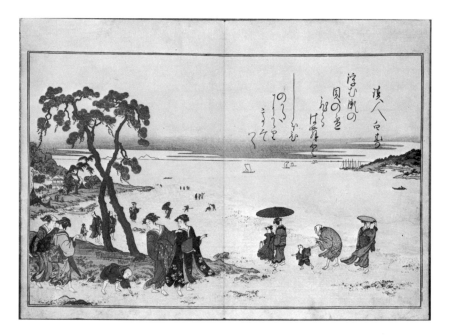

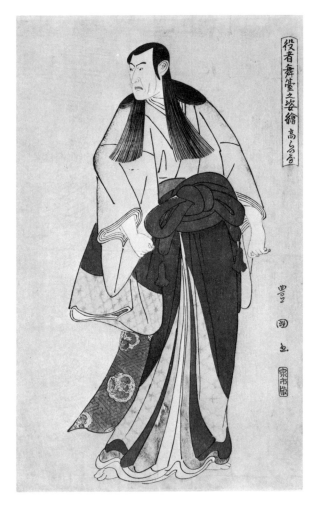

役者舞臺之姿繪 高ら子屋

豊
国
画

泉市版

462. Matsumoto Kōshiro IV (Kōrai-ya) from series "Yakusha Butai no Sugata-e" (Pictures of Actors on the Stage)

1950.581

Artist: Utagawa Toyokuni

Dates: 1769–1825

Gift of Mrs. William H. Moore

Wood block; H. 15″, W. 9½″

Pale gray ground with mica. Robes yellow, gray, green, and red. Upper part of robes embossed. Signed Toyokuni ga. Publisher Izumiya.

Date: Edo period, 1795.

Condition: Complete.

Provenance: Yamanaka, New York, 1919.

Parallel print illustrated in Louis Ledoux, *Sharaku to Toyokuni,* no. 50.

463. Segawa Kikunojō III as Courtesan Katsuragi and Sawamura Sōjūrō III as Nagoya Sanza

1957.31.1

Artist: Tōshūsai Sharaku

Dates: Active 1794–95

Gift of Walter Bareiss, B.A. 1940

Color wood-block print with mica ground; H. 14½″, W. 10″

Seated figure wears black robe over pink kimono. Standing figure in red brown and gray green. Signed Tōshūsai Sharaku ga. Publisher Tsutaya.

Date: Edo period, 1794.

Condition: Large loss at left margin.

Parallel print illustrated in Henderson and Ledoux, *The Surviving Works of Sharaku,* no. 43.

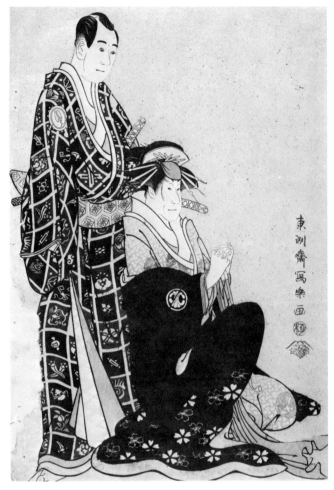

464. Ushibori, province of Hitachi
from series "Fuji take sanjū roku kei"
(Thirty-Six Views of Fuji)

1949.110

Artist: Katsushika Hokusai

Dates: 1760–1849

University Purchase

Color wood-block print; H. 10¼", W. 15"
Mainly in blue and white with a few touches
of green. Signed Zen Hokusai Iitsu hitsu. Pub-
lisher Eijudo.

Date: Edo period, c. 1823.

Condition: Complete.

Provenance: Louis Ledoux Collection.

Bibliography: Louis Ledoux, *Hokusai and
Hiroshige*, no. 18.

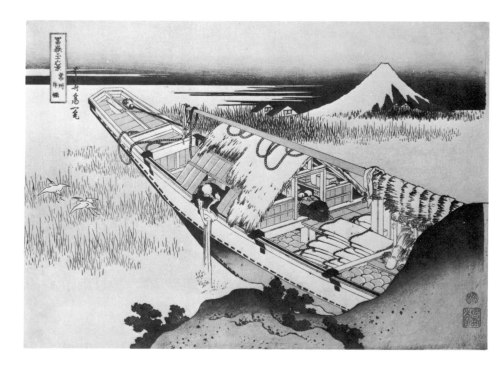

465. Ōji Shozoku Enoki, Ōmisoka no Kitsunebi (New Year's Eve, Fox-Fires at Ōji at the Enoki Tree) for series "Edo Meisho" (100 Views of Edo)

1955.9.4

Artist: Andō Hiroshige

Dates: 1797–1858

Hobart and Edward Small Moore Memorial Collection; gift of Mrs. William H. Moore

Color wood-block print; H. 13¼", W. 8¾"
Landscape dark grays with touches of green. Sky dark blue, shading into black. Foxes pale pink, fires orange. Signed Hiroshige ga. Publisher Eikichi.

Date: Edo period, 1857.

Condition: A few tiny wormholes.

Provenance: Roland Koscherak, New York, 1955.

Parallel print illustrated in Ledoux, *Hokusai and Hiroshige,* no. 51. This is one of the few impressions taken from the original block, for another block was cut soon thereafter from an imperfect piece of wood; see Ledoux, no. 51.

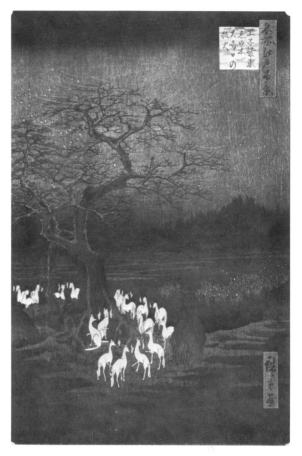

466. Kās'yapa (Kashō) from series "Shaka Jūdai Deshi Hanga Saku" (The Ten Great Disciples of Sakyamuni)

1967.64.5

Artist: Munakata Shikō

Dates: Born 1905

Gift of Mr. and Mrs. Fred Olsen, Mr. and Mrs. Laurens Hammond, and Mr. and Mrs. Knight Woolley, B.A. 1917

Wood-block print; H. 41″, W. 16″

Signed in pencil and sealed Munakata. Imprint number 77.

Date: Series executed 1939; this impression dated March 3, 1950.

Condition: Complete.

Parallel print illustrated in *Shikō Munakata*, no. 5.

Textiles, Lacquer, and Ivory

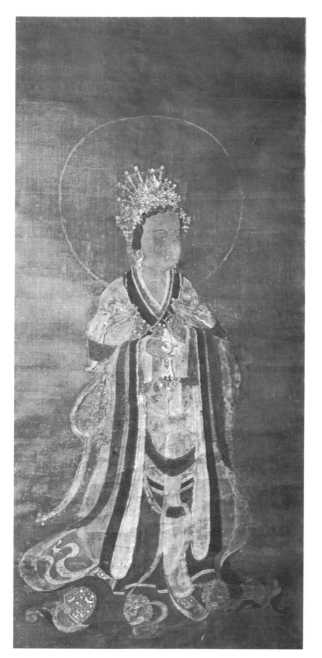

467. Wall scroll of Kuan-yin

1937.5599

Hobart and Edward Small Moore Memorial Collection; gift of Mrs. William H. Moore

Silk, embroidered; H. 39", W. 18⅜"

Figure of Kuan-yin on plain silk ground. Dress in gauze appliqué is purple, green, and blue. Features and jewels embroidered in satin stitch, outlined in couched metal thread.

Date: Yüan dynasty, fourteenth century.

Condition: Many repairs; very fragile.

General stylistic parallels between this picture and the figures depicted in the wall paintings at Yuan-lo kuan temple, Shansi province, open the possibilities of a Yüan date for the object; see Wang Hsün, "Yung-lo kuan San-ch'ing tien pi-hua ti ts'ai-shih-t'ing" (A preliminary inquiry into the subjects of the wall paintings at the San-ch'ing tien, Yung-lo kuan), pp. 31–32, text fig. 2.

468. Sutra cover

1947.108

Hobart and Edward Small Moore Memorial Collection; gift of Mrs. William H. Moore

Satin, brocaded; H. 13⅛″, W. 4¼″

Warps white silk, satin woven over four, weft white silk. Brocaded pattern on white ground consists of oval medallions, outlined in gold, containing pair of *fêng-huangs* (phoenixes) and peonies in blue, green, yellow, red, pink, and gold. Diamond-shaped lozenges with peonies. Yellow silk label.

Date: Ming dynasty, sixteenth century.
Condition: White ground worn and yellowed.
Provenance: Carl Schuster Collection.

469. Sutra cover

1947.124

Hobart and Edward Small Moore Memorial Collection; gift of Mrs. William H. Moore

Compound satin; H. 15¼″, W. 5⅛″

Warps purple silk, satin woven over four. Main weft purple, pattern weft three-ply yellow silk. Pattern of yellow peonies and lotuses in alternating rows on purple ground.

Date: Ming-Ch'ing dynasty, seventeenth century.

Condition: Complete.

Provenance: Carl Schuster Collection.

470. Sutra cover

1947.114

Hobart and Edward Small Moore Memorial Collection; gift of Mrs. William H. Moore

Compound satin; H. 14¼″, W. 5″

Warps green silk, satin woven over seven, wefts green silk and gold (metal on paper). Pattern in gold on green ground consists of clouds with some Buddhist precious things interspersed. Yellow silk label.

Date: Ch'ing dynasty, eighteenth century.

Condition: Discolored lower left.

Provenance: Carl Schuster Collection.

471. Sutra cover

1947.119

Hobart and Edward Small Moore Memorial Collection; gift of Mrs. William H. Moore

Plain cloth, embroidered; H. 14¼″, W. 5″

Warps red silk in pairs, spaced as in gauze weaving. One thread of each pair goes over and the other under each weft; no twist as in gauze. Brocaded pattern on red ground depicts white cranes flying one way and yellow cranes the other, with symbols in gold interspersed.

Date: Ch'ing dynasty, eighteenth century.

Condition: Wormhole; some of gold threads breaking off.

Provenance: Carl Schuster Collection.

472. Mandarin square for Imperial censor

1947.212

Hobart and Edward Small Moore Memorial Collection; gift of Mrs. William H. Moore

Satin embroidered; H. 14½″, W. 15″

Dark blue satin ground. Embroidered in satin stitch and laid and couched stitch. Pattern depicts ch'i-lin in gold with white horn and multicolored mane and tail; red flames shoot from body. Symbols of lozenges, books, and *jui* (sceptre) below.

Date: Ming dynasty, seventeenth century.

Condition: Complete.

Provenance: Krenz Collection; purchased Alice Boney, New York, 1936.

Identical piece in the Metropolitan Museum (36.65.27).

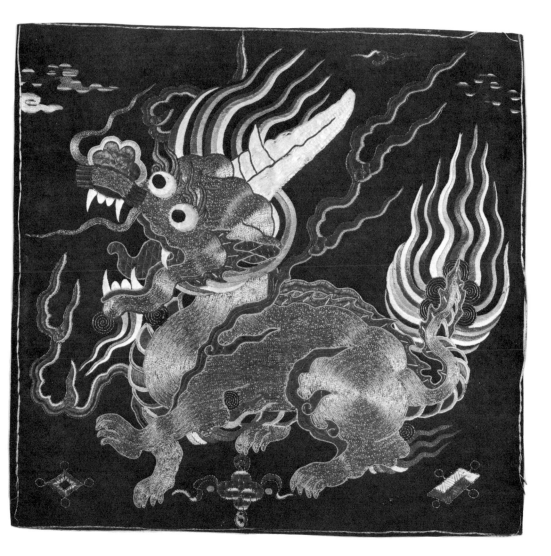

473. Mandarin square, rank of First Grade

1947.207
Hobart and Edward Small Moore Memorial
Collection; gift of Mrs. William H. Moore
Satin, embroidered; H. 12¾″, W. 12¾″
Gray satin ground. Embroidered in satin stitch
and laid and couched stitch. Pattern on gold
ground is white-winged crane holding peach;
rocks mainly green, clouds multicolored. Wide
range of colors throughout.

Date: Ch'ing dynasty, mid-seventeenth century.
Condition: Complete.
Provenance: Krenz Collection; purchased
Alice Boney, New York, 1936.
Identical piece in the Metropolitan Museum;
see Schuyler Cammann, "Development of
Mandarin Squares," fig. 14c.

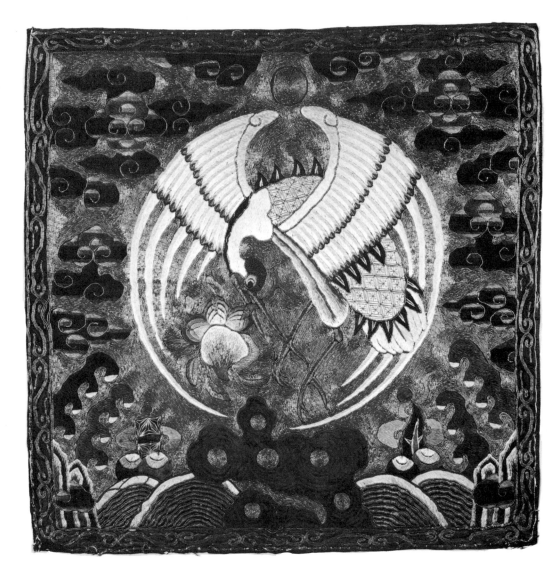

474. *Nō* dance robe

1951.12.33

Hobart and Edward Small Moore Memorial
Collection; gift of Mrs. William H. Moore

Compound twill, brocaded (*karaori* weave);
L. 59½″

Brown checkerboard squares brocaded with
stylized chrysanthemums in blues, greens, yel-
low, gray, and white; white checkerboard areas
with peonies in brown or gold and other colors.
Warps white silk, ikat dyed, shading at regular
intervals to brown; wefts white in white areas,
brown in brown areas.

Origin: Japan.
Date: Edo period, late seventeenth century.
Condition: Slightly worn.
Provenance: William L. Keane Collection.

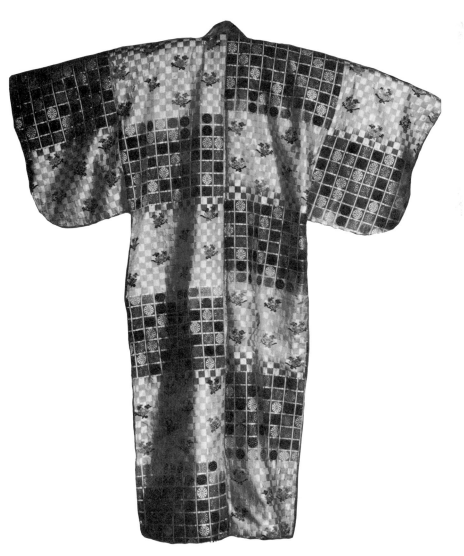

475. Priest's robe and stole (detail shown)

1951.12.2a,b

Hobart and Edward Small Moore Memorial Collection; gift of Mrs. William H. Moore

Compound twill, brocaded (karaori weave); (robe) L. 81¾″, W. 46″; (stole) L. 59½″, W. 11¾″

On green, red, or white ground are swirls of water in gold and aquatic plants in various brocaded colors. Warps ikat dyed, shading from green to white to red to white, etc.; wefts green where warps are green, red where warps red, white where warps white.

Origin: Japan.

Date: Edo period, late seventeenth–early eighteenth century.

Condition: Shi-ten, ni-ten, and cords removed.

Provenance: William L. Keane Collection.

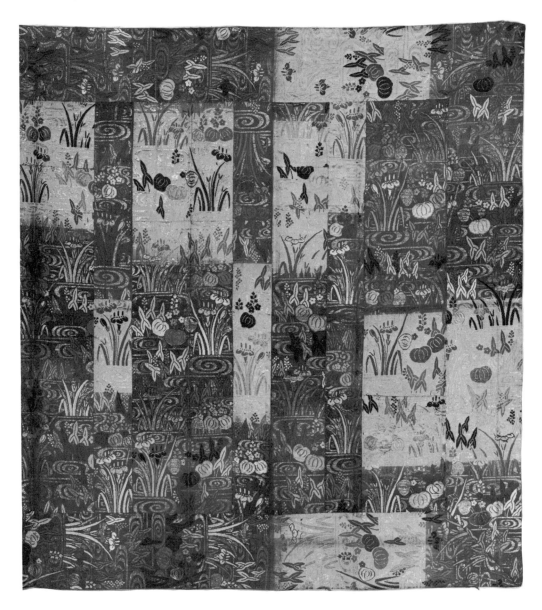

476. Kimono

1937.5890

Hobart and Edward Small Moore Memorial
Collection; gift of Mrs. William H. Moore

Plain cloth resist dyed, embroidered; L. 66"

Deep blue ground, resist dyed, with clouds
reserved in white. Flowering tree embroidered
in silk in satin stitch in shades of red, brown,
green, pink, and orange. Pink butterflies with
details in couched gold thread.

Origin: Japan.

Date: Edo period, c. 1700.

Condition: Several small holes.

Provenance: Yamanaka, Kyoto, 1932.

Exhibition: Japanese Exhibition, Friends of
Far Eastern Art, Mills College and San Fran-
cisco Museum of Art, California, 1936.

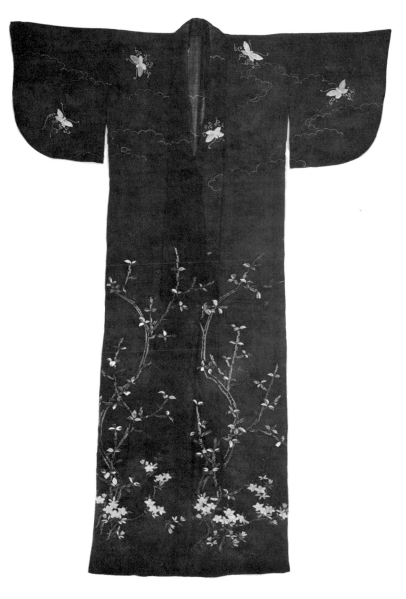

477. Kimono

1937.5889
Hobart and Edward Small Moore Memorial
Collection; gift of Mrs. William H. Moore
Fancy satin (damask), resist dyed, embroidered; L. 63″
Fabric of swastika meander ground is dyed
blue. Pattern of garden, stream, pavilion, and
fence, with stream reserved in white and the
rest given touches of green, brown, and pink
with stenciling and embroidery in satin and
laid and couched stitches.

Origin: Japan.
Date: Edo period, c. 1780.
Condition: Complete.
Provenance: Yamanaka, Kyoto, 1932.
Bibliography: Metropolitan Museum, *Japanese Costume* (New York, 1935), pl. 27.
Exhibition: Japanese Exhibition, Mills College and San Francisco Museum of Art, 1936.

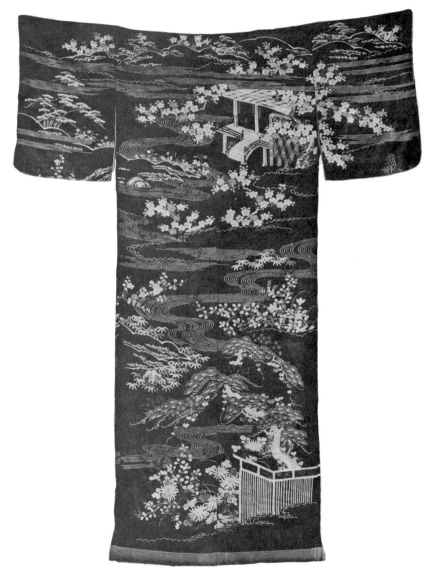

1928.224

S. Wells Williams Collection; bequest of F. Wells Williams, B.A. 1879

Lacquer on wood; H. 1″, D. 2¼″

A single peony and leaves deeply carved into red lacquer; yellow lacquer underneath. Interior and base lacquered black.

Date: Ming dynasty, early fifteenth century.

Condition: Major cracks on base, small cracks on cover.

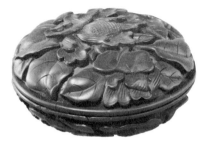

479. Covered box

1928.225

S. Wells Williams Collection; bequest of F. Wells Williams, B.A. 1879

Lacquer on wood; H. 1¼″, D. 2⅛″

A single peony and leaves carved into red lacquer; yellow lacquer underneath. Interior and base lacquered black.

Date: Ming dynasty, probably sixteenth century.

Condition: Major crack on base; repair on rim of cover.

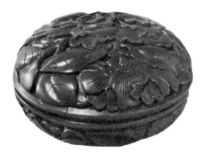

480. Covered box

1955.4.205

Hobart and Edward Small Moore Memorial Collection; bequest of Mrs. William H. Moore

Lacquer on wood; H. 1″ D. 3″

Exterior covered with several alternating layers of black, olive, and cinnabar red lacquers, the top layer red. Scroll pattern carved into layers at an angle (*guri* technique). Interior and base lacquered black.

Origin: Japan.

Date: Edo period, late eighteenth–early nineteenth century.

Condition: Complete.

Provenance: S. and G. Gump, San Francisco, 1930.

Parallel pieces in the Victoria and Albert Museum and the Seattle Museum; see Sir Harry

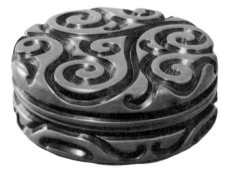

Garner, "Guri Lacquer of the Ming Dynasty," pl. 20f, and *Japanese Art in the Seattle Museum* (Seattle, 1960), no. 183.

481. Box with netsuke

1955.4.37
Hobart and Edward Small Moore Memorial Collection; bequest of Mrs. William H. Moore
Box, mainly lacquered wood; netsuke, ivory; (Box) L. 3¼", W. 2⅞", H. 1⅛"

Outer box decorated mainly with herringbone design in gold and black lacquer; with one rectangular and one circular opening with latticed pewter. Inner box decorated from one side to the other with lady of accomplishments seated at table, in gold and many lacquer colors. Ivory netsuke bears incised S-pattern.
Origin: Japan.
Date: Edo period.
Condition: Tiny section of inner box missing.

482. Dish

1951.51.26
Gift of Mrs. William H. Moore

Lacquer on wood; H. 1¼", D. 5"

A scene, presumably of ladies making a donation of fruit to a temple, depicted primarily in red, black, and gold lacquer, with small amounts of other colors.
Inscription: Trans. (in part) "Shōju made".
Origin: Japan.
Date: Edo period, nineteenth century.
Condition: Complete.

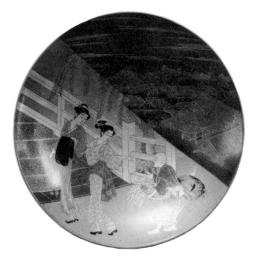

483. Arm rest

1954.49.59

Hobart and Edward Small Moore Memorial
Collection; gift of Mrs. William H. Moore

Ivory; H. 8″, W. 2½″

Convex surface incised with landscape scene
and the poem "The Red Cliff"; calligraphy
and many details darkened, probably with ink.
Other side hollowed out, thick at one end, be-
coming thin at the other.

Date: Ch'ing dynasty, probably Ch'ien Lung
reign.

Condition: Complete.

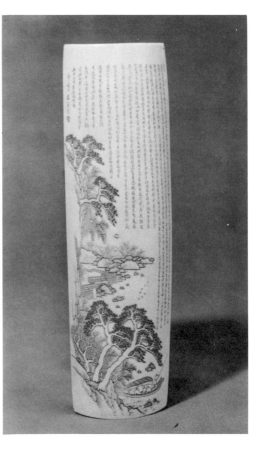

Selective Bibliography

Bronzes

Ackerman, Phyllis, *Ritual Bronzes of Ancient China*, New York, 1945.

Carter, Dagney, *Four Thousand Years of Chinese Art*, New York, 1948.

Chêngchou Municipal Museum, "Chêng-chou shih ming-kung lu hsi-ts'ê ti liang tso shang-tai mu" (Two Shang tombs excavated on the west side of Mingkung Road), *K'ao-ku*, 1965, no. 10, pp. 500–06.

CPAM, City of Sian, "Si-an shih tung-nan chiao Sha-p'o ts'un ch'u-t'u i-p'i t'ang-tai yin-ch'i" (T'ang dynasty silver vessels unearthed at Sha-p'o village in the southeastern outskirts of the city of Sian), *Wên-wu*, 1964, no. 6, pp. 30–32.

Davidson, J. LeRoy, "Three Bronzes in the Hobart and Edward Small Moore Memorial Collection," *Bulletin of the Associates in Fine Arts at Yale University*, 21, no. 2 (1955), pp. 1–5.

Gyllensvärd, Bo, *Chinese Gold and Silver in the Carl Kempe Collection*, Stockholm, 1953.

Hansford, S. Howard, "Pre-Anyang," *Oriental Art*, n.s. 4, no. 1 (1958), pp. 3–4.

Hentze, Carl, "Le Symbolisme des oiseaux dans la Chine ancienne," *Sinologica*, 5 (1958), 65–92, 129–149.

Hentze, Carl, *Objets Rituels, Croyances et Dieux de la Chine Antique et de l'Amérique* Anvers, 1936.

IAAS, *Shang-ts'un-ling kuo-kuo mu-ti* (The Cemetery of the State of Kuo at Shang-ts'un-ling), Peking, 1959.

Institute of Chinese Culture, *Wên-wu ching-hua* (The cream of proper things [art]), 10 vols. Taipei, 1961.

Jung Kêng, *Shang chou i-ch'i t'ung-k'ao* (The bronzes of Shank and Chou), 2 vols. Peking, 1941.

Karlgren, Bernard, "Huai and Han," *Bulletin of the Museum of Far Eastern Antiquities*, 13 (1941), 1–125.

Komai Kazuchika, *Chūkoku kokyō no kenkyū* (A study of ancient Chinese mirrors), Tokyo, 1953.

Kümmel, Otto, *Jörg Trübner zum gedächtnis*, Berlin, 1930.

Loehr, Max, *Ritual Vessels of Bronze Age China*, New York, 1968.

Loehr, Max, "The Stag Image in Scythia and the Far East," *Archives of the Chinese Art Society of America*, 9 (1955), 63–76.

Mizuno Seiichi, *In-shū seidōki to gyoku* (Bronzes and jades of Yin and Chou), Tokyo, 1959.

Salmony, Alfred, "A Problem in the Iconography of Three Early Bird Vessels," *Archives of the Chinese Art Society of America*, 1 (1945–46), 53–65.

Shensi Provincial Committee, *Shensi shêng ch'u-t'u t'ung-ching* (Bronze mirrors excavated in Shensi province), Peking, 1959.

Ssŭ-ch'uan Provincial Museum, *Ssŭ-ch'ûan shêng ch'u-t'u tung ching* (Bronze mirrors excavated in Ssŭ-ch'ûan province), Peking, 1960.

Su T'ien-chün, "Pei-ching hsi-chiao Hsiao-hsi t'ien ch'ing-tai mu-tsang fa-chüeh chien-pao" (Excavations of the Ch'ing dynasty tombs at Hsiao-hsi t'ien, Peking), *Wên-wu*, 1963, no. 1, pp. 50–58.

Tch'ou Tö-yi, *Bronzes Antiques de la Chine appartenant à C. T. Loo et Cie.*, Paris and Brussels, 1924.

Umehara Sueji, *Kodōki keitai no kōkogaku teki kenkyū* (Study of ancient bronzes by shapes), Kyoto, 1940.

Umehara Sueji, *Sengoku shiki dōki no kenkyū* (Study of Warring States bronzes), Kyoto, 1936.

Umehara Sueji, *Shina kodō seika* (The essence of ancient Chinese bronzes), 6 vols. Osaka, 1933.

Waterbury, Florence, *Early Chinese Symbols and Literature: Vestiges and Speculations*, New York, 1942.

Weber, Charles, "Chinese Pictorial Bronze Vessels of the Late Chou Period," *Artibus Asiae*, 28, nos. 2–3 (1967), pp. 107–40.

White, William C., *Tombs of Old Lo-yang*, Shanghai, 1934.

Jades

Arden Gallery, 3000 Years of Chinese Jades, New York, 1939.

Gure, Desmond, "Jades of the Sung Group," Transactions of the Oriental Ceramic Society, 32 (1959–60), 39–50.

Hsi-ch'ing shu-chien i-pien (Supplement to illustrated catalogue of bronzes in Manchu imperial collection), 38, Peking, 1931.

Hsüan-ho po-ku t'u-lu (Illustrated catalogue of Sung imperial bronzes), 30 pên ed., 6.

Salmony, Alfred, Archaic Chinese Jades from the Edward and Louise B. Sonnenschein Collection, Chicago, 1952.

Sullivan, Michael, Chinese Ceramics, Bronzes and Jades in the Collection of Sir Alan and Lady Barlow, London, 1963.

Ceramics

An-yang Archaeological Team, IAAS, "1962 nien An-yang Ta-ssŭ-kung ts'un fa chüeh chien-pao" (A short report of the 1962 excavations at Ta-ssŭ-kung village, An-yang), K'ao-ku, 1964, no. 8, pp. 380–84.

Archaeological Team, Bureau of Culture, Honan province, "Ho-nan shêng Ho-pi-chi tz'ŭ-yao i chih fa chüeh chien-pao" (Excavations of the remains of an ancient porcelain kiln at Ho-pi-chi, Honan province), Wên-wu, 1964, no. 8, pp. 1–12.

"The Arts of the Ch'ing Dynasty," Transactions of the Oriental Ceramic Society, 35 (1963–64).

Bushell, S. W., Oriental Ceramic Art, illustrated by examples from the Collection of W. T. Walters, 10 vols. New York, 1897.

Chou Tao, "Ho-nan P'u-yang pei-ch'i li-yun-mu ch'u-t'u ti tz'ŭ-ch'i ho mu chih" (Porcelain objects and burial records from the Li and other graves of Northern Ch'i times at P'u-yang, Honan), K'ao-ku, 1964, no. 9, pp. 482–84.

Chow, E. T., and F. S. Drake, "Sui-T'ang: a study of Sui Dynasty and early T'ang porcellaneous stoneware," Journal of Oriental Studies, 1 (1954), 355–56.

Christensen, Erwin O., Chinese Porcelains of the Widener Collection, Washington, D.C., 1947.

Cox, Warren E., The Book of Pottery and Porcelain, 2 vols. New York, 1944.

CPAM, Hupei province, "Wu-chang Cho-tao-ch'üan liang-tso nan-sung mu-tsang ti-ch'ing-li" (Excavation of two Southern Sung tombs at Cho-tao-ch'üan, Wuchang), K'ao-ku, 1964, no. 5, pp. 237–41.

CPAM, Shensi province, "Shen-hsi Ch'ang-an Fêng-hsi Chang-chia-p'o hsi-chou i chih ti fa chüeh" (Excavations of a Western Chou site at Chang-chia-p'o, Fêng-hsi, Ch'ang-an county, Shensi province), K'ao-ku, 1964, no. 9, pp. 441–47.

CPAM, Shensi province, "Si-an Wang-chia-fên ts'un ti 90 hao t'ang-mu ch'ing-li chien-pao" (Excavation report of T'ang tomb designated no. 90 at Wang-chia-fên, Sian), Wên-wu, 1956, no. 8, pp. 29–32.

Lady David, Illustrated Catalogue of Ch'ing Enamelled Wares in the Percival David Foundation of Chinese Art, London, 1958.

Exhibition of Chinese Art, Venice, 1954.

Farley, Malcolm, "The White Wares of Fukien and the South China Coast," Far Eastern Ceramics Bulletin, no. 7 (Sept. 1949), 1–10, and no. 9 (March. 1950), 51–63.

Fêng Hsien-ming, "Ho-nan shêng Lin-ju hsien sung-tai ju-yao i chih tiao-ch'a (Reconnaissances of the remains of Sung dynasty Ju Yao kilns at Lin-ju, Honan province), Wên-wu, 1964, no. 8, pp. 15–26.

Hobson, R. L., Chinese Pottery and Porcelain, 2 vols. New York and London, 1915.

Hobson, R. L., The Catalogue of the George Eumorfopoulos Collection of Chinese, Corean and Persian Pottery and Porcelain, 6 vols. London, 1925.

Honey, W. B., Guide to the Later Chinese Porcelain Periods of K'ang Hsi, Yung Chêng and Ch'ien Lung, London, 1927.

Hopei Bureau of Culture Archaeological Team, "Ho-pei Ch'ü-yang hsien Chien-tz'ŭ ts'un ting-yao i chih tiao-ch'a yü shih chüeh" (Reconnaissances and trial diggings con-

ducted on the Ting Yao kiln sites at Chien-tz'ŭ village, Ch'ü-yang county, Hopei province), *K'ao-ku,* 1965, no. 8, pp. 394–412.

Hsüeh Jao, "Kiang-si Nan-ch'êng Ch'ing-chiang ho Yung-hsiu ti sung mu" (Excavations of Sung tombs at Nan-ch'êng, Ch'ing-chiang and Yung-hsiu, Kiangsi), *K'ao-ku,* 1965, no. 11, pp. 571–76.

Japan Ceramic Society, *Chūgoku nisen nen nō bi* (China's beauty of 2000 years), Tokyo, 1965.

Jenyns, Soames, *Later Chinese Porcelains,* London, 1951.

Li Hui-ping, "Tz'ŭ-chou yao i chih tiao-ch'a (Reconnaissances of the remains of the Tz'ŭ-chou kilns), *Wên-wu,* 1964, no. 8, pp. 37–48.

Lindberg, Gustav, "Hsing-yao and Ting-yao: an investigation of some Chinese T'ang and Sung white porcelain in the Carl Kempe and Gustav Lindberg collections," *Bulletin of the Museum of Far Eastern Antiquities,* 25 (1953), 19–71.

Morgan, J. Pierpont, *Catalogue of the Morgan Collection of Chinese Porcelains,* 2 vols. New York, 1911.

Osgood, Cornelius, *Blue-and-white Chinese Porcelain,* New York, 1956.

Palmgren, Nils, *Kansu Mortuary Urns of the Pan Shan and Ma Chang Groups,* Peiping, 1934.

Palmgren, Nils, *Sung Sherds,* Stockholm, 1963.

Pope, John A., *Chinese Porcelains from the Ardebil Shrine,* Washington, 1965.

Der Preukischen Akademie der Künste, *Ausstellung Chinesischer Kunst,* Berlin, 1929.

Prodan, Mario, *The Art of the T'ang Potter,* London, 1960.

Schmidt, Robert, *Chinesische Keramik,* Frankfurt, 1924.

Sekai Tōji Zenshu (Ceramic Art of the World), 16 vols. Tokyo, 1955.

Seligman, C. G., "Early Chinese Glass," *Transactions of the Oriental Ceramic Society, 18* (1940–41), 21–22.

Trubner, Henry, *Chinese Ceramics from the Prehistoric Period through Ch'ien Lung,* Los Angeles County Museum, Los Angeles, 1952.

Trubner, Henry, *The Arts of the T'ang Dynasty,* Los Angeles, 1957.

Tseng, H. C., and R. P. Dart, *The Charles B. Hoyt Collection in the Museum of Fine Arts: Boston,* 2 vols. Boston, 1964.

Yeh Chê-min, "Ho-nan shêng Yü hsien ku-yao chih tiao-ch'a" (Reconnaissances of ancient kiln sites at Yü hsien, Honan province), *Wên-wu,* 1964, no. 8, pp. 27–36.

Sculpture

Ashton, Leigh, *Chinese Sculpture,* New York, 1924.

Ch'in Ting-yü, *Chung-kuo ku-tai t'ao-su i-shu* (A study of Chinese ancient clay-modeling art), Shanghai, 1956.

Davidson, J. LeRoy, *The Lotus Sutra in Chinese Art,* New Haven, 1954.

Goidsenhoven, J. P. van, *La Ceramique Chinoise,* Brussels, 1964.

Hochstadter, Walter, "Pottery and Stonewares of Shang, Chou and Han," *Bulletin of the Museum of Far Eastern Antiquities,* 24 (1952), 81–108.

IAAS, *Chên-chou Er-li-kang,* Peking, 1959.

Kidder, J. E., *The Birth of Japanese Art,* New York, 1965.

Kuno Takeshi, ed., *Kantō chōkoku no kenkyū* (A study of Kantō sculpture), Tokyo, 1964.

Loo, C. T., *Exhibition of Chinese Art,* New York, 1942.

Salmony, Alfred, *Chinese Sculpture,* New York, 1944.

Sirén, Osvald, *Chinese Sculpture from the Fifth to the Fourteenth Century,* New York, 1925.

Sirén, Osvald, "Chinese Sculptures of the Sung, Liao and Chin Dynasties," *Bulletin of the Museum of Far Eastern Antiquities, 14* (1942), 45–64.

Sirén, Osvald, "The Chinese Marble Bust in the Rietberg Museum," *Artibus Asiae, 25,* no. 1 (1962), pp. 9–22.

Painting

Bush, Susan, "Clearing after snow in the Min Mountains," *Oriental Art,* n.s. *11,* no. 3 (1965), pp. 163–72.

Cahill, James, *The Art of Southern Sung China,* New York, 1962.

Hackney, Louise, and Yau Chang-foo, *A Study of Chinese Paintings in the Collection of Ada Small Moore,* London and New York, 1940.

Matsushita Ryusho, *Ink Paintings of the Kamakura Period,* 9 vols. Kamakura, 1961.

Shih-ch'ü pao-chi, 44 vols. Peking, 1744 [Catalogue of calligraphy and painting in the collection of Ch'ien Lung].

Sickman, Laurence, ed., *Chinese Calligraphy and Paintings in the Collection of John M. Crawford, Jr.,* New York, 1962.

Sirén, Osvald, *Chinese Painting: Leading Masters and Principles,* 7 vols. New York, 1956–58.

Sirén, Osvald, *History of Early Chinese Painting,* 2 vols. London, 1933.

Takasaki Fujihiko, "Rakan ga nitsuki" (Lohan paintings), *Museum,* no. 123 (1961), pp. 24–28.

Tomita Kojiro, *A Portfolio of Chinese Paintings in the Museum,* Boston, 1933.

Tomita Kojiro, "Two More Dated Buddhist Paintings from Tun-huang," *Bulletin of the Museum of Fine Arts, 26,* no. 1 (1928), p. 12.

Tu Mu, *T'ieh-wang-shan-hu,* fifteenth century.

Umehara Sueji, "Nirerinfu shutsudo to tsutaeru ichi gun no kansai edagōki" (One group of brightly painted Han bronze objects passed on from the excavation in Yulinfu), *Yamato Bunka, 17* (1955), 67–76.

Wenley, A. G., Book Review, *Journal of the American Oriental Society, 61* (1941), 297–98.

Ch'ang-sha

Ch'ang-sha fa chüeh pao-kao (Cemeteries excavated in Ch'ang-sha), Peking, 1957.

Chêng Chên-to, ed., *Ch'üan-kuo chi-pên chien-shê kung-chêng chung ch'u-t'u wên-wu chan-lan t'u-lu* (A pictorial record of the profusion of historical material displayed through excavations resulting from the construction of public works projects all over the country), 2 vols. Shanghai, 1955.

Chou Shih-jung, "Lüeh-t'an Ch'ang-sha ti wu-tai liang-sung mu" (Short discussion of authentic tombs from Five Dynasties and both Sungs from Ch'ang-sha), *Wên-wu,* 1960, no. 3, pp. 59–63.

An Exhibition of Chinese Antiquities from Ch'ang-sha lent by John Hadley Cox, Yale University Art Gallery, New Haven, 1939.

Fêng Hsien-ming, "Ts'ung liang hsien t'iao-ch'a Ch'ang-sha t'ung-kuan yao so te tao chi tien-shou huo" (By two test investigations an attempt to gain a little genuine progress toward T'ung-kuan ware, Ch'ang-sha), *Wên-wu,* 1960, no. 3, pp. 71–74.

Hunan Provincial Museum, "Ch'ang-sha liang-chin nan-ch'ao sui mu fa chüeh pao-kao" (Report of excavated graves of the two Chin, Nan-ch'ao and Sui dynasties at Ch'ang-sha), *K'ao-ku Hsüeh Pao,* 1959, no. 3, pp. 75–105.

Hunan Provincial Museum, "Ch'ang-sha Lo-chia Ta-shan ku mu tsang ch'ing-li chien-pao" (The excavation of ancient undisturbed burials at Lo-chia Ta-shan, Ch'ang-sha), *Wên-wu,* 1960, no. 3 pp. 51–55.

Hunan Provincial Museum, "Ch'ang-sha nan-chiao ti liang-chin, nan-chao, sui tai mu tsang" (Excavations of Western Tsin, Southern Dynasties, and Sui tombs in the southern suburbs of Ch'ang-sha), *K'ao-ku,* 1965, no. 5, pp. 225–29.

Hunan Provincial Museum, "Ch'ang-sha Wa-cha-p'ing t'ang-tai yao chih tiao-ch'a chi" (A report of the investigation of T'ang dynasty kiln remains at Wa-cha-p'ing, Ch'ang-sha), *Wên-wu.* 1960, no. 3, pp. 67–70.

Lee, George, "Some Ch'ang-sha Ceramics," *Archives of the Chinese Art Society of America, 18* (1964), 62–63.

Newton, Isaac, "Chinese Ceramic Wares from Hunan," *Far Eastern Ceramic Bulletin, 10,* nos. 3–4 (1958), pp. 3–49.

Tregear, Mary, "Ch'ang-sha Pottery in Hong-kong," *Oriental Art,* n.s. 7, no. 3 (1961), pp. 126–30.

Wenley, A. G., "The Question of the Po-Shan-Hsian-Lu," *Archives of the Chinese Art Society of America, 3* (1948–49), 5–12.

Prints, Textiles, Lacquer, and Ivory

Cammann, Schuyler, "Development of Mandarin Squares," *Harvard Journal of Asiatic Studies,* 8 (1944–45), 71–130.

Garner, Harry, "Guri Lacquer of the Ming Dynasty," *Transactions of the Oriental Ceramic Society, 31* (1957–59), 61–73.

Henderson, Harold, and Louis Ledoux, *The Surviving Works of Sharaku,* New York, 1939.

Hirano Chie, *Kiyonaga,* Cambridge, 1939.

Ishida Mosaku, *Japanese Buddhist Prints,* Tokyo and New York, 1964.

Japanese Art in the Seattle Museum, Seattle, 1960.

Ledoux, Louis, *Bunchō to Utamaro,* New York, 1948.

Ledoux, Louis, *Hokusai and Hiroshige,* Princeton, 1951.

Ledoux, Louis, *Sharaku to Toyokuni,* Princeton, 1950.

Shikō Munakata, Cleveland Museum of Art, 1960.

Wang Hsün, "Yung-lo kuan San-ch'ing tien pi-hua ti ts'ai-shih-t'ing" (A preliminary inquiry into the subjects of the wall paintings at the San-ch'ing tien, Yung-lo kuan), *Wên-wu,* 1963, no. 8, pp. 19–40.

Subject Index

All numbers refer to catalogue entries.

Numbers with an asterisk following the name of an artist refer to entries of works by the artist, or attributed to him and the like, in the Yale University Art Gallery; numbers without an asterisk refer to entries where the artist or his work is mentioned or discussed collaterally.

Artists' names are printed in capitals.

HUANG CH'ÜAN, formerly attributed to, *71
Hui-hsien, Honan province, 1, 234
Hunan Provincial Museum, 164, 208

Incense burner, 102, 111, 241, 324
Ink stone, 136
Institute of Archaeology, Tokyo University, 404
International Exhibition of Chinese Art, London (1935–36), 5, 71, 246, 363, 417
Ishida Mosaku, 450–51
ISODA KŌRYŪSAI, *448

Janse, O., 122
Japanese painters, work illustrated: Isoda Kōryūsai, 448; Kanō Tanyū, 447; Suzuki Kiitsu, 449
Japanese printmakers, work illustrated: Andō Hiroshige, 465; Hishikawa Moronobu, 453; Katsukawa Shunshō, 458; Katsushika Hokusai, 464; Kitagawa Utamaro, 461; Kubo Shunman, 460; Munakata Shikō, 466; Okumura Masanobu, 454; Suzuki Harunobu, 457; Torii Kiyohiro, 456; Torii Kiyonaga, 459; Torii Kiyonobu, 455; Tōshūsai Sharaku, 463; Utagawa Toyokuni, 462
Jenyns, Soames, 49, 244, 366, 384
Jung Kêng, 3, 10, 15
Junkunc, S., Collection, 57

K'ai-shu, 67
Kamakura City Museum, Kamakura, 77
Kanegafuchi Spinning Co., Osaka, 451
KANŌ TANYŪ, *447
KANŌ TSUNENOBU, 447
K'ang Hou kuei, 230
Kao-lu, Sian district, Shensi province, 406
Karatsu ware, 394
Karlbeck, Orvar, 294
Karlgren, Bernhard, 2, 15, 231, 233–35, 238
KATSUKAWA SHUNSHŌ, *458
KATSUSHIKA HOKUSAI, *464
KEINYŪ, raku potter, *397
Kempe, Carl, Collection, 14, 27
Kêng Chao-chung, 74, 414
Kidder, J. E., 403–04
KIITSU. See SUZUKI KIITSU
Kim Chewon, 392
Kimono, 476–77
KITAGAWA UTAMARO, *461
KIYOHIRO. See TORII KIYOHIRO
KIYOMIZU GENEMON, potter, *400
KIYOMIZU ROKUBEI, potter, *395
KIYONAGA. See TORII KIYONAGA
KIYONOBU. See TORII KIYONOBU
Koerber, H. N. von, 63
Köln Museum, 420
Komai Kazuchika, 12
KŌNYŪ, raku potter, *397
KŌRYŪSAI. See ISODA KŌRYŪSAI

KU LIN, *416
KU WÊN-YÜAN, 434
Kuan type, Lung-ch'üan kilns, Chekiang province, 37, 313
KUBO SHUNMAN, *460
Kuei, 20, 236–37
Kümmel, Otto, 7, 63
Kuno Takeshi, 59
Kwen, F. S., 68–69
Kyoto University Collection, 9

Labouchere, Sir George, Collection, 305
LAN YING, *79
Laufer, Berthold, 105, 243
Ledoux, Louis, Collection, 460, 462, 464–65
Lee, George, 196–200
Li, T. Y., 431
Li Ch'ing-wa Collection, 368
Li Hsüan-chou Collection, 420
Li Hui-ping, 297
Li Lin-ts'an, 68–69
Li O, 415
Lien, 126, 270–71
Lindberg, Gustav, 27
Lin-ju hsien, Honan province, 33, 307, 320
Lion-Goldschmidt, Daisy, 56, 335, 389
Liu Lien-yin, 133
Lo-chia Ta-shan, Ch'ang-sha district, Hunan province, 208
Lodge, F. Brody, Collection, 34
Loehr, Max, 1, 7, 71, 237, 265
Lohan, 75, 256, 427
Loo and Co., New York, 17, 407, 409
Los Angeles County Museum, 30
Lotus sutra, 58
Lu Hsin-yüan Collection, 76
Lu K'ai, 329
LÜ T'IEN-JU, *415
Lüeh-t'an, Ch'ang-sha district, Hunan province, 175, 202, 204
Lung-ch'üan ware, Chekiang province, 38, 225, 310–12
Lung-hu shan, Kiangsi province, 213–14
Lung-shêng-k'ang, Canton, 120

MA YÜAN, formerly attributed to, *423
Makie, 65
Mandarin square, 472–73
Marbled ware, 285, 294
MASANOBU. See OKUMURA MASANOBU
Matsunaga Memorial Museum, Odawara, 59
Matsushita Ryusho, 77
Mayuyama Junkichi, 75
Medley, Margaret, 330
Mei-p'ing, 331, 344, 379
Menasce, G. de, Collection, 361
Menzies, J. M., 2
MI YU-JÊN, formerly attributed to, *76

Mills College, Oakland, 6, 13, 231, 476–77
Minneapolis Institute of Arts, 4
Mirror, 9, 12–13, 231, 233–34, 239
Mizuno Seiichi, 15
MO SHIH-LUNG, 76
Monkhouse, Cosmo, 338
Monochrome glazes, late Chinese: apple green, 348; *clair de lune*, 44, 341–42; peachbloom, 351–54; "powder blue," 369; mirror black, 370–73; *sang de boeuf*, 349–50; 377; sapphire blue, 343–45; "tea dust," 378–79
Moreau-Gobard, Jean-Claude, 335
Morgan, J. Pierpont, Collection, 46
MORONOBU. *See* HISHIKAWA MORONOBU
Morrison, John, Collection, 366
MUNAKATA SHIKŌ, *466
Musée de l'Orangerie des Tuileries, Paris, 31
Museum of Art, University of Michigan, Ann Arbor, 12
Museum of Far Eastern Antiquities, Stockholm, 264
Museum of Fine Arts, Boston, 61, 217

Nan-ch'êng, Kiangsi province, 32
Nan-fên-chou, near boundary of Shansi and Shensi provinces, 58
Nanking Museum, 182, 210
National Museum, Tokyo, 10
National Museum of Korea, Seoul, 392
National Palace Collection, Taipei, 74
Nelson Gallery–Atkins Museum, Kansas City, 57, 409, 451
Newton, Isaac, 88, 121, 144, 150, 155, 157, 161, 163, 168, 173, 182, 189, 205, 218
Ninna-ji, Kyoto, 65
Nishitani Shenji, 96–97
Nō robe, 474
Northern celadon ware, 35, 305–07
Nott, Stanley, 256

Oberlin Museum, 409
Oda Nobunaga, 452
OKUMURA MASANOBU, *454
Osgood, Cornelius, 39, 357
Overglaze enamels: *Canton*, 368; *famille rose*, 54, 56, 366, 389; *famille verte*, 48, 365; multiple, 47, 51, 53, 367, 386–87, 389–90

P'a ts'un, Yu district, Honan province, 286, 295
Pa-chi-hsiang (eight precious things, Buddhist), 362, 371
Palette, 161
Palmgren, Nils, 38, 263, 298, 306, 312–13
P'an, 232
P'AN KUNG-SHOU, *444
Pendant, 17, 246
Philadelphia Museum of Art, 74
Pi, 242, 245

Pi-hsieh, 19
Piecrusted bowl, 29
Pien Yung-yü, 76
Pilgrim bottle, 39
Pillow, 171, 183, 196, 297
P'ing-shih, 76
Plaque, 18
Plumer, J. M., Collection, 12
Po-shan-hsiang-lu, 102
Pole top, 4
Pope, John A., 328, 393
Priest, Alan, 60
Princeton University Art Museum, 4, 237
Prodan, Mario, 31
P'u-tu ts'un, Sian district, Shensi province, 266
P'u-yang, Honan province, 274, 281

Raku ware, 396–97
Reitberg Museum, Zürich, 410
RIYŌNYŪ, potter, 396
Rosette, designs of, 39, 148
Rousset, Robert, Collection, 407
Rowe, Margaret, T. J., 3, 351
Rowland, Benjamin, 71
Royal Ontario Museum, Toronto, 23, 409

SAKUGEN, *78
Salmony, Alfred, 3, 15, 17–18, 245, 247, 411
San-ts'ai, 326
Schiller Collection, City Art Museum, Bristol, 31
Schmidt, Robert, 375, 383
Scott, Hugh, 28
Seattle Art Museum, 480
Seiryō-ji, Kyoto, 75
Seligman, C. G., 23
Seligman, Mrs. C. G., Collection, 317
Sha-p'o, Sian district, Shensi province, 14
Shang-ts'un-ling, Honan province, 8, 9
SHARAKU. *See* TŌSHŪSAI SHARAKU
Shibayama Haniwa Museum, 403
Shidoro ware, 398
SHIH CHIH-LI, *442
Shih-ch'ü pao-chi, 71
Shu-fu ware, 318
SHUNMAN. *See* KUBO SHUNMAN
SHUNSHŌ. *See* KATSUKAWA SHUNSHŌ
Sickman, Laurence, 418, 429
Siren, Osvald, 60, 71, 410, 419, 431
Sizer, Theodore, 24
Sonnenschein Collection, Art Institute, Chicago, 18, 245
Städtisches Völkermuseum, Frankfurt, 38
Stemcup, 211, 225, 381
Stove, model of, 103
Su T'ien-chün, 241
Sui-yang, Honan province, 68–69
Sullivan, Michael, 20, 31, 34, 309, 328

Index by Accession Number

Index of Donors

Anonymous, 79
Art Gallery Associates, 77
Associates in Fine Arts, 406, 410
Bareiss, Walter (B.A. 1940), 455, 463
Bruce, Mrs. Mellon, 366
Bull, Mrs. C. Sanford, 378
Cho Duck-whan, Mr. and Mrs., 391
Cox, John Hadley (B.A. 1935), 22, 36, 90–118, 121–88, 190–228, 264–65, 274–81, 288, 295, 297, 301, 306
Dilworth, Mrs. Dewees W., 41, 325, 331, 373
Ficke, Mrs. Arthur Davison, 421
Fitch, George H. (B.A. 1932), and Mrs. Fitch, 25, 309
Foss, Wilson P., Jr. (Ph.B. 1913), 48, 350, 363
Gee, Mrs. John A., 431
Griggs, Maitland F., (B.A. 1896), 405
Guest, Winston F. C. (B.A. 1927), 16, 60, 344, 411
Hackney, Louise Wallace, 62
Hanna, Mrs. Howard, Mrs. Paul Moore, and Leonard C. Hanna, Jr. (B.A. 1913), 401
Howard, Mrs. Howell H., 349
Kneeland, Dr. Yale, Jr. (B.A. 1922), 33, 42, 49, 53, 334–35, 338–40, 345, 353–54, 356, 361, 372, 374–76, 381, 384–85, 387
Meek, Samuel W. (B.A. 1917), 409
Mellon, Paul (B.A. 1929), 189
Moore, Mrs. Paul, 240
Moore, Mrs. William H., 1–9, 11–15, 17–21, 23–24, 26–30, 32, 34–35, 38, 43–44, 46–47, 51, 54, 61, 63–69, 71–74, 76, 84–86, 119–20, 230–31, 233–39, 241, 243–50, 252–63, 266–67, 285, 287, 289–91, 294, 299, 302, 308, 310, 313, 315–17, 321–23, 326, 332–33, 337, 341–42, 346–48, 351–52, 355, 357, 360, 362, 364–65, 368–71, 379–80, 386, 392, 395–96, 398–99, 408, 412–18, 422–29, 436–37, 447, 451–53, 456–58, 460, 462, 465, 467–77, 480–83
Morse, Mrs. Charles J., 394, 397, 400
Morse, Earl, 70, 441
Morse, Mrs. Jared K., 75, 449, 454, 459
Olsen, Mr. and Mrs. Fred, 282
Olsen, Mr. and Mrs. Fred, Mr. and Mrs. Laurens Hammond, and Mr. and Mrs. Knight Wooley (B.A. 1917), 403–04, 448, 461, 466
Riggs, T. Lawrason (B.A. 1910), 430, 440
Steiner, Leopold, 442
Van Volkenburgh, Florence Baiz, 10, 45, 55, 328, 343, 358–59
Webb, J. Watson (B.A. 1907), and Electra Havemeyer Webb, 229, 242, 251, 271, 336
Wêng, Wango, H. C., 80–82, 419–20, 432–35, 438, 443–44, 446

Williams, Mrs. Frances Wayland, 31, 37, 39–40, 57, 268–70, 272–73, 283–84, 286, 292–93, 296, 300, 303–05, 307, 311–12, 314, 318–20, 324, 327, 329–30, 393, 402, 407
Williams, F. Wells (B.A. 1879), 50, 52, 56, 58, 367, 377, 382–83, 388–90, 478–79
Yamanaka and Co., 232